CAPACITY

HISTORY, THE WORLD, AND

THE SELF IN CONTEMPORARY

ART AND CRITICISM

CRITICAL VOICES IN ART, THEORY AND CULTURE

A series edited by **Saul Ostrow**

Seams: Art as a Philosophical Context

Essays by Stephen Melville
Edited and Introduced by Jeremy Gilbert-Rolfe

Capacity: History, the World, and the Self in Contemporary Art and Criticism

Essays by Thomas McEvilley
Commentary by G. Roger Denson

Forthcoming Titles

Hot Potatoes: From Formalism to Feminism. Essays by Lucy Lippard. Commentary by Laura Cottingham

Media Research: Technology, Art, Communication. Essays by Marshall McLuhan. Commentary by Michel A. Moos

Literature, Media, Information Systems. Essays by Friedrich A. Kittler. Edited and with a Commentary by John Johnston

This book is part of a series. The publisher will accept continuation orders which may be cancelled at any time and which provide for automatic billing and shipping of each title in the series upon publication. Please write for details.

G. ROGER

DENSON

THOMAS

McEVILLEY

CAPACITY

HISTORY, THE WORLD, AND

THE SELF IN CONTEMPORARY

ART AND CRITICISM

Essays by
Thomas McEvilley

Commentary by
G. Roger Denson

Australia Canada China France Germany India Japan
Luxembourg Malaysia The Netherlands Russia Singapore
Switzerland Thailand United Kingdom

Amsteldijk 166
1st Floor
1079 LH Amsterdam
The Netherlands

Early versions of chapters 1, 3, and 6 appeared in *Artforum* (1982, 1984, and 1983, respectively). Chapters 1, 6, and 9 were published in their present form in 1991 in *Art & Discontent: Theory at the Millennium*, McPherson & Company Publishers, Kingston, New York, copyright © 1991 by Thomas McEvilley. Chapter 3 was modified and printed in 1992 in *Art & Otherness: Crisis in Cultural Identity*, McPherson & Company, copyright © 1992 by Thomas McEvilley. These are reprinted here courtesy of McPherson & Company.
Chapters 5 and 8 debuted in *Artforum* (1993 and 1988, respectively).
Chapter 2 was first published in *La Couleur Seule: L'experience du Monochrome. Musée St. Pierre, Ville de Lyon* (1988). Chapter 4 originally appeared in *Kunst & Museumjournaal* (1991), and chapter 7 in *Krisis* (1985).

British Library Cataloguing in Publication Data

McEvilley, Thomas, 1939–
 Capacity : history, the world, and the self in contemporary
 art and criticism. – (Critical voices in art, theory and
 culture)
 1. Art, Modern – 20th century 2. Art criticism
 I. Title II. Denson, G. Roger
 759'.06

 ISBN 90-5701-051-8 (hardcover)
 90-5701-041-0 (softcover)

CONTENTS

INTRODUCTION TO THE SERIES

ritical Voices in Art, Theory and Culture is a response to the changing perspectives that have resulted from the continuing application of structural and poststructural methodologies and interpretations to the cultural sphere. From the ongoing processes of deconstruction and reorganization of the traditional canon, new forms of speculative, intellectual inquiry and academic practices have emerged which are premised on the realization that insights into differing aspects of the disciplines that make up this realm are best provided by an interdisciplinary approach that follows a discursive rather than a dialectic model.

In recognition of these changes, and of the view that the histories and practices that form our present circumstances are in turn transformed by the social, economic, and political requirements of our lives, this series will publish not only those authors who already are prominent in their field, or those who are now emerging—but also those writers who had previously been acknowledged, then passed over, only now to become relevant once more. This multigenerational approach will give many writers an opportunity to analyze and reevaluate the position of those thinkers who have influenced their own practices, or to present responses to the themes and writings that are significant to their own research.

In emphasizing dialogue, self-reflective critiques, and exegesis, the *Critical Voices* series not only acknowledges the deterritorialized nature of our present intellectual environment, but also extends the challenge to the traditional supremacy of the authorial voice by literally relocating it within a discursive network. This approach to texts breaks with the current practice of speaking of multiplicity, while

continuing to construct a singularly linear vision of discourse that retains the characteristics of dialectics. In an age when subjects are conceived of as acting upon one another, each within the context of its own history and without contradiction, the ideal of a totalizing system does not seem to suffice. I have come to realize that the near collapse of the endeavor to produce homogeneous terms, practices, and histories—once thought to be an essential aspect of defining the practices of art, theory, and culture—reopened each of these subjects to new interpretations and methods.

My intent as editor of *Critical Voices in Art, Theory and Culture* is to make available to our readers heterogeneous texts that provide a view that looks ahead to new and differing approaches, and back toward those views that make the dialogues and debates developing within the areas of cultural studies, art history, and critical theory possible and necessary. In this manner we hope to contribute to the expanding map not only of the borderlands of modernism, but also of those newly opened territories now identified with postmodernism.

Saul Ostrow

I have to admit for many years I read Thomas McEvilley's writing and just didn't get it. It was interesting, and he always made a compelling point, but what I didn't get was his principle: I couldn't figure where he was coming from. While it definitely was a critique of modernism, it didn't fall into any of those models that had gained currency in the 1980s. He didn't fit in with the post-structuralism of the October group and while there was an evident politic to his writing (we all remember his scathing attack of the primitivism show at the Museum of Modern Art, written in record time so as to make it into an issue of *Artforum* that was already on its way to press), it was neither of the Frankfurt School type nor did it fit well with the neo-Marxism of Frederic Jameson. McEvilley was out there on his own, arguing for diversity, multiculturalism and the intricacies of Neo-figuration, and against the claims of modernist metaphysics. Not that his own arguments were any less metaphysical, but then again it was a metaphysics that acknowledged itself.

In those days one had gotten used to various and sundry arguments—both truly philosophical and pseudophilosophical—making their way into art criticism; seldom were these of the classical kind. Who was prepared for Aristotelian and Socratic arguments, or an analysis of postmodernism based on the structure of ancient Greek culture? The idea of return, repetition, and variation had yet to gain currency. Most people still harbored a vision of Nietzsche as a Nazi ideologue, and still believed in dialectics, even if their politics weren't as Marxist as they had been at the end of the 1960s. It was my continued reliance on a dialectical model that made it nearly impossible for me at the time to see what McEvilley was actually up to. He

wasn't being arbitrary, opportunistic or merely eclectic; instead he was being discursive. He was bringing to bear on his subjects the differing approaches and information that they themselves seemingly required so as to be able to construct the critical tools essential to the task of exposing their inner workings and the assumptions that these were premised on. Yet he did not leave things there—his intent was neither to be reductive nor judgmental, but to propose what might be a corrective to modernism's instrumental views.

In just this spirit G. Roger Denson uses this opportunity to both analyze McEvilley's positions and to address the role of the art writer within the schema of postmodernism's multiple and divergent models. In his texts Denson addresses McEvilley's practices as an example of just the type of critical approach our times require. He premises this assertion on the theories of practice and critical discourses of postcolonialism that have developed in recent years. Proposing an intelligible though unorthodox account of the issues of multiculturalism, postcolonial discourse, and a discursive approach, Denson highlights the contradictions that exist between advanced art and how contemporary criticism is characterized, as well as what it claims to represent.

Denson views critics in general as restrained in their interpretations, as often seeking consensus rather than opening new areas of inquiry in the face of an art that has become unlimited in its capacity to signify "everything between and including itself and the world." These critics having become enamored of recent history, cannot see back past the last four or five generations. In turn they apply the same paradigmatic texts to what they perceive to be ready-made situations. In this way he sees the job of criticism as being hindered, and views "much of what is being published today in the name of criticism as functioning as advertising appropriating a theoretical style."

Using the 1991 Whitney Biennial's "reading room" as a problematic example of the representation of critical texts as isolated from the debate and dissents from which they are derived, Denson observes that the effect of this is to reenforce an image of serious criticism as being removed from everyday concerns. He laments that the ghettoization of art criticism sustains its compromised nature by establishing a hierarchy that speaks of democratization but thrives as

a form of validation. He complains that for all the art world's sup-
posed commitment to expanding or dismantling the existing
Western canon, art writers and cultural critics continue to uphold a
narrow and orthodox view. This situation of course is not unique to
the art world but seems to be a condition that is endemic to—and
sustained by—the homogeneity of the most accessible and popular-
ized versions of postmodernist theory.

His analysis of the isolation, academicism, and commercialism of
most contemporary criticism does not come from a "holier-than-
thou" attitude, nor is it explicitly political. Instead Denson implies
that we are missing out on something: the emancipation and exhila-
ration that comes with challenging the limits of one's knowledge and
beliefs, as well as putting forward varied and imaginative interpreta-
tions. To achieve this the critic must be able to recognize that there
is no essential or primary point of entry common to all art. He con-
cludes that it is through such ecstatic practices that criticism will
establish itself as part of the process of social change, rather than
remaining isolated from the greater body of knowledge that inspires
it. It is within this aspiration that Denson joins the new to the old for
his belief "that art itself can facilitate our nomadic passage through
the models of other lives, ideologies and cultures," empowering us
not only to imagine or represent, but to literally *experience* our capac-
ity and that of the world. In this, Denson recuperates for postmod-
ernism the vision of modernism inspired by the likes of Theodor
Adorno.

Saul Ostrow

*T*he view that art is a language or system of signs has predominated in the critical discourse for at least a quarter of a century. This view greatly expands the capacity of art over the views of those in history: the Platonists, who held art to be chiefly mimetic; the Aristotelians, who believed art is a realization of the ideal; the Romanticists, who thought art's chief virtues lie in its expression; and the formalists, who held art to be a reflexive articulation of universal consciousness and form. Making art a language has given it an unlimited capacity it never had before: to signify everything between and including itself and the world, from the singular and uniform to the infinite and heterogeneous. And now Western art is greeted by the many languages of other arts, some hailing from far parts of the globe which are as yet not well known.

Although this expanded capacity has been exploited by Western artists for decades, critics of contemporary art in the 1990s still seem constrained in their interpretations. Few enter the ocean of reference at points other than those of immediate and direct concern to the Western modernist or postmodernist positions. We have perhaps become so enamored of the small vein of history flowing through a mere four or five generations of Western European and American production that we often cite its texts and paradigmatic works rather than search the annals and excavations and living cultures of the hundreds, perhaps thousands of world societies extant, just as we as often and habitually apply the received ideologies of authorities to life's problems rather than work out specific solutions of our own design. If popular culture seems to generally shun the world of texts, intellectual culture too zealously insulates itself with them. Critics are probably the most bookish denizens of the art

world, so it is we who are most likely to be inhibited by what Edward Said has called the anterior restraint of texts. If so, our restraints in many cases have tightened, even as art's restraints have loosened.

Yet, myopic citation is not restricted to the artworld. It is an affliction found throughout postmodern, poststructural, feminist, and even multicultural discourse. Our educations encourage specialization, research-grounding, and appeals to prior authority over expansive or lofty speculation and visits to marginalized sites and cultures, and hence imagination and stylization of discourse has become circumscribed by the image of science and its method of narrowing down deductions and models to those approved by a tight consensus. Many of us carry this image of science into our discourse on art even when our subject is not of a scientific nature, which most of the time it is not. Of course, the authorities we cite bring immensely complex and vital material that is varied in interpretation, groundbreaking, and at times even emancipating. And even in the most rigorous work there exists a tension between freedom and constraint that can be exhilarating to the disciplined mind. Yet, when authority and discipline overtake the mind, we slide into convention and consensus. Today's most celebrated books are crammed with bibliographies and endnotes, but often they disclose that most of us are reading the same or closely related material and abiding by the same methods and structures. We are insulating ourselves in a closed system of approved texts and models. And our capacity is diminished.

When we see this tendency plaguing curators and artists outside the academies, we know the nadir of cultural invention has been reached. And that nadir seems to have been uncovered when, at the Whitney Museum of American Art's 1993 Biennial, an exhibition area was devoted to comprising a library in which a strictly prescribed selection of written material represented the new multicultural world view. Most of the exhibition's art was expansive, opening art's institutional context to political, ethnic, sexual, family, and gender issues long proscribed, and for this the museum should be extolled. But in assembling a library for the viewer to peruse an "introduction" to current multicultural theory and criticism, the curators inadvertently undermined the written works' emancipating value and diminished the writers' achievement of having become assimilated within the vast, diverse, and contentious archive of

humanity. For the work of the contemporary authors appeared isolated from the greater body of recorded history, civilizations, personal literature and art which inspired them, with which they debate and dissent from, and among which they are normally shelved as a part. By creating the impression that they require a special context, their alterity was ghettoized and their effectuality in mainstream civilization was downplayed. Their difference was also made monolithic and "other" rather than shown to be part of the heterogeneity that is extant everywhere in the world.

To accomplish the various agenda of social change in mainstream society, debate and dissent has to be carried on at its heart (or hearts). The Whitney Museum of American Art is one heart of current Western culture, and the curators have indeed brought debate to it. But that is why the lumping together of political and social writings, rather than representing them as distributed throughout society, made them appear to be still outside it, and then as only a fast and flatly received sign of didacticism and ideology. Furthermore, their symbolic severance from the larger history of world literature signaled a desired proscription of choice: we should read *this* and not *that*, and again the issue of debate is made secondary to the implementation of power. Regardless of how inadvertently the selection was conducted, or with whatever good intentions, the reading room's paternal conceit and closures impeded democracy.

This is no minor complaint: criticism has too often hindered art in the former's mimicry of science and quest for a utopian society. Yet, there is another confluence that is just as dangerous: the conflation and confusion of art with the appreciation of capital. The predilection for citations of authority is often instrumental in inflating the commercial value of art. This is not so much a hindrance to art writers as it is a conflict of interest. Clement Greenberg, whose authoritarian thought led us to one of the twentieth century's most famous *cul de sacs* (and that's what all tyrants do—lead us to points where thought closes off), once remarked that much of what was being written about art at the time was journalism, not criticism. Things have changed since then: in most catalogs and some trade journals on art today, much of what is being published in the name of criticism functions as advertising copy appropriating a theoretical

style. Science and commerce together kill off much more inquiry and production than they promote.

To my mind, the best art criticism is both acknowledging of anterior authority and irreverent to and sparring with it; it understands the market's necessity and yet is resistant to its manipulations. It also recognizes no foundational, essential, or primary entry point as common to all art. The entry to and egress from an artist's model is seen as relative to and shifting with each artist. A handful of such art criticism nurtured us through the art binge of the 1980s and the hangover of the 1990s, but only one critic consistently displayed both a range of erudition encompassing the greater history of civilization and an acute sensitivity to the features and aura of writing itself.

Beginning in the early 1980s, art aficionados had recourse to a new and altogether more capacious vision. The writings of Thomas McEvilley, appearing in the monthly magazine *Artforum* and in museum catalogues, gave us a remarkably sagacious pairing of a direct knowledge of the newest art and theory produced in North America and Europe with a comprehensive understanding of the classic and contemporary art and ideas of ancient and distant civilizations and cultures. By the early 1990s, some of McEvilley's essays had been gathered into collections, such as *Art and Discontent: Theory at the Millennium*, *Art and Otherness: Crisis in Cultural Identity*, and *The Exile's Return: Toward a Redefinition of Painting for the Post-Modern Era*. When compiled together the essays reveal a historical knowledge of art and its context unparalleled in scope.

It is rare to find a writer on contemporary art equally fluent in the writings and production of modernist aesthetics, postmodernist anti-aesthetics, T'ang dynasty Taoist painting manuals, the doctrines and rites of Tantra and Yoga, Pythagorean and Platonic mysticism, Aristotelian logic and empiricism, German and French Romanticism, the inscriptions of Old Kingdom Egypt, Buddhist Abhidharmic and Prajnaparamita literature, nineteenth Century occultism, Anglo-American analytic philosophy, language analysis and Logical Positivism, pre-Socratic philosophy and pre-Homeric literature, the doctrines of the Essenes, the Cabala, the Asian materialists, Kantian epistemology and aesthetics, the skeptics of all eras, subatomic physics, Afrocentric revisionism, postcolonial political theory, and contemporary technology.

McEvilley's command of the history of world cultures accounts for his ability to distinguish the singular contributions of contemporary Western artists and critics from among the often confusing and controversial convergence and collision of styles and ideas that compete for the attention of viewers. His encyclopedic range of cultural knowledge facilitates his ability to see beyond the shortsighted visions of his contemporaries, particularly regarding the issues of modernism, postmodernism, and multiculturalism, for his historical learning facilitates him with a seemingly reflex "sensor" of connections and discontinuities across space and time that most of us can hardly fathom.

As art at the millennium is one of great and changing capacity, especially art of the global arena, criticism can only keep apace if it does not bog down in central ideology or static systems. McEvilley is attuned to the world by employing a nomadic attitude. His is not a strict methodology—he's too pragmatic and adaptable for that—but a changing, responsive entry and egress of models from diverse origins considerate of the defining features and principles of those models. Be they local, national, ethnic, religious, scientific, gender specific, or personal, McEvilley critiques an artform or discourse according to the criteria it has apparently established for itself. McEvilley of course brings and projects criteria and judgment on the art or discourse, for to not do so would be something other than criticism, but he always conjoins that criteria and judgment with an expansive knowledge of the context in which it has been made. This is why the span of his knowledge is noteworthy: for it enables him to enter models that most of us consider too exotic or esoteric to understand.

McEvilley quite simply provides the reader with broader insights into an artist's or critic's work, crossing cultural and historic boundaries not explored by intellects with lesser erudition or experience of cultural diversity. Comparatively, his criticism embodies the difference, say, between placing the contributions of an artist like Ad Reinhardt in a context shared only by contemporaries like Barnett Newman and Kenneth Noland, or even with precursors like Malevich and Mondrian—as did a writer like Greenberg—and placing Reinhardt along with both his contemporaries and the writers and artists of Buddhist texts and Taoist mandala manuals with which Reinhardt himself was concerned.

SECTION ONE

History As Context: Expanding Modernist Form

*T*o many postmodern critics, the ancient issue of form versus content seems outmoded and surpassed by the more capacious issue of art's context. Defined as the intersection of cultural circumstances and environmental conditions variously giving rise to specific thought and production, context is thought in general today to determine how form and content will relate in each given case. This really isn't that new an idea; the form-content debate goes back at least to Plato, and something akin to the notion of context has been raised at various times in that legacy through the use of ordinary words like "intention," "circumstances" and "conditions," or special connotations of "history," "culture," "nature," and "the environment." But though these terms referred to the ways that an object is made or interpreted, they rarely if ever implied, as context does today, a relativistic determination of the ways in which form and content relate to each other. For form and content were thought to be governed by absolute and universal principles.

For the relativist, context has taken the place of the universal principle or the objective world. It is the arena in which all the people of the world project their subjective interpretations of form and content and receive the projections of others onto those interpretations. Context is the arena that links subjectivities, not in an objective frame, but in an overlapping and ever-permutating procedure that has no definite shape or metaphor with which to describe it. Context, then, is intersubjective: it is the product of the vague but commonly understood agreements of how to define the world and of what subjectivities overlap significantly enough to function in—and be represented as—conventional reality.

This view of context is, of course, shared by only a small minority of the world. But the importance of context as a mediator of form and content has been promoted and assimilated even in models that purport to have an objective and stable framework. In the objective model, context simply represents a slice of the objective world that is experienced in one way by some and in other ways by others; even here it functions relativistically, as it is the part of the world that defines, or is defined by, a local population at a specific time. The important thing to know is that context is generally agreed to determine the way that form and content become manifest.

In this assurance, at least in the world of art criticism and aesthetics, context has become our new conceit, much the way that the notion of universal quality was the conceit of earlier generations of artists and art critics. Because of the widespread recognition of context, many critics have come to assume that the old form-content debates have been solved or explained. I once held this view too, though now I believe they have been merely sidestepped. The reason I've changed my mind has much to do with the work of Thomas McEvilley, particularly that which sought to put to rest the old form-content debate waged by Clement Greenberg and the mid-twentieth century formalists. For McEvilley entered the postmodernist discourse on context by trying to show that the form-content breach was invariably the result of the projection of false claims for universality onto the artwork. And though he too believes that through an examination of the circumstances and issues surrounding the production of art the formalists' problem with content can be terminated rather easily, his hindsight allows him to identify and break down the problem further.

The formalists' problem with content, McEvilley indicates, stems from the same problem that most modernists had with principles in general: they tried to root all specific events and behaviors in a universal ground that was unchanging and absolute. For McEvilley, the relationship of form to content cannot be explained by universal principles because that relationship is different from case to case and thus requires a relativistic and practical approach to the interpretation and analysis of each case. The formalist, meanwhile, instead of measuring the values that form and content take on within a given cultural framework, tries to find a science that will describe the precise ways in which form and content conform to the harmony of uni-

versal principles. This creates a slippage between the way that the components of form and content are seen working in the art and the way that the analysis of it offered by the formalist is described. While many observers sensed this slippage was there, few could explain it as well as McEvilley.

Quite simply, McEvilley redefined the terms in which we spoke about art in the 1980s and 1990s by denying validity to the notion of universal form and content. After bringing the issue down to earth, he placed emphasis on the changing nature of value judgments in its place: "it's a matter of the framework shifting around the act of judgment," he said of the value judgment in an essay entitled "Revaluing the Value Judgment" (included in his book, *Art and Otherness: Crisis In Cultural Identity*). Although he doesn't always discuss context as such, it is implied when he speaks of a consensus of opinion built up over time and persisting through history as a received wisdom, and when he opines that all changes in value are made in reference to this received wisdom. Seeing the form-content debate in the light of context, we see that the different ways that form and content recombine do not imply that they must reconcile with some guiding and universal standard of harmony, but rather that they will come to terms with the contingent values and functions established for form and content by general consensus.

To show how this mediating context works, McEvilley refers usually to history and geopolitical terrain. But the histories and geopolitics McEvilley cites aren't restricted to the West's Plato-via-Kant-to-Greenberg aesthetic model, nor to the Giotto-via-Manet-to-Warhol model of painting that most Western art critics cite. All cultures and calendars offer rich rewards in his analysis. For example, in tracing back the nascence of the painted monochrome, McEvilley doesn't stop in Europe, as many art historians do, say, at the point in the 1840s when Turner's seascapes deliquesce into effulgent color. Rather, McEvilley goes back to the Tantric paintings of seventeenth-century Asia (see "Heads It's Form, Tails It's Not Content" and "Seeking the Primal Through Paint: The Monochrome Icon"), in which the embodiment of absolute unity is represented with a single field of color. No world civilization or precivilization is considered unworthy of citation alongside the formidable Western canon of masterpieces and modern contexts so long as the comparison seems

relevant and respectful to both contexts. In this capacious exploration, the articulation of the form's relationship to content is shown to be handled with astonishing variety.

As McEvilley's background in the classical and tribal literatures and productions of the world enable him to reread the formalist notion of *pure form* as a manner of "selective seeing," similarly, his background in logic enables him to see through and dispel the modernist myth of "art for art's sake" as no more than a variation on the Law of Identity. According to McEvilley, the Law of Identity, which states that "Everything, insofar as it is anything, is itself and is not not itself," is a proposition which is true of the identification of all things. Hence, when it is applied to art, as it was by artists like Ad Reinhardt and Joseph Kosuth, the Law of Identity denies art's special status, a side effect that most of those who invoked it throughout modernism's tenure might find undesirable. The myth of "art for art's sake" may have become unfashionable before McEvilley scrutinized it, but his logical analysis sounded the death knell of the modernist myths of the primacy of form and the displacement of content.

McEvilley's recourse to history also makes him keen to the issue that there has been a succession of "modernist" and "postmodernist" movements extending back to the Greeks of the sixth century B.C.E. and probably before. From this inference, McEvilley proceeds to compare the golden ages of the Egyptians, Sumerians, Greeks, Romans, and Indians with the activities of Duchamp, Picabia, Schwitters, and Warhol. By conducting his discussion of artistic production within a span of millennia rather than a few decades or even centuries, McEvilley easily sees the omissions of the formalists— Clement Greenberg, Michael Fried, Sheldon Nodelman, Susan Sontag, Suzi Gablik, and the early work of Rosalind Krauss—who together represent the claim that mankind had never before the mid-twentieth century so perfectly realized such pure, abstract form. McEvilley wages a powerful argument against this claim, citing the producers of imagery in the Paleolithic, Neolithic, and Bronze Ages and, millennia later, the artists of Tantric and Islamic systems, as having successfully eliminated representational elements from their production; he thus exposes and weakens late modernism's implicit conceit that abstraction and formalism were the intellectual pinnacles of a linear and progressive Western civilization.

Even more formidable is McEvilley's argument that content is implicit in all abstraction, citing how the ancient traditions were comfortable with reading content in abstract form and that, besides being a reality in itself, abstract form is an alternate language about reality. McEvilley argues that the formalist criticism that dominated the 1960s now seems autocratic and self-aggrandizing in comparison with the more ancient knowledge. In fact, McEvilley charges that critics like Clement Greenberg were disseminating a cultural prejudice that had disguised itself as a natural law when in actuality it operated like an absolute, theological doctrine. From his lead we see that the formalist critics were themselves divided on the metaphysical status of art, or that the language they used to impel their arguments was inconsistent to the point that the metaphysical aspects of their thought were tacitly pointed to in the very writings that were supposed to refute art's metaphysical underpinnings. In one instance, McEvilley finds the discrepancy glaring in Greenberg's thought, and he accuses him of resorting to "theological diction" when, in speaking of art's formal status as an absolute, he is ladling his argument "with hidden transcendental implications."

From this point, McEvilley proceeds to show how the "blank" left by the "annihilation of content" is filled by "a thinly disguised deus ex machina," such as Sheldon Nodelman's "higher centers of consciousness." With great relish, he describes the muddled thought as befitting "a mystery cult or oracle," and likens Nodelman to initiates of the astral plane. His wry conclusion that formalist criticism is not on the whole rational criticism severely weakens their points, as they are all edified on the same rationalist principles used from the Enlightenment on to secure thought (vainly, it seems) from metaphysical encroachment. McEvilley goes further, perhaps inspired by Derrida's exposure of the logocentric conceits and inadequacies of rationalist writings, to say that, "In fact, much interpretation masquerades as description, and much avowedly formalist criticism contains hidden references that can't escape content."

Many who read his earlier work regard McEvilley's use of formal logic to refute the arguments of his opponents to be one of his most effective stratagems against formalism. Although logic is standard fare in philosophical discourse, it is infrequently used by art critics. But the true ingenuity comes with his logical extension of the some-

what flawed writings of Ad Reinhardt and Joseph Kosuth, in which
he shows the two artists don't go far enough in their use of logic.
When their propositions are logically analyzed, the consistency of
their arguments break down. For instance, Reinhardt's dictum that
"art is art and art is not not art" was (and still is) heralded by many
critics as a radical conclusion to the formalist argument for reduc-
tion. But McEvilley adeptly shows how Reinhardt's "radical formal-
ism" is nothing more than Aristotle's Law of Identity restated, which
"applies equally and alike to all things in the realm of discourse." In
other words, everything, insofar as it is anything, is itself and is not
not itself (A = A and A ≠ –A), a law which does not confer special sta-
tus to art, but rather "demonstrates that art exists on the same onto-
logical footing as anything else." McEvilley then relentlessly shows
that "recognition of the Law of Identity does not mean that we have
come to the end of a line of reasoned thought, but we are now ready
to begin thinking." In other words, after logic, the stuff of life pro-
ceeds and relevant meanings are born.

Setting his sights on the most hyperbolic text of late Modernism,
McEvilley proceeds to deconstruct excerpts from *Against Interpre-
tation*, Susan Sontag's early lapse into formalist criticism. Among
Sontag's careless propositions McEvilley cites: "it is possible to elude
the interpreters by making works of art . . . whose address is so direct
that the work can be . . . just what it is," and, "The function of criti-
cism should be to show *how it is what it is*, even *that it is what it is*,
rather than to show *what it means*." Here McEvilley takes the analytic
realist's position that Sontag begs the question, for "just what it is"
has not yet been established. Sontag's erroneous departure point
leads her to form a faulty chain of reasoning, for she fails to see that
what a thing is is equivalent to *what a thing means*; in other words, all
things are what we deductively, and through the use of language,
define them as.

To my mind, the modernist's wrongdoing wasn't a covert eleva-
tion of phenomenal experience to transcendentalist fiction, but
rather the confusion of the subjective nature of such a transcendental
elevation with an objective reading of its expression. From this con-
clusion, McEvilley seems to assume that transcendental experience
isn't valid at all, and perhaps he confuses logical propositions of con-
sistency with a proof for the nonexistence of the transcendental expe-

rience. But there is no known continuity in the subjective space of individuals, hence it is not even appropriate to use logic to represent it. McEvilley in other essays shows an inclination to believe that the subjective experience is the only experience (see "Penelope's Night Work: Negative Thinking In Greek Philosophy") and even that the transcendental experience is viable at least as an expression or experience of art (see "Seeking the Primal Through Paint: the Monochrome Icon").

Transcendentalism is not an objective or universal condition, of course; it is even doubtful that much of its experience can be shared linguistically and symbolically through description. But it cannot be argued that it is not an experience that is real to the individual for whom it mentally takes place, in this case the formalist. Perhaps in "Heads It's Form, Tails It's Not Content," McEvilley merely got swept away in the logical model he was visiting—a model he only takes up to disprove the formalists because it is used by the formalists themselves to prop up their unstable positions. Nevertheless, McEvilley is on the mark in showing the formalists were at fault in assuming the formal mode of transcendence was a universal condition which could be placed at the apex of a systematic, cultural hierarchy governing all humanity and legitimately claiming hegemony over all other modes of expression and interpretation.

Whether or not abstraction leads to transcendentalism will always be a contentious claim. But today we are faced with a more mundane issue: whether or not abstraction in art and even painting will remain vital. What determines that vitality today is not the production of an entire movement or style, but the individual production of painters that makes us take notice. Styles or movements are required to build up momentum for new and challenging ideas and forms, to chip away at the culturally hegemonic proscriptions that obstruct their way, and to yield them the power and influence necessary to make their recognition both immediate and pervasive.

Both abstraction and painting, however, are immediately recognizable and plethoric, and though after nearly a century of significant abstract experimentation it is difficult to find innovators in this profusion, truly innovative painting and abstraction needs no movement or group theory like formalism for its defense. The pluralism and culturally nomadic versatility we are nurturing today is not entirely

pervasive, but it is widespread enough to uphold, not imperil, abstract painting and supports the production of modernist modes alongside postmodern modes. Painting today has largely become exactly what artists like Johns and Rauchenberg set out to make it almost forty years ago: a physical fact among many others.

The task today is not to single out abstraction from postmodern discourse, but to engage it in a dialogue with those issues not conveyed by painting or abstraction that are concerned with charting the relations (whether conciliatory or confrontational) of modernism and postmodernism. In this spirit, "Seeking the Primal Through Paint: The Monochrome Icon," is reprinted to explore the potential of painting and abstraction (and a criticism treating them) after they have been stripped of the privilege and hegemony once associated with them.

Some readers of McEvilley's argument against formalist claims think he is anti-formalist. This is not true. He is against the hegemony or dogma of formalism, and against formalism that is based on false claims. Formalism as an optional practice and exercise of sensory play is viewed by McEvilley as perfectly legitimate. Even reductionist claims are not under attack so long as they acknowledge the ineluctable deduction that reduction to form is itself a signification and that a simple field is itself a sign. But as the 1970s and then the 1980s seemed less and less hospitable to formalist ideology, McEvilley's writing was identified with the more polemical writings.

His influence can be seen on the artists who came of age in the mid- to late 1980s, a generation whose productions were marked by a highly critical form of art, with some artists constructing elaborate theories of a critical nature. Such a climate often made it seem that there was no room for simple formalist art. Painting that appeared abstract, like that of Philip Taaffe, Sherrie Levine, and Peter Halley, was heavily invested with ironic reference. McEvilley's critique against formalism's hegemony wasn't the only one at the time, nor was it the first. It even built upon the anti-formalist writings of previous critiques by artists and critics, as the many quotations made apparent for all to see. But it likely was the most devastating and decisive of the articles that helped nail the formalist coffin shut.

The timing of the ironic painters Taaffe, Levine, and Halley is unmistakably concurrent with McEvilley's "Heads It's Form, Tails

It's Not Content," and though there is no documentation showing that they were influenced by it, the critical climate was made more timely for them by McEvilley's analysis of the relationship of representation to form. That the ironic abstractionists or "Neo-geo" artists (as their journalistic moniker made them known) were concerned with making reference to some of the same authorities McEvilley rattled, showed that he had undoubtedly charted a terrain that was the most relevant of its time.

But McEvilley's attacks on modernism, particularly the metaphysical and spiritual underpinnings of its theory and criticism, had an even more profound influence on postmodern artists who sought to overturn everything they disliked about modernism, especially the clarification of spiritual and positivist meanings in art. What McEvilley failed to see at the time of the writing of "Heads It's Form, Tails It's Not Content," was that his ironic identification of formalism with theology and sacred ritual would help inspire a hegemony as rigid and proscribing as that of the formalists: that of the positivist and materialist marginalization of metaphysical and spiritual expressions found in contemporary art. In this respect, McEvilley's essay "Seeking the Primal Through Paint: The Monochrome Icon" sets his misinterpreters straight by considering sacred, mystical, and metaphysical practice alongside—and with equal consideration and integrity—that of the more culturally-based interpretation of art. And this diplomatic feat will be shown to be essential to postcolonialist and crosscultural criticism in the second section, The World and Its Difference.

This first section has been called History As Context, because history is the contextual field that McEvilley knows better than anyone else in contemporary art criticism. But McEvilley has had some important precedents in the historicist school, to follow or to disassociate himself from. Although the history of cultural phenomena had been invoked to legitimize arguments at least since Giambattista Vico separated historical study from the study of the natural world in the 18th century, history became an instrument of hegemony in art criticism after Clement Greenberg took it up in the 1950s. In Greenberg's view, the avant-garde was the lifeblood of civilization, a notion that is still with us in more subtle and ironic forms despite the desiccation of the avant-garde. Vanguard produc-

tion, by Greenberg's definition, is a necessary condition of history: an effect of significant, dissenting art caused by the stagnant academicism that bourgeois society uses to reinforce its values. This academicism, what Greenberg calls "Alexandrianism" in the introduction to *Art and Culture*, avoids provocative issues and favors a steady virtuosity in forms well established and recognized. Greenberg believes that, without the historicist's consciousness in criticism, innovation would be unlikely:

> In seeking to go beyond Alexandrianism, a part of Western bourgeois society has produced something unheard of heretofore: avant-garde culture. A superior consciousness of history—more precisely, the appearance of a new kind of criticism of society, an historical criticism—made this possible. This criticism has not confronted our present society with timeless utopias, but has soberly examined in the terms of history and of cause and effect the antecedents, justifications, and functions of the forms that lie at the heart of every society.

While Greenberg's "formalist" hegemony has eroded almost completely, his historicist views are still influential. And though the avant-garde component in this theory has been dropped, the search for the unique in cultural production remains constant. Clearly, it is a consciousness of history which Greenberg sees generating the innovation that is culture's salvation. But oddly enough, it is Greenberg's call for historicism that trips him up. For his historic references, though valid, are shortsighted in their Eurocentrism, and thus the authority he asserts is limited in scope. An example of this myopia can be gleaned from his writing on how painters in the twentieth century eventually came to the epiphany of flatness, for here he tells that the flight from the illusion of the sculptural, "Starting in Venice in the sixteenth century and continuing in Spain, Belgium, and Holland in the seventeenth," was an effort carried on at first in the name of color. But actually the planar, abstract painting, as pointed out earlier, was much older and its origin was not Western, nor was its intent purely for color.

Thomas McEvilley is the first critic that I know of to displace Greenberg by upstaging him with his own beloved appeal to history. In extending Greenberg's historicism and avant-garde logically in space and time, McEvilley takes us to societies that were the originators—the true avant-garde—of the flat painting.

Piet Mondrian, of course, was Greenberg's foremost example of an artist
whose work is set over against the "extra-pictorial references of old time
illusionist art." In effect, Mondrian was his proof of radical formalism:
"Mondrian . . . has shown us that the pictorial can remain pictorial when
every trace or suggestion of the representational has been eliminated."
But of course Mondrian was not the first to demonstrate that art can
survive without representing "recognizable objects, persons, and
places"; he was preceded by the abstract artists of the Paleolithic,
Neolithic, and Bronze Ages and by later Tantric and Islamic artists who
eliminated this type of representation in favor of abstract quadrature,
heraldic symmetry, monochromy, and so forth. In fact, abstract painting
is a practice that precedes our species; the earliest known examples are
Neanderthal finger-paintings. This historical quibble is important
because it points to a significant set of omissions in the Greenbergian
argument—and the reason for the omissions is not far to seek: in these
older traditions, content was read comfortably from abstract form. The
works produced by these pre-modern abstract artists are widely
interpreted as representing ideas about the nature of the universe.

Greenberg's omissions—Eurocentric and temporal in nature—
became even more glaring for an expanded audience after McEvilley
wrote this. From the postmodern perspective, McEvilley's appeal to
history and originality wins out over Greenberg's, but not only
because his appeal is inclusive of a far larger history and geography,
which would only make him Greenberg's heir, but because he
appeals to an audience that places emphasis on cultures outside the
fiat of the colonialist West, and in doing so, negates Greenberg's
notion of a radically inventive, Euro-American avant-garde.
Whereas Greenberg could appeal to an audience that believed in the
hegemony of the Euro-American avant-garde, McEvilley knew he
could never seriously make such an appeal, as the myth of the avant-
garde and, to a lesser extent, the myth of Euro-American preemi-
nence had, by the 1980s, tarnished dramatically.

So long as Greenberg's omission was not acknowledged—an
omission the prevailing canon of Euro-American art obfuscated—
Western, modernist abstraction could be seen as heroic and singular
in its radical newness; it could also be bolstered by a second, related
appeal, to that of the authority of universality. This appeal to univer-
sality has levelled competing power structures for centuries, allowing
both secular and religious hegemonies and imperialism to over-
power, govern, and transform local belief systems. In retrospect,
McEvilley has shown that the appeal to universalism appears as no

more than a euphemistic inflation and aggrandizement of one local belief system and power structure over, and at the expense of, all others it came in contact with. The final remaking of all colonized indigenous systems in the victor's image was then justified simply by invoking the great enterprise of universalism. This aspect of McEvilley's refutation of Greenberg, however, spills over into his discourse on globalism, which is treated in depth in the second section of this book, The World and Its Difference.

Of course McEvilley, as a critic of Greenberg, stands in a long line of contenders. Some of his objections have already been voiced in the same terms. Gregory Battcock's *Minimal Art: A Critical Anthology* contains Toby Mussman's complaint that Greenberg's "Kantian self-criticism" was "not relevant anymore for us to assume that the world is divided up into mutually exclusive areas of intellectual (analytical) concern." Lawrence Alloway's more substantial complaints in "Systemic Painting" were raised within a year of Greenberg's publication of "Modernist Painting," some of which foreshadow McEvilley's.

> What is missing from the formalist approach is a serious desire to study meanings beyond the purely visual configuration. Consider the following opinions, all of them formalist-based, which acknowledge or suppose the existence of meaning/feelings. Ben Hiller writes that Noland "has created not only an optical but an expressive art" and Michael Fried calls Noland's paintings "powerful emotional statements." However, neither writer indicates what was expressed nor what emotions might be stated.

This applies as well to Alloway's realization that Greenberg's supposed historicism is very selective in its recollection of the lineage of abstraction.

> According to Greenberg the Hard-Edge artists in his *Post-Painterly Abstraction* exhibition "are included because they have won their 'hardness' from the softness of painterly Abstraction." It is certainly true that "a good part of the reaction against Abstract Expressionism is . . . a continuation of it," but to say of the artists, "they have not inherited it (the hard edge) from Mondrian, the Bauhaus, Suprematism, or anything that came before," is exaggerating. Since Greenberg believes in evolutionary ideas, and his proposal that Hard-Edge artists come out of gestural ones shows that he does, it is unreasonable to sever the later artists from the renewed contact with geometric abstract art which clearly exists. . . .
> What seems relevant now is to define systems in art, free of classicism,

which is to say free of the absolutes which were previously associated
with ideas of order. Thus, the status of order as human proposals, rather
than as the echo of fundamental principles, is part of the legacy of the
1903–1915 generation.

It's clear that Alloway was objecting to the same closures of
meaning that McEvilley would find almost twenty years later. But
unlike McEvilley, he does not think that modernist artists are
advancing absolutes; rather they are engaging "human proposals," a
relativist and pragmatic terminology if ever there was one. Alloway
went on to complain that definitions of art as an object, particularly
those in relation to geometric art, have too often been conflated
within a "web of formal relations." Elsewhere in the same essay he
sites Robert Smithson's "nonformal approach" *in reaction* to Stella's
surfaces as "a reminder that shaped blocks of one color have the
power of touching emotion and memory at the same time that they
are being seen," hence they encourage interpretation from the start.

Alloway does not use logic as rigorously as McEvilley to buttress
his argument, but it's clear that at the time that Greenberg asserted
his purist authority of form Alloway was a formidable opponent to its
hegemonic completion. But no one prior to McEvilley used logic,
science, and history—the very principles Greenberg claimed sup-
ported his pure-form theory—to demolish the formalist argument so
thoroughly. In "Modernist Painting" Greenberg puts forth the opin-
ion that "Scientific method alone asks that a situation be resolved in
exactly the same terms as that in which it is presented—a problem in
physiology is solved in terms of physiology, not in those of psychol-
ogy." Had Greenberg based his formalist principles on subjective cri-
teria, they might not have incited the anti-formalist reaction that
swept the art world for thirty years has, but then they could not have
claimed to be scientific, and in Greenberg's mind, and in the minds
of positivists everywhere, they would have seemed secondary.

It would please me to see McEvilley focus on the positivist and
scientific hegemony. In the last quarter century Derrida, Foucault,
and Rorty, the most influential intellects of the time, have all placed
cultural production at a level on par with science, as had thinkers like
Ernst Cassirer decades earlier. McEvilley has indicated many times
that he too sees this parity. And his defense of subjective and skepti-
cal thought in ancient and modern history is further indication of

this. But his use of scientific method and logic to ground some of his arguments rather than an appeal to the viability of subjective and intersubjective value—which may be said even motivates and flows through science and logic—continues to elevate the import of science and logic above the production of art. Toby Mussman—in the article cited above, and a few years before Derrida, Foucault, and Rorty reappraised the relationship of science and art—felt secure in stating that Greenberg's "nice clean logical reasoning . . . is irrelevant to the kind of analysis that will lead to a real understanding of art. Art is not logical or scientific even though it may use an intellectual system for its springboard. Art cannot be reduced to a matter of problem solving." It strikes me from his writing that McEvilley believes similarly, and it would be the cultural world's good fortune if he were to someday treat in depth the issue of how science has done perhaps as much to diminish the range of human creativity in the nineteenth and twentieth centuries as it has done to understand it.

HEADS IT'S FORM, TAILS IT'S NOT CONTENT

> It has rightly been said that theory, if not
> received at the door of an empirical
> discipline, comes in through the chimney like a
> ghost and upsets the furniture.
> —Erwin Panofsky[1]

*P*assionate belief systems pass through cultures like disease epidemics. The great formalist critical tradition of the postwar period, embodied in the works of Clement Greenberg, Michael Fried, Sheldon Nodelman, and others, still has the art body in the last shivers of its fever. In their practice these critics opened the artwork to profound phenomenological analyses. But their concern with surface, figure, and color eventually coagulated into a repressive ideology that could allow no real theoretical discussion of the inspired practice, which seemed as given as life itself. It is time to reconsider certain basic questions that, from a formalist viewpoint, have long been regarded as closed.

> One of the characteristics of myths is that they seem to promise rules of
> order but never deliver them. —Jack Burnham[2]

Foremost, of course, is the problem of content. As the formalist approach to this problem, Rosalind Krauss presents the critic's perception of "feeling" in a work: "The experience of a work of art is always in part about the thoughts and feelings that have elicited—or more than that, entailed—the making of the work. And if the work is not a vehicle of those emotions, in no matter how surprising a form, then what one is in the presence of is not art but design."[3] To illustrate this strategy Krauss quotes Michael Fried: "Both [Kenneth] Noland and [Jules] Olitski are primarily painters of *feeling*, and . . . their preeminence . . . chiefly resides not in the formal intelligence of their work . . . but in the depth and sweep of feeling which this

intelligence makes possible."[4] The implication is that when a critic ascribes "feeling" to an artist's work the critic is dealing adequately—or at least as far as decency allows—with the problem of content. Indeed, one's sense of decency is the question; formalist writers often have spoken against content with a moralist intensity.

But what exactly does this word "feeling" mean? Krauss glosses the term once as "thoughts and feelings" and again as "emotions." Fried, similarly, calls Noland's paintings "powerful emotional statements" and ascribes "passion," "emotion," and "expressive freedom" to them. Yet in neither Fried's nor Krauss' essay will one find mention of any deciphered "thoughts" or specified "emotions," or indeed any mention at all of what it is that is "expressed." As Alan Tormey has noted, this view "does not establish a relevant distinction between art and any other form of human activity."[5] In fact, it seems that the word "feeling" is practically a verbal blank. To qualify the blank, as Fried does, as "the depth and sweep of feeling," is simply to expand it.[6]

> Irving Sandler and Robert A.M. Stern had a fight in our loft early this year . . . "I didn't see any content in [Mark Rothko's] pictures," said Stern. . . . Sandler . . . replied that content in Rothko's paintings is expressed in color, form, facture. Stern said that content requires a reference to the world outside . . . "Painting is color and light," counterpunched Sandler. "If nothing else, these paintings are about painting." —Douglas Davis[7]

When Fried ascribes "feeling" to the works of Noland and Olitski, while maintaining that these artists address themselves "to eyesight alone" and that their works are of a "purely visual nature,"[8] he is laboring under the difficult burden of Clement Greenberg's theory. Greenberg maintained that "visual art should confine itself exclusively to what is given in visual experience and make no reference to anything given in other orders of experience."[9] Content, he believed, must become "strictly optical" and "be dissolved . . . completely into form."[10] When Greenberg faced the question (which stymied both Plato and Aristotle) of how a form can be experienced without a content, he took the position, enunciated previously by Benedetto Croce and others, that content is an aspect of form. The painting's "quality," he declared (a matter of formal considerations), *is* its content.[11] This attitude, however valuable as a declaration of

faith, should not be mistaken for rational thinking. Of course, at the time Greenberg was writing, many people would have agreed with him. Illogic often grips small power groups that feel they have history by the neck.

> The basic requirement of this ideology is that no meaning of any kind can be allowed to pollute visual integrity. —Douglas Davis[12]

The impossible idea of pure form (form without content) quickly became an absolute. With the zeal of devotees, Greenberg, Fried, Susan Sontag, and others attempted to purify art of significations, whether by eliminating them from the viewer's awareness, by neutralizing them (as with, for example, blank "feeling"), or by enclosing them in a hermetic athanor of self-reference.

> Poetry is the subject of the poem.
> From this the poem issues and
> To this returns. Between the two.
> Between issue and return, there is
> An absence in reality.
> Things as they are.
> Or so we say.
> —Wallace Stevens, "The Man with the Blue Guitar"

This project is rooted in the Romantic tradition (and behind it in Neoplatonism), which yearned to see the artwork as transcendentally free, beyond the web of conditionality. Spurred on by the desire for the sacred in a secular age, the enterprise took on a quasi-religious aura, and by the mid-'60s Greenberg, Sontag, and the rest were preaching to the converted. By then, formalist theory was an accepted myth. In the Levi-Straussian sense a myth is a device to mediate between culture and nature, either by naturalizing culture or by culturizing nature; in this case, the mythifying tactic was to naturalize culture. Artworks were to be granted a self-validating status like that of objects of nature such as stones or leaves, which are not asked to refer, to signify, or to justify themselves in any external terms. Nothing was left to the artwork except pure sensory presence, with no concepts, no signification, no relationship to anything outside itself.

If the faces on Mt. Rushmore were the effect of the action of wind and
rain, our relation to them would be very different. —Frank Cioffi[13]

"The avant-garde poet or artist," Greenberg wrote, "tries in
effect to imitate God by creating something valid solely on its own
terms, in the way nature itself is valid, in the way a landscape—not its
picture—is esthetically valid, something given, increate, independent
of meanings, similars or originals."[14] That Greenberg's diction in this
passage is an essentially theological diction of absolutism was perhaps
not obvious when the words were written. But it should by now be
clear that here we are dealing with a cultural prejudice that, like many
others, has tried to disguise itself as a natural law. The technique of
the disguise is to promote a kind of selective seeing: filters are overlaid
on the cognitive processes to screen out significations—or rather, to
screen out signifieds, the plane of content, and to focus exclusively on
the emptied signifiers, the plane of expression (or form).

But the claim for the autonomy of the plane of expression, for its
freedom from any plane of content whatever, is a contradiction in
terms. As Ferdinand de Saussure made clear, "Though we may speak
of signifier and signified as if they were separate entities, they exist
only as components of the sign."[15] Similarly, Claude Levi-Strauss
denounced Russian formalism for neglecting "the complementarity
of signifier and signified."[16] "For [formalism] the two domains [form
and content] must be absolutely separate, since form alone is intelli-
gible and content is only a residual deprived of any significant value.
For structuralism, this opposition does not exist. . . . Form and con-
tent are of the same nature, susceptible to the same analysis."[17]

And the portrait show seems to have no faces in it at all, just paint
you suddenly wonder why in the world anyone ever did them
 —Frank O'Hara, "Having a coke with you"

For God's sake, do not explain that picture of the bright-haired girl on a
diamond black horse . . . These realities of delight and beauty at their
imperfect source are indiscreet, if not indecent, subjects for any lecture.
 —Horace Gregory, "Daemon and Lectern and a Life-Size Mirror"

In the attempt to free art from the plane of content, the formal-
ist tradition denied that elements of the artwork may refer outside
the work toward the embracing world. Rather, the elements are to be

understood as referring to one another inside the work, in an interior and self-subsistent aesthetic code. The claim is imprecisely and incompletely made, however, because the formalists take much too narrow a view of what can constitute "content." Greenberg, for example, often uses the term "non-representational" to describe "pure" artworks—those purified of the world. But as he uses it, the term seems to rule out only clear representations of physical objects such as chairs, bowls of fruit, or naked figures lying on couches. Similarly, Fried assumes that only "recognizable objects, persons, and places" can provide the content of a painting.[18] But art that is non-representational in this sense may still be representational in others. It may be bound to the surrounding world by its reflection of structures of thought, political tensions, psychological attitudes, and so forth.

> [Pollock's] pictures leave us dazzled before the imponderables of galaxy
> and atom. —Robert Rosenblum[19]

> Pollock's field is optical because it addresses itself to eyesight alone.
> —Michael Fried[20]

Jackson Pollock is one of Greenberg's prime examples of an artist whose work is supposedly "pure," without semantic function. But an interestingly different approach is suggested in Joseph Campbell's *The Mythic Image*, where Pollock's *Autumn Rhythm* is reproduced alongside a passage from the Buddhist Prajnaparamita literature: "Like stars, like darkness, like a lamp, a phantom, dew, bubbles, a dream, a flash of lighning, and a cloud—this is how we should look upon the world."[21] Campbell, in other words, reads *Autumn Rhythm* as a cosmological diagram of flux and indeterminacy, as at times Pollock himself seems to have done.

> Can art evoke emotions without recalling images? —Nicolas Calas[22]

Piet Mondrian, of course, was Greenberg's foremost example of an artist whose work is set over against the "extra-pictorial references of old time illusionist art." In effect, Mondrian was his proof of radical formalism: "Mondrian . . . has shown us that the pictorial can remain pictorial when every trace or suggestion of the representa-

tional has been eliminated."[23] But of course Mondrian was not the first to demonstrate that art can survive without representing "recognizable objects, persons, and places"; he was preceded by the abstract artists of the Paleolithic, Neolithic, and Bronze Ages and by later Tantric and Islamic artists who eliminated this type of representation in favor of abstract quadrature, heraldic symmetry, monochromy, and so forth. In fact, abstract painting is a practice that precedes our species; the earliest known examples are Neanderthal finger-paintings. This historical quibble is important because it points to a significant set of omissions in the Greenbergian argument—and the reason for the omissions is not far to seek: in these older traditions, content was read comfortably from abstract form. The works produced by these pre-modern abstract artists are widely interpreted as representing ideas about the nature of the universe. They are art as "a way of *thinking about reality*," in William Wilson's words.[24] They present two-dimensional models or schematic diagrams of the real; to call them diagrams of consciousness as then experienced, without altering the facts, would bring them into a more phenomenological framework. While non-representational in terms of physical objects, these works have clear metaphysical or cosmological content.

> Since Wittgenstein has described the proposition as an "image of reality," the image could be viewed as a proposition about reality.
> —Nicolas Calas[25]

In much the same way, Mondrian's mature paintings can be read as presenting a model of the real: they suggest a geometrically ordered universe made up of a few unchanging and universal elements which shift their arrangements to create the impression of changing particulars. The right angles signify mathematical consistency and rigor; the three primary colors hint at a small number of abstract building blocks; the sense of construction in the interlaced verticals and horizontals suggests the orderly underpinnings of the chaotic universe of experience.[26] Plato's *Timaeus* might be used as an accompanying text, just as Campbell juxtaposes the Pollock with a Prajnaparamita passage.

Furthermore, a blue monochrome by Yves Klein might be juxtaposed with any number of texts on philosophical monism, from

Parmenides to Sankara and beyond. Analogizing the alchemical notion of Prime Matter, Klein shows plurality totally absorbed within unity, which is viewed as the unchanging substrate of changing experience.[27] Clearly, the work of these three painters—which must be non-representational or without content in Greenberg's view—may be regarded as representative of basic metaphysical tendencies that constitute a type of content. Pollock models reality as indefinite and in perpetual flux; Klein presents a counterview of reality as unified and fundamentally static; Mondrian suggests a middle view of reality as stable in its elements but changing in its surface configurations. Greenberg himself was approaching something like this view in the essay titled "On the Role of Nature in Modernist Painting,"[28] but he did not, indeed he could not, integrate it into his "purely optical" theory.

> Now, the formalist would say that we needn't know [Courbet's politics] to respond to [his] painting. . . . But mid-nineteenth century viewers of these paintings did see their political qualities, which I contend are fused into the visual context of the work: they are not "literary."
> —Douglas Davis[29]

Marxist critics have insisted that any act (including any art act) is saturated with political meaning. Philosophers have argued similarly that any act is saturated with philosophical meaning. Each act is grounded in a subtext of implied assumptions about the nature of reality. The experiencing of a work of art, then, is not merely a matter of aesthetic taste; it is also a matter of reacting to a proposition about the nature of reality that is implicitly or explicitly shadowed forth in the work. As Wilson remarks: "That hypothesis—that a work of art is a proposal about what is real—might help to explain why art that people don't like makes them so angry."[30]

> [Barnett] Newman's best paintings address themselves to eyesight alone . . . They seek to create . . . an experience of spatiality that is purely and exclusively visual.
> —Michael Fried[31]

> Why these long, provocative titles and dedications? Behind them is a mind and a sensibility frustrated by the dogmas of anti-content.
> —Douglas Davis[32]

Once we have realized that the plane of content can contain much more than "recognizable objects, persons, and places," we must peer more shrewdly at the context of the work and cock a more attentive ear to the artists' own statements. When Harold Rosenberg wrote that "paintings are today apprehended with the ears"[33] he was revising Greenberg's entirely-through-the-eyes approach and pointing to the plain fact that verbal supplements are of crucial importance in relating to art. Marcel Duchamp may have had the same point in mind when he remarked that the most important thing about a painting is its title.

It is important to realize that the formalists' claim that such verbal indicators are not relevant is highly suspect in terms of their own practice. For example, Rosenberg points out that without Newman's cabalistic titles and writings we would be unable to distinguish his work with certainty from "Bauhaus design or mathematical abstraction."[34] Yet formalist critics do make that distinction—and not only since Thomas Hess' (in)famous catalogue essay laying bare the cabalistic roots of Newman's verbal supplements. Even Greenberg did so, saying, "Newman's art has nothing whatsoever to do with Mondrian's, Maelvich's or anything else in geometrical abstraction."[35] Greenberg refers to Newman's work as "an activated pregnant 'emptiness' "[36]: the phrase is virtually a quotation from Gershom Scholem's paraphrases of the cabalistic texts, which Newman admired, and the quotation marks around "emptiness" suggest that the word refers to some literary notion, not merely to the lack of a figure on the ground. In short, "activated pregnant 'emptiness' " is a description of Newman's content quite as much as of his form.

> Historians clearly recognize the metaphysical implications of art prior to the modern era, but they are remarkably ingenious in avoiding a confrontation with the metaphysical suppositions of contemporary art.
> —Jack Burnham[37]

Ad Reinhardt also belonged to what Rosenberg called the metaphysical branch of abstract expressionism. Yet the artist's own statements about the metaphysical intentions of his works have been largely screened out by the formalist filter. Reinhardt's writings contain clear allusions to the locutions of Buddhist texts and echoes of T'ang-dynasty Taoist painting manuals. His reductionism was in part

an attempt to express the Taoist/Buddhist doctrine of the absolute as dynamic emptiness. Critics seeking the content of his work should look neither to the Greek Christian cross nor to the problem of the surface, but to the four-limbed mandalas of the Orient—especially the Taoist mandala of 64 squares, which is virtually identical to the internal quadrature of Reinhardt's paintings.[38] That this is a traditional icon, bringing a weight of metaphysical content with it (unless the artist deliberately empties it out), is beyond doubt.

> The new movement is, with the majority of painters, essentially a
> religious movement. —Harold Rosenberg[39]

Finally one must wonder whether Reinhardt's and many related works are better read as mere sensory presences or as metaphysical statements like those of Tantric and other abstract allegories. They could be hung in the manner of icons in a church as readily as in the manner of pictures in a gallery. They are saturated with content, and the refusal to see it, the insistence on screening it out of our experience, is a kind of aggression against the work and against the artists themselves.

> The esthetic or artistic is an ultimate, intrinsic value, an end-value, one
> that leads to nothing beyond itself. . . . Knowledge and wisdom can
> funnel into, can serve, the esthetic, but the esthetic—like the ethical or
> moral in the end—can't serve anything but itself.
> —Clement Greenberg[40]

In a sense, the metaphysical quality of much abstract work is recognized, somewhat covertly, by formalist critics. At one moment Greenberg restricts the artwork to purely optical qualities; at another, sliding into theological diction, he speaks of art-for-art's-sake as a kind of absolute, with hidden transcendental implications. The discrepancy between emphasis on the optical surface on the one hand and implications of transcendental status on the other seems to trouble even today's leading formalists. Sheldon Nodelman, for example, attempts to carry the burden of the "purely optical" doctrine while opening wider those transcendental avenues hinted at by Greenberg's hidden theologizing. In doing so, he lays bare an irrational implication that underlies many statements of the formalist position.

In an article in the *Yale Architectural Journal*, Nodelman first nods to formalist orthodoxy by speaking of "the intense opticality of sixties' art" which has left "no residuum of content."[41] Then he attempts to overleap the limitations of this very doctrine. Color, he says, "addresses itself, through the visual sense, not mediately toward the physical apparatus with which the body moves and contends in the world, but immediately toward the higher centers of consciousness: it is the most 'spiritual' of all sensory qualities."[42] He is saying, in other words: (1) that color, while a sensory quality, bypasses the body system—an obvious contradiction in terms; (2) that it bypasses also the conceptual mind—a thing impossible to prove and unlikely in any modern view of human psychology, and (3) that it works on some undefined "higher center of consciousness" in a "spiritual" way.

The doctrine that color addresses "higher centers" stems from nineteenth century occultism (Madame Blavatsky, et al.), and is brought into formalist theory as a thinly disguised deus ex machina to fill the blank left by the annihilation of content. If all color inherently addresses "higher centers," then one might as profitably behold a colored wall as a painting hung on it, or one painting as well as another. If, on the other hand, the color presented by Morris Louis and Frank Stella (whom Nodelman is discussing here) has a special ability to reach those "higher centers," then wherein does this ability reside? Does their particular avoidance of any suggestion of figure and ground amount, as Nodelman implies, to a spiritual substance mixed in the paint? Shall we take the formalist critic's word that he or she perceives this spiritual substance, though we may not? This seems the procedure of a mystery cult or oracle, and Nodelman, in referring to non-sensory "higher centers," speaks like an initiate of the astral plane. The birth of the art experience turns out to be a kind of virgin birth, bypassing both the body and the conceptual mind, and whispering its message directly into the ear of the critic's soul, like the angel at the Annunciation. This is not rational criticism; Nodelman's retreat from the limitations of the "purely optical" doctrine at the same time that he is espousing it suggests an illicit yearning for content.

Do we itch for Content—for Meaning—when we see a blank tablet? Yes, yes, yes, yes, yes. We're itching now, more than ever. Hear me scratching? I can hear you.
 —Douglas Davis[43]

In fact, much interpretation masquerades as description, and much avowedly formalist criticism contains hidden references that can't escape content. Of course, if the critic must speak, then his or her thought must be qualified by the nature of language. But when Fried, for example, speaks of the "tortured" space of Willem de Kooning's paintings, when David Sylvester calls Henry Moore's work "organic," when Nodelman speaks of "forces and energies" on the canvas, these critics are moving further into covert interpretations than descriptive language requires.

> The avant-garde poet or artist sought to maintain a high level of his art by both narrowing and raising it to the expression of an absolute. . . . "Art for art's sake" and "pure poetry" appeared, and subject matter or content became something to be avoided like the plague.
> —Clement Greenberg[44]

The formalist myth has fed repeatedly on a kind of pre-logical incantation masquerading as reason. This is most obvious in the widespread cult slogan of "art for art's sake." Ad Reinhardt's writings, for example—which are often mentioned with approval by formalist critics—vacillate cunningly between radical formalism and metaphysical absolutism (two codes, with shared Platonic backgrounds, which also mingle in the writings of Kasimir Malevich, Klein, Newman, and others). Reinhardt's locutions often seem to express the purist art-for-art's-sake attitude. "The one thing to say about art is that it is one thing. Art is art-as-art and everything else is everything else. As art art is nothing but art. Art is not what is not art." Joseph Kosuth, who quotes this statement approvingly, adds his own to the same effect: "Art indeed exists for its own sake. . . . Art's only claim is for art. Art is the definition of art."[45] The problem with statements of this type is that they are meaningless when reduced to logical terms. When Reinhardt, for example, in his radical formalist mood, asserts that art is art and art is not not-art he seems to feel that he is stating a conclusion. But in terms of formal logic what he has stated is simply the Law of Identity—the principle that A = A and A ≠ –A (A equals A and A does not equal not-A).

> [If the Law of Identity is not assumed] then it is evident that there would be no discourse; for not to have some specific meaning is to have no

meaning, and when words have no meaning, conversation with another, or even with oneself, has been annihilated, since it is impossible for one who does not think something to think anything. —Aristotle[46]

The Law of Identity applies equally and alike to all things in the realm of discourse. Everything, insofar as it is anything, is itself and not not-itself. The application of the principle to art, in other words, does not in the least constitute a claim to special status. On the contrary, it demonstrates that art exists on the same ontological footing as anything else.

Reinhardt, Kosuth, and others who have made statements of this type have misunderstood an underlying ground rule for a reasoned conclusion of thought. The error might be paralleled by mistaking the axioms of Euclidean geometry for its conclusions. Recognition of the Law of Identity does not mean that we have come to the end of a line of reasoned thought, but that we are now ready to begin thinking.[47]

Kosuth compounds the problem by confusing the Law of Identity with an analytic proposition or tautology: ". . . Art is analogous to an analytic proposition, and . . . it is art's existence as a tautology that enables art to remain 'aloof' from philosophical presumptions."[48] This approach is a kind of closet formalism and shares formalism's logical weaknesses.[49] Kosuth seems to mean no more than that art is art—the Law of Identity again. Like the ascription of "feeling," such statements are universal blanks. Again, thought does not culminate in such an assertion, but begins with it.

Whatever it may have been in the past, the idea of content is today mainly a hindrance, a nuisance, a subtle or not so subtle philistinism.
—Susan Sontag[50]

Formalist doctrine finds its extreme expression in Susan Sontag's influential essays from the mid-'60s, which encapsulate conveniently the logical problems of formalism. Among the points Sontag argues are the following:

(1) "Interpretation is the revenge of the intellect upon art."[51] But the view that the intellect is either uninvolved in or antagonistic to art—that "in order to feed a thought you must starve a sensation,"

as the poet Mary Friedenn has written—can only serve to make art incomprehensible to intelligent beings.[52]

(2) "It is possible to elude the interpreters . . . by making works of art . . . whose address is so direct that the work can be . . . just what it is."[53] This statement begs the question, because "just what it is" has not been established yet. Furthermore, it is simply a restatement of the Law of Identity again. The work already is just what it is (how could it be anything else?), and this fact does not in the least take it out of the range of relationship, worldliness, and interpretation.

(3) "The function of criticism should be to show *how it is what it is,* even *that it is what it is,* rather than to show *what it means.*"[54] Here again is the mythifying tactic of naturalizing culture. Perhaps a stone can be without meaning, but it is very doubtful that any cultural object, being a product of human consciousness with its intricate weavings, can exist except in a web of intentions and meanings.

(4) "It is the habit of approaching works of art in order to *interpret* them that sustains the fancy that there really is such a thing as the content of a work of art."[55] Above all, Sontag carries to an extreme the formalist doctrine that the plane of content must be abolished by absorbing it into the plane of form. In fact, she states that the distinction between form and content is "an illusion."[56]

The question is what one means by *distinction.* The relation between form and content is one of universal concomitance; that is, neither of them ever appears without the other. The same relationship exists between many paired terms, such as cause and effect, up and down, right and left, and does not in the least mean that we cannot distinguish one from the other, but rather that the existence of one always implies the existence of the other. In fact, the attempt to absorb one of them into the other is self-defeating, because in the relationship of universal concomitance neither element can be self-sufficient or ontologically prior; each term of such a pair is dependent upon the other. Just as a cause can only exist as the cause of an effect, and an effect as the effect of a cause, so form can only exist as the form of a content, and content as the content of a form. The terms are distinguishable, though logically dependent on one another.

It is true that some artists choose to minimize one aspect or the other of the form/content tandem. In the work of the artists generally favored by formalist critics, content has often been minimized or blurred for the sake of the clarity and directness of form. In the work of Social Realists (as an example) formal values have been minimized, or rendered invisible through commonplaceness, for the sake of content.

An accurate model of this situation would show a *hypothetical* pure form at one end of a bipolar continuum and a *hypothetical* pure content at the other. In between is an area where they fade progressively into one another. As in a fade between two colors, there is no precise point where one principle ends and the other begins, nor does either term ever exist to the absolute exclusion of the other: they are mixed in different ratios at different points on the continuum. Critics irrationally defeat their own purposes when they deny reality to one term for the greater glory of the other, since the one that is favored, being dependent on the one rejected, must lose reality along with it. In a sense, then, the dispute over form and content has no inherent reality, but is merely a dispute between those passionately dedicated to one aspect or the other.

> If there be nothing besides the sensible, there would be no principle or order. . . . Real being is attributed in one way to the material, in another way to the form, and in a third, to their product. —Aristotle[57]

Ultimately the idea that references and associations are to be excluded from the art experience is naive. Panofsky has opined that to perceive an artwork without "perceiving the relations of signification" would be the approach of an animal, not a human.[58] Obviously the art experience is conditioned heavily by what one knows, by what one has learned to expect, and by what one likes. To quote Panofsky again, "the . . . experience of a work of art depends . . . not only on the natural sensitivity and visual training of the spectator, but also on his cultural equipment. There is no such thing as an entirely 'naive' beholder."[59]

> The big question here, of course, is whether it is possible to have aesthetic experience that is not culturally conditioned.
> —Donald Kuspit[60]

In art description and nothing but description is unjustifiable because
retinal images are automatically associated with cerebral images.
—Nicolas Calas[61]

Jacques Lacan and Noam Chomsky have argued in different
ways that linguistic activities extend far into the unconscious.
Language seems to provide a background stratum against which
every mental and perceptual event takes place. If this is correct, then
it is impossible that we could ever achieve a "purely optical" experi-
ence of a work of art—and indeed that idea may be a contradiction in
terms. (Without concepts, how do we know it is art?) Mental states in
which ordinary types of conceptualization are temporarily suspended
(such as those ensuing on long meditation, or on the ingestion of cer-
tain drugs) seem to be states in which all sensa are about equally fas-
cinating. The artwork as an unusually fascinating or beautiful sensum
may not exist outside a particular intellectual framework, and may
not even be possible outside it.

The principle of excluding non-optical elements from the work,
then, is not a real principle. It *must* be compromised and, given the
associative habit of the human mind, is *always* compromised. The
question, then, is simply where to draw the line. Are the viewers'
expectations in and the artists' intentions out? If so, why?

Do not enter this hotel with any intentions.
—Sign over hotel desk in Aurangabad, India

The heart of the form/content question is the question of the
relevance of the artist's intentions, which, of course, formalism
excludes as outside the physical work. This debate has been more
fully argued among literary than among art critics: in fact, the for-
malist position seems in part transposed from the arena of literary
debate. The so-called "New Critics" of an earlier generation (espe-
cially William Wimsatt and Monroe Beardsley) did for literature
what Greenberg and others both before and after him[62] have done
for the visual arts: they fostered a myth of the autonomy of the liter-
ary work, which "should not be judged by reference to criteria or
considerations beyond itself."[63] To the New Critics a poem consisted
not of referential statements about the world beyond it, but of "the
presentation and sophisticated organization of a set of complex expe-

riences in verbal form."[64] The emphasis on "experience," which must be apprehended by a non-conceptual aesthetic sense, brings us straight to the myth of the "pure" painting. Similarly the New Critics, like the Greenbergians, preached "a strenuous rejection of the authority or relevance of an author's or artist's intention on the grounds that the work of art is a self-contained object accessible in some perceptually fair sense to the objective appreciation of competent agents."[65]

> The conviction that a poet [or painter] stands in a certain relation to his words [or paintings] conditions our response to them . . . We are not ordinarily aware of this as these convictions tend to be held in solution "in the work itself." It is only in exceptional circumstances that we crystallize them as explicit beliefs and become aware of the role they play. Why should anyone wish to deny this? —Frank Cioffi[66]

But in several ways it is clearly impossible to exclude the artist's intentions from the critical process. Krauss, for example, allows the critic to be aware of "the sense of historical necessity" (that is, *art*-historical necessity) that brings a particular painting into existence at a particular time. The critic, then, should at least know the date (or the approximate date) of the work, and this information is of course biographical and intentionalistic. Imagine yourself looking at a painting in a gallery, by an artist whose name is unknown to you, and reading its date, from the wall label, as 1860; suddenly a gallery attendant approaches and corrects the label to read 1960. One's critical awareness shifts immediately in response to one's new sense of what the artist knew, what paintings the artist had seen, and what the artist's implicit intentions, given his or her historical context, must have been.

Even more basic is our awareness of the genre of the work. Is a white rectangle with marks on it being presented as a painting, a drawing, a poem, a news story, or something else? In each case one's sense of the work changes. Yet the genre classification is outside the physical work and constitutes, in effect, another appeal to the artist's intentions. We are asking, really, whether the artist *intended* it as a painting, a poem, or whatever.

Other "outside" elements that all critics, even the most hardened formalists, make use of regularly are (1) allusions, which are

based on the biographical assumption that the artist or author has seen certain paintings or read certain books; (2) the artist's reputation, and (3) the record of his or her earlier work. Clearly we use such facts because they indicate something of the artist's intentions. "If it [the poem or painting] had been written [or painted] by someone else," as Cioffi asks, "wouldn't this make a difference in our apprehension of it?"[67] Imagine the label switch again. You are looking at a painting attributed to Ellsworth Kelly when the label is corrected to read Barnett Newman. Hasn't your response to the work changed radically, too?

> Where
> Do I begin and end? And where.
> As I strum the thing, do I pick up
> That which momentarily declares
> Itself not to be I and yet
> Must be. It could be nothing else.
> —Wallace Stevens, "The Man with the Blue Guitar"

The question is not whether content is present, but what its relationship to form is. To use semiological terms: Is the form/content relationship *motivated*—that is, is the content inherent in the formal properties of the work—; or is it *unmotivated*—that is, is the content added from outside by the work's audience (including the artist)?

Formalist critics, bound to an essentially theological conviction that form is self-subsistent and absolute, have insisted that the impact of the visual surface of the work *is* its content. The formalist understandably fears a situation in which interpretation might run out of control and smother the visual life of the work beneath irrelevant intellectual overlays; if the form/content relationship is unmotivated a limitless number of possible interpretations exists, none more firmly bound to the physical object (the artwork) than any other. The process of interpretation, then, being uncontrollable to the point of randomness, should be avoided.

The alternative is a view like that which Edward Said expresses about literary texts, and which applies equally to visual ones. "Texts impose constraints and limits upon their interpretation . . . because as texts they *place* themselves . . . they *are* themselves by acting, in the world. Moreover, their manner of doing this is to place restraints

upon what can be done with (and to) them interpretively."[68] Of course, to say that works place themselves within certain limits of interpretation is not to say that every viewer will experience the work with the same feeling-tone and the same associations. The motivation of signifier and signified, when present at all, is partial, and responds both to cultural boundaries and personal sensibilities. Still, within these variable limits, some connections will be widely recognized as appropriate, others not. In representational art, for example, certain formal structures are read as chairs, others as bowls of fruit, others as naked figures lying on couches. The question is whether this relationship can be extended to clearly connect abstract forms and non-physical things such as thoughts, emotions, and structures of ideas.

In *Art and Illusion*, E.H. Gombrich argues that it can, and the formalist critics themselves, perhaps unknowingly, imply the same in their ascription to artworks of the power to convey "feelings," "emotions" and "thoughts." All such ascriptions must presume what philosophers have called the Expression Theory of art—that the artwork expresses a feeling or a complex of feelings. But, as Aristotle said, one cannot feel anything unless one feels something. It cannot be a generalized feeling or thought that is expressed, it must be a feeling or thought of a particular type.[69]

If paintings express "feeling," and if "feeling" must be some particular feeling, then the implication is unavoidable that feelings have recognizable visual correlates—that is, that the relationship between the feeling expressed and the form expressing it is motivated. There is then no limitlessness of interpretation. The feeling- or thought-content is recognizably related to the formal properties of the work, and grounded in them. The work has "placed itself" within a limited range of interpretation. The content is not added on but inherent. This conclusion, of course, is diametrically opposed to the doctrine that the work is purely optical. If art were in fact a purely optical experience then it would be like the experience of a robot, and could not involve "feelings."

Statements do not have to be explained: they must be understood.
Gazing at a kouros we feel the impact of Parmenides's dictum that man is an "all in the now." —Nicolas Calas[70]

If the relationship of representation can be extended from physical objects to thoughts and emotions, is it then implied that philosophical tendencies also have visual correlates? Are there formal configurations that inherently place themselves within a limited range of philosophical contents? Is it a fact, for example, as design handbooks say, that verticals are assertive, horizontals quiescent, and diagonals dynamic and transitional? Does a ziggurat-like form inherently suggest the idea of hierarchy? Does a monochrome surface inherently suggest the idea of unity? This last question can be pursued briefly, since so many practitioners of monochrome have made statements about it.

> Beyond the head, instead of painting the ordinary wall of the mean
> room, I paint infinity, a plain background of the richest, intensest blue.
> —Vincent van Gogh[71]

The earliest paintings in which a one-color surface is unambiguously presented as the art object are the Tantric paintings of the seventeenth century in which the state of *nirvikalpa samadhi*—the mental state in which only absolute unity is known—is represented by a monochrome surface.[72] This correlation recurs in Goethe's *Theory of Colors* (1810), in which the activity of beholding an unbroken expanse of a single color is said to awaken awareness of universality and to harmonize the beholder with the basic unity of things. Malevich, in writing on the white-on-white paintings, similarly declares them to "signify" infinity and the united ground of consciousness which underlies perceptions of apparent pluralities.[73] Related assertions are made in the writings of Klein, for whom the one-color surface is equated with the alchemical notion of Prime Matter; in Newman's concern with the cabalistic Zim-zum, which, as Gershom Scholem wrote, is "a primal space . . . full of formless hylic forces"[74]; and in Reinhardt's focus on the Buddhist Plenum-Void. For Agnes Martin, who acknowledges Taoist influence, monochrome surfaces are "esthetic analogies of belonging to and sharing with everyone."[75] Robert Rauschenberg, in 1951, described his white paintings as "one white as one God . . . dealing with . . . the plastic fullness of nothing."[76]

The fact that this correlation between a formal configuration and an idea-type is found in at least two widely separated cultures

(India and Europe/America), and over a stretch of centuries, may suggest that the correlation is motivated—that the works, by their formal properties, recognizably place themselves in this area of interpretation.

> I think of painting as possessed by . . . a structure born of the flow of color feeling . . . Color must be felt throughout. —Jules Olitski[77]

> I believe these are highly emotional paintings not to be admired for any technical or intellectual reasons but to be felt. —Brice Marden[78]

But of course this does not mean that a monochrome painting can be understood only in this metaphysical way. In fact, around 1960 a new way of talking about monochrome or near-monochrome paintings arose. Under the influence of the complete dominance of formalist criticism, artists limited themselves to speaking of undefined "feeling" and the direct impact of color. The point is that even if there is a more or less objective correlation between particular forms and concepts, it must still interact with the artist's intentions. The artist can willfully override this correlation, thereby introducing levels of tension into his or her work as part of its means of acting or placing itself in the world. A double bind between a manifest visual correlate and an artist's intentional rejection of it has the effect of placing the work in the zone of critical philosophy rather than metaphysics, but does not in the least remove it from philosophical attitude.

> The minimal artist has brought to his art concerns that many feel more properly belong to the field of semantics, criticism, and art philosophy.
> —Allen Leepa[79]

The history of philosophy shows a separation into two great streams: metaphysics, which builds up constructions of the mind; and critical philosophy, which tears them down, often in an attempt to return focus to direct experience. Both activities are explicitly philosophical. Though our culture has favored philosophers who fill up the mind to those who clear it out, this is a local blindness: for every Pythagoras there has been a Zeno, for every Plato an Antisthenes, for every Hegel a Russell.

In Anglo-American philosophy, metaphysics has been regarded more or less as kitsch since about 1910; as Bertrand Russell said, it is always a type of "wishful thinking." Fifty years later this attitude came into prominence in the art world. Many artists began to regard the metaphysical intentions of a Newman or a Klein as kitschy and to eschew such statements about their own work. At that time they passed from metaphysics to the critique of metaphysics.

When Kosuth referred to "art after philosophy," he seems to have meant simply "art after metaphysics." He was announcing that art had left the realm of metaphysics and entered the realm of critical philosophy (an event foreshadowed in 1913 by the influence of Pyrrho of Elis on Marcel Duchamp). Art, in other words, is no less involved with philosophical content than it ever was; like our culture in general, it has merely switched its allegiance, for the time being, from one philosophical tendency to another. Art could only remain truly "aloof from philosophical presumptions" (as Kosuth called it) through perfect application of the through-the-eyes-only approach of Greenberg, which, as we have seen, could not be expected from any artist (or critic) who had not been lobotomized.

> We may admire a Crucifixion of Giotto for a variety of reasons, religious, aesthetic, historical, psychological. The scholar's faultlessness becomes a fault.
> —Nicholas Calas[80]

> The philosophically most interesting feature of critical interpretation is its tolerance of alternative and seemingly contrary hypotheses.
> —Joseph Margolis[81]

An artwork, subject as it is to the complexity of the general causal situation, radiates meaning on many levels. Once we realize that artworks exist in the world and are of it, we are driven to a multimodel approach to criticism. Such an approach would recognize the work as a complex in which different semantic realms coexist and interpenetrate without interfering with one another. But the formalist claim to priority in method assumes that one of these realms (in this case that of physical form) can be called art-as-art, to the exclusion of all the others. This claim, characteristically, begs the question, because it assumes that the word "art" has already been defined. In fact, aesthetics, like philosophy, is an uncertain science. The question of

whether aesthetic value is inherent or projected from outside is open, quite as much as is the question of whether philosophical meaning is inherent or projected. That one critic should express a formalist model, another a Marxist, another a philosophical, is nothing untoward. So it seems that criticism, quite like art, expresses a *Weltanschauung* inescapably. It is not a metagame above art, but just another game on the same level, with similar motives and satisfactions. Like art, it operates on a constantly shifting foundation, peaking in flashes of special insight. Its greatest weakness is the dogmatic imposition of special focuses as if they were ultimate laws.

> We would be convinced if beauty . . . were subject to regulation and schematization. Must it be shown once more that this is without sense?
> —Jacques Derrida[82]

I have argued the following views as a tentative correction to the residual influence of formalist doctrine: (1) that there are serious omissions in formalist theory in the areas of content and intentionality, and that these omissions result from illogical assumptions at the very root of the theory; (2) that these illogical assumptions are specific to our culture in the postwar period and are not confirmed by the practice of other cultures and times; (3) that the "purely optical" theory is inadequate to account for the art experience; (4) that elements from outside the physical work cannot be excluded from any human mode of relating to the work, and that this is not a matter of personal decision but an outright impossibility; (5) that there is no apparent justification for denying that an artwork's conceptual resonances are as much a part of it as its esthetic resonances; (6) that the artist's intentions, when they are known or recoverable, cannot be neglected and in fact never are, though the critic might pretend that they are; (7) that the artwork exists in a context of both the viewer's and the artist's sensibilities, with all the conditioning and acculturation involved in them—it exists, in other words, not as an isolated absolute or an end in itself, but as a rounded cultural object which relates to philosophy, politics, psychology, religion, and so forth; and (8) that the ultimate criticism of an artwork would be a multi-leveled complex of interpenetrated semantic realms which would virtually contain the cultural universe in miniature, and that since the same is

true of any cultural object, the artwork has no privileged status outside the affections of its devotees.

> *What is there in life except one's ideas,*
> *Good air, good friend, what is there in life?*
> —Wallace Stevens, "The Man With the Blue Guitar"

Let's admit that formalism became for a time a "secular religion,"[83] and we can understand better the passionate appeal it has exerted. In the '50s and '60s, when the classic formalist essays were written, we all wanted to believe that form in art was a kind of absolute, a Platonic hyper-real beyond conceptual analysis.

Why did this idea attain such popularity? Politically, it was perhaps a safe response to McCarthyism and the McCarran Act, which for a time frightened filmmakers, artists, and (yes) critics away from political meanings. But perhaps even more basic than this political motivation was a desire for the self-congratulatory pride of the cult initiate. Ultimately the worship of form as an absolute is a distant resonance of the Pythagorean/Platonic doctrine of the Music of the Spheres—the belief that art vibrations pass constantly through the universe and in fact constitute its inner ordering principles. And if we, then, appreciate the "feeling" of a Noland or Olitski, doesn't this mean that we are, as it were, in the inner circle of the cosmos, moved, however dimly, by the Music of the Spheres?

Formalism made us feel good for a while. It was like a superstitious passion. It ran its course. But our world could mandate a similarly forced solution for the present moment.

SEEKING THE PRIMAL THROUGH PAINT: THE MONOCHROME ICON

*T*he monochrome painting is the most mysterious icon of Modern art. A rectangle of a single more or less unmodulated color is erected on the wall at eye level and gazed at by humans standing before it in a reverential silence. What is happening? The painting is not impressing the viewer through a display of skill. In it skill is negated. Draughtsmanship is negated. Compositional sense is negated. Color manipulation and relationship are negated. Subject matter, drama, narrative, painterly presence, touch are absent. The color may have been applied with a roller or spray gun; it may even be the natural color of the unpainted fabric. One might as well be looking at the wall the picture is mounted on. Yet here, in this ritual-pictorial moment, the deepest meanings of Western Modernist art are embedded—its highest spiritual aspirations, its dream of a utopian future, its madness, its folly.

In Western culture the theme of unity is occult; the everyday model of the world presents many separate things held together by relationships. The idea that an underlying but usually invisible unity may be a more fundamental reality than the surface world of separate things is found mostly in offbeat occult schools: Theosophy, Rosicrucianism, Cabala, and so on. Most of these traditions derive, at least in part, from the Neo-Platonic system, which was articulated most fully by Plotinus in the second century A.D. This philosophy focused on the Problem of the One and the Many—the contradiction between the appearance of cohesiveness in the universe and the equally convincing appearance of fragmentation. For Plotinus (as for many other philosophers both East and West) the universe seemed

in essence one and undifferentiated, only in appearance many and governed by difference. His philosophy (and its descendants) was intended to promote the intuition of Oneness behind the appearance of the Many.

Here and there in human history the One-Many theme has come to the forefront of the visual arts: in Egyptian funereal art, especially that of the New Kingdom; in Chinese landscape painting; in the Tantric art of India; and in the art of the sublime in the Modern period of Europe and America, especially that of the abstract sublime and, within the abstract sublime, quintessentially in the tradition of the monochrome. In European painting, the Problem of the One and the Many has resided primarily in the figure-ground relationship. The ground represents the one ground of being, or potentiality, which acts as support for the many different figures which rise from it, somehow, and dissolve into it, somehow, again. The monochrome painting, by portraying the ground alone, with no figure, asserts the primacy of the One. This assertion is characteristic of the tradition of the sublime.

A text from antiquity, *On the Sublime*, by a Roman literary critic known today as Pseudo-Longinus, began it. "Longinus" spoke of the sublime in terms of "dignity and elevation," "majesty and grandeur," and "vast cosmic distances." He said that it was "suggestive of terror," and discussed a sublime image in which, he said, "the whole universe is turned upside down and torn apart."[1] The sublime, in other words, is other than the ordered universe in which separate individuals live in societies together; it is vast, untamed, irrational, and overpowering. In the view of "Longinus," art and literature have the ability, when practiced at their highest pitch, to lock the sublime inside a finite object or text. This paradoxical event involves a negation of the boundaries of ordinary selfhood, a negation at once exalting and terrifying. One of the examples given by "Longinus" is a passage of Sappho (fr. 31) in which she describes an erotic frenzy coming over her like death. The sublime is the destroyer of form and thus essentially different from beauty, which is a quality of form. In terms of the Problem of the One and the Many, the sublime is the One, the beautiful is the Many.

Plotinus taught an interestingly similar view.[2] In the one passage where he discusses art, he held that the artist is able to portray things

higher than the particulars of everyday experience and closer to the ultimate reality of the One. The genuine artwork, then, would contain a special metaphysical essence quite apart from the pleasure of aesthetic form, which can reside in everyday things. While exhilarating, this can be dangerous, as "Longinus" implied in his imagery. The reality of the One, being infinite, cancels or voids all finite realities such as the appearance of a self or of a social realm of interaction among selves. A sublime art could function, in other words, as a channel leading from the everyday toward the beyond, toward the infinite which is the death of the self and the destruction of the finite universe of form.

In the early eighteenth century, the century in which Western aesthetic views were formulated for the Modern age, the sublime again entered the discourse on art, after a long period in which form and beauty had prevailed. In the milieu of the Cambridge Platonists, Anthony Ashley Cooper, the third earl of Shaftesbury, revived the ancient view, asserting that it was the destiny of art to unveil higher metaphysical reality—setting in motion a long tradition, in which the German philosopher F. W. J. Schelling would later say that a great painting pulls away the curtain from the realm of Platonic forms.[3] In the middle of that century, Edmund Burke, following hints in the text by "Longinus," refocused the debate on the sublime, which he described as vast, dark, solitary, awesome, and threatening. It is the reality that is posited on the annihilation of the self. Later in the same century Immanuel Kant wrote that the sublime is that which, by its immeasurable vastness and uncompromised otherness, dwarfs and threatens to extinguish the realm of the individual. This style of discourse is essentially religious, traditionally used to describe the ineffable godhead. The sublime, as defined in these terms, is equivalent to the *mysterium tremendum*—literally, "the mystery that makes you tremble."[4]

The belief that art's destiny was nothing less than to embody the *mysterium tremendum* became central to the Romantic view of things. The philosopher G. W. F. Hegel, following Plotinus, regarded art as an embodiment of the infinite—a contradiction in terms of the type that was central to Romantic discourse. Schelling similarly said that art was the resolution of an infinite contradiction in a finite object.[5] James McNeil Whistler, later in the same tradition of discourse, said

that art was "limited to the infinite"—that is, limited to the unlimited.[6] Still later, Van Gogh would remark in a letter to his brother Theo, "I paint infinity."[7] The act of really seeing a sublime picture, then, would involve a special kind of seeing related to that of the mystics, as when P. D. Ouspensky described his experiences in the fourth dimension by saying, "I 'see' infinity."[8] Such locutions came to dominate the Romantic discourse on art, the "infinite," the "absolute," and the "sublime" functioning loosely as synonyms.

The confrontation of an individual person with the sublime or the infinite was considered the climax of the Romantic heroic adventure, a glorious transfiguration of the self into something other than and greater than a self. But there is a dark side to this exaltation: from the standpoint of the world of the body, the sublime is dangerous. It can be seen as a suicidal concept—even worse, as an aggression against history, civilization, and the entire world of form. The desire to vacate one's selfhood involves abandoning the body and annihilating the world it lives in, as the infinite annihilates the finite. In Johann Wolfgang von Goethe's quintessentially Romantic novel, *The Sufferings of Young Werther*, the hero in effect falls in love with the sublime and under its spell kills himself ecstatically. Werther was the prototype of Romantic artists from Shelley to Pollock whose muse was the sublime (and whose end was often early death).

In the late eighteenth and the nineteenth centuries the sublime in the visual arts was conceived primarily as a landscape theme: the awesome vastness of nature towering over the simultaneously exalted and intimidated human observer, as in many paintings by François Boucher, Jean-Honoré Fragonard, northern Romantics such as Caspar David Friedrich, and others. In works such as Fragonard's *Fête at Saint-Cloud*, for example, though the ambience is of social pleasantry, the overhanging dark and shadowy irrationality of nature looms like a *memento mori* above the doll-like festivity. As the figure shrinks on the canvas, the vast surround of the universe is terrifyingly revealed. Behind such paintings lurks the Hegelian dread of culture dissolving into the vast irrationality or valuelessness of nature, of the dream of civilization's advance sinking into the swamp.

The fascination with the sublime progressively ate away at the figure and hypostatized the activated ground. In the twentieth century it devolved finally on the monochrome surface, the pure ground

into which all figures have dissolved, as its central icon, representing the blank of the erased cultural world, or the blissful sleep of the soul which has returned to the One. The evolution of the sublime from a landscape theme into the pure one-colored surface was foreshadowed in Goethe's book *Farbenlehre (Theory of Colors)*, published in 1810. In this work, in addition to various optical studies, Goethe attempts to bring the realm of color experiences into a unified Neo-Platonic view of the cosmos. The desire for unity leads him to the monochrome idea. Beholding an unbroken expanse of a single color, he says, awakens awareness of universality. As such it has a tonic effect on the mind and tends to harmonize the individual beholder with the basic unity of things. The one-color presence is a channel into the mystery of Oneness. He recommends living in a room which is all one color and looking at scenery and at paintings through a uni-colored lens, and so forth—practices which have close parallels in Tantric Buddhism. The relationship between universality and the monochrome is illustrated in a similar poetic mood by Stéphane Mallarmé's remark that the perfect poem would be a blank sheet of paper, which, containing nothing (in actuality), would contain everything (in potentiality).

J. M. W. Turner read Goethe's *Theory of Colors* and made at least two paintings to illustrate points in it. In his old age, Turner's work underwent a shift which has been called the beginning of Modern art; it was in effect a shift away from the figure toward the ground. In the years 1840–45 his seascapes changed. The horizon line disappeared, and so did almost everything else. Boats dissolved into the sea, waves merged imperceptibly with light, all the elements mixed as in a huge cauldron and returned partway along the road back to primal chaos. The drifting cloud-like mix of sea and sky is a visual analogue of the state of potentiality, or "chaos," described at the beginning of Ovid's *Metamorphoses*. It is the state of being that prevailed prior to the separation of opposites from the One—prior to differentiation—the state which Anaximander called the Boundless or Infinite, the substrate which has no qualities yet from which the distinctions which make qualities mysteriously emerge. This is the state of the primal ocean before the first dawn in the Egyptian funereal iconography which underlies the first verses of *Genesis*. There is a subtle and interesting polychromy in these paintings, but it is a ves-

tigial polychromy, a mere remnant of the separation that once existed on the artist's palette; it is as if the artist had begun to mix the colors back to neutral grey and had stopped just short of this, while streaks and smears of differentiated hues could still be seen. The surface of these paintings (e.g., *Sun Setting over the Sea, Sunrise with Sea Monster, Sunrise with a Boat Between Headlands*) has become a glimmering and shifting veil, totally ambiguous in terms of depth or flatness, often seeming while almost flat yet to reach back to infinity not just at a vanishing point but in all directions: every point has become a vanishing point!

Turner has dissolved the figures into the ground, the Many into the One, which is conceived as an oceanic womb. Through purifying loss of adventitious differentiating qualities, all things are restored to primal unity. In terms of cyclical views of time such as are found worldwide in pre-Modern cultures, this is the state at the end of the world, when particulars dissolve into the universal, often mythologically conceived as a sinking into a cosmic sea.

The monochrome tendency gained strength in the latter half of the nineteenth century, as the cult of the sublime intensified. Whistler, for example, exhibited it in three different styles: (1) the "color symphonies," works in which he emphasized one small area of the spectrum and played with the tension between figure and ground by making them either close-hued or identical in hue; the most familiar examples are the *Symphonies in White*, especially *Symphony in White No. 1, The White Girl* (1861–62), in which the girl's white dress plays metaphysical games with the white drapery of the ground (foreshadowing Malevich's *White on White* paintings); (2) a group of paintings, mostly seascapes (such as *Nocturne in Blue and Gold, Valparaiso*, 1866), in which figures and ground are close-hued blues interpenetrating and surrounding one another; (3) a group of paintings such as *Harmony in Blue and Silver, Trouville* (1865), in which almost all the canvas is covered by a flat unmodulated field of a single color (foreshadowing the flat monochrome of the twentieth century), cut by a single flat band of contrasting hue (usually horizontal, but still foreshadowing Barnett Newman's "zip") and similar strategies to activate the ground by contrast.

The tendency to simplify, learned from the Japanese, combined with his own growing detestation for the conventional subject mat-

ter of paintings—whether Courbet's realism or Ingres's story-telling—led Whistler in the 1860s to the verge of the abstract painting with a strong tendency toward monochrome. The Valparaiso seascapes of 1866 are near-monochromes with tonal gradation. The famous *Nocturne in Black and Gold: The Falling Rocket* (1875)—the work which touched off the Ruskin-Whistler trial—and *Nocturne in Blue and Gold: Old Battersea Bridge* (1872–75) show the same formula: monochrome surface with tonal gradations spotted here and there with complementary colors which serve to "activate" the monochrome surface. Perhaps the most extreme examples are *Nocturne in Blue and Silver: Trouville* (1865) and *Nocturne in Blue and Green: Chelsea* (1871).

In these years Whistler's portraits also show the holistic monochrome surface activated by small contrasting areas (face, hands, collar). The titles reflect this: *Arrangement in Grey and Black, Arrangement in Black, Arrangement in Black and Brown*, and so on. The near-monochromaticism of these works was offensive to many of his contemporaries; one critic, describing the paintings at the Grosvenor Gallery show of May 1871 (the show which led to the suit against Ruskin), said the Whistlers were just "one step nearer to pictures than graduated tints on wallpaper." A more appreciative critic, Henry James, invoked the presence of the spirit, in commenting that Whistler's technique was "to breathe on the canvas."

In the 1880s and 1890s, Van Gogh and others were increasingly wooed from the figure to the ground. In a letter of 1888 Van Gogh commented on this: "Beyond the head, instead of painting the ordinary wall of the mean room, *I paint infinity*, a plain background of the richest, intensest blue."[9] Mallarmé had also regarded blue as a special analogue of the sublime, and this identification recurs frequently in the monochrome tradition; blue of course is associated with both sea and sky, the most illimitable external objects which humans experience. After about 1887 the treatment of the ground as a symbol for infinity became more or less standard in Van Gogh's work. At the same time the figures became increasingly close-valued with the ground, protected only by their black outlines from melting into it, in canvases that are 80 or 90 percent monochromatic. Famous examples include *Wheatfield with Reaper* (1889), *Winter Landscape* (1889), *The Sheafbinder, after Millet* (1889), and *The Starry Night* (1889).

Perhaps it is no accident that these paintings all date from the three years before the artist's suicide, as Turner's hypostatization of the ground occurred only in the last five years of his life. In both cases, as the artist approached contact with the ground of being, as he prepared to yield up the limitations of his separate personality and return into the Boundless, his work reflected this in a shift of emphasis from figure to ground.

Something similar happened in the case of Claude Monet. In his work the monochrome tendency is first strongly apparent in the systemic studies of Rouen Cathedral, of haystacks, and of poplar trees, which, as one critic has said, "expressed a cosmic pantheism" and "are passive modulations of a wholly immaterial life."[10] But for Monet, as for Turner and Van Gogh, the monochrome tendency became overwhelmingly strong as the end of life approached. In the late water-garden paintings he was intuitively attuned to the philosophical and mythological implications of monochromaticism. An acquaintance who saw *Les Nymphéas* in the artist's studio expressed it well: "In that infinitude, water and sky have neither beginning nor end. We seem to be present at one of the first hours in the birth of the world."[11] These words could as well describe the late works of Turner—though the end of the world has flipped to the beginning. In Egyptian mythology, Hindu mythology, and many others, the ground of being is represented by a primal and terminal ocean. All the gods—that is, all potentialities and forces—are held to reside in a seed state in the primal sea from which they separate out at the beginning of the world, when a lotus blossom emerges on the surface of the ocean as the vaginal beginning of the parade of forms. Monet's lilies also mark the transition point at which phenomenal pluralism rises from the zero-point of beginninglessness.

The water-garden paintings, once so beautifully installed in the Orangeric, are a model of the cosmic ocean-womb; they surround the viewer, placing him or her at the center—the emergence or submergence point—of the womb of the sea, whose surface streams with myriad lilies through which the dynamic force of creation rises from the unfathomable abyss of potentiality. The viewer is re-embraced by a sense of the eternality of the original moment, happening now and always, as basis for the subsistence of all passing phenomena. As Monet said: "Il faut beaucoup travailler pour arriver à rendre ce que

je cherche: l'instantanéité [It is hard to express what I am seeking: the instantaneous]."[12] He expressed the desire "to see the world through the eyes of a man born blind who has suddenly gained his sight: as a pattern of nameless color patches." This is equivalent to seeing as a newborn might see, or as the birth of the world might be seen, without conceptual categories yet overlaid on primary sense-data.

A late water-garden monochrome found in Monet's studio after his death is titled *Nirvana jaune*. In his old age he was influenced by Buddhism, where symbolism similar to his is found in abundance. Amida Buddha, for example, sits on a lotus on the water, nursing beings toward that realization as of "a man born blind who had suddenly gained his sight." The latest of the water-garden paintings (ironically after considerable loss of color vision in the artist's eyesight) are almost completely monochromatic veils of yellow or blue, reposing in peaceful unity while shimmering with creative dynamism. When the artist died, returning at last "through the lily pad" into the primal sea, his studio was filled with such paintings, obsessively repeated literally hundreds of times in various monochromatic hues.

At the beginning of the twentieth century the limited monochromaticism of the Impressionists and neo-Impressionists was still in force. Picasso's "blue paintings," for example, involve the aesthetic of close-valued figure and ground. Around 1910, in Cubism, Futurism, and Fauvism, this tendency joined hands with a growing attention to the two-dimensionality of the surface, as in Matisse's *Red Room* (1909) (with its Whistleresque sub-title, *Harmonie Rouge*), *The Red Studio* (1911), and *The Blue Window* (1911), in all of which the uni-colored ground asserts itself as a two-dimensionality directly conflicting with the implied three-dimensionality of the represented space. Early Cubist works like Picasso's *The Girl from Arles* (1912) simultaneously fracture the commonsense "things" into semi-atomic planes and melt them into a more or less uniform ground color, edges melting into the flat surface as Turner's ships melted into the sea. *Green Still Life* (1914) represents Picasso's furthest advance toward monochromy, which was, of course, not to remain his most characteristic style. In the same years, Luigi Russolo (*Solidified Fog*, 1912) and other Italian Futurists were engaged in similar experiments in close-valued hues and tones. But it was in the works of the

Russian artists Kasimir Malevich and Alexander Rodchenko that the two great threads of the twentieth-century monochrome—the metaphysical and the materialist—were defined.

Malevich's Suprematism was influenced by the early works of P. D. Ouspensky, *Tertium Organum* and *A New Model of the Universe*, which appeared when Malevich was about thirty and solidified his mystical "fourth-dimensional" approach to the canvas. Ouspensky, a mathematician, mystic, and syncretic thinker, attempted, in *Tertium Organum*, to synthesize the legacy of Kant with the discoveries of modern physics (the four-dimensional space-time continuum), with liberal doses of Hindu mysticism, Plotinus, Böhme, Spinoza, and Burke thrown in. His work is extremely path-oriented and foresees the development of a race of "supermen" who will correspond, for our age and place, to the great yogis of the East, or the Inner Schools of the occultists. The essence of the Superman, as set forth in the *Tertium Organum*, is that he will have expanded his perceptual receptivity beyond the limits set by Kant; specifically, he will have gained the ability to perceive four-dimensionality whole, and thus all events in the three-dimensional world will be transparently, childishly, simple to him. Ouspensky's diagrams and descriptions of four-dimensionality lie behind many of the geometric abstractions of Malevich, and Malevich's "non-objectivity" is in part an attempt to penetrate, by way of art, into the four-dimensional awareness discussed by Ouspensky, who wrote of his intuitions of the fourth dimension: "Everything becomes alive! There is nothing dead or inanimate. I feel the beating of the pulse of life. *I 'see' Infinity* [italics added]. Then everything vanishes . . ."[13]

With a possibly exaggerated regard for the "path" qualities of art, for its ability to effect (or to be the field for) personal transformation, Malevich at times speaks as if his *Suprematist Compositions* are the fulfillment of Ouspensky's preliminary "experiments," the palpable means to expand our receptivity toward Supermanhood. Of the *White on White* paintings, for example, he wrote: "I have broken the boundary of color and come out into white. . . . I have beaten the lining of the colored sky. . . . The free white sea, infinity, lies before you."[14] The white painting, like Van Gogh's blue ground, is a gateway into infinity, into a reality beyond all form. So sure was he that a new age of fourth-dimensional awareness was about to dawn that

Malevich referred to these works as the ultimate paintings, the last two-dimensional artworks.

By discarding the concepts and forms of ordinary consciousness, Malevich wrote, "art reaches a desert where nothing can be perceived but feeling."[15] This "desert" is "pure" feeling, the substrate of consciousness, from which all the surface forms of personality, affectivity, and discursive thought have been erased; as the yogi attains the state of pure consciousness by *citta-vrtti nirodha* (Patanjali, *Yoga Sutras*, 1), "the cessation of surface fluctuations in the mind," so the painter will attain to the visual analogue of pure consciousness by erasing the surface fluctuations of line and color from the painting. The stripped canvas is an analogue of the opened mind. This desert beyond form, yet filled with pure consciousness, echoes the words of Meister Eckhart, who described his mystical experiences as taking place in a desert beyond form yet fuller than any form—a Nothing more existent than any Something. Path-oriented like the mystics, Malevich saw his art as a way to escape the relativity of the everyday world, which it annihilates by a kind of sympathetic magic in which the representation is taken to control the thing represented: represent the world as blank and it is voided:

> The ascent to the heights of non-objective art [Malevich wrote] is arduous and painful . . . but it is nevertheless rewarding. The familiar recedes further and further into the background.
> The contours of the objective world fade more and more and so it goes, step by step, until finally the world becomes lost to sight.[16]

This turn away from the world of form can be seen in part as a terrified and revulsed reaction against World War I, and the desert beyond form as an unintended description of a Europe lying in ruins. The sublime is an enthusiasm that seems connected with the aftermaths of great and devastating wars; it was prominent immediately after the Napoleonic Wars, World War I, and World War II. It may be, again, a sign of a disillusionment with the accomplishments of civilization that Malevich denounced artistic technique, conventionally perceived beauty, and all art bound to form, as futile and vulgar.

Extremely reductivist works such as *Black Square* (1915) and *White on White* (1918) did not, of course, remain Malevich's most characteristic expressions. He became a pioneer of a more complexly

aestheticized geometrical abstraction quite as much as of the empty or "deserted" painting. Yet his geometrical abstractions also often point in this direction: the *Suprematist Compositions* (1916) "expressing the feeling of fading away," as Malevich wrote of them, show black forms, geometrical like the Ideas of Plato, fading off into the white ground,[17] and the *Suprematist Composition Conveying a Feeling of Universal Space* (1916) and *Suprematist Composition Conveying a Feeling of a Mystic "Wave" from Outer Space* (1917) are almost completely white monochromes.[18]

The monochrome tendency was expressed in a different mood by Malevich's contemporary Rodchenko, also of course in the post-World War I milieu. His *Black on Black* (1918), *Pure Red Color, Pure Blue Color,* and *Pure Yellow Color* (all 1921) were less metaphysical than materialist in intention; they transformed the painting from an illusionistic field representing the deep space of infinity to a plainly stated material object with sculptural overtones. Rodchenko, like Malevich, called these the "last paintings," but with a different intention; he hoped to terminate with these works the tradition of idealist abstract art, the art of the sublime, and unmask the enormous lack of realism in Malevich's metaphysical pretensions at the same time. This approach to the meaning of the monochrome painting was one that would re-emerge only much later in the tradition. In fact, both the metaphysical and the materialist monochromes went on hold for a generation after these seminal articulations.

The reductionist tendency which rose to prominence in European art in the World War I era was short-lived; in the 1920s and still more the 1930s, when the Great Depression returned people's attention to concrete realities, painting tended away from emptiness and toward technique and formal complexity again. There is a lag of three decades before the full force of Malevich's and Rodchenko's legacies was felt. Still, there were some monochrome paintings in this period. Joan Miró made a remarkable painting in 1925 (called *Painting*), almost entirely blue with a tiny dot in the upper-left-hand corner. A certain turbulence in the brush work around the center has led some to interpret the work as a hidden landscape. Others have seen this painting and other Miros of the period which, though not monochrome, yet give overpowering emphasis to the ground, in mystical terms.[19]

In the same year Miró painted *Birth of the World*, an emphatic brown ground with disconnectedly floating geometrical "Ideas," suggesting the primal void and the first emanation of the Ideal forms from it. The subject of creation—and the linked subject of destruction or world-end—is intimately connected to the monochrome, which depicts the blank before or after the world and its history; its various modes hover around this transition point between form and non-form, some slightly on one side, some on the other.

Subsequent to 1925, Miró's work, in tune with the times, veered away from the monochrome; his decades of biomorphic abstractions followed. But later in life he returned to the subject of cosmic creation and the monochrome field. *The Birth of Day I* (1964) is a modulated field of blue-green with only the most incipient internal distinctions; it shows the fecund surface of potentiality in its first surging or breathing impulses toward birth. *Painting for a Temple I* (1962) is an orange near-monochrome with two small black dots floating in the upper left corner (more or less where the spot appeared in *Painting*, 1925).

In the 1930s various painters, influenced both by Malevich and Miró and by the vaguer "monochrome tendency" which, since their work, was "in the air," painted in near-monochrome styles. Ben Nicholson began making his *White Reliefs* in the late 1930s, and Tobey's *White Writing*, in the mood of Chinese "grass-style" calligraphy, first appeared in 1935, after the artist's stay in a Zen monastery in Japan. Both styles stem from the desire to bridge the separation between figure and ground—between Many and One, or particular and universal—yet without sacrificing the figure entirely, without plunging headlong into the desert or void of the empty canvas.

Many painters in this period stepped back from Malevich's "desert" and developed the implications of his more moderate geometrical abstractions. This generalization roughly covers the Polish followers of Malevich, the De Stijl painters, and some of the Bauhaus painters. Mondrian in the 1940s painted pure monochromes and hung them in various patterns in his studio—but did not exhibit them as completed pictures. His less monistic style, Pythagorean-Platonic (rather than Parmenidean) in its implications of a multiplicity of mathematical-geometrical underpinnings of reality, sometimes

approaches monochrome white (e.g., *Composition avec jaune*, 1938). But always the black rectilinear divisions criss-cross the field like Plato's geometrical abstractions attempting to enchain the division-less Parmenidean One. Walter Dexel and Lázló Moholy-Nagy were also close to monochrome at times in the 1930s, though always shying away from complete emptiness. Bart van der Leek made compositions 90 percent monochrome but with minimal geometrical abstraction in this period,[20] as did Carl Buchheister,[21] Friedrich Vordernberge,[22] and, in France, Georges Vantongerloo[23] and Jean Gorin.[24]

In terms of the Platonic metaphysics which not-so-distantly underlies much abstract art (virtually all geometrical abstraction), these paintings with minimal geometry on a near-monochrome ground are visual analogues of the phase right after the absolute has yielded up the first principles of being. In Plato's later works and in the extant reports of his lectures this moment is described: the formless and attributeless ground yields up first the basic principles of geometry and mathematics; then, from varying combinations of these, the world of "things" is produced, first the highest genera, then the lesser, till finally, at the bottom of the ontological hierarchy, the commonsense world of particulars appears. Malevich's geometrical abstractions on nearly empty grounds, like those of Mondrian and others, represent this early stage of ontological unfolding, closer to the absolute void than to the commonsense realm of particulars, yet hesitating to face it directly. This is an intermediate stage between realistic representational painting, which affirms the realm of particulars, and monochrome painting, which affirms the ultimate void. Malevich's call for an art beyond form and technique, an art of the void or the absolute, was taken up less by his immediate successors than by their successors. In the aftermath of World War II the desert beyond form once again became a leading theme of painting.

The exact beginning of this movement is hard to pinpoint. Yves Klein first exhibited monochromes publicly in London in 1950 (though not in an art gallery)—but says that he made his first one-color pictures three years earlier. Robert Rauschenberg exhibited his white monochromes for the first time in 1951—the earliest exhibition of pure monochromes in an art gallery—but says that he made

them two years earlier. Ad Reinhardt exhibited his red and blue monochromes for the first time in 1953—but says that he started to make them in 1951. Clyfford Still's *Untitled, 1948/9*[25] is an almost pure brown-black monochrome with two tiny streaks of red and one of blue. Robert Motherwell's *The Homely Protestant* (1947–48) is an almost completely brown monochrome with half a dozen red streaks. Sam Francis's *White* and *White Green Earth* (both 1951) are near-white monochromes with lozenge-like modulations of the ground. Barnett Newman's *Galaxy* (1949) is a red-violet near-monochrome with two close-valued stripes: in 1951 he made an all-white painting, and the famous *Day One* (1951–52) is a nearly pure pink monochrome. Ellsworth Kelly's *Study for Twenty-five Panels: Two Yellows* (1952) is a square monochrome with internal division into twenty-five smaller square monochromes. From 1950 on the pace accelerated. By 1955 Jasper Johns had monochromed the American flag. By 1958 Joseph Albers' *Homages to the Square* were approaching monochrome, as were some of Mark Rothko's floating rectangle compositions. By the 1960s and 1970s the monochrome tendency had spread into all types of painting and become a pervasive element of the mainstream vocabulary.

It was Klein above all who gave conceptual definition and verbal formulation to the monochrome in the post-World War II period. Like Malevich he saw it as an aspect or a sign of a spiritual path and attempted to embody its principle—"the monochrome spirit," as he put it—in his life.[26] Like Malevich, Mondrian, and others,[27] Klein had been deeply influenced by an occult tradition of spirituality which preserved the Neo-Platonic obsession with the One. In Klein's case the One-Many theme appeared in a Rosicrucian formulation.[28] In this tradition (as in Neo-Platonism) essential unity and apparent plurality are mediated by an emanational theology: the universe emanates out of primal unity in seven stages. The last and "lowest" of these is the corporeal plane, on which human life is currently conducted. Here the boundaries of the Many are rigidified by material form and its conditions such as gravity and unilocality. This debased age, in Klein's view, was about to give way to an age of immateriality and levitation in which humans would have special powers, like the Ouspenskyan Supermen whom Malevich anticipated in the supposedly imminent fourth-dimensional age. Klein wrote:

> We will become aerial men, we will know the force of upward
> attraction, toward space, toward the void and the totality at one and the
> same time; when the forces of terrestrial attraction have been dominated
> in this way we will literally levitate to total physical and spiritual liberty.[29]

For Klein, as for Van Gogh, blue was the color of infinity, in Klein's
case because of its connection with the sky, the site of the levitated
humanity of the next age. He called his blue monochromes "portraits"
of the sky—which he claimed to have signed, in an act of levitation, on
its other side—and in general addressed the empty sky as a pure spir-
itual condition. His 1957 show of eleven identical blue monochromes
was called *L'Epoca blu*, and was Klein's formal announcement of the
new age of art; blue had become for him (as for Goethe and as in
much traditional iconography) the symbol for the absolute—the
empty infinitely extended sky of his "aerial" kingdom.

> Through color [he wrote] I experience a feeling of complete
> identification with space, I am truly free.
> If a color is no longer pure, the drama may take on disquieting
> overtones. . . .
> As soon as there are two colors in a painting, combat begins; the
> permanent spectacle of this battle of two colors may give the onlooker a
> subtle psychological and emotional pleasure, that is nonetheless morbid
> from a purely human, philosophical point of view.[30]

There are similar formulations in Buddhist literature, which
holds that the healthy or enlightened mind is like pure space or, as
some texts have it, like the open sky. This open and spacious mind,
with no internal division based on opinion or ego-projection, is one
with the Dharma, or Transcendent Truth. As soon as the first division
appears in it, neurosis rules. As the Tibetan Buddhist Milarepa said:

> The mind is omnipresent like space . . .
>
> . . . the mind, like the sky, is pure . . .
>
> It was fine when I contemplated the sky!
> But I felt uneasy when I thought of clouds . . .
> Therefore rest right in the sphere of the sky!
>
> A wise man knows how to practice
> The space-like meditation.
> In all he does by day
> He attaches himself to nothing . . .[31]

Milarepa balances his sky and clouds imagery with a parallel imagery of sea and waves, which recalls the monistic implications of Turner's late paintings:

> It was fine when I contemplated the sky!
> But I felt uneasy when I thought of clouds . . .
> It was fine when I contemplated the great ocean!
> But I felt uneasy when I thought of waves . . .[32]

Klein's worship of the sky (and specifically the far, empty sky, beyond atmospheric phenomena, what he called the "other side" of the sky— the sky as pure undivided space) is another imagery for worship of the one foundation rather than the many transient forms which rest upon it. His monism or absolutism is thus more abstract and radical than that of Turner and Monet and the mother-oriented mythologies. It represents the absolute rather as above and beyond all forms than as below and underlying them. Thus, Klein's celebration of pure monochromatic color and his attempt to take its nature into himself—adopting the sobriquet "Yves the Monochrome"—express his desire to attain to a transcendent condition of non-differentiated consciousness (what Malevich called "pure feeling") to which all differentiation (all line or form) is mere accident—a principle more austere than that of the nourishing and mothering One of the sea-womb. The space-like mind has become like Mallarme's blank page which, containing nothing, contains everything. As prime matter holds all things in a state of potentiality, so, Klein felt, the monochrome painting holds all things in a state of "pictorial sensitivity." When beholding the ground without figures—the blank monochromed canvas—one is looking at infinite and original omnipresent Sky-like mind. The empty canvas is free, absolute, transcendent; the filled canvas is imprisoned, relative, tortured by limitations.

From this ethical-psychological stance Klein posited a dichotomy between color, which represents the wholeness and universality of space and of space-like mind, and line, or drawing, which represents neurotic fragmentation into a realm of discordant particulars; color fills space, line divides it:

> Color, in nature and man, is saturated with the cosmic sensitivity, a sensitivity without recesses. . . . For me, color is sensitivity materialized.

It is saturated with the all just as everything is that's indefinable,
formless, limitless sensitivity. It is, indeed, the abstract space matter.
 Line may be infinite . . . but it lacks the ability to fill the
immeasurable all. . . .[33]

As unmodulated color = space = Sky = infinity = cosmic sensitivity =
omnipresent mind = the absolute = the immeasurable all, so, in a neg-
ative and "disquieting" equation, line = obstruction = world = limita-
tion = insensitivity = neurotic personality = the relative = the
measurable finite particular. Thus Klein saw not only art history but
life itself as a "battle between line and color," and proclaimed him-
self, in his artistic knight-errantry, the "Champion of Color" against
line, of unity and openness against discord and division. By relating
to pure color, as the alchemist related to his symbols of Prime
Matter, one is to be restored to one's original nature before the onset
of dualistic fixation, mythically, to Eden: "By saturating myself with
the eternal limitless sensitivity of space I return to Eden. . . ."

The "monochrome spirit," then, was an urge to seek Sky-like
mind, which constitutes the return to Eden, and to relate directly to
the absolute; if an artist's life was not based on this premise, then his
paintings could not be "true" monochromes embodying the "mono-
chrome spirit." Seeing artistic imperatives as deeply ethical, Klein said
that Rauschenberg's white paintings, for example, looked like mono-
chromes but did not have the monochrome spirit.[34] Monochrome
painting meant art as a spiritual path of the most direct kind, far more
direct than the old religious art of painting gods and angels: here one
painted only the "blue deep" (as Gaston Bachelard called it) from
which all gods and angels arose (or descended) or were temporarily
and ambiguously constituted apparitionally as clouds which cannot
disturb the distant blue emptiness of the sky. Alongside his mystical
monochromes Klein heralded the empty sky and the purity and unity
of space in a variety of altogether immaterial works—"zones of imma-
terial pictorial sensibility"—which portray space as the Prime Matter,
or realm of potentiality, from which transient forms arise and into
which they dissolve again in time. In the Malevichian-Kleinian tradi-
tion the "immaterial" work is closely linked with the monochrome,
which, as the "last" material artwork, makes way for it and heralds its
advent.

Klein's charismatic influence spread the monochrome spirit widely in the next generation of European art. The attraction of this world-renouncing ideology can hardly be divorced from its historical position in the aftermath of a world war. In the war-torn nations of Europe, even some older artists, such as Lucio Fontana, felt the attraction of Eden and responded. Between 1957 and 1959 Fontana produced works in slashed paper, and from 1959 to 1969 the hundreds of slashed monochrome canvases (usually in white, but often pink, gold, green, grey, etc.) for which he is most famous. Their monochromaticism is as essential to these works as their semi-sculptural cutting—indeed, the cuts and slashes are in a sense simply reinforcements of the monochrome idea, reaching through the surface as an acting out of the idea of attaining pure space, higher dimensionality, immateriality, and so on.

Fontana was rooted in Futurism and, through Futurism, in Constructivism and Malevich; he was influenced by Klein and influenced him in turn. He was part of an international Malevichian avant-garde of the 1950s and 1960s which rejected the values of the School of Paris, attempting to define Malevich's ideas of "higher space" through painting, environment, aerial art, and light art.

In 1927 Malevich had written, "The artist (the painter) is no longer bound to the canvas (the picture plane) and can transfer his compositions from canvas to space."[35] Fontana's art is an embodiment of this principle. In 1965 he wrote:

> As a painter, while working on one of my perforated canvases, I do not want to make a painting: I want to make a painting: I want to open up space, create a new dimension for art, tie in with the cosmos as it endlessly expands beyond the confining plane of the picture.[36]

"Creat[ing] a new dimension" is an obvious Malevichian/Ouspenskyan echo, and the aim of "[tying] in with the cosmos" suggests the path-oriented approach with its resonances of sympathetic magic, that is, the belief that changes in art represent changes in ontology: as art creates a new dimension so life will be elevated to new dimensions of power and awareness.

In another sense, the often violently slashed and gouged openings seem to represent a violent explosive breaking of the limits of the mind, opening it endlessly in all directions as it were (the fourth

dimension, according to Ouspensky, must be at right angles to all our known dimensions, and thus must open as it were in all directions).

> Thus the fourth dimension is born [says Fontana], volume is now truly contained in space in all its directions.[37]
>
> . . . the discovery of the cosmos is a new dimension, it is the infinite, so I make a hole in this canvas . . . and I have created an infinite dimension. . . . That is precisely the idea, it is a new dimension corresponding with the cosmos.[38]

The hole then is not intended as a destructive gesture, but as a channel or bridge between the relative and the absolute, between something and nothing (Fontana describes the holes as "a bridge thrown toward nothingness"), between the finite space of the canvas surface and the infinite space "beyond" the canvas.

Still, no less than Malevich's desert beyond form and Klein's empty sky, Fontana's invitations to infinity to assert itself implicitly involve the annihilation of the world of forms and individuals; they seem to reflect the horror of world-devastating war as well as the onset of nuclear endgame weaponry. It cannot be ignored that the emptiness these artists invoke is one with the end of the world. Ultimately the monochrome painting is a picture or emblem of the end of the world, or the moment after. In Hindu Tantric art the monochrome is especially sacred to Shiva, the god of the end of the world, whom Oppenheimer invoked at the first atomic explosion, which occurred shortly before Fontana's slashed surfaces and other beginning-and-end-of-the-world art such as Pollock's *The Deep* and Newman's *Day Before One*. As Fontana wrote:

> Once man has been able to convince himself that he is nothing, absolutely nothing, nothing but pure spirit, then he will no longer be blinded by material ambitions . . . then man becomes like God, he becomes pure spirit. There you have the end of the world and man's release from matter. . . .

Thus, art has the potential to actualize not only higher-dimensional awareness, but also the destruction of the world and of art itself. The madness of this (With this painting I destroy the universe) derives from the Hegelian view of history, with its predication of an end of history in a condition of complete spirituality—a view which is paral-

leled in the various occult traditions with their prophecies of immi-
nent new ages metaphysically beyond the corporeal.

Klein's influence was especially strong in Italy and Germany, the
European nations most devastated by the war. In Germany the
young artists who called themselves the "Zero Group" (again with
hidden implications of the end of the world) felt Klein's influence
intensely. From 1957 until after Klein's death in 1962, Otto Piene,
Heinz Mack, and others of this group spoke of "liberation" through
color, of the "spiritual sensitivity of the surface," and so forth. In
1958 the group presented an exhibition of paintings showing the
monochrome tendency—"The Red Painting"—accompanied by the
first issue of their magazine, *Zero*. Piene says of this period, "Yves
Klein had perhaps been the real motor in provoking a Zero move-
ment. . . . His influence . . . came from his personal genius and his
universal attitude toward purification."[39] Writing in 1964, Piene sees
that the "individual tendency" of the Zero artists "had only a loose
connection with his [Klein's] ambitions." But this was not so clear at
the beginning, when, in *Zero*, no. 1 (April 1957), the Zero artists
speak as Klein epigons, writing of "purifications of color," "purifica-
tions by color," and so forth. At the time, these artists were into
monochrome styles with sculptural variations of the surface by per-
foration and imprint, showing the influences of both Klein and
Fontana; but it was already evident by the time of *Zero*, no. 2,
"Vibrations" (October 1958), that these artists by "individual ten-
dency" had more in common with the *Yellow Manifesto* of Vasarely
(1955) than the Blue Revolution of Klein; more in common with the
Spanish group Equipo 57 (founded in 1957 to study the interaction
of motion and vision) than with the School of Nice. Already the
influence of Klein was giving way to the influence of Tinguely and
Fontana and of the writings of Moholy-Nagy, leading toward a
science-and-technology-worshipping three-dimensional non-
sculptural art with kinetic elements.

The title *Zero* (long sought for, according to Piene) indicated "a
zone of silence and of pure possibilities for a new beginning"[40] (again
not unlike Mallarmé's blank page). In the first issue this silencing for
a new beginning was expressed through the theory of the mono-
chrome. It resided in "The purification of color . . . the peaceful con-
quest of the soul by means of calm serene sensibilisation."[41] Behind

the echo of Klein is an older echo, of the semi-Tantric teaching of Goethe in the *Farbenlehre*, that exposure to an unmodulated color pacifies and universalizes the soul.

Mack, in his article in *Zero*, no. 1 ("The New Dynamic Structure"), starts out by echoing Klein ("If I set one color in contrast to another, I may possibly intensify the first, but at the same time I am restricting its freedom . . ."[42] but soon shows a Vasarely-like bent for optical motion rather than Kleinian illimitable emptiness:

> . . . it is possible to bring one color into play so that it becomes completely self-sufficient. We can achieve such intensity of color vibration through a continuum of deviations from an ideal monochrome, or through a continuum of graduated value of the same.[43]

For Klein the ideal had been to set color free from manipulation. Mack sees minor chromatic manipulation as a way to set color free rather than as a type of color-bondage. This revision amounts to a partial rejection of the monochrome idea as defined by Klein, which now is seen as too anti-visual. Mack draws the monochrome spirit down from the heights of the noumenal and re-involves it in phenomena—but with a mystical vibratory relationship to them:

> Purity of light . . . takes hold of all men with its continuous flow of rhythmic current between painting and observer; this current under certain formal conditions, becomes a forceful pulsebeat, total vibration. . . .

He concludes with another nod to Klein and, beyond Klein, Malevich (and the Tantric thinkers of India): "Color [is] a manifestation of spirit. . . ."

Mack and Piene set up their idea of "vibration" as a middle position between figure-ground "paralysis" and the more or less static monochrome. Mack dismisses "the tumult of polychromy" and Piene defends vibration as "the activity of the nuance, which outlaws contrast, shames tragedy, and dismisses drama."[44] This amounts to a claim that the "disquieting overtones" which "enter the drama," according to Klein, when any line or second color is added to the pure monochrome, do *not* arise in the "activity of the nuance" which makes for vibration; in this type of work we are, as it were, some-

where in between the figure and the ground, on a vibrational bridge between the One and the Many—avoiding the schizophrenia or alienation of the figure-ground painting while also avoiding the world-rejecting autism of the pure monochrome.

B. Aubertin, a French artist connected with the Zero Group, published in *Dynamo* (1960) an interesting statement on the monochrome in which he attempts to establish it as a school in the art historical sense in which Cubism was a "school," and one of comparable importance. His statement shows the climaxing force of monochromism around 1960 and its intense appeal to painters who had been struggling to push and pull and otherwise manipulate their colors; the monochrome's rejection of technique, which had been emphasized by both Malevich and Klein, offered a sense of liberation from academic constraints which is comparable to that felt by French painters when Impressionism liberated them from Neo-classicism:

> Color [Aubertin wrote] has two values—an absolute value (pure tone) and a relative value (obtained by physically mixing the pigments with one another and by optical mixing—placing pure colors side by side).
>
> As soon as several colors meet on a canvas, they lose their absolute value (pure tone) and acquire a relative one. . . . Monochrome painting preserves absolute value for each color.
>
> The aim of color is totally realized in monochrome painting. The fascinating fullness of color is tangible only in monochrome painting. Here, deprived of its intermediary function, color finally exists. Radiating through space, it imposes its magic. . . . Thus color adds an ontological expression to its physical property.

Color's "ontological" aspect means that it is not only a quality, but an embodiment of the substrate of pure being, and that it can exercise the force of pure being, beneath or beyond all qualities. This is a restatement of the idea expressed by Malevich, Klein, and others: the monochrome, as a "gateway to infinity," draws one into it and out of oneself simultaneously; it exerts a purifying attraction toward unity and away from the separated-ego point of view which is represented by line, drawing, and the figure. The absolute space of pure consciousness prior to all images is projected onto the unbroken monochrome surface, and that surface then, charged, as it were, with the energy of this projection, is able to open a channel into the absolute space beneath the surface or image-mind of the viewer. This power,

which Malevich called "pure feeling" and Klein "immaterial pictorial sensibility," Aubertin calls "pictorial reality":

> When pictorial reality is present in an invention, we are dealing with a pure autonomous creation. . . . The monochrome painter addresses himself to pure imagination. It is within the power of imagination to provoke a feeling of ecstasy in the spectator. . . . Complete control of it is demanded by the monochrome painter.

The painting, by awakening awareness of the absolute space within the self, engulfs the viewer, as it were, from within; functioning as the trigger of awareness of a greater Self, it engulfs the smaller self of the viewer: "The painting no longer merely presents itself to the spectator—it engulfs him." Finally the monochrome absorbs into its grandly simple "solution" of art history both the old illusionistic painting of depth and the action painting: the action of the painter on the material (like the action of the priest or white magician while transforming profane substances to divine) leaves the formless but all-important "pictorial reality" palpably on the canvas, ready to exert its purifying magnetism upon the viewer:

> The color material must . . . be worked with exceptional force in order to produce a radiance and an intensity that, while giving it quality, establish a pictorial presence.
>
> The painter's gestures, his technique, and the fact that he constantly reworks his canvases give his pictorial reality an uncontrolled freedom. The free action of the knife, the brush, and the hand on the canvas . . . counts for the most in the expression of a unique quality whose nature is pictorial reality. . . .
>
> . . . the life of the painted surface is conditioned by the presence in it of the pictorial reality, introduced through a particular material and by means of a qualitative manual execution in which sensuality and sensibility rise to the surface.[45]

Aubertin's formless but palpably present and spiritually crucial "pictorial reality," like Klein's "immaterial pictorial sensitivity," goes back to Hellenistic-Roman alchemical ideas and Aristotle's Prime Matter. It relates to the Vedantic concept of *akasha*, the Buddhist term *shunyata*, and the Cabalistic *Zim-Zum*, the creative space produced by the "contraction of god." This type of idea occurs regularly with the metaphysical monochrome. The materialist monochrome

involves another attitude, one which, first expressed by Rodchenko, reappeared ambiguously in the career of Piero Manzoni.

In 1957 Manzoni, then 24 years old, saw Klein's show of identical blue monochromes in Milan. A few months later he signed the *Manifesto Against Style*, which was also signed by Klein and which marked a turning away from the School of Paris with its emphasis on technique and beauty and was a defining document of the Malevichian avant-garde as opposed to the Matissean. In the fall of that year Manzoni produced his first gessoed canvas rectangles, calling them— in a conceptual one-upping of Klein's "monochromes"—"achromes." In the remaining four years of his life he produced achromes in a variety of materials and with a variety of non-painterly techniques (such as stitching, rumpling, and creasing) adding definition to the surfaces. In addition, recalling Klein's dichotomy between line and color, but reversing his championship of color, Manzoni began producing the long, sometimes kilometers long, rolled-up lines which suggest the linear infinity of the world of form as a balance to the quasi-theological dogma of formless spatial infinity posited by the Kleinian monochromes.

In several brief writings Manzoni articulated the idea of the monochrome without the traditional "path" orientation, though often ambiguously echoing Klein's messianic-Edenic discourse. The echoes of Klein's absorption of traditional spiritual disciplines coexist ironically with an understated espousal of a Marxist materialistic view. At moments Manzoni sounds religious or inspirational: "Why shouldn't this surface be freed? Why not seek to discover the unlimited meaning of total space, of pure and absolute light?" This language balances ambiguously between history and spirituality. Seen within history it is more of the end-of-the-world discourse characteristic of the post-war monochromist. Discovering pure and absolute light is talk of heaven, and the surface which might as well be cleared is not only the human soul but also the face of ravaged Europe, the slate of history which might be voided by the will against form. Elsewhere Manzoni echoes with ironic ambiguity the anti-form art-discourse of infinity: "Infinity is rigorously monochrome, or, better still, it has no colour."[46] Manzoni's reductionism is that of Marxist materialism, not that of spiritual absolutism. His use of dinner rolls as sculptural elements in achromes, his exhibition

of his excrement in answer to Klein's use of gold, his map-works, his exhibition of old shoes—in these and other details of his work there is an attempt to redirect attention to the material necessities of life in society without involving self-important displays of virtue and purity:

> Art for Manzoni is not in fact a means of resolving the problematic nature of the individual in flight from the everyday into an escape towards the universal, the immaterial, the magic of the primary. It is the declaration of an individuality that has been lived out in a real time and space, and with a concrete and unmanipulated body.[47]

The "monochrome adventure" (as Klein called it) is brought from the other side of the sky down to earth; the monochrome spirit is to be held identical with the physical surface, not a special, spiritual presence within it. Manzoni is transitional between the metaphysical monochromists, with whom he shares a passion for the "freedom" of "infinity," and the formalist monochromists of the 1970s and after, with whom he shares an insistence on the ordinary physicality of the plane.

These artists—Klein, Fontana, Manzoni, and the Zero Group— were, if not a "school," at least a "movement"; they shared not only the monochrome style, but a kind of monochrome vision: a world transformed into "higher space" by the conjoined art and science of the immaterial infinite. Science sent its cosmonauts into space; art will now make of each of us a cosmonaut into his or her own inner spaces, delving below the level of personality (drawing) and undergoing a transformation into a more whole and unified being (undifferentiated color), one whose inner space is unified with cosmic space in a living vibration. Whether or not they literally expected their art (or any art) to transform human consciousness on a wide scale and lead society into a purified utopia, they expressed themselves this way. For them, as for various Asian schools, painting was allied with the spiritual and occult traditions and disciplines; it was also, in a more Western mood, allied with what they regarded as the inner meaning of modern science: higher-dimensional unity and evolutionary path-orientation. For them painting and the other arts were to become parts of a new culture of unity, forming, with science and religion, a bridge to a new evolutionary age.

On the American scene in the post-war period the mystical view of the monochrome as the medium of a transforming voyage into deepest inner space was equally prevalent—but in a more alienated mood, without the Europeans' messianic-utopian faith in art as an effective instrument for social change. In the 1940s those painters whom Harold Rosenberg was later to call "the theological sector of Abstract Expressionism" turned radically away from Cubist and Geometric formalism and toward a content-dominated art which attempted to express the permanent spiritual foundations of human life. In the early and middle 1940s this urge was expressed in the Jungian- and surrealist-influenced work of the "mythmakers." In the late 1940s, after the war, the mythic schema of archetypal forms floating on a ground of consciousness gave way to a direct seeking of the absolute beyond form, and thus to monochrome and near-monochrome styles.

The earliest datable American metaphysical monochromes (or near-monochromes) were made by Clyfford Still, who in 1948—49 (before Klein's private London exhibition of 1950) painted a group of almost-all-black canvases.[48] At the same time he opened his palette to other (mostly earth) colors, and established his mature or "classical" format of open holistic expanses of one color or close-valued hues and shades, with ragged flame-like edges and intrusions of contrasting colors at the lower corners, usually the lower right, which, rather than nullifying the overall monochromatic effect, heighten it by pointing it out. Seminal works of this type include *1948-F*, *1951 Yellow* (an almost completely yellow near-monochrome), and *1951-N* (a near-monochrome in close shades of red). The holistic and expanding monism of these works is not contradicted by their perceptible areas, which, as one author has said, "are not separable forms against a background but function as zones of a holistic field."[49]

Literary influences which Still was aware of working out in his art included Pseudo-Longinus's *On the Sublime* and the works of Blake, especially *The Marriage of Heaven and Hell* with its attempt to re-unify a humanity fallen into dualistic inner divisions (Klein's "disquieting overtones"). The paintings have been appropriately described as "symbolic," provoking "sensations of exaltation and liberation," "universal," "transcendent," creating "visual metaphors for the sublime."[50] The artist himself referred to his work as "the genesis of a liberating

absolute."[51] And indeed it was, for American artists, a genesis, a beginning of a daring exploration of the monochrome idea—the idea of an *absolute* painting, a painting which goes beyond sensual relativism (figure-ground relationship) toward an expression of the whole-cloth of being—which for Still as for Klein was to be described primarily by the word "freedom." To Klein it was the internal divisions of the ground which seemed authoritarian limitations and insults to freedom; to Still, it was not the internal line so much as the framing rectangle that was a denial of holism and freedom:

> To be stopped by the frame's edge was intolerable; a Euclidean prison, it had to be annihilated, its authoritarian implications repudiated without dissolving one's individual integrity and idea in material and mannerism.[52]

He sought a surface with implications of infinite expansion beyond the frame. The rectangle is, after all, a shape, and all shape is a limitation of open space—in a sense an insult to it. Klein chose to deal with this problem conceptually, calling his blue monochromes "portraits," through a studio window, of the night sky; thus, the rectangle is not implicated in the surface itself, nor does it surround it. We are looking *through* the rectangle at a boundless space behind it. Still arrived at a different, more visual, solution. Snaky lines (as in *1943-A*) enter the rectangle from outside, uniting it with the whole continuum of being; intrusive color fields begin at the lower corners and lead not into the rectangle but out of it, into other areas implied but not seen.

When Still made his breakthrough, Barnett Newman was also on the verge of breaking out of the quasi-figurative "mythmaker" style and into the sublime of pure color. In the "Euclid" paintings of 1947–48 the continuous ground is broken by one or two vertical stripes (Newman would later call them "zips") which, like Still's glimpses of contrast in the corners, accentuate rather than contradict the basically monistic ground. The crucial work *Onement 1* (1948) shows the mature plan of a vertical stripe on an unbroken and unmodulated ground. *Galaxy* (1949) has two stripes, both simply near shades of the ground. In 1950 and after Newman moved closer to pure monochromy, making the zips close-valued to the ground or moving them to the edges of the canvas, leaving the monochrome expanse not broken but framed by them, and often producing such

paintings in pairs: *The Voice* (1950) and *The Name II* (1950) are both white paintings with off-white zips; *Day Before One* (1951) and *Day One* (1951–52) are a complementary pair (orange and blue) with only the most minimal edge stripes; *Vir Heroicus Sublimis* (1951) and *Cathedra* (1951) are eighteen-foot canvases, red and blue respectively, incorporating hidden squares which are in themselves lesser mono-chromes framed by the zips; *Eve* (1950) and *Queen of the Night* (1951) have only one side zip each; *Prometheus Bound* (1952) has a bottom stripe only; *Primordial Light* (1954), side stripes; *L'Errance* (1954), a single stripe which is set near the edge and does not qualify the monochrome statement significantly. From 1948 until his death in 1970 Newman made variations on these types, always hovering near the heart of monochromatic absolutism, as in the "stretched" red (as he called it) of *Who's Afraid of Red Yellow and Blue III* (1967), the half-dozen white near-monochromes in the *Stations of the Cross*, and the side-striped monochromes *Be II* (1961, 1964), *Noon Light* (1961), and others. The monochrome tendency in one particular gradation of intensity is the central theme of Newman's mature work.

Like Still, Newman felt the importance of the Pseudo-Longinian work *On the Sublime*. In 1948 he wrote of the conflict in art between the quest for beauty (which is an aspect of form) and the quest for sublimity (which is "beyond" form, even the destroyer of form).[53] He resolved the conflict for himself (and for a generation of painters after him) by a radical repudiation of form and beauty in favor of an art in which "form can be formless"—that is, a rejection of the figure-ground relationship in favor of the ground alone, asserting that the One, not the Many, is the proper goal of art as of mysticism. The historical reference of this idea in the immediate post-war period is clear enough:

> Modern art, caught without a sublime content, [is] unable to move away from the Renaissance imagery of figures and objects except by distortions (Cubism, etc.) or by *denying it completely for an empty world.* [Italics added]

Newman's "empty world" echoes yet again Malevich's "desert beyond form," Eckhardt's emptiness fuller than any form, and so on. Newman wrote, "We are re-asserting . . . man's natural desire to express his relation to the Absolute."

The precise scenario which he selected to reveal "man's . . . relation to the absolute" was the moment of creation, or cosmogony—the mythological first moment, when absolute emptiness yields up the first suggestion of relative forms. His titles, which he described as "metaphors" of "the emotional content" of the paintings, hover persistently around this farthest reach of the human imagination: *The Beginning* (1946), *The Command* (1946), *Genetic Moment* (1947), *Abraham* (1949), *By Two's* (1949), *Covenant* (1949), *Galaxy* (1949), *Eve* (1950), *Day One* (1951–52), *Day Before One* (1951), *Adam* (1951), *Primordial Light* (1954) *Shining Forth* (1961), and so on. Still other titles show an awareness that the Creation is a mythological analogue to the philosophical concept of the ground of being which at every moment is creating and sustaining the universe: *Moment* (1946), *Be I* (1949), *Here I* (1950), *Be II* (1961–64), *Not There—Here* (1962), *Now I* (1965), *Now II* (1967). Still other titles show that Newman's is an art that tries to become a yoga, a path to union or a symbol of a path to union: the *Onement* series (1948 and after), *The Promise* (1949), *The Way I* (1951), *The Way II* (1969), *The Gate* (1954), *The Stations of the Cross* (1958–66). Through the art of the sublime (the infinite, the absolute), Newman said, the artist performs "an act of defiance against man's fall and an assertion that he return to the Adam of the Garden of Eden."[54]

Newman's subject, in other words, was not, like Klein's, the absolute in itself, but, more like Malevich's, the absolute at the borderline of the relative, the transition point between absolute and relative, through which each flows into the other. His titles and statements indicate that for Newman this transition point was conceived in Cabalistic terms found in the Luriac creation myth, especially *Zim-Zum*. In the process of *Zim-Zum*, god contracts himself so as to leave room, as it were, for the universe to flow into—the universe which will be distinguishable from him, yet within him. The space produced by god's contraction is, as one scholar put it, "a primal space full of formless hylic forces."[55] It is the ground before figures have arisen on it. This concept is analogous to ideas such as Prime Matter, potentiality, plenum-void, Malevich's "desert filled with pure feeling," and Klein's Rosicrucian-based "immaterial zones of pictorial sensitivity." The zip paintings, and also Newman's synagogue design, are meant to embody the principle of *Zim-Zum*—of

continual uninterrupted flow from and to god, the zip emerging from the ground only to plunge into it at once (or simultaneously), and so on. His interest in the First Moment was a mythic translation of his interest in the NOW—the first moment ever repeating itself in the ongoing mystery of Being.

After Klein, Ad Reinhardt is the artist whose work most uncompromisingly and persistently embodies the monochrome idea. The many-colored rectangles of his paintings of the 1940s settled finally, in 1953 and 1954, into red and blue monochromes, or near-monochromes with distinctions of tonality; in 1955 the red and blue gave way to black, which was to remain, in different shades, the only pigment Reinhardt used till the end of his life. By 1960 the black monochromes had developed the distinctive inner geometry based on the traditional four-square mandala of the Orient. He, above all the painters whom we have considered, has become the symbol of ultimate reductionism. Echoing earlier remarks made by Malevich, Rodchenko, Mondrian, and Klein, he said, "I am simply making the last paintings which can ever be made."

Reinhardt too felt that he was working out in his art the impetus of certain literary sources; these included Buddhist texts and, especially, the classical painting manuals of the Chinese and Japanese, with their foundations in Ch'an or Zen Buddhism, which he often echoes in his own writings. His gradual chromatic reductionism itself is to some extent based on the records of this non-Western tradition. The Japanese painter Kubota, for example, "often declared he hoped to live until he might feel justified in discarding color and employing *sumi* (black) alone for any and all effects in painting."[56] In this tradition art was based on the idea of *shunyata*, "emptiness," and its relation to the painterly treatment of space.

In Buddhist thought, "emptiness" is the creative principle which makes room for things to happen in—and at the same time the extinguishing principle, the black hole through which all would-be entities pass away. Often symbolized by space or the clear sky, it is related to the Cabalistic *Zim-Zum*, to Klein's "immaterial zones," to the alchemists' Prime Matter, and so on. One author writes:

Space was not to them [Chinese painters of the T'ang and Sung dynasties] a cubic volume that could be geometrically constructed, it

was something illimitable and incalculable which might be to some
extent suggested by the relation of forms and tonal values but which
always extended beyond every material indication and carried a
suggestion of the infinite. . . .
 . . . When fully developed as in the compositions of the Ch'an
painters, where the forms often are reduced to a minimum in proportion
to the surrounding emptiness, the enveloping space becomes like an
echo or a reflection of the Great Void, which is the very essence of the
painter's intuitive mind.[57]

In terms of Western art history in the twentieth century, the idea of
illimitable space as a symbol of the Great Void which is the essence
(non-essence) of self points directly and unequivocally toward the
monochrome, the featureless or nearly featureless painting which
apotheosizes empty space.

"Complete realization is like unchanging space," says a Tibetan
Maha-ati text. A scholar comments on the Buddhist doctrine
involved, in language that could be a comment on the monochrome
painting:

What we see and immediately experience is nothing determinate or
definite which any adjective referring to a specific quality can designate.
It is an utter openness which nevertheless is emotionally moving and
aesthetically vivid, even more so than anything else.[58]

In the Buddhist literature the ideal of "vivid" emptiness is described
negatively, as is the One in the negative theology of Plotinus. The
Astasahasrika Prajnaparamita says, "Space has not come nor gone, is
not made or unmade, nor effected; it has not stood up, does not last,
nor endure; it is neither produced nor stopped."[59]

Reinhardt's various writings on the monochrome style in
painting are rooted in this tradition of discourse; they express his
recognition of the parallel between the reductivism expressed
around him by formalist critics and the metaphysical reductivism of
emptiness. When he writes in a certain vein he seems to be express-
ing an extreme formalist, art-for-art's-sake, anti-contentualist view,
while in fact he is imitating the style of the Ch'an and Zen books on
painting:

Art is separated from everything else, is related to nothing, and so is one
thing only, only itself.[60]

> The one thing to say about art is its breathlessness, lifelessness, deathlessness, contentlessness, formlessness, spacelessness, and timelessness. This is always the end of art.[61]

This is art at the zero point, evolving out of illusionism to flatness and then through blue and red and gold flatness to white flatness and finally to black:

> Only blankness [can be serious art, only] complete awareness. . . . Only the artist as artist . . . vacant and spiritual, empty and marvelous. . . .
>
> Only in this way is there no grasping or clinging to anything. Only a standard form can be imageless, formless. There is no other way to get rid of all qualities and substances. Finally there is nothing in the purest art to pin down or point out. Nothing is attached to anything.

And so on: again the monochrome as an icon of the absolute, of the annihilation of form:

> . . . no sketching, no drawing, no line or outline, no forms, no figure, no foreground and background, no volume or mass, no cylinder, sphere, cone, cube, etc., no push or pull, no shape or substance, no design, no colors, no white, no light, no chiaroscuro, no space, no space divisions within the painting, no time, no size or scale, no movement, no object, no subject, no matter, no symbols, no images, no signs. . . .

He concludes, "The fine artist should have a fine mind, free of all passions, ill will, and delusion."[62] Passion, ill will, and delusion are known in Buddhism as the three "roots of evil" and are a formula as readily recognizable to a Buddhist as, say, the Lord's prayer to a Christian. For the act of painting, Reinhardt gives the elimination of the three roots of evil in the personality priority over every other requirement. The pure painting can rise only from a purified mind— a mind without internal divisions, like the open sky. Painting which is not a reflection of this openness of mind is no painting at all. As the artist's inner world is cleared of the "disquieting overtones" of passion, ill will, and delusion, his work must inevitably veer toward the absolute monochrome, the "last painting," which Reinhardt called "the pure icon."

Mark Rothko's work evolved from a somewhat tentative social realism in the 1930s to the Mythmaker style of the 1940s and, in late 1949 and early 1950, stabilized in his mature pattern of fuzzy-

edged rectangles floating ambiguously upon (or behind? or inside?) a more or less contrasting surround. The viewer's sense of which area was figure and which was ground was ambiguous and shifting. Throughout the 1950s these works emphasized earth colors—magnetic oranges, yellows, reds—and toward the end of the decade the monochrome tendency became more and more clear; along with a slow darkening of the palette, the floating rectangles became ever closer in hue and shade to the surround; this tendency culminated in the late 1960s in the vast "plum" monochromes of the Rothko Chapel (1971) and their companion near-monochrome black-on-brown triptychs. The Chapel group is Rothko's culminating work; it is also, arguably, the last great monument of Modernism and the abstract sublime. It is clearly in the monochrome tradition: seven of the canvases are pure monochromes with internal brush turbulence, especially around the centers, and seven are near-monochromes.

Rothko was a seeker in the vague and confrontational way of existentialism rather than along any path defined by previous passage: humanity unknowable in its lack of essence facing canvas unknowable in its plunge toward infinity. In his most revealing published statement,[63] about a year before arriving at his mature style and format, it is more his diction, his choice of words, than the sense of his statements, which reveals the inner meaning of art for him: within two pages the adjective "transcendental" occurs twice, the verb "transcend" once; there are phrases like "the transcendent realm," "the urgency for transcendent experience," "the artist's . . . ability to produce miracles," "Pictures must be miraculous," "the solitary figure," "solitude," "human incommunicability." From this foundation—an oppressive sense of silence and solitude, an undefined or unguided urge toward transcendence and freedom—arose his increasingly holistic paintings. The concerns of his art were with transcendence of the limited individual self, and with the infinite as goal of such transcendence. "I don't paint to express myself," he once said, "but to express my not-self."[64] Again, "I try to express both the finite and the infinite."[65] In describing the chapel paintings to a visitor to his studio in the late 1960s Rothko said that "he was trying to suggest—state rather—the infinity of death by a single monochromatic color."[66] The chapel group is a surrounding matrix like

Monet's *Nymphéas* when they were in the Orangerie, but relating more to death than to birth, to reimmersion in the One rather than emergence from it. The somber statement about the melting away of the world of form surrounds the viewer, pointing to both his mortality and his afterlife. The death-dark monochrome is the symbol of the door beyond doors—the gateway to infinity. It is a launching pad or ascension point to the beyond—a chamber, uterine in shape and bloody in color, suggesting both death and an ambiguous rebirth after death, as by sympathetic magic.

One critic has written that Rothko was seeking "a universal principle," "an ultimate sign," "an absolute art"; "his purged paintings affirmed the purged ego. . . . Each work was an evidence of the mind's approximation to zero. . . ." His painting was "a ritual of self-purification."[67] And another: he aspired to "a pantheistic content"; "The passivity and impersonality of Rothko's brush and reductive design . . . suggest a desire on his part that the viewer vacate the active self."[68] A third: his art was "a quest presented . . . in terms of the void. . . . The logical result would be a blank canvas . . . that would be full, an absence that would be rich."[69]

In the early 1940s Robert Motherwell's work showed the influence of Miró, Cubism, and geometrical abstraction; this development culminated in 1948, when the first of the *Elegies to the Spanish Republic* appeared. In the same year Motherwell painted a brown near-monochrome with half a dozen red streaks, *The Homely Protestant* (1947–48). These two works contained the seeds of his art for the next three decades. At first the direction indicated by the *Elegy* took hold, leading to the famous compositions of black splotches and splatters on lighter grounds (with a brief reversion to near-monochrome, in a format much like Still's, in *Iberia #2* and other works of 1958). A new format, near-monochrome with outlined "window" near the top center of the rectangle, sometimes with elements of contrasting color inside the "window," appeared with *Open No. 35* and *Open No. 38* (both 1968) (foreshadowed by *In Black and Pink with Number 4*, 1966). Subsequently Motherwell extended this format into a variety of color schemes in a decade of consistently near-monochrome works.

In 1948 and again in 1951, Motherwell published statements in the tradition of mystical abstraction. As in Malevich's formulation,

the pursuit of pure feeling is held to lead away from the world of form toward an emptiness which is experienced as mystical:

> One of the most striking aspects of abstract art's appearance is her nakedness, an art stripped bare. How many rejections on the part of her artists! Whole worlds—the world of objects, the world of power and propaganda, the world of anecdotes, the world of fetishes and ancestor worship. . . .
> What new kind of mystique is this, one might ask. For make no mistake, abstract art is a form of mysticism.[70]

The mysticism of abstract art lies in its effectiveness as a path to union: ". . . one's art is one's effort to wed oneself to the universe, to unify oneself through union."[71] Art which, through stripping off the transient forms of selfhood, unites us with the cosmos is sublime art. The sublime is defined in terms often used to describe mystical experience: it is silent, it transcends the personal, it comes unannounced and unsolicited to those who are ready for it and cannot be induced by those who are not ready:

> . . . painting becomes Sublime when the artist transcends his personal anguish, when he projects in the midst of a shrieking world an expression of living and its end that is silent and ordered. . . . In the metaphysical sense, it can not be a question of intent, one experiences the Sublime or not, according to one's fate and character.[72]

In 1950 Sam Francis arrived at his first version of the monochrome, an all-over monochromatic pattern of "lozenges" or "corpuscles" or "billows of smoke" with a lighter ground showing through here and there, especially at the edges, to activate and frame the amorphous but vibrant center (e.g., *Opposites*, 1950; *Black*, 1950; *White Painting*, 1950; *White Painting No. 4*, 1950–51; *Red and Pink*, 1951; *White Green Earth*, 1951; *Saint Honoré*, 1952; *Blue-Black*, 1952; *Big Red*, 1953; *Saturated Blue*, 1953). This style dominated his work from c. 1950–55, giving way to a more or less biomorphic style (with lots of white space showing), which lasted till around 1965. In 1960, however, this style began undergoing an evolution toward the monochrome—the second approach to the monochrome in the oeuvre. The figurative incident was pushed more and more toward the edges, leaving an increasingly dominant monochrome white space in the

center, an empty space which asserted itself more and more as the subject of the paintings (e.g., *Untitled [Blue Balls]*, 1960; *Blue Ball Composition*, 1960–61). By 1963 this assertive central white expanse was pushing painterly incident off the edges of the canvas (e.g., *Untitled*, 1963; *Open Composition*, 1964; *Iris*, 1965). By 1966 (e.g., *Mako*, several *Untitleds*) the format was an all-white monochrome with internal frame along the edges. By 1972, the process turned in the other direction again: the framing elements moved back toward the center, asserting themselves not as frame but as drawing on the ground (e.g., *Untitled No. 16*, 1972; *One Ocean, One Cup*, 1974) and in some cases filling it completely (e.g., *Polar Red*, 1975). In short, this artist's oeuvre shows a repeated turn toward the monochrome absolute, punctuated by renewed excursions into the realm of form until a need for renewal at the blank source becomes dominant again.

Francis's work has been influenced by his familiarity with Eastern thought (especially Zen), Jungianism, and various occult traditions, including alchemy. His two monochrome periods suggest a changing and deepening perception of, and relationship to, concepts such as voidness, energy, pure space, and the union of these three.

Whiteness comes to dominate his work as early as *The Whiteness of the Whale* (1957). (The title is a quotation from the "whiteness chapter" of *Moby-Dick*, where Melville says that whiteness "shadows forth the heartless voids and immensities of the universe.") In the paintings of this period the painted forms explode in the whiteness, in a mood influenced by the Chinese "flung ink" style, like fragile organisms barely emerging from the void and still surrounded by it, momentarily to be engulfed by it again. Sir Herbert Read saw the effect as a bubbling evolutionary soup, "the color and turmoil of primordial substance," in other words, creation. The white void from which creative force emerges is experienced as a vast silence in which the color incidents are brief sounds. In the almost all-white paintings of the 1960s silence asserts itself as the center of all sound, more basic than sound, more all-embracing and ultimate. Whiteness, said Francis, is "ringing silence . . . an endless, ultimate point at the end of your life." White is the void, infinity; color is energy coagulating into finite streams and flashing across the face of the void to disappear at once into it again. "Silence and arrest," Francis has said, "equal ecstacy," and the question is where ecstasy resides, in the eye or in the mind.

The eye perceives many differences among the various styles of metaphysical monochromes mentioned here—the scabrous impasto of Still's paint surfaces in contrast to the thin wash of Rothko's; the expanding flatness of Newman's as opposed to the contracting gleam of Reinhardt's; the subtle activation of Klein's blue as against the matter-of-fact presence of Manzoni's achromes; and so on. But beneath these various surface differences the works share the role of milestones along the road of the Romantic quest, insignia of the inner travail of rejecting phenomenal multiplicity and attempting to gaze into the Grail of primal oneness, where Sir Thomas Malory's Galahad saw the individual break open into the infinite. Throughout the twentieth century the broad one-color field has functioned both as a symbol for the ground of being and as an invitation to be united with that ground. The monochrome painting may be the only important religious icon produced in the twentieth century: the expanse of a single color mounted at altar level and gazed at by the faithful in a silence as of worship or transcendent intimation.

The intensity of both cosmogonic and eschatological focus in the post-World War II metaphysical monochrome was the last gasp of the Romantic ideology of art as (in words used by Rothko) "an adventure into an unknown world, which can be explored only by those willing to take risks."[73] Thereafter the monochrome would be practiced for different motives and with different attitudes. For painters who reached maturity after the monochrome style had already been established as one of the dominant modes of Modernist abstraction, the metaphysical and mystical utterances of their predecessors in the 1950s and early 1960s lacked novelty and danger. For them the monochrome was no longer an adventure into the unknown but an inherited situation, an art historical fact which had to be taken into account even if only for formalist reasons.

In the 1970s the monochrome spread, as an indubitable fact, like a snowfall, into all areas of the Fine Arts. Several new uses took over the form: the formalist use of it as an inherited design challenge to be met; the materialist use of it as a critique of the tradition of sublime or idealist art; the conceptualist use of it as a bridge between painting and concept. These three monochrome modes were related: the materialist monochrome merged with the formalist monochrome to the extent that both emphasized physical presence, and with the con-

ceptualist monochrome in that both emphasized critical potential; the conceptualist and formalist monochromes, finally, merged in the austerity of their decisions. All three shared a sublime reductivism— understanding radical irony as one of the modes of the sublime. Their differences were primarily in styles of discourse.

Younger artists who practiced the formalist mode talked not about a color that opens into infinity, but about a color that holds the surface, declaring its flat physicality; not about ecstasy and the absolute, but about surface and edge. The cult of space had been replaced by the dogma of flatness. The idea of a monochrome surface expressing infinite three-dimensional extension behind the canvas came to be seen as a residuum of the illusionistic depth of representational painting. Although this attitude was already present at least as early as Jasper Johns's *White Flag* (1955), the real turning point was around 1960. The statements by the Zero Group artists mark the end of the alchemical phase of the monochrome, with its belief that the monochrome was at least a symbol for the absolute and at most a special container of it, and the beginning of a less idealistic, more factual or physical approach to the one-color field.

But there was a hidden problematics to this distinction that was not recognized at the time. The formalist ideology that dominated in the 1960s came from the same roots which produced the Romantic ideology of art. They shared certain assumptions at an unacknowledged level. Both incorporated the Kantian view of art as disinterested and autonomous. Both involved a mystical reverence for color as opposed to the traditional valuation of drawing, and both derived satisfaction from reducing the number of their elements.

Formalist work such as color field painting was based, not necessarily articulately, on Kant's doctrines of disinterest and autonomy. The artists saw their work as self-sufficient or non-relational simply itself. At the heart of this feeling was the conviction that their work did not relate to concepts and metaphysics. What they did not see is that this non-relationality is in itself a transcendentalist metaphysical idea, and the same one, beneath the surface, that the metaphysical monochrome was based on. It is the belief that artwork relates to the absolute that makes it appear non-relational in terms of the world of concepts and experiences. The claim to disinterest and autonomy is based, whether outspokenly or tacitly, on the

assumption that art was concerned with the beyond rather than the here below. What had changed was more a style of discourse than an underlying belief system.

The case of Robert Rauschenberg illustrates the transition. In 1949 he made *White Painting with Numbers* and in the next two or three years exhibited a variety of all-white paintings: a white canvas four feet square, a set of four white squares arranged in a larger square, a set of three upright white rectangles, and a set of seven upright white rectangles. When he exhibited white paintings in 1951, Rauschenberg provided them with an explanatory statement in the metaphysical tradition of the sacred fullness-emptiness:

> They are large white (one white as one God) canvases organized and selected with the experience of time and presented with the innocence of a virgin. Dealing with the suspense and excitement and body of an organic silence, the restriction and freedom of absence, the plastic fullness of nothing, the point where a circle begins and ends.[74]

"The plastic fullness of nothing" is equivalent to Mallarmé's blank sheet which, containing nothing, contains everything, or the Cabala's "primal space filled with formless hylic forces." Rauschenberg speaks, in this statement, in the intoxication with the sublime that was so prevalent around 1950. In 1968, he described these pictures very differently. Instructing that they should be hung to catch viewers' shadows, he declared, "The white paintings were open compositions by responding to the activity within their reach."[75] No longer pointing to the beyond, the white paintings are reinterpreted as sites for a concrete interaction between art and everyday life. Rauschenberg, like Manzoni, was transitional between the metaphysical monochrome of the 1950s and the formalist, materialist, and conceptualist monochromes that followed.

In the 1960s and 1970s the influence of the metaphysical monochrome entered every other mode of art. In formalist and Minimalist painting it is found in Frank Stella's Black Paintings, in Jules Olitski's veils of color, Jo Baer's edge-striped white canvases, Brice Marden's impenetrably physical color surfaces, Robert Ryman's subtly differentiated white paintings, Robert Mangold's void expanses with minimal geometry and oddly shaped empty frames, Blinky Palermo's decorative arrays of bright mono-

chromes, Imi Knoebel's systemic series of identical white pictures, and so on. In these years Rauschenberg's serial sequence of identical white monochromes hung together to make a larger horizontal rectangle became a recurring format, seen in Knoebel's work, in Gerhard Richter's sets of identical *Grey Paintings* (1975), and in the sets of identical grey paintings made by Alan Charlton since around 1967.

These artists, while repudiating much of the metaphysical equipment of the elaborate artists' statements of the 1950s and earlier, still unconsciously echoed them. Marden, for example, like many artists of his generation, continued in the 1970s to invoke nonspecific or undifferentiated feeling echoing Malevich and behind him Kant. "I believe," he has said of his own work, "these are highly emotional paintings not to be admired for any technical or intellectual reason but to be felt."[76] The essentially transcendental nature of supposedly undifferentiated feeling—which is what Malevich meant by "pure" feeling—is not overtly acknowledged. When the discourse of mysticism is hinted by artists born (say) after 1930 or 1935, it is the mute mysticism of the formalist. What Aubertin called "the life of the painted surface," with its "ontological" force, the surface seen as a palpitating membrane of creation, enters the toned-down discourse of the 1970s more mutely. Marden, for example again, has said, "As a painter I believe in the indisputability of The Plane." This is not exactly the mysticism of the metaphysician, who believes he perceives the infinite in The Plane, but neither is it clearly beyond it; it is the mysticism of the Minimalist or materialist, who hopes to relate to the object simply as object, but has not shaken off a residual mystical reverence for the cosmogonic surface—or its discourse.

The simplicity of the monochrome, its ability to be more or less fully described in words, pushed it into the realm of conceptual art, too. The British artist Bob Law declared in the early 1970s that his black monochromes were "the transition from pictures on the wall to conceptual art in the head."[77] In fact, the monochrome has from its beginning asserted a critique of previous types of painting—of their incorporation of drawing and their apotheosis of technique—and it was natural to engage the monochrome idea in Conceptualism's relentless critique of painting in the late 1960s and the 1970s. Both

Klein's and Manzoni's oeuvres featured Conceptualist irony. Klein's exhibition of literally invisible "paintings" (the "zones of immaterial pictorial sensitivity") foreshadowed many Conceptual works that carried the inflated idea of the "last painting" ad absurdum.

In the 1960s and 1970s language invaded the visual arts. In 1967 Daniel Buren and others hung paintings in an inaccessible room in a Paris museum and distributed a leaflet verbally describing them in detail. The immaterial art which the metaphysical monochrome had been held to presage was proving, ironically, not to be the immateriality of a higher spiritual dimension but of critical conceptualism, not to involve levitation so much as parody. In 1969 Tom Marioniheld an art exhibition entitled "Invisible Painting and Sculpture" in Richmond, California. In 1967–68 Mel Ramsden exhibited a black monochrome with a text saying that the black was not its color but its concealment. Robert Barry stood in front of would-be viewers and telepathically communicated his painting's appearance to them. John Baldessari's *Work with Only One Property* (1966–67), made to the artist's specifications by a sign painter, parodied the thin line between monochromy and Conceptualism.

In the 1970s and 1980s the monochrome idea extended into virtually every branch of the Fine Arts. It entered performance art in the blood and red paint surfaces of Hermann Nitsch; it graced the outdoor city in Maura Sheehan's monochrome treatments of parking lots, transitional spaces, and abandoned buildings; it nodded to space-light art in the scrimmed spaces of Robert Irwin and the indefinite light zones of Doug Wheeler; it penetrated sculpture in Allan McCollum's arrays of framed rectangles painted all over with one color.

From an adventure into the unknown the monochrome idea has become a staple of the contemporary art vocabulary. Its metaphysical seriousness is not entirely gone but is localized in terms of social reality. Monochromes of the Great Void can still be made, for example, in California, by an artist like Eric Orr. But in New York and Europe the "monochrome spirit" is overlaid with layer upon layer of ironic and critical distance. Its metaphysical seriousness peers out through these revisionist distorting lenses.

The absolutely simple field of color, with its appeal to "pure" feeling, has become an intricate iconographic manifold that can be

entered from any direction and adapted to any purpose. As an element of sheer design it may live for another couple of decades—perhaps past the end of its century. But as a major conquest, like the discovery of a continent or a galaxy, in the adventure of art, it lies in the past, exhausted and wrung dry of meaning. It is the banner on the grave of the mad ambition of Modernist abstraction.

SECTION TWO

THE WORLD AND ITS DIFFERENCE

Once the purity of art is abjured as a dishonest and authoritarian myth, we contend with art's relationship to the viewer—its theatricality—and from that, the size, character, and patronage of the theater it is presented in. In modernist art, which presumed that art represented only itself, we had difficulty in determining why such art would be of interest to people. For if art were not theatrical, and existed only for its own sake, what was the point of its entry into a human context?

Another difficulty arises when we assume that we are only attending to objects in art; that is, what absolutist and purist views assume are essences of form. In such belief systems, we forget that we are not just attending to objects; we are attending to objects that represent artists and cultures by virtue of their histories. In other words, through art we are attending to other people; art is a manifold of humanity. Hence, we cannot simply project willfully on art without consequence, the way we do with other commodities we may possess. Generally speaking, unless the ordinary commodity also has a resonance beyond that of its "objecthood" (say, as an heirloom or antique), we project our desires upon an object whose history has been detached from its already disinterested manufacturer once its commercial value has been realized in the monetary transaction for which it has been designed. In art, however, the artist and culture of origin sustain and enhance the value of the object or process, at least when successful. We as viewers thus project our desires upon prior projections that have a lingering currency after the sale, a currency that becomes all the more sustained when publicly validated, documented, and appraised. Art in this sense is always collaborative. It

therefore is reasonable that the context and the intentions of the artist and culture of an art's production be respected.

Among McEvilley's most significant contributions to art criticism is his appeal to expand the framework in which this process takes place and is discussed. To do this he has striven to shift art world interests away from universal principles, which really are representative only of the consensuses of local cultures (albeit geopolitically large and aggressive ones), and turn them toward a global understanding of difference. Through his reference to various models from around the world, readers get an idea of how much more liberating it is to capaciously represent and experience the world's heterogeneity. McEvilley was, of course, informed by the same international, political, literary, and cultural dynamics that motivated Stuart Hall, Kobena Mercer, Edward Said, Gayatri Chakravorty Spivak, Molifi K. Assante, Kwame Anthony Appiah, Stephen Greenblatt, and Hayden White, among others, and which gave rise to the discourses of multiculturalism, cultural studies, and the New Historicism that we came to know well in the 1980s and 1990s. But McEvilley also seems to borrow much more from the Enlightenment than do postcolonial critics like Henry Louis Gates, Jr. and Michelle Wallace, who denounce its humanist principles for having excluded people of color from its postulations of universal equality. Like them, McEvilley explicitly denounces humanism's myopia, but he also transforms its notion of universality into a relativistic and diverse permutation of cultures that are becoming increasingly linked in a communicative network of globalism.

Among the intellectuals sifting through modernism's remains, McEvilley is well equipped to point the West toward some of the most egalitarian models of globalism. But his jurisdiction is the American terrain. For he realizes he must continually meet with the representatives of the various European, Asian, African, Australian, and South American cultures to collaborate on the terms for a new global discourse. This may sound like a truism of statecraft today, but the negotiation of cross-cultural exchange and understanding lags far behind even the progress of nations to affect communication and trade. It is unlikely that a central model of the world, like that of the former spirit of colonialism, will ever again be upheld. McEvilley has suggested that a nomadic discourse may be what is required to keep

art a valid production in the new global network. Although he has not elaborated on that nomadism, many of us have taken his suggestion to heart and have been working to set it in motion.

Globalism and diversity, as McEvilley represents them, have come to replace the esteem of universality. Globalism, in contrast to universalism, compels cooperation and exchange from multiple sources (cultures and geographies) without imposing any one as primary; it is the composition or network potentially encompassing all diversity without imposing a unity or other singular principle on it. Globalism replaces the singular principle of universality while retaining its geographical scope, or more accurately, multilaterally shifting emphasis from the geographic scope of the universal to the geopolitical scope of the global by being inclusive of the world's local governments. This becomes quite clear in McEvilley's long review of "Third World Biennials" that appeared in the November 1993 *Artforum*, which to my mind is the single most important report on art to have appeared in some years, certainly of this decade.

In discussing the various manifestations of modernism, postmodernism, and indigenous production being exhibited together in the biennials and triennials of New Delhi, Cairo, Dakar, Kinshasa, Sao Paulo, Istanbul, Havana and elsewhere—and in mentioning the planned Asia-Pacific Triennial in South Brisbane—McEvilley writes his report without making critical assessments, excepting those judgments that rather provisionally categorize the work as "modernist," "postmodernist," or "indigenous." For the most part, McEvilley suspends his prerogative to criticize in order to, instead, promote globalism and diversity. For there is no recognized criterion that wouldn't inevitably compromise the local principles and values of a population. Such descriptive reporting naturally limits the kind of criticism—and authority—many of us expect from an art critic, but it does so purposely in recognition that the *inauguration* of a truly global criticism that abjures cultural hegemony is best facilitated by a diverse assembly of opinions emanating from myriad cultures and not by a single voice which comes from one of the former colonial "centers" that would only perpetuate Eurocentric authority. McEvilley's practice of deferring a system of criticism other than one of nomadic visitations thus exemplifies how globalism at this stage can only be a meeting of ways. For this is McEvilley's suggestion of how exchanges and large

assemblies of world art can proceed in multilateral and unobtrusive ways while minimizing the risk of any regional practice or system of values from imposing itself hegemonically in the future. (He has more recently written, in *Art and America*, about the first Johannesburg biennial and the first Estonian biennial).

In this effort, McEvilley seems to employ a tactic suggested by Cornell West in "Race and Social Theory: Toward a Genealogical Materialist Analysis" (1987), and which seems to describe the example set by Foucault: "We must become more radically historical than is envisioned by the Marxist tradition. By becoming more 'radically historical' I mean confronting more candidly the myriad effects and consequences (intended and unintended, conscious and unconscious) of power-laden and conflict-ridden social practice—e.g., the complex confluence of human bodies, traditions, and institutions." Again the history of the world is called upon to inform an emerging ideology. But McEvilley's task of routing out ethnocentric practice in art exhibitions and discourse is subject to far more obstruction than was his more contained confrontation with Greenberg's universal aesthetic, for this time around the prejudice targeted exists on an international scale and at every level of discourse.

As with his reframing of the issue of the relationship of form and content in the context of global history, McEvilley begins his reframing of cross-cultural relations between Western cultures and non-Western ones by confronting a leading authority for the conventional view. In this case, the conventional view is the ideal of universal quality, the prejudice it masks is the pervasive Eurocentric criterion, and the authority targeted is a major institution. In 1984, The Museum of Modern Art, under the guidance of the museum's then director of Painting and Sculpture, William Rubin, and his protégé, Kirk Varnedo (the current department Director), erected the ambitious exhibition, *"Primitivism" in Twentieth Century Art: Affinity of the Tribal and the Modern*. The show would prove to be the pivotal point in the formation of a new global criticism, and McEvilley would take the lead in reconfiguring this criticism with his *Artforum* article, "Doctor, Lawyer, Indian Chief."

From McEvilley's point of view, *"Primitivism"* was a banner exhibition for all the central principles of modernist Eurocentrism. He saw the show as embodying the Kantian doctrine of universal

quality, the Hegelian view that history is a narrative of Europeans leading the world toward spiritual realization, and the cartographic model of the West's centrality and the non-West at its margins. McEvilley would go on record among the first art critics to denounce the mainstream practice of exhibiting and discussing non-Western production without naming the artists or dating the production and, when comparing it to Western art derived from tribal and other pre-modern sources, treating it as so many footnotes to modernist pro-duction, "illustrating something other than itself."

This confrontation with the high church of modernism and one of the most powerful men in the artworld not only made McEvilley's new globalism something of a *cause célèbre* in the artworld of the mid-1980s, it also made this landmark article the model for all future cri-tiques on Eurocentric practices in art history, curatorship, and art criticism. And yet "Doctor, Lawyer, Indian Chief" only sketched out the concerns of the critic interested in implementing a postcolonial-ist globalism in art practice. Later pieces by McEvilley would expound further on this globalism, as in the lecture "History, Quality, Globalism," and then point us to the new centers where this globalism was most likely to be practiced in curatorial and creative efforts, as do "Arrivederci, Venice: The Third World Biennials," the historic *Art in America* articles on the first South African and Estonian biennials, and other pieces.

But in writing of the ethnocentrism of modernism, I think that McEvilley rhetorically anthropomorphizes modernism as if it had a repressive will that does not necessarily belong to the epoch so much as to many (but not all) of its leading proponents from the past. Modernism was not hegemonic: many modernists were. Modernist attitudes persist today in many fields without a hegemonic grip, and significant artists still operate within modernist territory. Some are even making apologies for the alignment of modernism (and human-ism as well) with such malversations as racism, colonialism, religio-centrism, and imperialism. The breakdown of hegemonies are indeed postmodernist in character because postmodernists made them a major, explicit part of their theorizing in response to the hegemony they saw ubiquitously around them. But hegemony was not necessary to modernist thought, though it was often incidental. Even when a modernist theory or movement asserted itself hegemonically, it was

asserted in a climate of intense competition, for most such theories were composed within democratic and capitalist societies.

McEvilley is correct in assuming that modernism served as the cover for various heinous seizures of world power for the last five centuries, but he doesn't explain why these seizures are to be considered modernist when they are really premodern. Aside from this rhetoric, we all know military and colonial aggressions in fact cast a recorded line extending from the archaic epochs of Ramses and Sargon (and of course less empirically even further back) and leading to the eras of Isabella and Elizabeth when modernist colonialism can be said to truly begin. Yet for at least the last half-century, modernism and humanism have taken the heat of intellectuals for their coincidence with military and political malfeasance. That malfeasance, however, predates the development of either of these world views and their vestiges in modernism and humanism should not be confused with modernism and humanism themselves.

The competition and diversity already visible in modernism was made more prominent in postmodernism. But it could not have become so had modernism's democratic spirit and facilitation of communication not already become pervasive throughout our civilization. And yet postmodernism, at least in art, was not always as diverse or as global as McEvilley wished. It was, after all, premised on the historical fact of modernism's constant upheaval and overturning of that which came before, though modernism was myopic in that what *it* considered was almost wholly of Western invention. But modernism did not always follow modernization—that is, industrialization, development of cultural production, increased proficiency in education, medicine, agriculture, communication, and transportation. Some writers too often, or too generally, conflate the notion of ubiquitous modernization with the far lesser incidence of modernism's spread. Nations like China, Iran, and Zaire may have modernized their societies technologically, but the values of Western modernism hardly ever took hold without having to be radically altered in their assimilation with indigenous traditions.

McEvilley is confident that postmodernism indicates a change in the way the colonialist West will relate to the rest of the world, and that it is relevant to all cultures and not just Western cultures. In "The Common Air," his 1986 essay on contemporary Indian art, and in

Fusion, a book he wrote on contemporary art from Senegal and Cote d'Ivoire in 1993 for the Museum of African Art in New York, he demonstrates that some contemporary artists in nations once colonized or ravaged by Western nations are self-consciously working with a postmodernist agenda. He notes that some cultures, such as that of India, may be described as having become postmodernist in terms of cultural relativism before they were ever modernist in terms of Hegelian hegemony. For him modernism is an ideology, not a material fact such as industrialization; it has more to do with multiculturalism than with technology. It is less "the cultural logic of late capitalism," as Jameson called it, than the cultural reflection of postcolonialism.

But there are other visible attitudes about this. For when viewed from an intercultural standpoint, postmodernism is inapplicable to many non-Western cultures. When considering recent critical and creative efforts to eradicate sexist, colonialist, and racist hierarchies, postmodernism can be seen as invaluable to the democratic redefinition of Western civilization. But if a truly equilateral exchange and convergence of cultures is about to be negotiated, as McEvilley advocates, then in following the postmodern path to extra-Western territory, we might try abandoning the postmodernist bias for something larger. For even in postmodernism we find ourselves halting before a cultural precipice, a falsely elevated promontory stratified by the history of Western imperialism and conquest. We can see the world's multifarious cultures from this precipice, even communicate with them, but we are cut off from their vitality by a myopic ethnocentrism. As it is, postmodernism leaves the far-cultural experience beyond Western understanding, even as it reminds us that ethnocentrism cannot be avoided so long as we both delimit national and historic boundaries and attempt to interact with the cultures *placed* beyond them. We might circumvent ethnocentrism were we to envision a single world culture that is both diffusely different and profoundly the same: an interchangeable whole without boundaries. However, if we do not, then we must devise new means to surmount the ethnocentrisms that boundaries necessitate and circumscribe.

Even if postmodernism is not succeeded immediately by a reflexive, global cross-culturalism, the thought and language of postmodernism will likely be amended over time, for they provide artists and critics in the Western and Northern hemispheres with only the foun-

dations—and not the bridges—required to be crossed in order to greet our counterparts in the Eastern and Southern hemispheres. To interact equitably and empathically with the diverse peoples of the world, we require a global discourse—not a global consensus—that considers not merely the postmodern perspective of the West, but all possible indigenous views accommodating cross-culturalization. Although espousing pluralist and relativist relations, postmodern thought is not always or by itself a viable alternative for non-Western peoples; it was developed as a Western elaboration concerned with critiquing and revising Western history, structures, and values and by itself cannot always traverse the vast intercultural canyon. McEvilley accepts—and celebrates—the fact that non-Western cultures will all revise the postmodernist or postcolonialist moment in terms of their indigenous formations. Thus, he thinks, a global slippage will result in the creation of bridges or overlaps.

Postmodernism, McEvilley argues, still involves residual ideological baggage from modern and pre-modern production and criticism—and will no doubt continue to. For example, though the modernist myth of *art for art's sake* has long been laid to rest and its overcompensating denial of traditional content and institutions is succeeded by the idea of art as subject to the ineluctable and ubiquitous determinants of context, the ghost of modernism is still invoked by postmodern artists and critics in the persistent separation of Western and non-Western art. This separation McEvilley argues, still to an extent falsely exalts Western art as universal and inherently more reflexive and critical, when really the Euro-American elite standard can be matched in reflexivity and criticality by various non-Western practices. Furthermore, the insidious hierarchy of Eurocentrism remains entrenched, leaving Western purviews on interculturation intact and circumscribing most non-Western art as a subdivision of ethnology or coalescing it into a questionable theory of "the Other." To combat Eurocentrism, we can abjure the modernist and romantic notions of art as a production elevated above craft and industry and, instead, speak of cultural production as a whole, making the distinction of function secondary to human ingenuity. This redefining of art would, in effect, be the death of *art* as we in the West have come to know it; but as *Western art* has died and been resurrected from many deaths before, this might be its most capacious incarnation.

An ongoing argument I have with McEvilley regards his view on the myth of the Other, which he uses with only the best intentions in the title of his book on multiculturalism and postcolonialism, *Art and Otherness: Crisis in Cultural Identity*. McEvilley's use of the terms self and other is based on Plato's use of sameness and difference in the *Philebus* and the *Sophist*. He intends them as universal "shifters": that is, everything is a self to itself and an other to everything else. There is no specificity to the terms. I am not arguing against this ontological or psychological usage of the term "other," in the sense that "I" am different from the vast array of the world, the sense that McEvilley intends.

It is postmodernism's frequent use of the hegemonic myth "Other" (capital "O") in the ethnological sphere that I object to, for it presumes the reader or viewer shares the speaker's cultural, sexual, ethnic, and even ideological center. And it perpetuates an equation dividing the world into *us* and *them*, with the Other assuming, however inadvertently, an implicit inferiority, while denying the common features of humanity (though not common in any universalist or essentialist sense). When using the myth of the Other in this traditional (really modernist), specific way, postmodernism conserves the grand conceit of ranking vanguard Western art as more cultured, more rational, or more purely spiritual than non-Western and, of course, implies its own myth that postmodernism too is more politically enlightened than the expressions of the non-Western artist; in the end, Western critics judge that the cultural production of the West and the non-West cannot even be compared. McEvilley does not desire such a connotation; his universal shifters equate the self and the other.

I agree with him that socio-specific forms, contents, and contexts of signification are not universal, but I also believe there is a common human structure, or what I call the human well of imagination, which impels these forms, contents, and contexts, and facilitates all inspiration and imagination. This human well of imagination, alone, bonds the necessary biological, material, metaphysical, and political conditions that catalyze art. Western art, for example, may no longer be inextricably attached to religion or mainstream polity, as it is in various cultures, but Western art is no less detached than any other production from the human well of imagination that is both source and replenishment to these institutions. If the modernists confused the well of imagination with the forms it saturates—thinking they had

unveiled the universal impetus of art when all they had discovered were the forms and contents this impetus could take on (particularly the Kantian notion of *universal abstraction* exploited by Clement Greenberg)—then it becomes necessary to amend this view, as McEvilley has, by placing it in a larger scheme showing difference as settling everywhere, among everything and everyone, and rendering the universal too obliquely and simply to underpin *a priori* criteria for discussing international cultural modes.

One crucial component for cross-culturalization that McEvilley broaches that is largely omitted by many other of postmodernism's chief proponents, is the notion of empathy. The continued proscription of aesthetic empathy in Western or global discourse is incompatible with cross-culturalization, for a strong empathic vision guides most non-Western aesthetic systems. As a writer from Dakar, A. Hampate Ba, said in 1978, "Fine behavior and great knowledge are inseparable from beautiful language."

In citing this, I am not calling for a return to the privileging of aesthetic taste, but rather am urging we consider the local, national, and cultural structures and systems underpinning each specific consensus of beauty so that we understand its relative import. Even culturophiles not acquainted with non-Western cultures may appreciate the importance of empathy in art, for if the clear distinction between "high" and "low" cultural orders is to be eradicated in postmodernism (another of McEvilley's reevaluated judgments), then empathy must be given an equal and alternative status to the conceptual basis of art which is paramount today. This does not mean that we merely open the door of postmodernism to an empathy for non-Western styles, but that (as McEvilley put it in "Marginalia: The Global Issue") we open that door widely to the non-Western artists who are responsible for developing those styles in ways that combine features that are both emic (inside a culture) and etic (outside it).

The Western predilection for demystification that is a strong underpinning bias of McEvilley's might require some amendment—not that processes of demystification are not of value to intellectuals from China, India, Nigeria, et. al., but that the impulse to demystify must be understood not as the replacement of myth by truth, but as the replacement of an antiquated, myopic, and obfuscating myth by a more ideologically relevant and pragmatically potent, if temporary,

myth, in this case, one that promotes rather than inhibits cross-culturalization. Of course, in an equilateral, truly cross-cultural discourse, the myths of religion and magic—normally discounted by Western, secular sciences—must be placed alongside those of empiricism and reason so long as any of the participating cultures vitalize them. And if a critic feels incapable of this neutralism, s/he should at least identify the dominant, underpinning bias of the discourse s/he engages for all readers.

The pretext of difference separating extra-European from European art is based on the idea that the Western artist, from the late Renaissance and early Enlightenment on, elevated art above, and divorced it from, its historic institutions. In reality, Western art was never any more estranged from social settings, rituals, or functions than the art of the non-West; it merely began to disguise its cultural settings, rituals, and functions in a transcendental aestheticism and, subsequently, in a formalism that variously pretended to avoid quotidian, practical, political, and metaphysical affairs. Western culture is but one of the many different focalizations of humanity; it is equilateral (in the relative sense) and continuous (in the general sense) with the focalizations of Eastern Europe, Asia, Africa, South America, and Australia. But the binary opposition of art and ethnology inhibits cultural production from leading the world's polities and peoples to a more highly evolved internationalism—an internationalism that reflects the ongoing conflation of indigenous technology, economies, and traditions and renders old national and cultural orders obsolete.

If we, critics and artists, do not participate, as McEvilley does, in securing this internationalism to a planned agenda that strives to implement cultural equilateralism, the international ethos will continue to evolve as but a reflection of the interests of multinational corporations, the governments they empower, and the race by non-Western nations to become part of the Western, technocratic franchise. As McEvilley repeatedly points out, few cultural vehicles are as well equipped to facilitate the spread of global equilateralism as art, entertainment, and world-web communications. This condition places extreme pressure on artists to choose between promoting a more responsible crosscultural discourse or facing the often violent consequences of ignoring the international call for cooperation.

Doctor, Lawyer, Indian Chief: "Primitivism" in Twentieth-Century Art at the Museum of Modern Art

*S*omething clearly is afoot. Richard Oldenburg, director of the Museum of Modern Art, describes one of its publications and the exhibition it accompanies, both titled *"Primitivism" in Twentieth Century Art: Affinity of the Tribal and the Modern* [1984], as "among the most ambitious ever prepared by The Museum of Modern Art." "Over the years," he continues, "this Museum has produced several exhibitions and catalogues which have proved historically important and influential, changing the ways we view the works presented, answering some prior questions and posing new ones."[1] Indeed, this is an important event. It focuses on materials that bring with them the most deeply consequential issues of our time. And it illustrates, without consciously intending to, the parochial limitations of our world view and the almost autistic reflexivity of Western civilization's modes of relating to the culturally Other.

The exhibition, displaying one hundred fifty or so Modern artworks with more than two hundred tribal objects, is thrilling in a number of ways. It is a tour de force of connoisseurship. Some say it is the best primitive show they have seen, some the best Eskimo show, the best Zairean show, the best Gauguin show, even in a sense the best Picasso show. The brilliant installation makes the vast display seem almost intimate and cozy, like a series of early Modernist galleries: it feels curiously and deceptively unlike the blockbuster it is. Still, the museum's claim that the exhibition is "the first ever to juxtapose modern and tribal objects in the light of informed art history"[2] is strangely strident. Only the ambiguous word "informed"

keeps it from being ahistorical. It is true that the original research associated with this exhibition has come up with enormous amounts of detailed information, yet since at least 1938, when Robert Goldwater published his seminal book *Primitivism in Modern Painting*, the interested public has been "informed" on the general ideas involved.³ For a generation at least, many sophisticated collectors of Modern art have bought primitive works too, and have displayed them together. For five or so years after its opening in 1977, the Centre Pompidou in Paris exhibited, in the vicinity of its Modern collections, about a hundred tribal objects from the Musée de l'Homme. Though not actually intermingled with Modern works, these were intended to illustrate relationships with them. More recently, the exhibition of the Menil Collections in Paris' Grand Palais, in April, 1984, juxtaposed primitive and Modern works (a Max Ernst with an African piece, Cézanne with Cycladic, and so on). The premise of this show, then, is not new or startling in the least. That is why we must ask why MoMA gives us primitivism now—and with such intense promotion and such an overwhelming mass of information. For the answer, one must introduce the director of the exhibition and, incidentally, of the museum's Department of Painting and Sculpture, William Rubin.

One suspects that for Rubin the Museum of Modern Art has something of the appeal of church and country. It is a temple to be promoted and defended with passionate devotion—the temple of formalist Modernism. Rubin's great shows of Cézanne, in 1977, and Picasso, in 1980, were loving and brilliant paeans to a Modernism that was like a transcendent Platonic ideal, self-validating, and in turn validating and invalidating other things. But like a lover who becomes overbearing or possessive, Rubin's love has a darker side. Consider what he did to Giorgio de Chirico: a major retrospective of the artist's work in 1982 included virtually no works made after 1917—though the artist lived and worked for another half-century. Only through 1917, in his earliest years as an artist, did de Chirico practice what Rubin regards as worth looking at. This was a case of the curator's will absolutely overriding the will of the artist and the found nature of the oeuvre. A less obvious but similar exercise occurs in Rubin's massive book *Dada and Surrealist Art*⁴—a book not so much about Dada and Surrealism as against them. The Dadaists, of course, and follow-

ing them the Surrealists, rejected any idea of objective esthetic value and of formally self-validating art. They understood themselves as parts of another tradition which emphasized content, intellect, and social criticism. Yet Rubin treats the Dada and Surrealist works primarily as esthetic objects and uses them to demonstrate the opposite of what their makers intended. While trying to make anti-art, he argues, they helplessly made art. Writing in 1968, at a time when the residual influence of the two movements was threatening formalist hegemony, Rubin attempted to demonstrate the universality of esthetic values by showing that you can't get away from them even if you try. Dada and Surrealism were, in effect, tamed.

By the late '70s, the dogma of universal esthetic feeling was again threatened. Under the influence of the Frankfurt thinkers and of post-Modern relativism, the absolutist view of formalist Modernism was losing ground. Whereas its esthetics had been seen as higher criteria by which other styles were to be judged, now, in quite respectable quarters, they began to appear as just another style. For a while, like Pre-Raphaelitism or the Ashcan School, they had served certain needs and exercised hegemony; those needs passing, their hegemony was passing also. But the collection of the Museum of Modern Art is predominantly based on the idea that formalist Modernism will never pass, will never lose its self-validating power. Not a relative, conditioned thing, subject to transient causes and effects, it is to be above the web of natural and cultural change; this is its supposed essence. After several years of sustained attack, such a credo needs a defender and a new defense. How brilliant to attempt to revalidate classical Modernist esthetics by stepping outside their usual realm of discourse and bringing to bear upon them a vast, foreign sector of the world. By demonstrating that the "innocent" creativity of primitives naturally expresses a Modernist esthetic feeling, one may seem to have demonstrated once again that Modernism itself is both innocent and universal.

"Primitivism" in Twentieth Century Art is accompanied by a two-volume, 700-page catalogue, edited by Rubin, containing more than a thousand illustrations and nineteen essays by fifteen eminent scholars.[5] It is here that the immense ideological web is woven. On the whole, Goldwater's book still reads better, but many of the essays here are beautiful scholarship, worked out in exquisite detail; Jack

Flam's essay on the Fauves and Rubin's own hundred-page chapter on Picasso exemplify this strength. The investigation and reconstruction of events in the years from 1905 to 1908 recur in several of the essays: these years constitute a classic chronological problem for our culture, like the dating of the Linear B tablets. At the least, the catalogue refines and extends Goldwater's research (which clearly it is intended to supplant), while tilling the soil for a generation of doctoral theses on who saw what when. Its research has the value that all properly conducted scientific research has, and will be with us for a long time. In addition to this factual level, however, the catalogue has an ideological, value-saturated, and interpretive aspect. The long introductory essay by Rubin establishes a framework within which the other texts are all seen, perhaps unfortunately. (Some do take, at moments, an independent line.) Other ideologically activated areas are Rubin's preface and Kirk Varnedoe's preface and closing chapter, "Contemporary Explorations" (Varnedoe is listed as "codirector" of the exhibition after "director" Rubin).

A quick way into the problems of the exhibition is in fact through Varnedoe's "Contemporary Explorations" section. The question of what is really contemporary is the least of the possible points of contention here, but the inclusion of great artists long dead, like Robert Smithson and Eva Hesse, does suggest inadequate sensitivity to the fact that art-making is going on right now. One cannot help noting that none of the types of work that have emerged during the last eight years or so is represented. Even the marvelous pieces included from the '80s, such as Richard Long's *River Avon Mud Circle*, are characteristic of late '60s and '70s work.

A more significant question is the unusual attention to women artists—Hesse, Jackie Winsor, Michelle Stuart, and above all Nancy Graves. Though welcome and justified, this focus accords oddly with the very low proportion of women in the show that preceded *"Primitivism"* at the new MoMA, *An International Survey of Recent Painting and Sculpture*. That show had a different curator, yet in general it seems that curators need a special reason to include a lot of women in a show—here, perhaps the association of women with primitivism, the unconscious, and the earth, a gender cliché which may have seemed liberating ten years before but may seem constricting ten years hence.

In the context of Modern art, "primitivism" is a specific techni-cal term: the word, placed in quotation marks in the show's title, des-ignates Modern work that alludes to tribal objects or in some way incorporates or expresses their influence. "Primitivist," in other words, describes some Modern artworks, not primitive works them-selves. "Primitive," in turn, designates the actual tribal objects, and can also be used to denote any work sharing the intentionality proper to those objects, which is not that of art but of shamanic vocation and its attendant psychology. Some contemporary primitivist work may loosely be called primitive;[6] yet the works selected by Varnedoe are conspicuously non-primitive primitivism. The works of Smithson and Hesse, for example, may involve allusion to primitive informa-tion, but they express a consciousness highly attuned to each move of Western civilization. Rubin and Varnedoe make it clear that they are concerned not with the primitive but with the primitivist—which is to say they ask only half the question.

There are in fact contemporary artists whose intentionalities involve falling away from Western civilization and literally forgetting its values. These are the more nearly primitive primitivists; they are edited out of the show and the book altogether. The furthest the museum is willing to go is Joseph Beuys. Varnedoe explicitly states a dread of the primitive, referring darkly to a certain body of recent primitivist work as "sinister" and, noting that "the ideal of regression closer to nature is dangerously loaded," that such works bring up "uncomfortable questions about the ultimate content of all ideals that propose escape from the Western tradition into a Primitive state."[7] The primitive, in other words, is to be censored out for the sake of Western civilization. The museum has evidently taken up a subject that it lacks the stomach to present in its raw realness or its real raw-ness. Where is the balance that would have been achieved by some attention to work like Eric Orr's quasi-shamanic objects involving human blood, hair, bone, and tooth; or Michael Tracy's fetishes of blood, hair, semen, and other taboo materials? The same exorcising spirit dominates the schedule of live performances associated with the exhibition: Meredith Monk, Joan Jonas, and Steve Reich, for all their excellences, have little to do with the primitivist and less with the primitive. Where are the performances of Hermann Nitsch, Paul McCarthy, Kim Jones, and Gina Pane? Varnedoe's dread of the

primitive, of the dangerous beauty that attracted Matisse and Picasso and that continues to attract some contemporary artists today, results in an attempt to exorcise them and to deny the presence, or anyway the appropriateness, of such feelings in Western humans.

Our closeness to the so-called contemporary work renders the incompleteness of the selection obvious. Is it possible that the classical Modern works were chosen with a similarly sterilizing eye? Was primitive primitivist work made in the first third of this century, and might it have entered this exhibition if the Western dread of the primitive had not already excluded it from the art history books? Georges Bataille, who was on the scene when primitive styles were being incorporated into European art as Modern, described this trend already in 1928, as Rosalind Krauss points out in the catalogue's chapter on Giacometti. He saw the estheticizing of primitive religious objects as a way for "the civilized Westerner . . . to maintain himself in a state of ignorance about the presence of violence within ancient religious practice."[8] Such a resistance, still dominant in this exhibition almost sixty years later, had led not only to a timid selection of contemporary works but to the exorcising of the primitive works themselves, which, isolated from one another in the vitrines and under the great lights, seem tame and harmless. The blood is wiped off them. The darkness of the unconscious has fled. Their power, which is threatening and untamed when it is present, is far away. This in turn affects the more radical Modern and contemporary works. If the primitive works are not seen in their full primitiveness, then any primitive feeling in Modernist allusions to them is also bleached out. The reason for this difficulty with the truly contemporary and the truly primitive is that this exhibition is not concerned with either: the show is about classical Modernism.

The fact that the primitive "looks like" the Modern is interpreted as validating the Modern by showing that its values are universal, while at the same time projecting it—and with it, MoMA—into the future as a permanent canon. A counterview is possible: that primitivism on the contrary invalidates Modernism by showing it to be derivative and subject to external causation. At one level this show undertakes precisely to co-opt that question by answering it before it has really been asked, and by burying it under a mass of information. The first task Rubin and his colleagues

attempt, then, is a chronological one. They devote obsessive atten-
tion to the rhetorical question, Did primitive influence precede the
birth of Modernism, or did it ingress afterward, as a confirmatory
witness? It is hard to avoid the impression that this research was
undertaken with the conclusion already in mind. The question is
already begged in the title of the exhibition, which states not a
hypothesis but a conclusion: *"Primitivism" in Twentieth Century Art:
Affinity of the Tribal and the Modern.*

The central chronological argument, stated repeatedly in the
book, is that, although the Trocadero Museum (later the Musée de
l'Homme) opened in Paris in 1878, primitive influences did not
appear in Parisian art until some time in the period 1905 to 1908.
This thirty-year lag is held to show that the process of diffusion was
not random or mechanical, but was based on a quasi-deliberate exer-
cise of will or spirit on the part of early Modern artists—in Rubin's
words, an "elective affinity."[9] It was not enough, in other words, for
the primitive images to be available; the European receptacle had to
be ready to receive them. As far as chronology goes, the argument is
sound, but there is more involved than that. What is in question is
the idea of what constitutes readiness. Rubin suggests that the
European artists were on the verge of producing forms similar to
primitive ones on their own account—so positively ready to do so, in
fact, that the influx of primitive objects was redundant. For obvious
reasons, Rubin does not spell this claim out in so many words, yet he
implies it repeatedly. For example, he writes that "the changes in
modern art at issue were already under way when vanguard artists
first became aware of tribal art."[10] The changes at issue were of
course the appearances of primitive-like forms. The claim is
strangely improbable. If one thinks of Greco-Roman art, Renaissance
art, and European art throughout the nineteenth century, there is
nowhere any indication that this tradition could spawn such forms; at
least, it never came close in its thousands of years. A counter-model to
Rubin's might see readiness as comprising no more than a weariness
with Western canons of representation and esthetics, combined with
the gradual advance, since the eighteenth century, of awareness of
Oceanic and African culture. The phenomena of art nouveau (with its
Egyptianizing tendencies) and *japonisme* filled the thirty-year gap and
demonstrate the eagerness for non-Western input that was finally ful-

filled with the primitive works. Readiness, in other words, may have been more passive than active.

Clearly, the organizers of this exhibition want to present Modernism not as an appropriative act but as a creative one. They reasonably fear that their powerful show may have demonstrated the opposite—which is why the viewer's responses are so closely controlled, both by the book and, in the show itself, by the wall plaques. The ultimate reason behind the exhibition is to revalidate Modernist esthetic canons by suggesting that their freedom, innocence, universality, and objective value are proven by their "affinity" to the primitive. This theme has become a standard in dealing with primitivism; Goldwater also featured the term "affinities," rather than a more neutral one like "similarities."

A wall plaque within the exhibition informs us that there are three kinds of relations between modern and primitive objects: first, "direct influence"; second, "coincidental resemblances"; third, "basic shared characteristics." This last category, referred to throughout the book as "affinities," is particularly presumptuous. In general, proofs of affinity are based on the argument that the kind of primitive work that seems to be echoed in the Modern work is not recorded to have been in Europe at the time. Ernst's *Bird Head*, for example, bears a striking resemblance to a type of Tusyan mask from the upper Volta. But the resemblance, writes Rubin, "striking as it is, is fortuitous, and must therefore be accounted a simple affinity. *Bird Head* was sculpted in 1934, and no Tusyan masks appear to have arrived in Europe (nor were any reproduced) prior to World War II."[11] The fact that the resemblance is "fortuitous" would seem to put it in the category of coincidental resemblances. It is not evidence but desire that puts it in the "affinities" class, which is governed as a whole by selection through similarly wishful thinking. In fact, the Ernst piece cannot with certainty be excluded from the "direct influences" category, either. The argument that no Tusyan masks were seen in Europe in 1934 has serious weaknesses. First of all, it is an attempt to prove a negative; it is what is called, among logical fallacies, an *argumentum ex silentio*, or argument from silence.[12] All it establishes is that Rubin's researchers have not heard of any Tusyan masks in Europe at that time. The reverse argument, that the Ernst piece shows there were probably some around, is about as strong.

A similar argument attempts to establish affinity between Picasso and Kwakiutl craftspeople on the basis of a Kwakiutl split mask and the vertically divided face in *Girl Before a Mirror*, 1932. For, says Rubin, "Picasso could almost certainly never have seen a 'sliced' mask like the one we reproduce, but it nonetheless points up the affinity of his poetic thought to the mythic universals that the tribal objects illustrate."[13] The argument is weak on many grounds. First, Picasso had long been familiar with primitive art by 1932, and that general familiarity, more than any "universals," may account for his coming up with a primitive-like thing on his own. The same is true for Ernst and the *Bird Head*. Modern artists don't necessarily have to have seen an object exactly similar to one of their own for influence to exist. Anyway, the similarity between *Girl Before a Mirror* and the "sliced" Kwakiutl mask is not really that strong. The mask shows a half head; the girl has a whole head with a line down the middle and different colors on each side. Rubin attempts to correct this weakness in the argument by noting that "Northwest Coast and Eskimo masks often divide integrally frontal faces more conventionally into dark and light halves."[14] But most of the world's mythological iconographies have the image of the face with the dark and light halves. Picasso had surely encountered this common motif in a variety of forms—as the alchemical Androgyne, for example. There is, in other words, no particular reason to connect his *Girl Before a Mirror* with Kwakiutl masks, except for the sake of the exhibition.

In addition to Rubin's reliance on the notoriously weak argument from silence, his "affinities" approach breaches the Principle of Economy, on which all science is based: that explanatory principles are to be kept to the smallest possible number (*entia non multiplicanda sunt praeter necessitatem*). The Principle of Economy does not of course mean keeping information to a minimum, but keeping to a minimum the number of interpretive ideas that one brings to bear on information. The point is that unnecessary principles will usually reflect the wishful thinking of the speaker and amount to deceptive persuasive, mechanisms. In the present case, ideas like "elective affinity," "mythic universals," and "affinity of poetic thought" are all *entia praeter necessitatem*, unnecessary explanatory principles. They enter the discourse from the wishful thinking of the speaker. An account lacking the ghost in the machine would be preferred. The question of

influence or affinity involves much broader questions, such as the nature of diffusion processes and the relationship of Modernist esthetics to the Greco-Roman and Renaissance tradition. In cultural history in general, diffusion processes are random and impersonal semiotic transactions. Images flow sideways, backwards, upside down. Cultural elements are appropriated from one context to another not only through spiritual affinities and creative selections, but through any kind of connection at all, no matter how left-handed or trivial.

The museum's decision to give us virtually no information about the tribal objects on display, to wrench them out of context, calling them to heel in the defense of formalist Modernism, reflects an exclusion of the anthropological point of view.[15] Unfortunately, art historians and anthropologists have not often worked well together; MoMA handles this problem by simply neglecting the anthropological side of things. No attempt is made to recover an emic, or inside, sense of what primitive esthetics really were or are. The problem of the difference between the emic viewpoint (that of the tribal participant) and the etic one (that of the outside observer) is never really faced by these art historians, engrossed as they seem to be in the exercise of their particular expertise, the tracing of stylistic relationships and chronologies. The anthropologist Marvin Harris explains the distinction:

> Emic operations have as their hallmark the elevation of the native informant to the status of ultimate judge of the adequacy of the observer's descriptions and analyses. The test of the adequacy of emic analyses is their ability to generate statements the native accepts as real, meaningful, or appropriate. . . . Etic operations have as their hallmark the elevation of observers to the status of ultimate judges of the categories and concepts used in descriptions and analyses. The test of the adequacy of etic accounts is simply their ability to generate scientifically productive theories about the causes of sociocultural differences and similarities. Rather than employ concepts that are necessarily real, meaningful, and appropriate from the native point of view, the observer is free to use alien categories and rules derived from the data language of science.[16]

The point is that accurate or objective accounts can be given from either an emic or an etic point of view, but the distinction must be kept clear. If etic pretends to be emic, or emic to be etic, the account becomes confused, troubled, and misleading.

MoMA makes a plain and simple declaration that their approach will be etic. Materials in the press kit which paraphrase a passage of Rubin's introduction argue, "As our focus is on the Modernists' experience of tribal art, and not on ethnological study, we have not included anthropological hypotheses regarding the religious or social purposes that originally surrounded these objects." Rubin similarly argues in his own voice that "the ethnologists' primary concern—the specific function and significance of each of these objects—is irrelevant to my topic, except insofar as these facts might have been known to the modern artists in question."[17] The point of view of Picasso and others, then, is to stand as an etic point of view, and is to be the only focus of MoMA's interest; emic information, such as attributions of motives to the tribal artists, is to be irrelevant.

This position is consistent in itself, but is not consistently acted on. In fact, it is frequently violated. It must be stressed that if the emic/etic question is to be neglected, then the intentions of the tribal craftsmen must be left neutral and undefined. But Rubin's argument frequently attributes intentions to the tribal craftsmen, intentions associated with typically Modernist esthetic feeling and problem-solving attitudes. The very concept of "affinity" rather than mere "similarity" attributes to the tribal craftsmen feelings like those of the Modernist artists, for what else does the distinction between affinities and accidental similarities mean? The claim that there is an "affinity of poetic spirit" between Picasso and the Kwakiutl who made the "sliced" mask attributes to the Kwakiutl poetic feelings like those of Picasso. The assertion that their use of "parallelisms and symmetries" demonstrates a "propinquity in spirit"[18] between Jacques Lipchitz and a Dogon sculptor attributes to the Dogon a sensibility in general like that of Lipchitz. And so on. Rubin says that the "specific function and significance of each of these objects" is irrelevant—for example, what ceremony the object was used in, how it was used in the ceremony, and so on. The use of the word "each" here is tricky. It is true that Rubin ignores the specific function of each object, but it is also true that he attributes a general function to all the objects together, namely, the esthetic function, the function of giving esthetic satisfaction. In other words, the function of the Modernist works is tacitly but constantly attributed to the primitive works. It is easy to see why no anthropologist was included in the

team. Rubin has made highly inappropriate claims about the intentions of tribal cultures without letting them have their say, except through the mute presence of their unexplained religious objects, which are misleadingly presented as art objects. This attitude toward primitive objects is so habitual in our culture that one hardly notices the hidden assumptions until they are pointed out. Rubin follows Goldwater in holding that the objects themselves are proof of the formal decisions made, and that the formal decisions made are proof of the esthetic sensibility involved. That this argument seems plausible, even attractive, to us is because we have the same emic view as Rubin and MoMA. But connections based merely on form can lead to skewed perceptions indeed. Consider from the following anthropological example what absurdities one can be led into by assuming that the look of things, without their meaning, is enough to go on:

> In New Guinea, in a remote native school taught by a local teacher, I watched a class carefully copy an arithmetic lesson from the blackboard. The teacher had written:
>
> $$4 + 1 = 7$$
> $$3 - 5 = 6$$
> $$2 + 5 = 9$$
>
> The students copied both his beautifully formed numerals and his errors.[19]

The idea that tribal craftsmen had esthetic problem-solving ambitions comparable to those of Modernist artists attributes to them an evaluation like that which we put on individual creative originality. An anthropologist would warn us away from this presumption: "In preliterate cultures . . . culture is presented to its members as clichés, repeated over and over with only slight variation." "Such art isn't personal. It doesn't reflect the private point of view of an innovator. It's a corporate statement by a group."[20] Yet, again relying only on his sense of the objects, without ethnological support, Rubin declares, "The surviving works themselves attest that individual carvers had far more freedom in varying and developing these types than many commentators have assumed."[21] Surely Rubin knows that the lack of a history of primitive cultures rules out any judgment about how quickly they have changed or how long they took to develop their diversity. The

inventiveness Rubin attributes to primitive craftsmen was probably a slow, communal inventiveness, not a matter of individual innovation. In prehistoric traditions, for example, several thousand years may be needed for the degree of innovation and change seen in a single decade of Modernism. Rubin asserts formalist concerns for the tribal craftspeople "even though they had no concept for what such words mean."[22] Consider the particular value judgment underlying the conviction that the only thing primitives were doing that is worth our attention, their proof of "propinquity in spirit" with the white man, was something they weren't even aware of doing.

From a purely academic point of view, Rubin's project would be acceptable if its declared etic stance had been honestly and consistently acted out. What is at issue here, however, is more than a set of academic flaws in an argument, for in other than academic senses the etic stance is unacceptable anyway. Goldwater had made the formalist argument for tribal objects in the '30s; it was a reasonable enough case to make at the time. But why should it be replayed fifty years later, only with more information? The sacrifice of the wholeness of things to the cult of pure form is a dangerous habit of our culture. It amounts to a rejection of the wholeness of life. After fifty years of living with the dynamic relationship between primitive and Modern objects, are we not ready yet to begin to understand the real intentions of the native traditions, to let those silenced cultures speak to us at last? An investigation that really did so would show us immensely more about the possibilities of life that Picasso and others vaguely sensed and were attracted to than does this endless discussion of spiritual propinquity in usages of parallel lines. It would show us more about the "world-historical" importance of the relationship between primitive and Modern and their ability to relate to one another without autistic self-absorption.

The complete omission of dates from the primitive works is perhaps one of the most troubling decisions. Are we looking at works from the '50s? (If so, are they Modern art?) How do we know that some of these artists have not seen works by Picasso? One can foresee a doctoral thesis on Picasso postcards seen by Zairean artists before 1930. The museum dates the Western works, but leaves the primitive works childlike and Edenic in their lack of history. It is true that many of these objects cannot be dated precisely, but even know-

ing the century would help. I have no doubt that those responsible for this exhibition and book feel that it is a radical act to show how equal the primitives are to us, how civilized, how sensitive, how "inventive." Indeed, both Rubin and Varnedoe passionately declare this. But by their absolute repression of primitive context, meaning, content, and intention (the dates of the works, their functions, their religious or mythological connections, their environments), they have treated the primitives as less than human, less than cultural—as shadows of a culture, their selfhood, their otherness, wrung out of them. All the curators want us to know about these tribal objects is where they came from, what they look like, who owns them, and how they fit the needs of the exhibition.

In their native contexts these objects were invested with feelings of awe and dread, not of esthetic ennoblement. They were seen usually in motion, at night, in closed dark spaces by flickering torchlight. Their viewers were under the influence of ritual, communal identification feelings, and often alcohol or drugs; above all, they were activated by the presence within or among the objects themselves of the shaman, acting out the usually terrifying power represented by the mask or icon. What was at stake for the viewer was not esthetic appreciation but loss of self in identification with and support of the shamanic performance.[23] The Modernist works in the show serve completely different functions, and were made to be perceived from a completely different stance. If you or I were a native tribal artisan or spectator walking through the halls of MoMA we would see an entirely different show from the one we see as twentieth century New Yorkers. We would see primarily not form, but content; not art, but religion or magic.

Consider a reverse example, in which Western cultural objects were systematically assimilated by primitives into quite a new functional role. In New Guinea in the '30s, Western food containers were highly prized as clothing ornaments—a Kellogg's cereal box became a hat, a tin can ornamented a belt, and so on. Passed down to us in photographs, the practice looks not only absurd but pathetic. We know that the tribal people have done something so inappropriate as to be absurd, and without even beginning to realize it. Our sense of the smallness and quirkiness of their world view encourages our sense of the larger scope and greater clarity of ours. Yet the way

Westerners have related to the primitive objects that have floated through their consciousness would look to the tribal peoples much the way their use of our food containers looks to us: they would perceive at once that we had done something childishly inappropriate and ignorant, and without even realizing it. Many primitive groups, when they have used an object ritually (sometimes only once), desacralize it and discard it as garbage. We then show it in our museums. In other words, so far are we from understanding each other that our garbage is their art, their garbage is our art.

The need to co-opt difference into one's own dream of order, in which one reigns supreme, is a tragic failing. Only fear of the Other forces one to deny its otherness. What we are talking about is a tribal superstition of Western civilization: the Hegel-based conviction that one's own culture is riding the crucial time-line of history's self-realization. Rubin declares that tribal masterpieces "transcend the particular lives and times of their makers";[24] Varnedoe similarly refers to "the capacity of tribal art to transcend the intentions and conditions that first shaped it."[25] The phrase might be restated: "the capacity of tribal art to be appropriated out of its own intentionality into mine."

As the crowning element of this misappropriation of other values comes the subject of representation. Rubin distinguishes between European canons of representation, which are held to represent by actual objective resemblance, and the various primitive canons of representation, which are held to represent not by resemblance but by ideographic convention. Our representation, in other words, corresponds to external reality, theirs is only in their minds. But the belief that an objective representational system can be defined (and that that system happens to be ours) is naïve and inherently contradictory. It is worth noting that tribal peoples tend to feel that it is they who depict and we who symbolize. Representation involves a beholder and thus has a subjective element. If someone says that *A* doesn't look like *B* to him or her, no counterargument can prove that it does. All conventions of representation are acculturated and relative; what a certain culture regards as representation is, for that culture, representation.

Rubin's love of Modernism is based on the fact that it at last took Western art beyond mere illustration. When he says that the tribal artisans are not illustrating but conceptualizing, he evidently feels he

is praising them for their modernity. In doing so, however, he alto-
gether undercuts their reality system. By denying that the tribal
canons of representation actually represent anything, he is in effect
denying that their view of the world is real. By doing them the favor
of making them into Modern artists, Rubin cuts reality from under
their feet.

The myth of the continuity of Western art history is constructed
out of acts of appropriation like those Rubin duplicates. The redis-
covery of Greco-Roman works in the Renaissance is an important
instance of this, for the way we relate to such art is also in a sense like
wearing a cereal-box hat. The charioteer of Delphi, ca. 470 BC, for
example, was seen totally differently in classical Greece from the way
we now see him. He was not alone in noble, self-sufficient serenity in
the room of transcendental angelic whiteness that we see. He was
part of what to us would appear a grotesquely large sculptural
group—the chariot, the four horses before it, the god Apollo in the
chariot box, and whatever other attendants were around. All was
painted realistically and must have looked more like a still from a
movie than like what we call sculpture. Both Greco-Roman and
primitive works, though fragmented and misunderstood, have been
appropriated into our art history in order to validate the myth of its
continuity and make it seem inevitable.

A belief in the linear continuity of the Western tradition necessi-
tates the claim that Western artists would have come up with
primitive-like forms on their own, as a natural development. The pur-
pose of such theorizing is to preclude major breaks in Western art his-
tory; its tradition is to remain intact, not pierced and violated by
influence from outside the West. The desire to believe in the whole-
ness, integrity, and independence of the Western tradition has at its
root the Hegelian art-historical myth (constructed by the critical his-
torians Karl Schnaase, Alois Riegl, and Heinrich Wölfflin) that
Western art history expresses the self-realizing tendency of Universal
Spirit. (This is Rubin's vocabulary. He once declared, for example,
that Pollock's paintings were " 'world-historical' in the Hegelian
sense."[26]) When brought down to earth—that is, to recorded his-
tory—this view involves not only the conclusion that the shape and
direction of Modern art were not really affected by the discovery of
primitive objects, but another conclusion equally unlikely, that the

shape and direction of European art were not really influenced by the discovery of Greco-Roman works in the Renaissance.

In fact, Western art history shows three great breaks: one when the population of Europe was changed by the so-called barbarian invasions in the late Roman Empire, which led to the transition from Greco-Roman to Christian art; the second with the Renaissance, the transition from Christian art to European art; the third at the beginning of the twentieth century, with the transition from European to Modern art. Each of these breaks in tradition was associated with a deep infusion of foreign influence—respectively, Germanic, Byzantine, and African/Oceanic. To minimize these influences is to hold the Western tradition to be a kind of absolute, isolated in its purity. In order to support that claim, the adoption of primitive elements by early Modernists is redefined as a natural, indeed inevitable, inner development of the Western tradition. But the context of the time suggests otherwise. In the nineteenth century the Western tradition in the arts (including literature) seemed to many to be inwardly exhausted. In 1873 Arthur Rimbaud proclaimed his barbarous Gallic ancestors who buttered their hair,[27] and called for a disorientation of the patterns of sensibility. The feeling was not uncommon; many artists awaited a way of seeing that would amount simultaneously to an escape from habit and a discovery of fresh, vitalizing content. For there is no question that the turn-of-the-century fascination with archaic and primitive cultures was laden with content: Baudelaire, Rimbaud, Picasso, and Matisse were attracted, for example, by the open acknowledgment of the natural status of sex and death in these cultures. By repressing the aspect of content, the Other is tamed into mere pretty stuff to dress us up.

Of course, you can find lots of little things wrong with any big project if you just feel argumentative. But I am motivated by the feeling that something important is at issue here, something deeply, even tragically wrong. In depressing starkness, *"Primitivism"* lays bare the way our cultural institutions relate to foreign cultures, revealing it as an ethnocentric subjectivity inflated to co-opt such cultures and their objects into itself. I am not complaining, as the Zuni Indians have, about having tribal objects in our museums. Nor am I complaining about the performing of valuable and impressive art-historical research on the travels of those objects through ateliers (though I am

worried that it buries the real issues in an ocean of information). My real concern is that this exhibition shows Western egotism still as unbridled as in the centuries of colonialism and souvenirism. The museum pretends to confront the Third World while really co-opting it and using it to consolidate Western notions of quality and feelings of superiority.

Hamish Maxwell, chairman of Philip Morris, one of the sponsors of the exhibition, writes in the catalogue that his company operates in a hundred seventy "countries and territories," suggesting a purview comparable to that of the show. He continues, "We at Philip Morris have benefited from the contemporary art we have acquired and the exhibitions we have sponsored over the past quarter-century. . . . They have stirred creative approaches throughout our company."[28] In the advertisement in the Sunday *New York Times* preceding the *"Primitivism"* opening, the Philip Morris logo is accompanied by the words, "It takes art to make a company great."

Well, it takes more than connoisseurship to make an exhibition great.

HISTORY, QUALITY, GLOBALISM[1]

*T*he past usually absorbs more of our fascinated attention than the future, perhaps because it is more known. Yet we are at a moment in our cultural history now when the future at last is becoming more interesting than the past. We sense that our story—our little game, our reality—is undergoing, or about to undergo, fundamental change. This moment of change is still new enough that there is more of a sense of an end in it than of a beginning—yet. Like premonitory winds the rumours of endings rustle around us. One such rumour that has been repeated a lot lately is the idea of the End of Nature, meaning that the environment has been so altered by human interventions that it can no longer be called exactly nature. Chemicals in air and water, biological engineering of new species of plants and animals suggest that nature has become a part of culture, something made (or, rather, remade) by humans for their own purposes. Of course to say that nature has become culture is to say that the distinction between nature and culture is dissolving, or collapsing. On the one hand nature is declared a part of culture. On the other hand, culture is increasingly being perceived as a disguised part of nature, a somewhat marauding natural force that has cloaked itself in the illusion that it is outside of and above nature. This is an indicator of a crucial change going on in our attitudes. The dichotomy between nature and culture was one of the essential premises of Modernism.

This distinction arose in the sophistic age, that is the early fifth century BC in Athens. The idea was that nature has its own laws, which we can do nothing about, such as, say, the temperature at which water will boil. But culture, on the other hand, was believed to

operate by laws that we make for it and which we are free to change in any way we want in order to engineer society into a shape that we desire. So nature was supposedly not in our power whereas culture supposedly was or is. Modernism was very deeply committed to this distinction. By "Modernism" I mean that ideology whose articulation is found in the works of Kant and Hegel and which underlies, at an often unacknowledged level, most of what we do as cultural beings. When this ideology begins to shift and change it means that the very presuppositions by which we live are changing.

As a part of this shifting we now see the nature-culture distinction very differently. The original sophistic distinction seems to have been ironically reversed. It is clear today that we can in fact control nature to a significant extent—to such an extent as to be able to destroy it, for example, or reduplicate or alter it. Now it is culture which seems out of our control. We used to think of culture as the thing that would protect us from nature—from the earthquake and the famine and the cold. Now we look helplessly to nature for some cure for culture. And nature might not be there to offer a cure, having reciprocally been absorbed into culture at the same time that culture was being revealed as sunken into the chaos and randomness of nature.

This inversion of the old distinction between nature and culture relates to radical changes that are going on in our view of history. In a Hegelian mood, these changes are also being called an end. For some years now one has been hearing about the so-called end of history. Michel Foucault, for example, spoke not only of the end of history but of the end of humanity as well. This is not apocalyptic talk—it does not literally mean the end of the world or the end of civilisation. It means the end of a certain way of understanding things, a certain myth of what history was and of what humanity was, what it had to be in order to occupy that myth. What seems to have ended is a certain way of looking at time, a certain way of editing and rendering events, that we have long called history.

Specifically this is the view of history enunciated by Hegel at the beginning of the nineteenth century. So the end of history means the end of the Hegelian idea of history. In this view history was a force instilled with an inner directive, heading toward a culminating self-realisation which would be at once its triumph and its end. This

advance toward history's culmination could not happen by itself. It had to be driven onward by specially dedicated individuals—what Hegel called "world historical" individuals, meaning that what these individuals did with their will and their actions had significance for the entire world. To Hegel Napoleon was the big example. But in the Romantic tradition (of which Hegel was a part) the emphasis was soon shifted to artistic endeavours. Through the work of Schnaase, Schelling and the Schlegels, art history came to be seen as the most significant channel through which the goal of advancing history in general could be carried out. Great art, it was believed, had the ability to see beyond the illusion of things to the realm of Platonic Ideas or eternal realities. It was through this process that the world was to be pulled continually toward that higher reality which would be its consummation. These various claims of endings are all parts of the much discussed end of Modernism. When I say that Modernism is an ideology, I mean a set of values which is designed, usually covertly, to maintain and justify a certain social situation or class structure or pattern of repression. The Modernist ideology started to come together in the Renaissance and peaked in the nineteenth century. This historical confirmation is not insignificant. What we see more and more clearly, is that Modernism was an ideology that grew up alongside colonialism and imperialism. It was in effect their cover story. Of course early imperialistic endeavours, in the sixteenth and seventeenth centuries, were largely justified by the Christian goal of baptising the savage. By the eighteenth century this became inadequately believable, and an ideology of history took its place—an ideology that was secretly based on the Christian idea of providence. History had a goal, comparable to the restoration of Eden, and it would be implemented by a handful of world historical individuals more or less comparable to the returning Messiah who would usher in the final age. The point is that more or less anything these individuals had to do to achieve that goal was justified by the goal. It was for the good of the whole world that that goal be advanced.

Now it follows that if a number of different people or peoples are advancing toward a goal, then some of them may be farther along toward that goal than others. This is the basis on which cultures came to be understood as on different levels of advancement, that is, as hierarchised. Modernism was characterised by the concepts of the

hierarchy and the centre-and-periphery. In this case, the centre stream of human endeavour was located in Europe, since after all this was a European myth, and, since World War II, also American. Naturally it was the duty of supposedly higher cultures to forcibly raise lower ones, to engage them in the history of the mainstream. This of course was the justification for imperialism. Empire was, as Rudyard Kipling said, "the white man's burden". The rest of the world was in effect nature; Western civilisation was culture.

Hegel rephrased the culture-nature dichotomy as what he called Work and Madness. Culture was Work, because it was the arena where dedicated world-historical individuals were to push history along the arc of progress toward its goal. Nature he called Madness, because it seemed to have no direction and to be inaccessible to human control. In terms of the imperialistic project which this ideology ultimately served, the Work was to be done by the Western colonising nations: the Work, in other words, was the White Man's Burden. The rest of the world, the world of people of colour, was Madness. It was the raw material of unconscious unhistoricised nature which the colonising cultures were to drag into history and make a part of the Work. So the distinction between centre and periphery, higher and lower, Western and non-Western, is dependent on or anyway syntactically linked with the nature-culture distinction. As that distinction breaks down, so does the belief in hierarchy, and the belief in the centre, and the belief in the significance of the distinction Western-non-Western, and with it history as a hegemonic discourse linked to specific covert purposes. Post-Modernism in its early phases is characterised precisely by the project of inverting the values of Modernism: instead of hierarchy, a levelling; instead of a mainstream, a decentering; instead of colonialism, the search for a post-colonialist way to mingle cultural streams. Several years ago Arthur Danto's book "The End of Art" appeared. Like most of these other proclaimed "ends", it was based on Hegelian theory. Hegel had argued that history was instilled with an arc of progress taking it always in the direction of greater self-awareness; when its self-awareness was complete, history would end in an ecstatic state of restored oneness. That this was essentially a theological idea, concealing the Christian idea of the restoration of Eden at the end of history, seems obvious now, but in its day evi-

dently did not. When Hegel's student Schnaase reapplied this doctrine to art history in particular, the Romantic cult of art arose which Matthew Arnold perceptively remarked was to buffer the shock of the dechristianisation of Europe, and which remained in effect pretty constantly until sometime in the sixties.

Danto, in the Hegelianly titled "The End of Art", argued that, with the maturation of Conceptual Art, art had in fact entered that stage of complete self-awareness when all it did was to be conscious of itself, that Hegel had specified as the goal and end. Hegel's idea of the self-aware universal mind at one with itself is based on Aristotle's idea of the thought that thinks itself: that the central engine of the universe, so to speak, is a transcendent mind that just goes on knowing itself, or being self-aware, at all times. Conceptual Art in its early or "classical" period approached this idea repeatedly. For example, a piece of 1964 by William Anastasi was a tape recorder which had recorded the sound of itself recording itself, then played that sound back on an endless loop, like the thought that thinks itself thinking itself forever. Danto felt that with works of this type art had reached the culminating self-absorption that Hegel had predicted as the end of history. Hence the end, socalled, of art. Another "end" which has become prominent in the recent discourse is the socalled "end of art history". Again what is meant is the end of a certain view of what art history is: namely, once more, the Hegelian view—or maybe I should say sub-Hegelian because it was not enunciated by Hegel himself but by those under his influence. In this view, history consists exclusively of the Work, which is being done by the European colonising cultures as they channel what Milton called "barbaric pearl and gold" into their coffers. Similarly, art history means only the stream of transcendent object-making that is historically conscious, consciously working toward the goal. In other words, only European art is art history. Objects made, say, in China may look like art but they are not really because they are not engaged in the Work which is the essence of art, the work of pushing always onward along the arc of progress through the patient step by step solutions of formal problems, which then become new problems demanding new solutions and so on. So art history as defined in the sub-Hegelian or Romantic view was a very exclusive realm indeed. It excluded all non-white non-European peoples—that is, it excluded the art of 80% of the

world, because, of course, all the world-historical individuals were in Europe and, after World War II, in America. Jackson Pollock, for example, was declared a world-historical artist by William Rubin and others, meaning that when he put one colour next to another in his barn in East Hampton late at night, he was somehow affecting the salvific situation of the billion Chinese who would never see his work yet were supposedly being dragged along toward self-realisation by it. Exactly how this was supposed to work was never clear, but the incredible grandiosity of this idea of the artist's function, it seems to me, must have had something to do with the extreme anxiety with which much modern art, such as Pollock's, has been imbued.

So the End of Art History means, to me, the end of this view that there is a single, tiny, distinct mainstream which is all we need to study. In the global village the single stream or mainstream concept of following selected developmental sequences as if that were really what existed is no longer tenable. It no longer matches the world that we live in. That kind of art historiography could only be believed in a Europe, or a West, which knew nothing of the outside world except as Empire. During the colonial era, while the world was under the domination of Europe and European cultural hegemony was unquestionable, it seemed natural enough to limit socalled art history to the products of a tiny proportion of the world's object makers—those in Europe and, later, America, the temporary surrogate centre.

Events put an end to this way of thinking, or anyway have pushed it temporarily into the background. The clearest indicator of the dawning of a Post-Modernist attitude is the loss of confidence that history is on our side, the realisation that this might all have been a wishful thought and that history might have the most dreadful things in store for us. The reality of endgame weaponry showed that, as far as the Hegelian idea of the end of history goes, the joke was on us. The great spiritual culmination would be many Hiroshimas. The great self-awareness would be a cry of anguish. The post-historical Eden would be a nightmare of disease and exhaustion. Modernism brought us up to the abyss and pushed us to look right in.

The most obvious trait of Modernism was the belief in progress, the belief that history was going somewhere and somewhere good. The end of the belief in progress is the moment of the dawning of Post-Modernism. It is of course the horrific events of history that

bring such a moment about. It's like Stephen Dedalus said in Joyce's "Ulysses": "History is a nightmare from which I am trying to awaken". Joyce's view of history—that it is a trap in which we have entrapped ourselves—is already a partly Post-Modern view (though of course in other aspects he remained Modernist).

Post-Modernism doesn't dawn all at once, as Lyotard remarked, it appears unevenly in a culture, popping up first in one area of activity, then in another. I think that for some very sensitive people Post-Modernism really began with World War I. Marcel Duchamp, for example, was an early advocate of much of what is currently being called the Post-Modern attitude. For many Europeans the loss of faith in history occurred after World War II. But then the full dawning was postponed by the euphoric postwar period of growing American hegemony, a euphoria which lasted approximately through the first manned lunar landing. In the eighteenth century America was traditionally regarded as outside of history. Many of the founding fathers felt that this was why it should be possible to build a new type of society there: the whole devastating karma of European history was not hanging over everything. When America entered World War I and even more so World War II, it entered history. It acknowledged or demonstrated that it was part of that European causality. But still, it was not invaded and devastated by those wars; their lessons were more distant to Americans. After World War II, when Europe could no longer convincingly claim to be advancing history toward any desirable conclusion, America stepped in and took on the white man's burden for a while. This lasted through the fifties and into the sixties. But events of the sixties and seventies pretty much shook faith in history in America, too. It is an interesting game to date that event, but of course it doesn't happen all at once. Such dates are really symbolic. John Barth once remarked that for him Post-Modernism began in America with the first Kennedy assassination in 1963. In the same panel discussion the art critic David Hickey said that he dated it, in the fine arts realm, to the first Pop Art exhibitions in 1962. I suggested that in terms of art criticism it might be dated to Clement Greenberg's 1961 "Artforum" article, "Lament of an Art Critic", in which what he was lamenting was the passing of the Kantian model of art. These three dates are interestingly close. They indicate a feeling that is still growing, namely that

Modernist art history, with all its overheated sense of working through the linked problems and solutions, was not really going anywhere anyway, and that its self-important sense of its high minded mission was to be mocked rather than revered.

So Post-Modernism isn't anything yet really except for a possibly premature claim of the end of Modernism, a terrified recoiling back from the abyss of Modernist progress. It is defined by the negation of Modernism, by an attempt to invert its values in the hope that somehow this process will define a new position that might be positively characterised in one way or another. So far it's just "post". The question is what we can make out of it. And the question is also: will Modernism surge back (it surely still lives) into the position of dominance which for the moment it seems to have abdicated or to have been dragged down from. Because such a transition is not a *tabula rasa*, of course, the old causality still falls upon us from the past.

In the hopes of avoiding a regressive Neo-Modernism we need to move aggressively into the project of redefining history. The Modernist faith in a single linear history has to be replaced by a vista of many histories without either invoking meta-narratives to unify them or allowing them to collapse into chaos. And this project involves a similar redefining of the idea of value, because any model of history brings quality judgements with it in its hierarchisation of human actions as more or less deserving of attention and discourse. The old Modernist idea of history was that it had a single unchanging meaning. This meaning was guaranteed by universals which could bind different cultural ages or situations together through transcendent value judgements. These universals of quality were regarded, in the tradition that links Plato and Kant, as inborn in all humans identically, in what Plato called "the Eye of the Soul" and Kant "the Faculty of Judgement". In the Modernist era in the West it was this universality of value that gave meaning to life.

Yet there are several types of evidence that suggest that quality is not objective and universal. First, historically, the fact that taste changes indicates that quality changes. There are countless examples that could be invoked of course; we're all familiar with them. Similarly, the criteria for the appreciation of quality change. The types of things that we thought about to approach the quality of a picture in, say, the Abstract Expressionist period seem no longer

valid for art that is produced today. So quality is not an eternal real but changes with the changes of ambient circumstances, of which it would appear to be an epiphenomenon.

Looking at it not historically but in terms of cultures that exist at the same time, the differences between ideas of quality in different cultures also indicate that quality is not universal or objective. What is valued as a "good" picture is different in New York or Kinshasa, Beijing or Alice Springs. The Modernist (which is to say colonialist) solution was to say that every culture but ours was simply wrong. Nowadays we've come to feel that there is no extra-cultural vantage point from which such a judgement could be made about cultures not one's own. Our solution, then, is to say that the reality of quality changes from culture to culture, and that no culture's idea of quality can claim more validity than another's.

So quality, it seems, changes constantly both in regard to time and to place. The situation is not complete chaos, however. Quality judgements have a certain degree of stability within limited contexts of time and space. People in the same class, with the same education, in the same culture, at the same time in history, are apt to have simi- lar ideas of quality, which means that their value judgements are meaningful among themselves. That a trained viewer of, say, Modernist abstract paintings should have a better sense of what is a good work of that type than an untrained viewer is obvious; "good" in fact seems to mean what a consensus of trained viewers would agree on. And they *would* agree, loosely, which shows that something *is* going on in the value judgement, though what is going on seems not to be a perception of universals but a response to conditioning. In this conditioning several factors are involved: tradition, class, region, gender, age, occupation etc. So the conditioning situation does not mean that all members of one culture will agree; there will be a com- plex but still limited set of options within a culture.

A factor that has come in for a lot of attention lately is the fact that we are conditioned by the forces that control the society around us and that these forces will use their position to advance their own programme. Hence value judgements are subject to the influence of what Adorno called the Culture Industry and Althusser Ideological State Apparatuses. The value system thus will in part be a concealed ideological tool. The famous use of Abstract Expressionist painting

as what Max Kozloff called "a tool for the Cold War" is only the most conspicuous example. The fact that value judgements and the conditioning that produces them will be ideologically motivated means that it is to the advantage of the controlling influence to posit them as eternal and universal. So the Platonic-Kantian tradition here performs class-service. Plato of course was an aristocrat whose whole system of thought serves the interests of that class.

All this does not mean that value judgements are necessarily invalid. The powers that be are smart and will make their system as good as they can, as convincing as they can. They make use of the finest human qualities in the service of bonding society around the structure they desire. So a value judgement, though not a universal, is still in a sense the highest and purest expression of a culture, and it is valid to appreciate a culture's soul, so to speak, by coming to understand its value judgements, which is to say its connoisseurship. And the reach of a culture's connoisseurship will of course go way beyond the socalled fine arts. In our culture, if you listen to fifteen year old kids talking about video games, or to basketball fans appreciating a player's moves, or to art fans appraising an exhibition, you hear connoisseurship. I for one feel forced to the conclusion that there is no difference of scale or quality among these types of connoisseurship. It is hard to see what would privilege one type over another in any objective sense.

I am not, in other words, advocating that we dispense with the value judgement. I am advocating that we learn to make new uses of it. First of all we have to criticise our own tastes and see that certain elements in them are fake and local and temporary and have lowdown hidden motivations. Secondly, we should learn to relativise our own value judgements, to see them in relation to other options. One part of being sane is to understand the value judgements of various points of view. It is part of the global project of decolonisation, for example, for white Westerners to make a conscious effort to understand the value systems of non-white and non-Western cultures. The realities of wealth and power are drawing them into ours, and we must resist the temptation to feel that this means that ours are universal. Another part of sanity is the ability to attempt to see through any and all value systems by appreciating their hidden motives—yet without trashing and disregarding them.

A really important question right now is: is it possible to make transcultural value judgements? In a debate recently in Europe, when I asserted that value judgements were valid within a conditioned group but not among groups, someone asked: "Am I supposed to say that Polish culture is as great as Russian? I *know* it's not." Similarly Richard Rorty in discussing relativism has said that it is a view that no one really holds—that one thing is as good as another. I think that there is a rather elementary misunderstanding here. We all like what we like, and there is no argument with one's preferences. From any point of view some cultures will seem preferable to others. And everyone has a point of view, no matter how relativised. The question is how to phrase such a judgement. This can be done in two ways. It is always valid to say "I like this better than that just because of the special and peculiar person I am." If one seeks more objectivity, one can say: "Granted such and such a set of values A seems better endowed in these terms than B", or: "Granted such and such a purpose, A is better or more useful than B," and so on.

So what are value judgements *for*? As a social practice they serve to define and bond groups in ways that are often useful and always dangerous. In addition they serve some of the needs of individual selfhood. The pleasure of exercising value judgements is a pleasure of self-realisation, self-recognition and self-distinction. One reflects oneself, and contemplates the reflection of oneself, by bouncing one's radar of appreciation off of this and that, rejecting this, rejoicing in that, putting certain things in a class with oneself, excluding others from it, and so on. This process has enormous usefulness if it is pushed farther, if we allow ourselves to adopt different viewpoints in the course of time: behind the rigidification of taste in adulthood is a not necessarily articulated assumption of universality. Once this is abandoned we realise that from a certain point of view we once held such and such a judgement was valid, but from a different point of view which we now hold, another becomes valid.

Thus the act of self-recognition can be extended progressively into an act of expanded self-creation. By learning to appreciate the value stance of another group than the one we were born into we expand our selfhood. In this piecemeal way we can approach the project of becoming, not universal in a metaphysical sense, but global in a pragmatic sense—I mean the sense of incorporating through delib-

erate effort some feeling of what is meant when an Indian, or a Japanese, or a Senegalese, or an Australian says this or that is good. This seems to be the main point of our current confrontation with the idea of value judgement, that there are ways that this human activity can be used far more sanely than it has been used in the past, and that this is our great opportunity to articulate them and put them into use.

Basically what we need to do is complexify the judgement of quality. The Kantian model was of a completely unitary judgement based on the immediate presence of aesthetic feeling. This approach is not thoroughly invalidated, but it is very limited in relevance today. Today a value judgement must attempt to incorporate awareness of alternatives and counterjudgements. The arena in which this complexification is apt to take place most intensely is the multi-cultural situation—what Marshall McLuhan in the fifties somewhat prematurely, yet prophetically, called the "global village". In the postcolonial situation the individual self will be expanded and refashioned through the interpenetrations of different traditions and attitudes.

Jean-Paul Sartre, in his introduction to Frantz Fanon's "The Wretched of the Earth", wrote of the first members of a conquered culture to adopt the ways of the conquerors. He saw them as essentially lost beings, who have sold their souls and those of their natural fellows and have in consequence become blanks, soulless, neither one thing nor another. They have betrayed the whole project of identity. But this feeling seems to assume that the integrity of the colonised individual before the colonialist overlay has affected his or her livelihood and, hence, personality. It seems a wishful Edenic myth of cultural purity to believe that humans were once psychologically and socially whole, and that it is culture-mixing that destroys this wholeness and creates monsters. Does this then mean that culture-mixing is impossible, or inevitably destructive and that it can never produce healthy results? There is something misbegotten and puritanical here, like an insistence on ethnic purity. Sartre's detestation for the colonialised servant's betrayal of his or her race implies that all cultural influence from outside should be rejected or resisted. The popular 1980 movie "The Gods Must Be Crazy" shows a "native" African community rejecting a Coca-Cola bottle (representing "Coca-colonialism", or cultural neo-colonisation) the way a living

body may reject a surgical implant. The motif relates to the utopian and puritanical idea of returning all objects to their original places. It represents a desire to freeze the world, and to prevent all change in it—ultimately a desire to maintain the emic point of view forever. This attitude, with its hidden essentialism, assumes something like the Hegelian idea that each culture has a nature or essence. In the metaphysical puritanism of Modernism, to compromise a thing's essence seems perhaps worse than to destroy the thing outright: it is to make it into something that ideologically annihilates it while simultaneously taking over its being. The intrusive force activates the thing's survival in such a way as to betray it at every moment it survives. Its existence is based on a continuing betrayal of its reason for existing. The desire to return objects to their originary places implies that an artifact has an essence that reflects its maker's ethnicity. Since essences do not change, any significant culture-mixing is impossible or, even worse, hideous.

The servant whom Sartre denounces is apparently a kind of monster, in the Greek mythological sense of a being with the traits of two or more species at once: a human collage or pastiche. The point that Sartre may have missed, viewing these things from the heart of late Modernism, is that the process of change works through such monstrosity: a being containing part of one era and part of another at the same time is a being moving into the future, like Zeno's arrow occupying two places at once in its flight. Cultural change occurs through the interposition of pastiche, and the ontology of monstrosity, collage, and pastiche is absolutely characteristic of the Post-Modern or postcolonial project. Western artworks by Picasso incorporating elements of African or Oceanic art are pastiche monsters; so are Indian artworks by Tyeb Mehta that incorporate elements of Matisse, and African artworks by Iba N'Diaye incorporating School of Paris painterliness. The fecundity of these new hybrid species offers a cross-fertilisation from which a challenging future might grow.

The dialogue that takes place when goods travel back and forth is complex. At first, it is often a dialogue of exploiter and exploited: beads are traded for gold. Later it becomes more two-directional: refrigerators for gold. Then popular imagery spreads, usually from the centre of greater wealth: Coca-colonialism, Marlboro ads,

Marilyn, Elvis. Finally high imagery flows: one high art and other mutually merge, in a series of uneven steps. If one understands art as an expression of the identity of a culture, then the artwork might be seen as the embodiment of the culture's soul. When different arts flow into one another it is as if the souls of cultures were merging. The merging of Sumerian and Egyptian icons in ancient Near Eastern cultures subject to influence from both, the merging of Greek sculptural forms into Indian Buddhism, the back-and-forth influences between postwar American and Japanese cultures—these are examples of this process.

This dialogue of objects is a channel for a type of communication that was missing in the colonial period and in the generation or two of its aftermath. In that era, even ethnographic writing, for all its intentions of neutrality and objectivity, was generally uni-ocular: the gaze went all one way. *We* represented *them* through *our* ways of representation. What resulted was often either Western discourse applied blindly outside its sphere of relevance, or, in perhaps the most sensitive cases, what Clifford Geertz has called "haunted reflections on Otherness". James Clifford has written of the need for ethnographic discourse to become a dialogue in which the identities of both observer and observed are in question—that is, in which each party is open to influence, to being changed inwardly, by the other— as opposed to "discourses that portray the cultural realities of other peoples without placing their own reality in jeopardy." Will the long-insular world of Western contemporary art receive contemporary art from previously colonialised cultures with such openness? It is a difficult task to find ways into this project, with the cloud of colonial history still lying so dark and heavy over attempts at communication. At least the development of such dialogue is finding, after long drought, some advocates among white representatives of Western institutions. In the Modernist period, we in the West thought our representations were more real than others. We were living in a dream peopled and propped by our representations. Now we wake up—or think we wake up, though we may still be in just another dream, maybe a framing dream or maybe a detail, we can't really tell yet. Anyway, seeming to awaken, we embarrassedly see that our inherited modes of representation were not more real than others in a general sense, they were only more real to us. They were

emic and like damn fools we thought they were universals. And it was so easy to do that. To think one's representations are etic may be the most characteristic of all emic simplicities. Cut loose from the anchors of our ignorance we float rudderless on a sea of the real-without-name. And we call it Post-Modernism, a name with the advantage of being a non-name, a concept shaped by negation rather than by position. (Modernism was all about position.)

But is there a nonposition that is not also a position? Is there an etic stance that is not also emic? "They stand firmly because they stand nowhere", says Subhuti, describing the Bodhisattvas. We too wish to stand firmly yet stand nowhere, to act as two rather than as one, to incorporate difference into the felt sameness of existence. The current crisis in our views of history and quality seems to offer a mechanism for such a communal rite of passage.

ARRIVEDERCI VENICE: THE THIRD WORLD BIENNIALS

*T*he Venice Biennale, founded in 1895, is the oldest and, along with Germany's Documenta series, the most influential of Europe's major recurring international exhibitions. Both those shows occur in formerly imperial nations and reflect a Eurocentric history, for they concentrate not just on Western art but on the art shown in the West's prominent commercial galleries. Now, however, as the colonial era fades, the biennial tradition has spread beyond the Western world. With the post-Modern shift of emphasis from the previous centers to the previous margins, the idea that one's own city, wherever it may be, can act as an international hub has become widely available.

Recently a number of recurring, usually biennial, international survey exhibitions have appeared in non-Western, often previously colonized capitals. The spectrum of difference exhibited at these shows suggests varying relationships with the West: some artists identify with or at least acknowledge the Western tradition, some contemn it. At one extreme are non-Western biennials that are directly involved in the Western moment. The Sydney Biennales (many of these shows use the Italian or other European forms of the word "biennial" in their names), for example, closely resemble the survey shows of Europe and the U.S.; though they do examine Australian artists, including aboriginal artists, they are primarily Euro-ethnic. (But then, Australia is basically a First World nation.) The São Paulo Biennial similarly explores the Western "cutting edge" while shifting emphasis somewhat toward Latin America. The work in these shows is often based in post-Modernism, but the curators' residual sense of center emanates a continuing Modernist aura.

Other shows are not merely non-Western geographically but take place within more distinctly non-Western cultures. Several have begun quite recently—1984 was a pivotal year. These exhibitions' inaccessibility to the vast majority of Western critics, and the truly daunting difficulty of getting information about them in the West (some of the biennials I discuss here I was unable to see, and I write on them from their catalogues, themselves hard to find), are part of their story, and part of their paradox. The institution of the international juried show may be a Western phenomenon, but the Third World biennials are sprouting with or without Western attention; clearly they have audiences and cultural functions of their own, quite independently of their resemblance to Western art practice. On the other hand, these exhibitions are often committed to the project of becoming "modern," or Modernist in a classical sense. The New Delhi Triennials, the Cairo Biennials, and the Bantu Biennales (usually held in Libreville, Gabon), for example, largely eschew historical regional styles; there is little that looks "Egyptian" or "Islamic" in the Cairo shows, little "Indian" in New Delhi. There is an implication, rather, of a community of taste adjusted to Western tendencies of a couple of generations ago, when the West's idea of internationalism was still founded on an assumption of Modernist universals. But if works in the indigenous traditions are not apt to be seen, neither are the Western Modernist works that lie in the background: many of the works seem to be Third World embodiments of classical Modernism, with admixtures of regional points of view. They resemble, for example, the so-called "Shona" African sculpture that traveled the U.S. last year, a smooth amalgam of Modernist motifs from the heyday of Brancusi with nods to the African styles that influenced him.

Again like classical Modernism, much of the work—especially the sculpture—emphasizes craft in a way that post-Modernist Westerners tend to regard, somewhat arrogantly, as archaic. The Western viewer may have trouble with this art, for much of it looks like what we might see as kitsch Modernism: "mushy abstract paintings with pyramids in them," as one American summarized the Cairo Biennial. Yet a great deal of this sort of work is now being produced around the world, and the ambitions of at least some of it could intrigue a post-Modernist: a picture exhibited by Zairean artist Kamba Luesa at the second Bantu Biennale, in 1987—a loosely

allover field of mazelike abstraction coalescing here and there into hints of faces—is titled *Cultural Identity*. Perhaps the Western art world needs to find a way to understand this art's meanings and gradations. It's not as if European influence on non-Western traditions was ever a one-way transaction, and given post-Modern practices of quotation and appropriation, the esthetic processes at work in these exchanges, which are going on more all the time, should already be part of our vocabulary.

The oldest of the non-Western biennial-type shows are the New Delhi Triennials, begun in 1968. Their historical priority, among other traits, reflects the fact that many Indian artists and intellectuals have come to accept the legitimacy of a multicultural heritage, acknowledging their selfhood as simultaneously Hindu and Moslem. Asian and European, and interested in forging a cooperation between East and West in which each incorporates elements of the other without losing its selfhood. There have been problems: instead of empaneling its jury locally, for example, the second Triennial, in 1971, reached out to an international jury including the European curator Pontus Hulten and the Mexican writer Octavio Paz—but the catalogue revealed in a small-print footnote that neither of these luminaries could attend the jury meeting "due to indisposition." Still, the Triennials have remained far more global in reach than their Western equivalents. The 1982 Triennial set delegations from Czechoslavakia, Iraq, Nepal, Bangladesh, Vietnam, Nigeria, Egypt, and Sri Lanka alongside those from France, Germany, and Britain. The United States sent just one artist, Vernon Fischer, whose post-Modern takeoffs on the "Nancy" comic looked strangely out of place among Third World Modernisms.

A show that has striven to go beyond the influence of classical Modernism is the Istanbul Biennial, begun in 1987, and curated in 1992 by Vasif Kortun under the influence of the "*Magiciens de la terre*" exhibition at the Centre Pompidou, Paris, in 1989. Most of the art in Kortun's show was post-Modern in type, and what Modernist-style art there was looked decidedly out of place. The emphasis was on varieties of neo-Conceptual installation, a mode that seems to be becoming a global style for the time being. It may be that the genre's emphasis on iconographic coding gives it a linguistic function at the same time that it ends linguistic boundaries.

Outstanding pieces in Istanbul by artists who would be (and in some cases have been) at home in Venice or Kassel included Belgian artist Jan Fabre's installation of bathtubs and owl sculptures (*The Scheldt*, 1989). British artist Damien Hirst's claustrophobic office, and Polish Mariusz Kruk's furniture crucified by hardware. The Turkish artists represented were no less proficient: Gülsün Karamustafa's installation of wastebaskets stuffed with quilts, and Hale Tenger's ranks of priapic midgets. *I Know People Like This*, both 1992 were among the most striking and likable works.

In the catalogue, Kortun describes Istanbul not as a center but as a place "in the middle," "situated between North and South and [severing] Asia from Europe as a 'non-space.' " Yet the Biennial was generally oriented northward, with only Israel lying to the south. The special resource the show offered because of its location was the surprisingly strong presence of Central European nations. This might have been the first major international exhibition of which one could straight-facedly say, "The Bulgarians stole the show." And indeed Nedko Solakov's two-room installation—which showed the Earth age of the universe winding down in a hilarious yet profound toilet-bowl intrusion from another world and time—seemed to be widely appreciated, as did the wooden machines of Lyuben Kostov, which constituted a comic drama of a man both applauded and eradicated. The primarily Westernizing nature of the Istanbul show may have reflected Turkey's desire to enter the European community. The setting, in a former fez factory renovated by the well-known Italian architect Gae Aulenti, was telling: Turkey outlawed the fez in 1925, as part of the Westernizing program of Kemal Atatürk. Here its place of manufacture was turned to a Westernizing use.

The United States Information Agency, which generally handles U.S. participation in biennial-type shows, asked Patricio Chavez, of San Diego's Centro Cultural de la Raza, to curate the American contribution. The result denounced the intervention in the Western hemisphere begun by Christopher Columbus—a popular theme in the quincentennial year of '92—and featured installations by Amalia Mesa Bains, David Avalos, and others. These works might have seemed intelligent and visually dynamic in America, but I spoke to a number of non-Americans who saw them as parochial and self-absorbed—as failing to represent the cultural diversity of the U.S.,

let alone of the contemporary world. Yet here more than anywhere else in the exhibition, or in most others like it, was a straight-out rejection of Western values. Indeed a minor contretemps ensued when the USIA got cold feet and canceled the show, which was sent anyway through independently obtained funding.

The exhibition that has rejected Western values most thoroughly is the Havana Biennal. Once known explicitly as the "Third World Biennial," this show has rarely shown First World artists: in its nine years of life, which cover a crucial period in post-Modern art, it has shifted from an emphasis on Latin America (along with some representation of Spain and Portugal) in 1984 toward a broader sense of Third World solidarity in 1991, when the third Havana Biennal included artists from Korea, the Philippines, India, Thailand, Egypt, and Sudan.

These exhibitions are based on, among other things, the premise that the world art system is "a system of apartheid."[1] Curator Gerardo Mosquero sees the centering of the Third World in its own culture as a part of a new global era: "If most of the world," he writes, "aspires to new international orders in the economic and information realms, seemingly it would also be necessary to defend a new international order of art and culture."[2] This new international order will not entirely reject Western culture, yet will transform it beyond recognition. "We, the Africans, the Asians, the Latin Americans," Mosquero writes, ". . . have to shape Western culture, as the 'barbarians' shaped Christianity. I am certain that the result will not resemble today's Western culture."[3] The Havana Biennals have tended to emphasize Latin America's relationship with Africa more than that with Europe or the U.S.; Mosquero, for example, has written on the elements of Bantu visual tradition in contemporary Cuban art. Still, despite the Biennals' premise of providing an alternative to Western Modernism, much of the work echoes Modernist abstraction and near abstraction. An emphasis on photography may reflect the Marxist ambience, with its technological and documentary emphasis.

The Bantu Biennale, or more properly the Biennale de l'Art Bantu Contemporain, is regional in tone, focusing on artists from southwestern Africa. Much of the work invokes Modernist universals, but the Brancusi-like pieces of Angolan sculptor Afonso Massongui and others don't simply imitate Modernism; on the con-

trary, they reflect an awareness that Brancusi drew his work in part from African models. Thus they promote an Afrocentric shift in emphasis: the true universals are to be found in African art, from which Modernism stole. Works like those of Central African Republic painter Jean Tubind Makouna are more explicitly political but no less hybrid, combining the theme of opposition to apartheid with the heritage of French Impressionism.

The Cairo Biennales are more Europe-oriented and use the English language in their catalogues. In 1984, their first year, all the prizes went to artists from the Arab world (from Egypt, Kuwait, Sudan, and Iraq), but by the third event, in 1988, the awards included Europeans as well. The fourth Biennale, in November 1992, showed art from 41 countries including various European nations, the U.S., and a few Far Eastern and Latin American nations, along with a heavy representation from the Arab world and Africa. By and large, however, countries like France and Germany did not send the same artists they generally send to Western shows such as Venice nor, for that matter, did India.

The Third World offerings were mostly Modernist-style paint- ing and sculpture: a Western viewer would quickly link Mohamed Hagras' white-marble *Labourers*, 1992, say, to the tradition of Henry Moore and Barbara Hepworth. It's not in condescension but in recognition that the Western viewer connects such work with European models, yet it is altogether possible that the Modernist influence has by now become local tradition, with Arab-world artists of a generation ago serving as the models for these contemporaries. Part of the point of this Modernist-type work would seem to be a desire to present a facadelike impression of the visual mode of a "developed" culture. As in the Delhi Triennials, one often has the sense here that the rest of the world is still trying to embrace the esthetic values of Western Modernism. The idea that Modernist art grew partly from African sources doesn't seem to have found favor in Cairo.

As in Istanbul, the U.S. exhibit in Cairo, curated by Kathleen Goncharov, was the most confrontational in this Biennale: an instal- lation by Fred Wilson called "Re: Claiming Egypt," combining this artist's familiar museum interventionism with an Afrocentrism based on Cheik Anta Diop's and Martin Bernal's idea of ancient Egypt as a

generator of Western culture, and with a more generalized critique of colonialist attitudes and their aftermath. Using some objects bought in the Cairo markets and others signifying contemporary African-American culture. Wilson constructed the scenario of a room in a colonial administrator's home. Western, Egyptian-influenced furniture stood amid vitrines filled with purchases from the bazaar, some of them souvenir copies of objects in Cairo's archaeological museum. On the floor large pots lay as if spilled, with tape recorders in them from which spoke a variety of French and English voices saying things like, "I want what you have, I want to figure it out, I want to get inside of it, I want to overpower it; it's not really yours, it belongs to the world." Meanwhile, from an Egyptian-style pot, a voice replied in Arabic, "It's mine, it's always been mine, I may not talk about it, I may not even think about it, but it's mine." Nearby, another voice said in African-American cadences, "They think we have no history, but though we have never met, we are you and you are us," asserting the unity of diaspora Africans and present-day Egyptians. A text in Arabic, on a traditional Egyptian gown lying on the floor, asked, "Is the West more interested in the past than in the present? Is it more threatened by the contemporary culture than by the ancient?" Other elements included T-shirts printed with Afrocentric slogans and the music videos of Queen Latifah and of Michael Jackson (as King Tut), and so on. Perhaps understandably, Wilson's work had Egyptian critics inquiring what school or movement he belonged to.

The Dakar Biennales, emerging in the city of both Diop and the great postcolonial filmmaker Ousmane Sembene, are more solidly black African. And if the main essay in the catalogue for the '92 show is titled *"Dak' Art 92: Les Promesses d'un rendezvous international"* (The promises of an international rendezvous), the organization that mounted the exhibition is called "The Dakar Festival for the Revival of the African Arts." Still, the exhibition included work from Canada, Japan, Portugal, Sweden, Italy, Mexico, and elsewhere besides Africa and the African diaspora. The work was generally somewhat more current in terms of Western styles than that in the Bantu Biennales. Some of the Modernist-style art, such as the beautiful paintings by Fode Camara and Iba N'Diaye, has been shown in New York. Bangladeshi Ahmed Shahabuddin's expertly executed

canvases seemed derived in part from Francis Bacon. Other works were primitivizing sculptures, like the Belgian artist Jephan de Viliers' mixed-media fetish, or the Cameroonian Pascal Kenfack's *Ancestral Presence*, a wood sculpture alluding to traditional African styles. A bridge between Africa and the West was provided here and there, as in the mediating works of Ouattara, Diagne Chanel, and others whose works refer both ways.

As in Istanbul, the USIA chose a minority curator for the American show—Corinne Jennings, of New York's Kenkeleba Gallery. But the result addressed colonial issues very differently than the Istanbul or Cairo delegations. Jennings focused on the African-American tradition of abstract easel painting from the Harlem Renaissance on, a tradition for the most part excluded from the art-historical record of white society. Yet the Harlem Renaissance was inspirational not only for other diaspora communities but for African culture too. Jennings' show of five artists ranged from Joe Overstreet, a Color Field and post-Color Field painter inspired as much by French Impressionism as by the Harlem Renaissance, to Leonardo Drew, a younger artist who has lately come into the awareness of the white American art audience. In addition, the handsome and eloquent works of abstract painters Frank Bowling, Mildred Thompson, and Mary O'Neal took the ambiguous trip back to the island slave fortress of Gorée, on the Senegal coast at Dakar.

This has had to be a selective survey. Other shows, both actual and planned, could be mentioned, such as the first Asia-Pacific Triennial, currently open in South Brisbane. Writing from New York, without having personally visited all the exhibitions under discussion, I'm sure my information in this article is in some cases out of date and my catalogue-based reporting in need of fleshing out. Geographically and chronologically widespread, the Third World biennials are simply impossible for most critics to watch closely enough fully to understand their differences and commonalties of purpose.

Still, as multiplying sites of intercultural communication, and as instances of changing global relations, are these biennials signs of the developing postcolonial world family? The idea of such a family has been found in both East and West since ancient times. The Cynics taught that all human societies formed a vast culture, the world com-

munity or *cosmopolis*.[4] Zeno the Stoic, in his *Republic*, called for a world government based on brotherly love. "The world is the mother of us all," wrote Seneca in the first century A.D. In south India a Tamil poet of the first or second century A.D. echoed the sentiment: "Every country is my country and every person is my kinsman."[5] (The downside of this idea, of course, is the fact that the family can be an inwardly torn and hostile community.

Like the family drama, the postcolonial situation is a play of deep and obscure shiftings of identity. The process of postcolonial readjustment is going on; no doubt it includes covert power strategies and identity appropriations, but previously colonized peoples and cultures are constructing their own places to stand and their own networks of relationships. And art, which both embodies tradition and allows direct intervention in it, is a fit medium for the search. As different cultures present their images to one another in these more or less open exchanges, the forces that shape the world are laid out in diagrammatic clarity only to shift as they both incorporate and resist one another. Out of the tumult of images, perhaps a new vision will be born.

SECTION THREE

Commentary by G. Roger Denson

The Self and Subjectivity

Essays by Thomas McEvilley

"I Am," Is a Vain Thought
Penelope's Night Work: Negative
 Thinking in Greek Philosophy
empyrrhical thinking (and why
 kant can't)

THE SELF AND SUBJECTIVITY

I have remarked in the heading of the second section, The World and Its Difference, that McEvilley is entering a nomadic phase of his criticism, which I define as a dynamically shifting employment of relativism and a successive visitation of models not of his own making. This worldly attitude can only be undertaken because it presumes a subjective, inner experience. That inner experience, whether of the artist, the critic, or the most casual viewer of art, has been central in the discourse on art since at least the time of Plato (with regard to the discourse on subjectivity) in general, and in terms of the individual experience, goes back even further.

This discourse on the self is an area that McEvilley is not celebrated for in the art world, at least not as much as he is for his dismantling of formalism's chief tenets and colonialism's Eurocentric vestiges. Yet his reasoned subjectivism is the underpinning of all his positions on historical and worldly operations and is especially informative to his challenge of authority in art and thought. Skepticism of authority, after all, is how he once defined criticism (in his first "Forum" section in *Artforum*). And though skepticism is in greater abundance and in more systematic or thought-out forms of discourse today than it has ever been since the Hellenistic period— what with Deconstruction, neopragmatism, and the variety of emancipation movements redefining identity in terms of gender, race, ethnicity, and sexual preference—this radical skepticism seems to mark only a few notable writers on contemporary art.

It seems ironic that art critics around the world venerate Marcel Duchamp for displacing the romantic notion that artists have special expressive powers and insights while refraining from applying this

scrutiny to their own profession. To some critics, the critic still legislates the last word in cultural taste, or a reasoned corrective, sometimes even an ethical standard, as if they were guardians of the categorical imperative. Perhaps this is because critics recognize that in diminishing the worldly authority of artists, Duchamp ironically elevated his own worldly authority in the annals of art history. Duchamp's case exemplifies the postmodern intellectual's double standard of asserting and empowering the very prophets who nihilistically deny truth and preach disempowerment. Recognizing this, many critics refuse to sacrifice themselves by reifying and making mythic a single critical figure or system advocating the deposition of broader, more diverse, and more diffuse figures of authority.

This is one reason why I chose to reprint McEvilley's essay "emphyrrical thinking (and why kant can't);" for McEvilley is not afraid to delve into the heart of Duchamp's skepticism and make it a feature of his own writing. In this essay, McEvilley argues against the claim that Duchamp was a nihilist or infantile narcissist; instead, he opines that Duchamp only seemed so to commentators "for whom there is no world outside the Kantian inheritance," that is, the inheritance of an objectivist world view. Duchamp's indifference and negativism is, instead, McEvilley argues, "a precise and mature theoretical critique, an overthrow of the Kantian aesthetic along with the demonstration of a Pyrrhonist openness as a space for the art of the future to move in."

The remainder of this essay is a consideration of Duchamp's brief encounter with the thought of Pyrrho of Elis (ca. 365–275 B.C.E.) around the pivotal year of 1912 and how that brief encounter profoundly revolutionized cultural development in the West ever since. In this context it seems especially remarkable that McEvilley writes this essay with understated aplomb, for he knows he is the spokesman for a tradition of thought that has been repressed by the padagogical, religious, and scientific institutions of the West for about 2,500 years (since the age of the sophists). This article could have been more effusively entitled, "Revenge of the Pyrrhonic Greeks." For with the possible exceptions of Hume's, Nietzsche's, and Derrida's scrambling effect on modern Western thought, no one has done as much as Duchamp (and possibly Joyce?) to overturn the rationalist hegemony of the West. If Duchamp's contribution (or

anti-contribution, as it were) has never before been described in such terms, it is because Duchamp's remark on his reading of Pyrrho has been brushed aside by art historians. And with understandable reason: for to open the portal to Pyrrho's radical negativism is to open the door to the undermining of reason, logic, and science.

The essay "Penelope's Night Work: Negative Thinking In Greek Philosophy" might be thought of as a companion piece to that on Duchamp, but really it is a prior manifesto, a statement of McEvilley's intention to reintroduce the Greek skeptics who have been repressed by the canons of Western metaphysics until contemporary theorists like Derrida and Rorty and critical historians like McEvilley made the reprisals of such canons essential. Now McEvilley is trying to demonstrate that Duchamp too has made recourse to ancient skeptical thought a profitable enterprise. Published in the philosophical journal *Krisis* in 1984, "Penelope's Night Work" is named for the wife of Homer's famed Odysseus, King of Ithaca and victor in the Trojan War. Faced with the prospect of her husband's death, Queen Penelope tried to ward off her persistent suitors, the nobles of Ithaca, who insisted she remarry for the sake of the kingdom. She did this by announcing she would remarry after she finished weaving a shroud for her father-in-law Laertes. She wove the shroud every day for three years, but every night she unraveled her day work so that when she began the next day she would be at the same point at which she began the day before. This analogue and the essay it names is as subversive an entry to philosophical studies as other writings of McEvilley's are to the criticism of contemporary art and global discourse. McEvilley's reprieve of the texts of ancient Greek skeptical and critical writers like Gorgias, Antisthenes, Democritus, Protagoras, and Diogenes, is as much the unraveling of the history of Western philosophy as were the attempts of those Greeks he invokes to unwrite or deconstruct the foundations of the positivist "daylight" metaphysics of their time. And by their comparison, Duchamp is shown to be equally unravelling.

The essay having the most relevance to culture-at-large, "I Am Is A Vain Thought," is of McEvilley's earlier, more capacious modes. It examines how the idea of the self is central to cultural development as a whole. But a skepticism of the kind one customarily encounters

in Madhyamika or Zen Buddhism is here seen to be unravelling the notion of the self even as it evolves in Western society. McEvilley cites three principal, ongoing reconfigurings of the definition of the self as postmodern examples: the self as constantly changing consciousness, a stream of impressions and thoughts with no apparent unifying principle; the self as a corporal event that is the temporary by-product of molecules combined in certain ways; and the self as a soul that is not dependent on consciousness or molecular structures, but rather which survives the destruction and decay of both. McEvilley characteristically compares Western concepts of the self with crosscultural views, paying special attention to the Buddhist idea of "not-self," or soullessness. Citing Abhidharma texts as examples, McEvilley compares Buddhist analyses of human mental processes with Western positivist approaches, settling essentially with the description of self as a series of disconnected atomic events of consciousness "that run through so fast that they blur into an apparent continuum." The treatment of flux common in Western thought from Heraclitus to Hume is thus paralleled with that of Eastern texts from the Visudhimagga of Buddhaghosa to Lama Anagarika Govinda, paying close attention to the notion of the self as issuing from a "false attitude: what we regard as an enduring and unified center of subjectivity is not a constant thing, but an ever-flowing process." Similarly, the Buddhist teaching of the self is shown to be like that of Cybernetics and the literature of computers combined, where the self is like a mechanically constructed device with atomic units of consciousness (*information*, in cybernetic terms) that are so fast they race beyond 100 billion operations per second.

Where McEvilley particularly excels is in his inferences on the profound cultural consequences of these philosophies. In examining the impending robotization of civilization, McEvilley compares the Japanese response to the American. The Japanese person sees nothing that s/he has not been familiar with and at home with for centuries, McEvilley states, explaining a point escaping many Western economic analysts, and which helps indicate why the Japanese excel in the electronics industry: "Judeo-Christian faith in the soul . . . provides a solid barrier of resistance and paranoia toward artificial intelligence." In McEvilley's view, the same-soul concept that opposed Darwinism opposes artificial intelligence, and for the same reason.

But McEvilley isn't oversimplifying the Japanese view as mono-lithic; he points out the differences not as clear-cut East-West dichotomies. "As certain areas of Eastern thought have paralleled the Western naturalistic view, certain areas of Western tradition have paralleled the not-self doctrine." He cites as being shared by both East and West the extrapolations of self embodied in the analy-ses of language, whether it be by Western thinkers like Ludwig Wittgenstein, Gilbert Ryle, P. F. Strawson, and Roland Barthes, or Eastern philosophers like the nineteenth century Vedantic practi-tioners Ramakrishna and Ramana Maharshi. Furthermore, the larger intellectual currents emitted from psychology, physics, genetic biol-ogy, and electronic technology are eroding the Judeo-Christian view of the soul-self so drastically as to place it closer to the Buddhist view of not-self.

And yet, McEvilley feels it necessary to point out that computer dread persists in the Christian West, perpetuated by the fear that a general preoccupation with machines will come to replace human gregariousness and activity with "solipsistic circular-gazing" and "cold-screen abstraction," a fear that will soon be tested as virtual reality technology becomes available to consumers and "each person sits before his or her cool, dotted screen, energy passing in a self-enclosing circle from fingertips to screen to eyes to fingertips." As is apparent throughout the book, however, McEvilley sees this process partaking in an even larger, on-going process: he shows how the pre-sent transference of information evolved from a time when people did not read silently to themselves but rather read to one another. Reading to oneself only developed in the West in early Christian times as part of devotional practice involving "monkish silence and the attention of the heart."

Similarly, McEvilley links the phenomenon of computer-dread to the widespread fear that humanity is being severed from direct experience with nature—an experience important to the develop-ment of concepts about time and space (e.g. weights and measures, clocks)—and replacing that experience with abstractions. McEvilley also questions the dread that abstractions make a process less human when the meaning of humanness is seen not as an essence but as a process itself. When he comes to the argument that the elimination of the self facilitates the requirements of centralized authority

already armed with virtually all the technological advances, he admits that the self and its potential for freedom become central to the defense of basic freedoms. But this, he says, in no way requires a belief in the soul; in fact, he sees the claim of the soul as conflating the self with the idea of self. This belief in a charismatic self, McEvilley claims, is the root of tyranny, from which arise Christianity and Islam, among the most violent traditions in history. The Buddhist teaching of not-self, however, in his view promoted a freer consciousness.

"I Am," Is a Vain Thought

"I am" is a vain thought; "I am not" is a vain thought; "I shall be" is a vain thought; "I shall not be" is a vain thought. Vain thoughts are a sickness, an ulcer, a thorn. But after overcoming all vain thoughts one is called a silent thinker. And the thinker, the silent one, does no more arise, no more pass away, no more tremble, no more desire.

—Majjhima-Nikaya 140

Robot Robert knew he was a robot, knew he was programmed to know it, suspected he was programmed to rebel against it. Question: how can Robot Robert bust his program with full assurance that he has not been programmed to bust it? —Marv Friedenn

Ankebuta, an ancient Babylonian scientist, wrote a work on "artificial productions" in which he claimed to have manufactured a living human being.[1] Babylonian culture, which did without the idea of a soul, assumed that by meticulous imitation of natural processes humans could create plants, animals, and even other humans (i.e., they "foresaw" genetic engineering). The Hebrew cabalistic texts in which the story is preserved do not allow it a happy ending; it emerges not as a tale of scientific triumph, but of theological shame. Ankebuta's homunculus, we read, had neither speech nor locomotion, but could only open and close its eyes. The poor creature was doomed to inadequacy because the act of creating it was an affront to God. The moral is that only God can create a soul; any being not made by God must be soulless and, as a consequence, horrible. Similarly, the golem, a being created by a rabbinical successor of Ankebuta, was a general affliction to all who had contact with him, and a terrible omen for human destiny as a

whole. The later monster of Dr. Frankenstein was represented as brain-damaged for the same hidden theological reason Ankebuta's was; the attempt to create a person is always perceived as impious in cultures that have a myth of the soul. Monotheistic religions feature this kind of anxiety especially.

A case from Greek polytheistic mythology—that of Asclepius, a human physician who became so skilled that he brought a patient back from death—provides instructive contrast. For this overstepping of mortal power he himself had to die, but after his death the gods admired his skill so much that they made him one of them; he became the god of medicine. Within the loose and shifting structure of a polytheism, with no idea of a fixed soul, and the conception of a changing universe, there was room for new deities of science.

Today the question of the self can be clearly focused by its relation to artificial intelligence. The issue, for example, of whether computers do, or will, "think like people" has become a cutting edge to divide those who believe in the soul from those who do not. Yet the question of whether computers—or stones, or plants or homunculi—think like people is unanswerable until we know how people think—and so far we don't. Perhaps for this reason Alan Turing, a cyberneticist involved in the early development of computers, regarded the question as meaningless.[2] Still, the question whether human minds have possibilities that other systems can never attain has elicited much passionate debate, because it is, finally, a question about what it is to be a human being.

For some, humanness is a process that achieves definition, if at all, only by happening; like Heraclitus' river it may never be defined, for it may never be the same for two moments in a row. For others, humanness is a metaphysical essence that persists and remains the same, outside the flowing stream of nature. To this latter group the homunculus or robot seems an ontological perversion, a thing which, merely by existing as itself, diminishes us in what we are: it is a sign that the fall from grace is still tragically in progress. A recent advertisement in the *Houston Chronicle* for a Baptist church identified the computerization of society with the devil's campaign against the human soul.[3] The same case, but in milder terms, was made in a letter to the editors of the *New York Post*: "Concerning *Time* magazine's Man of the Year Award: to substitute a computer for a human being

is an insult to those of us whose feelings and emotions run deeper than a 'mechanical object'."[4]

Presuppositions about the self fall mostly into three categories. In a purely phenomenalistic approach, the self is seen as a constantly changing stream of impressions and thoughts with no apparent unifying principle. Even the body is not acknowledged as a ground of unity (or substrate), because what we experience directly is not a body, but mental impressions that may (or may not) be interpreted as evidence of a body. For David Hume, for example, our experience is a stream of ever-changing "point-instant events" with nothing that may be regarded as a unifying principle. Seen in this way, the self is not a perceived object, but a mental object, created by an organizing operation performed on a stream of impressions which in themselves lack such organization. As Hume said, "What we call a mind is nothing but a heap or collection of different perceptions."[5] From this heap of random images a sense of personal identity is constructed.

Other thinkers recognize the existence of a body as a temporary substrate for the sense of self. From the time of Democritus, materialist thinkers have taught that consciousness is a temporary by-product of the combination of chemicals in the body. When certain molecules are combined in certain ways, a kind of "buzz" is set up that experiences itself as consciousness; in fact, since it is centered in a body, it experiences itself as a finite center of consciousness, or subject. When the molecules in question are separated by bodily death, the self simply ceases to appear to exist. This view, which is found also among Asian materialists such as the Carvakins, harmonizes well with recent discoveries about the chemistry of emotion, memory, and other elements of the traditional self.

Still other thinkers have made an additional evidential leap beyond the body, to the existence of something (a soul) that is not dependent either on the steam of impressions in consciousness or on the chemical combinations in the body. This soul, being somehow outside the changing finite body and mind, will survive them both. This type of view, which may roughly be called Platonist, is found primarily in the Western monotheistic religions among the soulists, as Douglas Hofstadter has called them.[6] Modern American culture has inherited the Platonic-Christian concept of eternal soul as its most common presupposition about the self; the idea of the unique

value of the individual and his or her ethical and aesthetic decisions is a somewhat secularized version of it.

In Japan the situation is quite different. Japanese culture is based to a large extent on the Buddhist idea of not-self, or soullessness. This traditional Buddhist view, which is formulated most extensively in the Abhidharma texts, is relevant to any comparison of Japanese and American attitudes toward robots and the self. The Abhidharma analysis of human mental processes operates through direct introspection; meditational practices are used to slow down the time sense until the flowing stream of consciousness can be studied. The procedure is essentially a positivistic use of what our culture calls ESP. What is reported by those who have mastered the microscopic apprehension of time is that the self is a series of disconnected atomic moments of consciousness that run through so fast that they blur into an apparent continuum. Hume's "heap of perceptions" is a close parallel; even closer is the phenomenon of persistence of vision that makes a series of still photographs, when run through a projector at a speed too fast for the eye to refocus on each one individually, appear as a continuum of movement.

The idea of a self then "arises from a false attitude," as Lama Govinda puts it. What we regard as an enduring and unified center of subjectivity is "not . . . a constant . . . 'thing' but an ever-flowing process . . ."[7] As Buddhaghosa put it in the *Path of Purification*: "Perception of impermanence should be cultivated for the purpose of eliminating the conceit 'I am.' "[8] The Buddha, who had gone beyond the conceit "I am" to the realization of not-self, is portrayed in early Buddhist art either by an empty chair or a pair of empty footprints or both: the illusion of selfhood is gone; "he" is not there. A Buddhist teaching image portrays the self as a mechanical construction which can be taken apart as easily as put together. The self is said to be like a chariot which, when disassembled, appears as two wheels, a seat, an axle, and a pole; everything that was present in the chariot is still present, but the "chariot" is no longer seen.

In this view, then, the human self is like a mechanically constructed device, a model that has much in common both with Hume and with Cybernetics. One remarkable correspondence lies in their views of the rate of mental operations. The atomic consciousness units, or "mind-moments," into which Abhidharma analyzes the

apparent continuum of subjectivity are described as enduring individually for only a billionth of an eye-blink or lightning flash. If an eye-blink occupies about a quarter to a third of a second, we may translate this to three or four billion mental events per second. This apparent hyperbole is found again in the literature on computers. "Supercomputers" at present perform from 20 million to 400 million operations a second; Japanese-planned general purpose computers will soon perform ten billion operations in a second; American-planned computers designed for specific purposes will soon accomplish up to 100 billion mental operations per second. The Buddhist view of the self, in other words, while it is amazingly unlike our inherited Christian view, is similar to a description of a computer.

When our culture faces robotization, it faces a satanic and terrifying reduction of its selfhood. When Japanese culture faces robotization, it sees nothing that it has not been familiar with, and at home with, for centuries. In Japan, for example, a Buddhist Abhidharmic text called the "Heart Sutra" is generally ambient in the culture, as are texts like the "Our Father" prayer in ours. While the "Our Father" is a direct personal appeal for the safety of a self which will not escape from the consequences of its personal choices throughout eternity, the "Heart Sutra" expresses the not-self doctrine relentlessly and calmly. "Here in this emptiness," it says, "there is no form, no feeling, no perception, no impulse, no consciousness; no eye, no ear, no nose, no tongue, no touch, no mind; no form, sound, smell, taste, touch-object, concept; no sight sense, hearing sense, taste, smell, touch or mind sense."[9] And so on. It is no surprise that a culture imbued with such doctrines does not feel its humanity threatened by robotization; Judeo-Christian faith in the soul, on the other hand, provides a solid barrier of resistance and paranoia toward artificial intelligence. In terms of Western history this unrest is simply a continuation of the faith-reason controversy that has been a keynote of Christian culture since the Middle Ages. The same soul concept that opposed Darwinism opposes artificial intelligence, and for the same reason. Darwinism suggests that humanness is not an ontological but an existential concept, not an unchanging essence but a discovery which is constantly being discovered; it is there precisely to be reshaped. For Darwinism the soul has evolved out of the stream of

nature and hence is subject to being washed away and dissolved in that stream again; on the cybernetic analogy, the self was constructed, through an act of interpretation, by a finite intelligence which itself is subject to the quasi-mechanistic stream of natural events. Either view is intolerable to the fundamental soulist doctrine which underlies much of our culture.

But the situation is not a simple and clear East-West dichotomy. As certain areas of Eastern thought have paralleled the Western naturalistic view, certain areas of Western tradition have paralleled the not-self doctrine. Language analysis, for example, has been perceived very similarly in the two settings. Ramakrishna, the famous nineteenth century Vedantin practitioner, eliminated the words "I" and "mine" from his vocabulary, referring to himself only as "this." Ramana Maharshi, another Vedantin, felt that "the conceit 'I am' " could be dispelled by keeping the question *"what* am I?" constantly before the mind. Ludwig Wittgenstein, not so unlike Ramakrishna saying "this" instead of "I," noted that one should not say "I think" but "There is a thought."[10] Gilbert Ryle was not so distant, either, when he referred to "the 'systematic elusiveness' of the concept of 'I.' "[11] "What we have to acknowledge," said P.F. Strawson, ". . . is the *primitiveness* of the concept of a person."[12] Roland Barthes has argued that the modern liberal idea of "the prestige of the individual, of, as it is more nobly put, the 'human person,' " is a by-product of the distortions of a particular cultural moment; an empirical-rational disguise of the Christian soul, arising by way of the Reformation emphasis on personal faith.[13] To some extent, both the unreconstructed doctrine of soul and the liberal-secular version of it are losing their grip on Western culture.

In the West, certain intellectual currents of the twentieth century have functioned in part as critiques of the self. Freudian analysis reduces the self to a conglomerate of impersonal warring forces: the ego, or conscious subject, is merely an emissary of a vast impersonal sea of genetic and infantile contents. Marxism reduces the self to an impersonal by-product of class forces: one's social position determines one's thoughts and feelings. Physics has blurred selfhood into relativity curves, quantum leaps, and observers who cannot observe because they are really participants, caught up in the same shifting river that they are attempting to observe.

Modern biology also shifts the concept of selfhood from the category of substance to that of process. If a neuron alters in the brain every time we experience anything, then the self is a constantly changing thing like John Locke's sock (which acquired one patch after another till no fiber of it was the same: Did it become another sock? When?). Structuralism and semiology have brought about an apotheosis of language into a kind of transpersonal mind that renders the individual self trivial. Barthes, for example, insisted on "the necessity to substitute language itself for the person.... It is language which speaks, not the author...." Language, as the ultimate speaker, both transcends and voids the self: "*I* is nothing other than the instance saying *I*: language knows a (grammatical) 'subject,' not a 'person' ..."[14]

The traditional Western idea of the self as an unchanging essence is threatened in the face of all these critiques. Roman Catholicism made peace with evolution by declaring that God put souls into a certain male and female ape at a certain moment in early hominid development, these being, then, Adam and Eve. The soul, in other words, is removed from the process of evolution; it did not evolve along with the body but entered the species fully prefabricated and not subject to modification in the future. Evolution is declared simply irrelevant to the destiny of the soul. Thus modern religion defends itself from science not, as once, by denying science, but, more cunningly, by declaring it irrelevant.

As the idea of the integral individual self has been reduced to some conditioned response or other (from DNA to bourgeois individualism), the related idea of personal godhead has been replaced by a variety of transpersonal selves, universal minds, or mastercodes. Language, the collective unconscious, the Oedipus complex, the historical dialectic, natural selection, the double helix, all have acquired something of the metaphysical status of impersonal godhead. In these emerging post-theistic and post-self religions the individual person recedes as his or her free will is increasingly co-opted by the code. For a self which transpires through a melting and merging of intricate transpersonal patternings, the idea of freedom becomes ambiguous or even ironic. It comes to seem, as B.F. Skinner proposed, that freedom is what we call the way we feel when we do what we have been conditioned to do.[15] The idea of a special quest for

freedom, for a point of view that would transcend all codes, gets tangled in an infinite regress of programs, as in the parable quoted at the beginning of this essay. The quest for freedom from frameworks becomes simply another framework. The self remains relative, and cannot escape into the absolute. Modern scientific thought, finally, has evolved a composite view of the self as a shifting ripple in the Heraclitean river, a view that has much in common with that of Buddhist psychology.

Specific arguments against the analogy between artificial and human intelligence follow a characteristic pattern: one part of human experience is isolated as outside conditioned causality; it is then declared to be inherently free or irrational or innocent, and hence not replicable by mechanical analogues. This part, whichever it may be, is shifted to the center of the human self as a residual soul or trace of soul. Intuition, introspection, memory, aesthetic sensibility, and emotionality have all served as the centers of such arguments. Some, for example, deny intuition and original thought to computers, since they think only by proxy. The argument is blurred by at least one case of original mathematical discovery by a computer, and by ignorance of the workings of human intuition to begin with. Others have fastened on affect (or emotionality) as the essentially human trait, and have asserted: "No mechanism could feel pleasure at its successes, grief when its valves fuse," and so on.[16] This formulation begs the question by assuming that there is something nonmechanical to the emotive processes—an assumption that remains unproved. The metaphysical nature of the claim seems apparent in light of neurotransmitter research. There is no obvious reason why emotional processes should not parallel and be paralleled by mechanical models; on the chemical level, it seems that a parallel modeling is already partly available.[17]

To yet other exponents of the unique human self it is the perception of beauty that is the specifically and inalienably human trait. But the relativism of canons of beauty suggest that they too are conditioned by the ambient causal net. Erich Neumann, for example, has written of the extreme changes observed in the images of female beauty through human history.[18] The sense of beauty, in other words, seems to be involved in evolution as much as is the sense of self. It will not serve as a foundation for a Platonic absolutism of the

soul. Since the sense of beauty responds to external forces, there is no reason why it should not parallel mechanical processes or, for that matter, be caused by them. The belief that the apprehension of beauty is unconditioned or preternaturally free harks back to the myth of Eden; it postulates a residual level of innocent perceptiveness still active in the human mind, still apprehending things with Edenic Grace.

Nostalgia for Eden brings with it the sense that continuity with the past is essential to selfhood, that the self is only on a solid footing when rooted in the past. Memory is then seen as necessary to humanness, and as a treasure threatened by the electronic storage and recovery of information. To empiricists in general, as much as to those who are nostalgic for a golden age, memory is seen as a primary evidence or constituent of the self. For Locke, for example (who still represents the common-sense consensus of empiricist thought), "If X remembers doing such and such, then he is the person who did that thing." For Carl Jung also the sense of personal identity arises from the apparent continuity of memory. Alterations in the working of memory, then, are viewed as assaults against the self and as a loss of humanness. (The not-self point of view necessarily reads these facts in reverse: for Patanjali, the memory is not the trace of the self, but the self the trace of the memory; the self, in other words, is a habit system built up entirely by memory, and waiting to be taken apart.)[19] What is at issue is not so much a sudden shift as a long-standing process. Technology has been altering our relationship to information and its storage and recovery all along.

Julius Caesar, in the *Commentaries on the Gallic War* (VI, 14), notes that the Druids preserved the strength of their memories by refusing to commit their traditions to writing. Memory, he says, is the defense of literature. In oral traditions the inherited texts were stored directly in the human person, merging with it somewhat like the "book people" of Ray Bradbury's novel *Fahrenheit 451*. The Romans, on the other hand, like us, remembered not information itself but where information was stored. Some experience this as a loss of essential humanness, while for others it is a potential nirvana of escape from the prison of the individual self with its burden of past and future. One person's enlightenment is another's dehumanization.

Related to the defense of memory is the belief that introspection or self-awareness is an essentially human trait, one that machines cannot incorporate. Introspection means that the mind is both self-knowing and other-knowing in the same moment: it knows a sensum and simultaneously knows its own knowing of the sensum. A machine, on the other hand, is seen as limited to retrospection; it assimilates a piece of information, then in the next moment remembers assimilating it. This model is very questionable, however. Gilbert Ryle argues that people know their sentience through memory, not through simultaneous or layered awareness. (The Abhidharma agrees.) Simultaneous other- and self-awareness would lead to an infinite regress, he argues, the mind being conscious of a sensum and conscious of being conscious of it, and conscious of being conscious of that, and so on.[20]

Lacking in self-awareness, the machine is also seen as obstructive to our need for direct experience. It threatens to inculcate a kind of solipsistic circulargazing in place of human gregariousness, change, and activity—ultimately, to replace direct human touch with indirect cold-screen abstraction. E.M. Forster presents this case in "The Machine Stops," a nightmare projection of computer-dread into a complete loss of human vitality and relationship. In Forster's vision of a machine-dominated world, emotion and impulse are blurred out by a "horror of direct experience" that is the unavoidable consequence of the addiction to abstraction on the screen. "The desire to look directly at things" passes from the world. "Cover the window, please," one character says to another; "these mountains give me no ideas." Finally, "People never touched one another. The custom had become obsolete, owing to the machine." Each person sits before his or her cool, dotted screen, energy passing in a self-enclosing circle from fingertips to screen to eyes to fingertips. Under the influence of the machine, the human being seems to have become as silent and still as Ankebuta's winking homunculus.[21]

But another comparison may be more appropriate than that of the brain-damaged monster. The shift of human activity toward sedentary information processing (already, of course, promoted by TV) is, like everything else, part of a long ongoing process. In antiquity, people did not read silently to themselves, but aloud to one another. Cicero had a reader who followed him around all day with

the book in hand; at any idle moment—in the street, in the bath, at table—he would recommence the reading. Those who were not, like Cicero, professional readers and writers, read aloud to one another or to themselves. Literature did not yet seem separate from the voice, from the body, from the living breath (spirit); it did not yet seem a silent world of abstraction into which one might wander away from the world of sense and relationship. The first person on record as having read silently to himself is Augustine of Hippo's teacher Saint Ambrose. Here is Augustine's description of it: "When he read, his eyes, scanned the page and his heart explored the meaning, but his voice was silent and his tongue was still. . . . Often, when we came to see him, we found him reading like this in silence. . . . We would sit there quietly, for no one have the heart to disturb him when he was so engrossed. . . . After a time we went away. . . ."[22] So Ambrose sat silent with his book, lacking apparent speech or locomotion, like Ankebuta's pitiful monster (was *his* heart also "exploring the meaning"?), as isolated from other people as George Segal's computer victim on the cover of *Time* magazine's "Machine of the Year" issue. The practice of reading silently to oneself spread as a part of Christian devotional practice, involving monkish silence and the attention of the heart. Now we all do it. (Has it made us less human?)

Forster's anxiety was that the machine would remove us from a commitment to direct experience, addicting us to abstractions. The replacement of direct experience by abstract signs is again a long historical process that cannot be apocalyptically concentrated into a single moment like that of computerization. In ancient societies, before weights and measures were standardized, time and space were regarded in terms of direct experience. Chinese texts use "as long as it takes to eat a bowl of rice" as a time unit; Vedic texts use "as long as it takes to milk a cow." Buddhaghosa measures distances in units like "the range of a stone thrown by a man of medium stature," and "the distance that a woman throws a bowl of water from her back door."[23] Meters and miles are dead abstractions in comparison with these. But has their use made us less human, or more? Isn't the question meaningless once humanness is seen not as an essence but as a process?

In addition to his nostalgia for a natural state, Forster expresses another powerful and widespread type of computer-dread: the fear

that "The Machine," with its potential for detailed monitoring of people, could become a tool for authoritarianism, that it might, indeed, stimulate authoritarian regimes to arise. In "The Machine Stops," as in humanistic science fiction in general, the machine, through its home terminals, becomes an extension into the private realm of the attitudes and values of centralized authority. This objection is weighty and significant; but again it is worth pointing out that an historical process is involved, rather than a single monstrous cataclysm. Virtually all technological advances in history that could be used to the advantage of power and authority have been so used. When iron smelting was first developed, its Indo-European inventors did not even pause to consider making improved ploughshares, but straightaway forged the iron sword and launched a campaign of conquest. The radio, the internal combustion engine, the airplane, the television tube, all have been applied to the extension and consolidation of power structures. The present confrontation with new technologies is not radically different from these past ones. The same vigilance is called for to be conscious of their applications.

It may certainly be argued that a belief in the integrity of the self and its potential for freedom is necessary for the defense of basic freedoms from authoritarian inroads. It is, after all, the individual who is moved to his or her own protection. But a soulist belief is in no way an advantage for the maintenance of freedom. The Buddha, while teaching not-self, instituted a society far freer and more open than that of the great states of his day; and it is precisely the authoritarian claims of the soul that have rendered Christianity and Islam among the most violent and repressive traditions in history. The belief in auratic selfhood is often the root of tyranny.

The various theological myths—of the soul, of innocence, of Eden, of a sense of loss through history—that fuel the anxiety about the survival of human Selfhood also lie, in inverted form, behind the opposite point of view, which looks forward to a sort of freedom or salvation to be attained through the age of space. From this point of view, the artificial mind seems an instantiation of the not-self preached by the "Heart Sutra." The computer's flatness of affect is seen as preferable to irrational human passions. In the art realm, Andy Warhol embodied the mythological aspect of this point of view when he said, "I want to be a machine." The half-million-dollar

Andy Warhol robot under construction in Valencia, California, is the symbol of this mechanistic messianism. Warhol's interesting ethical reflections in *The Philosophy of Andy Warhol (From A to B and Back Again)*[24] show an aversion to affect that parallels that of some Abhidharmic texts. In Buddhism it is the "tendency to react by emotions" that is the source of unnecessary bondages.[25] Warhol bases his preference precisely on the assumption that machines are not tossed about by fluctuating affect as humans are. Again he shows a trend in our society toward something like the not-self doctrine of primitive Buddhism.

According to the Abhidharma, "disturbances by emotionality will be removed by changes in interpretation"[26]; the goal is to rearrange one's relation to language so that the metaphor of selfhood is not constantly presupposed in one's thought processes. Effects that the computer might be expected to exert on the language-emotion linkage are relevant here. Jean-Paul Sartre, in reviewing Albert Camus's *L'Etranger*, originated the term "white writing" (*l'ecriture blanche*) for a style that is relatively de-anthropomorphized and stripped of metaphor. Barthes recommended the elimination of verbal gestures that aim at modifying nature (that is, interpretive gestures) on the grounds that they express "the approach of a demiurge."

As the goal of this purification of discourse Barthes looked toward a "neutral writing . . . a mode of writing which might at last achieve innocence" from ethical presuppositions, a writing that would realize that "expressiveness is a myth." Through a "transparent form of speech", "the social or mythical characters of a language are abolished in favor of a neutral and inert state of form."[27] Something like a neutralized speech is found in the extremely dispassionate and anti-metaphorical discourse of the Abhidharma texts themselves. Computer jargon also tends to bleach metaphorical color out of language; it has been described to me by an enthusiast as a "clean language," freed from anthropomorphism, as human feelings, for example, are reduced to the neutral status of "information." In the terminology of information processing—data, input and output, storage and retrieval, and so on—only the most basic and neutral metaphors remain, such as the spatial picturing involved in the term "data base." Like Ramakrishna saying "this" instead of "I," Alfred

Korzybski argued for improving sanity by eliminating the verb "be" from our speech.[28] Computer talk, with its distancing of claims and metaphors, may itself go some distance toward bleaching soulism from speech.

In fact, the computer screen may have a tendency to bleach metaphor and affect from information. Books are different plastic objects; when rare or prized they are auratic, with all the implications for selfhood and objecthood involved in aura and fetishism. But on a readout or printout every text looks the same. The cathode screen, with its low resolution, small image, and impersonal format is a cold medium compared to the electric typewriter.[29] As the word-processor spreads among writers, it is not unreasonable to expect something like the "enormous changes which," as Walter Benjamin said, "printing . . . has brought about in literature. . . ."[30] Again what is in question with nostalgia for the book as a unique object is not a single event but an historical process. The hand-copied parchment book was far more unique and auratic than the printed book. Such nostalgia leads ever further back into history because fascination with the unique object is another disguised Edenism. Robert Graves has said that he writes poetry only in a room where every furnishing is handmade. The gesture expresses a belief in a primally innocent level of human character, as does Forster's dread that the machine will separate man from nature. In this respect the concept of self functions in art much as it does in religion, rather than as it does in science and philosophy.

Questions of the originality and authenticity of the auratic artwork depend on the belief in the integrity and creative freedom of the self that produced it as a trace of soul. The abstract expressionist phenomenon was especially dependent on this Romantic (ultimately Platonic) view of self. But the art that followed it, epitomized symbolically in this respect by Warhol, seemed to accede to Benjamin's prophecies about the age of mechanical reproduction. Indeed, the division into crafts-arts and technician-mediated arts may to some extent reflect the divided or shifting attitude toward the self.

The Warhol robot again seems to symbolize the denial of the Romantic belief that art and science are opposed forces or sensibilities. (Of course, Warhol's works are themselves auratic in a pale, vampirical way.) The acceptance of a scientific relationship to aes-

thetics expresses an acceptance of the idea that aesthetics is not a fixed absolute but a dependent in the causal net. This view, in turn, may be seen as despairingly tragic by those committed to the belief that aesthetic canons are objective and unchanging in their essentials.

Henri Poincaré wrote that in mathematics "the useful combinations are precisely the most beautiful." Werner Heisenberg talked of science proceeding by "aesthetic criteria of truth."[31] But clearly Graves and Forster, in their nostalgia for the culture of the hand-made object, will not be enticed by demonstrations of, say, the aesthetics of molecular structures in plastics. Graves and Forster (and many others) in effect adopt the myth of the Golden Age and locate humanity's "true" self in the past; Poincaré and Heisenberg imply instead the myth of the millennium, and locate the "true" self in the future. Surely the computer does diminish the past before the future: the Loeb Classical Library, a repository of more or less all the literature that survives from ancient Greece and Rome, could be entirely stored in a compact disc held between one's fingertips.

The myth of the millennium, which colors much of the positive feeling about computers and robots and a labor-free society, is bound up with the mythology of space and of salvation arriving from space. As our culture approaches the second Christian millennium, the myth of the promised return of the messiah from the sky becomes translatable into increasingly popular forms. A full-page newspaper advertisement that appeared around Christmas of 1982 across the country shows E.T.'s long, froglike finger reaching from outer space to touch a human hand, with a glint of light at the contact point. The take-off of the Sistine ceiling says simply that E.T. is God: from extra-terrestrial beings will our salvation arrive. Part of the great appeal of the movie *E.T.* is its hidden rearticulation of the ancient mythic structure of salvation from the sky. This myth first clearly appears in the Egyptian afterlife texts in which the soul of the deceased pharaoh was believed to ascend, after death, to the zone of the circumpolar stars, there to reside as a perfected being forever. It appeared again among the Orphics and, through them, in Plato; it is part of Plato's "Egyptianism" (as Nietzsche called it) which passed into Christian theology. In the Orphic-Platonic form of the myth, a being from the sky descends to earth, reveals the destiny of the human soul as residing not on the earth but in the sky, then returns

to the sky, showing the way to others who will strive to follow. Jesus is a representative of this mythic type, as is E.T., who is in fact patterned on Jesus as much as on Peter Pan. He is a youngster of his own species because he echoes Jesus, the Son, not the Father. Like Jesus inviting little children to come to him, E.T. communicates his message primarily to children. "E.T. phone home" is the vade mecum, the call to return to primal perfection in the sky.

This mythologizing is of course another form of disguised soulism, welcoming the shining-faced messiah with the keyboard as another brand of soulists reject it. The implication that this world, the Earth, is inadequate and imprisoning is again in the mood of Plato— and specifically in that mood for which Karl Popper called him an enemy of the open society.[32] Both the dread of technology and the expectation of salvation from it are irrational projections based on mythic structures. They are the stuff of theological disputes.

The degree of hidden metaphysics that still saturates the discussion of the self suggests the degree of anxiety it produces. This anxiety would seem implicated not only in dread of mortality and wishful projection of the self into an afterlife, but also in a concern for social order and the maintenance of class structure. The decentered self is out of harmony with a society still based on central authority. In the art realm, as elsewhere in culture, these tendencies toward centering and decentering are at the heart of the tension between Modernist and post-Modernist modes. The former's emphasis on the purity and wholeness of the image is dissolved into the latter's chaotic overlays of discordant codes—as the self of the future stirs to be born.

PENELOPE'S NIGHT WORK: NEGATIVE THINKING IN GREEK PHILOSOPHY

*I*n this paper I will delineate an aspect of Greek philosophy that has been ignored and in a sense even repressed in our culture. The repression of this tradition began with Plato and is still dominant in Guthrie's *History of Greek Philosophy*, the standard authority in English today.[1] There Plato and Aristotle appear as the permanent sponsors of western civilization; Gorgias and Diogenes as peripheral eccentrics vainly flailing against the authority of reason. Plato himself mythologized the situation as a battle between gods and giants (*Soph.* 246). By "gods" he meant Parmenides, Pythagoras, and their descendants (including, of course, himself), who laid the foundations of metaphysical absolutism in western thought. By "giants" he meant the Democritean-Sophistic line, which foreshadowed modern linguistic philosophy, phenomenology, and deconstruction. In Greek mythology, of course, the giants attempted to destroy the distinction between heaven and earth—that is, in Plato's terms, between the noumenal and the phenomenal realms. The giants went down to ignominious defeat before the gods, as the Greek anti-metaphysicians were routed by the idealist tradition of Plato.

The repression of the works of Greek skeptical and critical thinkers—who, as one modern author noted, "have been fallaciously criticized or simply ignored more than any other major group of thinkers in the history of western thought"[2]—has led to skewed perceptions of the general shape of that history. Nietzsche, for example, denounced the Greek philosophers for equating truth with logic and failing to consider that their logic might be merely another rhetoric,

that is, another mode of persuasion. In fact, this criticism only applies to Plato's "gods." Similarly, Derrida's reading of Nietzsche himself as "the first knowingly to unwrite or deconstruct the history of metaphysics"[3] ignores the fact that the history of metaphysics was being unwritten as it was being written, by Gorgias, Antisthenes, Diogenes, Sextus Empiricus, and many others. These thinkers, rather like the Derridean deconstructors today, sought out and brought to light the *aporiai* or impasses of thought; they focused on the blind spots and repressed contradictions of texts, and, by rhetorical subversion of logic, treated it as just another rhetoric. A certain amount of what critical and phenomenological thinkers have accomplished in this century had already been accomplished in this neglected, and even hidden, branch of our own tradition.

I will present this dichotomy between gods and giants as the interplay between two modes of negative thinking which coexisted antagonistically in the Greek tradition for about seven hundred years, appropriating each other's devices for opposite ends. By negative thinking I mean: (1) thought that emphasizes the *reductio ad absurdum* rather than the constructive logic of the syllogism and which can posit only by disproving the counterthesis of the thesis to be posited; (2) thought that rejects the power of thought or emphasizes its limits by criticism, disproof, paradox, and Uroborism; (3) thought that holds certain negative propositions to be ultimate carriers of truth or as close to such as can be attained.

The essence of the disagreement between gods and giants is the status of truth claims that are ostensibly based on reason and, with an appeal to its authority, effect a radical conceptual closure on human experience. This appeal to an alleged reason as an authority transcending the free play of experience occurred with the first systematization of negative thinking, in the early Eleatic school. There, arguments against the legitimacy of experiences of change and motion were presented as negative proofs of the ultimacy of an unchanging absolute being.

The Ur-argument of this type, rugged as an early *kouros* in its primeval confrontation with the world, was provided by Parmenides. It is impossible, he claimed, for anything to come into being, because it must either come from something, in which case it already existed, or from nothing, which is impossible, since nothing does not exist.

Similarly, nothing can pass out of existence, for it must pass either into something, in which case it still exists, or into nothing, which is impossible. "Therefore," concludes Parmenides in a staggeringly bold appeal to the authority of reason, "origination and destruction are eradicated."[4] That is, the phenomenal is "eradicated" in favor of the noumenal.

Thus the belief that reason can lead forthrightly to inescapable conclusions made the most dramatic possible entrance on the stage of history. It threw down a challenge to generations of philosophers—to save human experience from the apparent black hole of negative argument that Parmenides had caught it in.

This problem brought with it, as its formal aspect, the confrontation with a structure that appeared for the first time in Parmenides' argument and became the characteristic instrument of Greek dialectic. A proposition is dichotomized into A or not-A, and each limb is then shown to have unwelcome consequences. Since, according to the principle of the excluded middle, no third limb is available, the investigation reaches an impasse; the original proposition must be abandoned. Thus, Parmenides dichotomized the proposition that something comes into being into the alternatives (A) that something comes into being from being, and (not-A) that something comes into being from non-being, and pursued each limb of the dichotomy into contradiction. The proposition that something comes into being must finally be abandoned; its counterthesis, that being is an unchanging fullness, is tacitly established.

This style of thought exerted power in Greece for almost a thousand years; it was never fully eclipsed by the emergence of the propositional logic of the syllogism, but stood as, in effect, an alternative intellectual esthetic that tended to attract minds for whom paradox was a basic feature of awareness. As its technique was elaborated, it acquired sub-structures for the disproof of the two limbs of the dichotomy: to Parmenides' use of contradiction were added infinite regress, circularity, and denial of partial identity. Each of these strategies involves the terms of the original proposition in semantic collapse, rendering the proposition absurd.

The strategy of infinite regress, which was to be the elegant stylistic signature of Greek negative thinking, was developed by Parmenides' student Zeno, who used it as a cutting edge to further

dismantle the concepts of motion and change. "The 'Dichotomy' and 'Achilles' paradoxes reduce to an absurdity the idea of motion through continuous space; the 'Arrow' and 'Stadium' reduce motion through discontinuous space."[5] The overall shape of Zeno's system of arguments, then, is that space-time must be either (A) continuous or (not-A) discontinuous—and in either case change or motion is proved impossible. By excluded middle, there is no third possibility.

Parmenides and Zeno, of course, were among Plato's "gods." They used disproof not to forestall conceptual closure but to enforce it by proving the counterthesis. By disproving plurality and motion they posited static unity as a hyper-experiential real which is radically different from phenomena and which drains them of ontological integrity. A truth claim based on logic has set itself against the imperative of human experience. Heaven and earth have been separated by an unbridgeable gap. This use of negative thinking in the service of metaphysical absolutism soon produced its own counterthesis, in the form of the skeptical, rather than dogmatic, negations of the "giants."

Attempts to save phenomena from the Eleatic trap were to take two forms. One culminated in the atomism of Leucippus, based on the strategy of altering the ontological model without rejecting the type of thinking which had produced it. The other, more subversive and indirect, led to the lucid deconstructions of Gorgias, Antisthenes and others, designed to break apart the trap from within (not unlike what Derrida calls "boring from within") or to indicate, by mischievous parody, its rhetorical emptiness.

Around 445 B.C., perhaps twenty years after the writing of Parmenides' book, a *tour de force* masterpiece of dialectical deconstruction appeared in the poem *On Nature or On Non-Being* by Gorgias of Leontini.[6] Gorgias goal was to use the very elements of Eleatic discourses to reduce the Eleatic conclusions to absurdity. This goal is codified into the very title of his work. Parmenides and his more orthodox follower, Melissus of Samos, seem to have entitled their books *On Nature or On Being*; Gorgias' title, *On Nature or On Non-Being*, announces his intention of using their own stylistics to controvert their position. Specifically, he devotes himself to demonstrating the conclusion, denounced by "Father Parmenides" (as Plato was to call him), that what is is not (*oude to on estin*)—that is, to undermining the logical credibility of the Parmenidean concept of absolute being.

Despite the scant attention it has received in our time, Gorgias' book is of the first importance in the history of thought. It is the earliest extant example of a *total* dialectic—one which relentlessly reduces to absurdity the central questions of ontology, epistemology and semantics without implying the establishment of a positive counterthesis. The work is a rigorously patterned and multi-directional structure of dichotomy-and-dilemma units generating one another until they are terminated by the incursion of infinite regress, contradiction, or circularity.

Gorgias presents three propositions: first the ontological proposition, that nothing exists; second, the epistemological proposition, that if in fact something does exist it can never be known; and finally the semantic proposition, that if in fact something both exists and can be known, the knowledge of it can never be communicated to anyone else. The ontological confrontation is first, as if in emulation of Father Parmenides, dichotomized into being and non-being (A and not-A). But whereas Parmenides had reduced non-being to absurdity in order to establish the exclusive and total authenticity of being, Gorgias, on the contrary, reduces both limbs of the dichotomy. If anything exists, he argues, it must be either being or non-being. It cannot be non-being, for then it would both be and not be, which is absurd by contradiction. But it cannot be being either, for if it is being it must be either created or uncreated; but it cannot be uncreated, for then it would not have a beginning, and if it has no beginning, it is infinite; if it is infinite, then it is nowhere, for it must be either in something, in which case it is not infinite but bounded, or in itself, which is absurd because the container and the contained are not the same thing; therefore it must be nowhere, and what is nowhere in the universe does not exist. If being exists, then, it cannot be uncreated and hence must be created; but it cannot be created either, for if it is created it must be created from something, that is, either from non-being (which is impossible, as Parmenides had shown) or from being; but being cannot come from itself, for then it would be different from itself and would no longer be. Therefore being, which, if it exists, must be either created or uncreated, cannot in fact be either, and therefore can't exist. Finally nothing can either exist or not-exist, and by excluded middle there is no other available formulation. Ontological discourse has been brought to an impasse.

After this display of Zenonian dialectical patterning, Gorgias rejects knowledge by denying that it can be known whether the senses relate to the same or different worlds, and, finally, rejects communication by denying that there is a demonstrable connection between words and their alleged referents. Gorgias' perception of the three-levelled structure of the debate—ontology, epistemology, language criticism—was truly revolutionary. His criticism of language—that words are merely arbitrary sounds and have no real connection with referents—anticipates Saussure's perception of the "arbitrary" nature of the conection between signifier and signified, which has been so significant in recent critical thought. Still, in the ontological part of his discourse, Gorgias did not alter the arena of debate significantly, but maintained the Eleatic dichotomy between being and non-being at the heart of it.

The nature of this debate was changed significantly, however, through the turn toward subjectivity that is associated with Protagoras and, more ambiguously, Democritus. These thinkers altered the primary dichotomy from being/non-being to being/appearance. The debate was no longer between ontological absolutes, but between ontology on the one hand and epistemology on the other. This turn toward the subject which anticipated the Kantian-Husserlian revolution in European philosophy, was adumbrated with different emphases by Protagoras and Democritus, thinkers who are ambiguously connected in the ancient commentaries, where Protagoras is sometimes called Democritus' student and sometimes his adversary.

Protagoras, who was approximately a contemporary of Zeno, seems to have shared Gorgias' desire to establish skepticism through universal negations of the efficacy of reason. He wrote two books called *Contradictory Arguments* in which he argued both sides of classic questions negatively and left the dilemmas unresolved.[7] As a general principle, he stated that it is possible to argue both sides of any question equally well; logic, in other words, was just another mode of persuasion. This was to be a guiding principle in the Greek skeptical tradition, which was to occupy itself for centuries with producing counterarguments to the leading philosophical tenets of the day, on the assumption that equal and opposite arguments will simply cancel each other out. But Protagoras went a step farther in negative think-

ing by rendering his principle Uroboric or self-devouring: it is possible to argue both sides of every question equally well, he said, including the question whether it is possible to argue both sides of every question equally well (DK 80a20). From a logical point of view the proposition has negated itself and hence is invalid. But from the antilogical stance, with its different purpose, this is not the point. By negating itself as well as all other propositions, the statement completes itself as an image of solipsistic circularity. This type of slogan is a parody of *a priori* universal propositions; it shows them to be enwrapped in Uroboric subjectivity by lack of access to true noumenal criteria. As time passed this type of proposition became a central feature of the critical thought of the "giants," one which both Plato and Aristotle would argue against on logical grounds (*Euth.* 286bc, *Met.* 1062b2-7).

Protagoras' most significant contribution, however, was his transference of the question of reality from the noumenal to the phenomenal realm. His famous declaration of relativity ("Man [the individual consciousness] is the measure of all things, of those that are that they are, and of those that are not that they are not") [DK 80B1] overthrows the authority of the Eleatic *logos*, or "reason," and portrays Parmenides' position as merely a personal preferences. Similarly, Protagoras' maxim "everything is true" (DL 9:51) should be understood to mean, "All experience is real": access to objective noumena being cut off by solipsistic circularity, subjective phenomenality is left as the only effectual absolute, in and by its givenness to consciousness, which needs no ontological investigation. On the absolutist side, the dialectical echo of this principle is given by Xeniades of Corinth who insisted, in the cause of pure being, that "everything is false, every sense impression and opinion is false," (AL 1.53). Xeniades thus championed the Eleatic overthrow of life in the name of the beyond; Protagoras sought to reconstitute the here and now in terms that would rescue it from this overthrow. In this pair of statements the direct confrontation between the absolutist negation of phenomena and the Sophistic negation of noumena is clearly seen.

Democritus is better known today for his atomic theory than for his role as proto-skeptic and proto-phenomenalist. But it should be emphasized that Democritus accepted atomism from his teacher Leucippus virtually as a package, and that his own relationship to it is

highly ambiguous, especially in the area of theory of knowledge.[8] Leucippus was said to be a student of Zeno of Elea, and from him Democritus inherited the Eleatic *a priori* pursuit of ontological noumena. But the evidence (including fragments, testimonia, and observable lines of influence) indicates that another aspect of his work leaned in the direction of the emerging phenomenalistic skepticism. Both aspects of his thought were influential: his noumenal atomism passed into the Epicurean line, his phenomenalistic skepticism into the pyrrhonist. Their connection lies in the idea of convention (*nomos*) if nature is only atoms and void, Democritus argued, then the qualities of the "things" of experience exist only by convention. These conventions, then, by reason of their givenness and exclusive availability, constitute another reality system in themselves. Eleatic absolutism, in other words, had pushed phenomena so far from objectivity that, cut adrift from ontological bearings, they must function as a truth unto themselves. Again, the relationship to the Kantian-Husserlian strategy of attending to the reality of the life-world is obvious.

The concept *nomos*, or convention, relates Democritus closely to the Sophistic movement, with its language criticism, its relativistic skepticism, and its phenomenalistic turn toward the subject. Democritus saw the "conventional" models of reality by which we live as projections onto a field which is in itself free from their structures. "We know nothing really about anything," he said, "but each man's subjectivity is a reshaping."[9] Like many modern thinkers, he saw this reshaping process as operating to a large extent through language. Linguistic categories, that is, correspond to "things" only by convention. There is no language-reality isomorphism, but a life-world of experiences which are shaped by language as much as they are reflected by it.[10] In this situation the search for truth is denounced as impossible of attainment.[11] Immediate experience remains as the effectual ultimate: ("The phenomenon is truth" [DK 68A10].) It was this position, along with the materialistic determinism of his physics, that rendered Democritus an abomination to Plato, the champion of essences.

The relationship between Protagoras and Democritus is encapsulated in a famous exchange. When Protagoras said that all appearances are true, Democritus replied that if it should appear to

someone that no appearances are true, then that, being an appear-
ance, would be true and would contradict the original proposition.[12]
Democritus is often interpreted as opposing the phenomenalism of
Protagoras here and implicitly championing (Eleatic) logic. But as
we have seen, the Uroboric form of these propositions is precisely
their point. They demonstrate, by their actual dynamic workings;
the fact that logic also is enclosed within phenomenology and lacks
privileged access to a beyond. Democritus, then, may be understood
as completing the Uroborism of Protagoras' statement through a
kind of collaboration. This interpretation is strongly supported by
the fact that propositions of this type continue to be prominent in
the Democritean-skeptical line; they are expressions of a sensibility
that does not whole-heartedly accept the law of contradiction.
Democritus' student Metrodorus of Chios, for example, "used to
declare that he knew nothing, not even whether he knew nothing"
(DL 10.58).

One branch of the Democritean-Sophistic movement culmi-
nated in the ambiguous figure of Socrates, who, foreshadowing mod-
ern linguistic philosophy, specialized in aporetic or unresolved
discussions in which knowledge claims and reality models are criti-
cized by close attention to language usages. It was among his students
that the stream of negative thinking was primarily carried into the
Greece of the fourth century and after.

Dialectic was, of course, one of Plato's principle concerns, and
he found different meanings in it in different stages of his career. The
early dialogues employ negative thinking primarily to explore the
problem of knowledge and map its relation to language in more
detail. In these, dialogues the teaching figure of Socrates attacks the
blind spots of an interlocutor's discourse to undermine the very con-
clusions they are meant to safeguard, and never offers a positive
teaching of his own. In the late dialogues such as the *Sophist*, Plato
seems to attempt to formulate the elements of a constructive propo-
sitional logic; the first crude steps toward syllogism are taken here.
But in the middle dialogues he seems to employ dialectic and nega-
tivity for the Eleatic and Pythagorean purpose of attaining insights
into hypersensual reals and beyond them, an undifferentiated ulti-
mate absolute. "The dialectic," he says, "proceeds by its method of
destroying the hypotheses, back to the very beginning."[13]

It is in connection with this statement that the most problematic of Plato's uses of the dialectic may best be seen—I mean the virtuoso dialectical display of the *Parmenides*, a dialogue which may belong either to the middle or to the late period. In the *Parmenides* Plato offers, in a distinctly Eleatic style, a more massive demonstration of dialectical play than that of Gorgias, employing the dichotomy-and-dilemma pattern to turn the contraries being/non-being, one/not-one, same/not-same relentlessly against one another. The argument, too long to summarize here, is put into the mouth of Parmenides, suggesting, despite the apparent totality of this dialectic, an absolutist purpose behind it. Finally ontology and phenomenalism are melted together in the aporetic final sentences. "Whether the One is or is not, it and the others, in relation both to themselves and to each other, both are and are not, and both appears and do not appear, everything in every possible way." This dialogue was received by Plotinus, and also by modern interpreters such as J. N. Findlay,[14] as a demonstration of semantic collapse at the event-horizon of infinity; understood in this way, it links Zeno's perception of the negativity of the infinite with the negative theology of Plotinus, Guthrie and others, however, unwilling to see Plato the rationalist dive so headlong into the abyss of paradox, have regarded the *Parmenides* (as they have Gorgias' book) as a kind of elaborate quasi-musical game in which ontological concepts appear, give place, and reappear like decontextualized leitmotifs.[15]

Plato's position in the battle of gods and giants is of course clear. He was deeply hostile toward the Democritean-Sophistic line of thought with its skepticism and humanistic phenomenalism. Democritus himself, despite his enormous importance in the Presocratic tradition which Plato is usually at such pains to sum up and incorporate, is never mentioned in the dialogues. He was, in effect, the shadow force whose name Plato, in a mood like that of ritual *euphemia*, would not even mention, but who lurks behind the materialist side of the "battle" passage. Parmenides, on the other hand, is Plato's "Father".

From Plato's time until the second century A.D. the two streams of negative thinking were in full flow: the absolutist tradition which extends from Plato to Plotinus, and the phenomenalistic-skeptical line which extends from Antisthenes to Sextus Empiricus: It was in the Platonist tradition that the mystical/metaphysical vocabulary of

western thought was sketched out in the form of a series of variations on Parmenides' concepts of absolute being as featureless unity and absolute consciousness as its epistemological correlate. This project, brushing so close to the ocean of infinity and the desert of the absolute, necessarily made much use of negative formulations. Speusippus, Plato's successor as head of the Academy, spoke of a One which is prior to Mind and which he called "non-existent"—echoing in a more negative formulation Plato's statement in the *Republic* (509a–511d) that the Idea of the Good is "beyond being."

At a later stage, the Neo-Pythagorean Eudoros expanded this into a two-aspected One, a "higher" aspect prior to all dualities and hence susceptible only of negative formulation, and a lower generative aspect that can be discussed with positive predications. Moderatus expanded this schema into the three-levelled form which passed (by way of the Middle Platonists Numenius and Albinus) into Plotinus' thought, and described the "highest" aspect with the wholly negative phrase, "It is neither this nor that," i.e., language cannot reach it, since language operates by distinctions or differences.

Plotinus, in describing this highest and wholly transcendent ontological level inherited from Parmenides, expanded the vocabulary of negative formulation enthusiastically, attempting to find in it a way to surround and ambush a concept that is inherently ineffable. The One, says Plotinus, is called the One only negatively—that is, only to indicate that it is not-many; in fact, even oneness as a positive quality cannot be ascribed to it since it is beyond all differentiation or duality such as that between unity and not-unity. The goal of his discourse being absolutely Other, Plotinus advanced toward it by negations and strippings away. "Nothing," he wrote, "can be affirmed of the One which is suitable to it." "It is, even for itself, nothing." "The One is neither thing nor quality nor intellect nor soul; not in motion, not at rest, not in place, not in time." "The One is other than all things." In various passages it is called beyond being, beyond language, beyond change, beyond affection, beyond partition, beyond form, beyond limit, beyond evaluation, and so on. Once, in fact, Plotinus called the One "the not-this" and Inge has suggested that he used the word "one" only because the Greeks did not yet have a word for zero.[16] This practice of speaking about the absolute through a kind of non-speaking or negative predication is, of course, the

famous negative theology which was to become a central expressive tool of European mystical utterance.

But negative formulations occur in other areas of Plotinus' thought also. Like Plato, he calls matter "non-being" and denies that it possesses any qualities (*Enn.* 2.5.5). Thus, through a certain poverty of language to describe negative realities, matter sounds remarkably like the unqualified non-dual absolute. Plotinus of course meant no such thing. These two negatively described regions are at ontologically opposite ends of the universe: the non-being of matter lies in the fact that it is "below" being, that of the One, in the fact that it is "above" being; the non-being of matter, in other words, derives from the total absence of the One, that of the One, from its own total presence. The negative theology, in order to sort this out, would have had to speak not only in negations, but in negations of negations; Plotinus did not go that far.

After Plotinus, the absolutist (or Parmenidean) mode of negative thinking passed into the emerging Christian tradition, where it had such effect on the Scholastics, Eckhardt, and others down to and including Heidegger. The phenomenalistic tradition, on the other hand, has been much less well known and much less appreciated in later European culture, though it has, in the twentieth century, left marks on such major cultural figures as Ludwig Wittgenstein, Edmund Husserl, Jacques Derrida, and Marcel Duchamp. To survey it, we will return our attention to the age of the Socratic schools.

In addition to Plato, three other students of Socrates founded philosophical lineages: Eucleides, founder of the Megarian school, Antisthenes, founder of the Cynic line, and Aristippus, founder of the Cyrenaic. Aristippus taught an extreme form of hedonic phenomenalism. Following Democritus, he asserted that things are assigned qualities merely by convention and are in themselves unknowable, that only of mental states (*pathe*) can we be certain, and that no concept can meaningfully be attached to bare phenomena, which simply mean themselves and offer no basis for metaphysical model-building. "The affection which takes place in us," he said, "reveals to us nothing more than itself."[17] Resonances of Democritus' "The Phenomenon is Truth" cling round the statement.

A more Eleatic form of negative dialectic was featured by the Megarian school, which for this reason was known as Eristic and Neo-

Eleatic. Eucleides (anticipating Nietzsche's criticism of Socrates) argued against the analogical proofs of his teacher, employing for this purpose the denial of partial identity, or sameness/difference dichotomy (which had already surfaced in the Platonic dialogue called *Euthydemus*): either the things compared are the same, in which case the comparison is unnecessary and tautological, or they are different, in which case the comparison is invalid and misleading (DL 2.107). No third possibility, that is, no partial identity, is recognized.

This line of thought was extended by Antisthenes, who was first the student of Gorgias, by whom, as we have seen, the Eleatic absolutism had been reduced to absurdity, and then of Socrates, whose gadfly approach to the reality-systems of others he especially adopted. His great contribution to negative thinking was a total denial of predication, based, as was Eucleides' rejection of analogy, on the denial of partial identity: in regard to any statement that A is B, if A really *is* B, then the sentence is a mere tautology; if not, then the sentence is meaningless. Like some modern skeptics, in other words, he regarded only tautologies as demonstrably true statements. It is important to stress that Antisthenes was criticizing language itself on the ground (familiar from Saussure, Sapir, Whorf and other modern thinkers) that it imposes a sort of patterned veil between the subject and its experience. His belief that the mind distorts and remakes reality through the veil of language is illustrated by his advice to the Athenians that if they ran short of horses they should simply vote that asses are horses. Against Plato he made the nominalist complaint that the "forms" are only linguistic categories metaphysically reified. His ethic of direct attention to present experience undistorted by the shaping of language is expressed in the story that when he heard the Eleatic disproofs of motion he got up and walked away. Being asked what learning is the most necessary, he said, "stripping away and unlearning." (DL 6.8, 39, 7.)

The Cynics perpetuated Antisthenes' perception of the obscuring role of language in life in the conception of *typhos*, "smoke" or "mist", describing the blurring effect that preconceived ideas of reality have on the sharp edges of raw experience. The Cynic Monimus summed up this position in the universal negation, "All opinions are like smoke" (*to hypolephthen pan esti typhos* [DL 6.83]). Through their ethics, the Cynics exercised a profound influence on the Stoics, and,

through their epistemology, on the Pyrrhonists. It is the Pyrrhonist line which is of more importance for the present subject.

Pyrrhon of Elis studied first under a Megarian and then under the Democritean Anaxarchus. At age thirty-five or so he accompanied Alexander the Great to India,[18] and, returning to Greece some ten years later, taught for about forty years. We have only two sayings attributed directly to him, both of which are clearly in the Democritean tradition: (1) "Nothing really exists" (that is, nothing we experience is objectively noumenal) "but human life is governed by mere convention." (2) "No single thing is in itself more this than that" (DL 9.61). It is worth dwelling briefly on this second formulation, as it exemplifies the Uroboric type of statement mentioned above. The statement that nothing is more this than that is attributed to Democritus himself[19] and was used by the Democritean Nausiphanes as well as by the Pyrrhonists. Plato and Plutarch both attribute it to Protagoras also, again indicating his connection with Democritus.[20] At the other end of this lineage the slogan is still central to Sextus Empiricus. These thinkers clearly regarded such statements as useful conclusions.

Yet in the rationalist tradition, as opposed to the skeptical, the phrase became, on the contrary, a "formula of refutation."[21] "No more this than that" means also no more "no more this than that" than "more this than that." As Aristotle said, if an affirmation is no more true than its negation, then the affirmation that an affirmation is no more true than its negation is itself no more true than its negation.[22] For Aristotle, in other words, the "no more" formula cancels itself. A difference in sensibilities is apparent: for Aristotle the fact that this statement devours itself seemed a disproof of it; for Sextus and others (who were clearly aware of the principle of contradiction) it seems to perfect and complete itself by cancelling itself along with all other propositions. Basically different attitudes toward the function of philosophy are involved here. For Sextus (as for Wittgenstein) philosophy itself was Uroboric and would complete itself by destroying itself (or destroy itself by completing itself). It was, in effect, an Uroboric statement on a vast, macrocosmic scale. In the absolutist and rationalist tradition, on the other hand, such formulas are safely excluded from the phenomenal realm, where logic is to be the supreme mode of persuasion. Moderatus and Plotinus used related

phrases ("It is neither this nor that"; "It is the not-this") to describe the transcendent and absolute aspect of the One; the formula in their hands indicates nothing else than separateness from phenomenality. Pyrrhon and others, on the other hand, used the Democritean form, "not more this than that," to describe every phenomenon. The freedom from conceptual closure which the Platonic-Pythagorean tradition attributed only to the transcendent Other is, in the Democritean-Pyrrhonic tradition, the essential quality of all experience when viewed without linguistic overlays and projections.

Even the skeptical branch of Plato's own school, the Academy, featured this type of self-cancelling and hence truly universal negation. Arcesilaus, for example, taught that "nothing is comprehensible," (*OP* 1.226) and the statement was "completed" by his successor Carneades (as Democritus may once have "completed" Protagoras' thought) in the form "nothing is comprehensible, including the statement that nothing is comprehensible."[23] In addition, both these authors continued the sophistic project of constructing counterarguments against every known philosophical position. This activity was fundamental also to later Pyrrhonism, where the Democritean-Sophistic tradition culminates.

The extent of Pyrrhon's involvement in negative thinking is indicated by the brief formulaic account of his teaching left by Timon of Philus, a first generation student of Pyrrhon.[24] Three questions are asked: (1) What is the nature of things? (2) What is our position in relation to them? (3) What, under the circumstances, should we do? The answers are series of formulaic negative adjectives involving the alpha-privative prefix (= the Latin prefix *non-*). Things are "non-different" (from one another), or "without distinguishing marks" (*adiaphora*), "non-stable," or "without fixed essence" (*astathmeta*), and "nonjudgable" or "unable to be reached by concepts and value judgments" (*anepikrita*). As a result, says Timon (giving the proper skeptical balance to Protagoras' "Everything is true" and Xeniades' "Everything is false"), "Neither our perceptions nor our opinions are either true or false." Question three is also answered with three negative adjectives: we should remain "without opinions" (*adoxastoi*), "without preferences" (*aklineis*), and "without agitation" or "firmly balanced within" (*akradantoi*). Finally, Timon rejects all possible verbal formulations in a summation which, in both spirit and

form, goes back toward Democritus: "We should say of each thing that it no more is than is not, than both is and is not, than neither is nor is not."[25]

In the generations after Timon, the skeptical and eudaimonistic phenomenalism which Pyrrhon had purveyed by personal example accumulated a dialectical apparatus to support it. Little remains of this dialectic until the culmination of the tradition in the encyclopedia compendia of Sextus Empiricus, a contemporary of Plotinus who summed up the Pyrrhonist tradition in a series of anti-discourses with titles like "Against the Logicians," "Against the Mathematicians," "Against the Physicists," and so forth. These are classical works of critical thought, in which Sextus dismantled the texts of the philosophers by turning their own concepts and methods against them. At the same time, Sextus' project bears close resemblance to Wittgenstein's desire to get "the fly out of the bottle", and to Husserl's phenomenological reduction, in its essentially therapeutic purpose; the process of dialectical criticism was intended to cure the reader's or interlocutor's mind of the disease of opinions, which, functioning like a screen or template, shape parts of experience to a model which is based on the repression of others. The study of the counterarguments to one's own opinions was meant to lead to a general state of *épaché*, or suspension (an effect crucial to Husserl's project also), which in turn leads to a state of inner freedom from linguistic categories (*aphasia*), which in turn steadies into an affective balance (*arepsia*) which is naturally and effortlessly followed by a state of imperturbability (*ataraxia*).[26]

It is worth pausing over these negative ethical formulaes and their place in the Greek tradition in general. In a sense our two streams of negative thought seem ethically antithetical: the one is bound to recommend a turning away from sense experience and the other to recommend a specially intense or focused turning toward it. Yet the ethical preachments of the representatives of the two streams are very similar. Both traditions basically teach an ethics of imperturbability, advocating an attitude which regards with similar affection those events which are to one's personal worldly advantage and those which are not. In the absolutist tradition, this attitude rises from the conviction that worldly events are "unreal" and hence one should avoid emotional entrapment in them; in the phenomenalistic systems, it arises from the belief that interpretive models are unsub-

stantiable and hence the tyranny of the value judgments that are based on them should be diminished. Unlike the ethics of the western theisms, it is not acts themselves which are regarded as inherently good or evil, but the states of mind which attend actions. In this tradition ethical terms are usually negative adjectives designating some state of mind to be avoided. Like the Pyrrhonist formulae preserved by Timon, these terms are usually compounds of the alpha-privative with some adjectival or nominal root.

The term *ataraxia*, "inability to be perturbed," is attributed by Stobaeus to Democritus (DK 68A167); it descended through the Democritean lineages, becoming central to both Epicureanism and Pyrrhonism. The extant fragments of Democritus show also the related term *athambia*, "inability to be astonished, alarmed, etc." Speusippus, the successor of Plato, also featured the term *ataraxia*, and the central ethical term for the Cynics and Stoics was *apatheia*, "lack of passionate response to events that are not in one's control." The Pyrrhonist terms *aphasia*, "lack of passionate involvement in linguistic category projections," and *arepsia*, "lack of inclination (as of a balance beam)," are the final terms of this tradition; they embody the idea, encountered in a seed form in Democritus' thought at the beginning of the same tradition, that emotions or passions are set going by words attached to events rather than directly by events themselves. It was, then, with the goal of promoting *aphasia*, *arepsia*, and *ataraxia* that Sextus undertook his massive project of dialectical reduction. It is impossible to give much sense, in the brief scope of an article, of the extent and integrity of Sextus' work; a few examples of his style must stand for the whole.

Sextus approaches the critique of causality from several vantage points, each derived, it seems, from the literature of some school whose texts he is implicitly attacking. First he applies the sameness/difference dichotomy; if cause and effect are the same, then the terms are meaningless; if they are different, there can be no contact or continuity between them. This tactic goes back, by way of Antisthenes' denial of predication and Eucleides' rejection of comparison, to Gorgias' and Democritus' linguistic nominalism. Sextus begins with the dichotomy and dilemma framework, proceeds through an elaborate account of the denial of partial identity, and concludes in an elegant coda of infinite regress.

If there exists any cause of anything, either it is separate from the matter affected or it coexists with it; but neither when separate from it nor when coexisting with it can it be the cause of its being affected, as we shall establish; therefore no cause of anything exists. Now, when separated from its matter obviously it is not a cause, since the matter with respect to which it is termed a cause is not present, nor is the matter affected, since that which affects it is not present with it. But if the one is coupled with the other [then the arguments against contact apply:] . . . In order that a thing may act or be acted upon, it must touch or be touched; but, as we shall establish, nothing can either touch or be touched; therefore neither that which acts nor that which is acted upon exists. For if one thing is in contact with another and touches it, it is in contact either as a whole with the whole, or as a part with a part, or as a whole with a part or as a part with the whole . . . Now it is according to reason that a whole does not touch a whole; for if whole touches whole, there will not be contact but the union of both . . . Nor again is it possible for part to touch part. For the part is conceived as a part in respect of its relation to the whole, but in respect of its own limited extent it is a whole, and for this reason again either the whole part will touch the whole part, or a part of it a part. And if the whole touches the whole, they will be unified and both will become one body; while if with a part it touches a part, that part again, being conceived as a whole in respect of its own limited extent, will either touch as a whole, the whole part, or touch a part of it with a part—and so on ad infinitum (*APh* 1.252–261). Sextus now addresses the question whether the cause can somehow contain the effect, and, underlining the long coherence of the Greek tradition, applies an argument that goes back to Father Parmenides: if the cause contains the effect then the effect "is already in existence and being already in existence it does not become, since becoming is the process toward existence" (*APh* 1.226). A last possibility which Sextus considers is whether an effect might be self-produced by the reduplication of the cause. This he chooses to deal with through an infinite regress reduction: if the nature of the cause is to reduplicate itself, then the effect, being a duplicate of the cause, will also have this nature, will also reduplicate itself, and so on ad infinitum. Causality will be an endless stream of identical events (*APh* 1.220–221).

Now, beginning a new dichotomy-and-dilemma cycle, Sextus focuses on the element of time in the causal link:

If anything is the cause of anything, either the simultaneous is the cause of the simultaneous, or the prior of the posterior, or the posterior of the prior . . . Now the simultaneous cannot be the cause of the simultaneous owing to the coexistence of both and the fact that this one is no more capable of generating that one than is that one of this one, since both are equal in point of existence. Nor will the prior be capable of producing

that which comes into being later; for if, when the cause exists, that whereof it is a cause is not yet existent, neither is the former any longer a cause, as it has not that whereof it is the cause, nor is the latter any longer an effect, since that whereof it is the effect does not co-exist with it. For each of these is a relative thing, and relatives must necessarily co-exist with each other, instead of one preceding and the other following. It only remains for us, then, to say that the posterior is the cause of the prior; but this is a most absurd notion . . . for we shall have to say that the effect is older than what produced it and consequently is not an effect at all since it is without that whereof it is an effect.
(*APh* 1.232–235)

A third movement of the critique of causality uses the problem of relationality as the cutting edge. Here Sextus uses ammunition based originally on Heraclitus and developed by Plato in his critique of relative as opposed to absolute being. What exists only in relation to other things, Sextus says, cannot be demonstrated to be anything at all in and by itself; though we may mentally abstract the "thing" from its relationship system, we have thereby only created a mental entity, not one which can be encountered in experience. "Relatives," he concludes, "are only conceived and do not exist" (*APh* 1.208). "Relative terms are in and by themselves unknowable" (DL 9.88). Finally, applying the principles to cause and effect: "A cause is something relative, for it is relative to what can be caused, namely the effect. But things which are relative are merely objects of thought and have no substantial existence" (DL 9.97).

Finally three basic dialectical tactics emerge which can be applied to anything within the realm of discourse. The denial of partial identity leads to the reduction of predication in general. The infinite regress leads to the impossibility of any proof, because (says Sextus) "the thing adduced as proof of the matter proposed needs a further proof, and this again another, and so on ad infinitum, so that the consequence is a suspension of judgment, as we possess no starting point for our argument" (*OP* 1.166–167). Finally, since every proposition is meaningful only in relation to its negation, the denial of relatives reduces every proposition to nothing. As Sextus says, "Every proposition is annulled by an equal and opposite proposition" (*OP* 1.202).

Finally, having reduced relatives, Sextus takes care not to be interpreted as a devotee of "things in themselves". By a meta-step in

perspective he extends the argument against relatives to include the Platonic Forms also: "Do things which exist 'in themselves' differ from relative things or not? If they do not differ, then they too are relative; but if they differ, then, since everything which differs is relative to something (for it has its name from its relation to that from which it differs), things which exist 'in themselves' are relative too" (*OP* 1.137).

Sextus systematically reduces to absurdity all philosophical notions current in his day, but he must not be understood as taking a stand on his dialectic as an ultimate mode of thought, however negative. On the contrary, he was well aware that deconstruction, as Derrida writes, "always in a certain way falls prey to its own work."[27] Sextus presents his dialectic as Uroboric or self-destroying. Since it is an attack on opinions, the dialectic is itself relative to the state of having opinions; when opinions are gone, it is no longer possible for an attack on them to subsist. The dialectic, says Sextus, "is like a fire, which, after consuming the fuel, destroys itself also" (*AL* 2.480). Sextus elaborates: "And again, just as it is not impossible for the man who has ascended to a high place by a ladder to overturn the ladder with his foot after his ascent, so also it is not unlikely that the Skeptic, after he has arrived at the demonstration of his thesis by means of the argument proving the nonexistence of proof, as it were by a step-ladder, should then abolish this very argument" (*AL* 2.480–481). This image of Sextus has left a subterranean trail in the critical thread of European philosophy. We may compare Nietzsche, in *Twilight of the Idols*: "For me they were steps, I have climbed up upon them—therefore I had to pass over them." And above all Wittgenstein, at the end of the *Tractatus*: "My propositions are all elucidatory in this way: he who understands me finally recognizes them as senseless, when he has climbed out through them, on them, over them. (He must, so to speak, throw away the ladder, after he has climbed up on it). He must surmount these propositions; then he sees the world rightly."[28]

Sextus sums up this Uroboric dialectical attitude in a series of negatively formulated slogans which resonate back to the very beginnings of the Democritean tradition: "Nothing is true"; "Nothing is comprehensible"; "No more this than that"; "I define nothing," or "I assert nothing." Of these slogans Sextus says, "They themselves are included in the things to which their doubt applies" (*OP* 1.206).

Thus, "nothing is demonstrable, including the statement that nothing is demonstrable," and so forth. We recognize echoes of the Ur-statement of this kind, by Democritus' student Metrodorus, "I know nothing, not even whether I know nothing." So firmly, in fact, does Sextus refrain from regarding his own negative arguments as positions to which one might finally adhere, that he says he rejoices if his opponent in debate presents a positive proof as convincing as Sextus' negative one, for then the futility and essentially rhetorical nature of the quest for truth are made most obvious (*AL* 2.476–477).

In the foregoing pages I have sketched an aspect of Greek philosophy which it may be unwise to continue to ignore in our present philosophic situation. All the thinkers discussed here worked in some degree of awareness of what Derrida has called *différance*—the endless distancing of meaning through the infinite regresses and metaphorical circularities of language and logic. The crucial distinction is that one group (Plato's "gods") applied these perceptions of the limits of thought and expression only to cogitations about absolute being; the other (the "giants") saw free play and undecidability as elements present in all texts at all times and as conditions indigenous to human life. Sometimes, as in Sextus' pure phenomenalism, they abjured the metaphysics of presence and meaning altogether. By what seemed to Plato a kind of perversity or ill will, they sought always to address the blind spots and rifts of consciousness and thought—including their own thought. By methods varying from the guerilla theatre of Diogenes to the rigorous reductions of Sextus, they sought to open, or to reveal, cracks and gaps in the authoritarian discourse of reason—cracks and gaps through which the free play of the intellect might escape the limits of its own fabrication and return to the open air of life.

There are of course differences in emphasis between these ancient and modern critical movements. Ancient thinkers pried texts apart by the dialectical turning back of logic against itself, rather than by the characteristic Derridean tactic of unpacking the hidden metaphors of a text and reading in them the demise of the text's surface meaning. But both tactics are, to an extent, shared. Derrida has employed reductions by infinite regress (for example, of the attempt to penetrate into the realm of the signified) which are virtually Zenonian in pattern. And the ancient critique focused closely on

what Derrida has called "the problematic of the metaphor."[29] The denial of partial identity of course rejects metaphor as rigorous communication. Eucleides used this argument to deny proof by analogy, or indeed analogical discourse of any kind; Antisthenes used it, in parallel, to reject predication. The perception that language is interiorly founded on a process of metaphor is clearly implied.

A thorough comparison of the methods of these ancient and modern movements (which has not of course been attempted here) would reveal many detailed correspondences. A similar situation exists in the histories of Indian and Chinese thought, where, as in Greece, dialectical criticism was a part of the general fabric of thought, challenging the constructions of metaphysics with its perception of repressed contradictions and rhetorical tropes.

What effect does this awareness have on the widespread feeling that recent thought, especially that centered around Derrida, has at last pointed the way toward an escape from the metaphoricism of metaphysics? Could it be that both metaphysics and its deconstruction are recurring moments in a cyclicity from which no escape has yet been found?

EMPYRRHICAL THINKING (AND WHY KANT CAN'T)

*T*he critical literature portrays many different Marcel Duchamps: Arturo Schwarz's alchemic dabbler, Octavio Paz's tantric initiate, the full-scale occult master described by Jack Burnham, the publicity-seeking self-mythifier of Gianfranco Baruchello, the critical rationalist of the dialogues with Pierre Cabanne, André Breton's "most intelligent man of the twentieth century," the failed artist and tragic neurotic portrayed by Alice Goldfarb Marquis, John Canaday's "most destructive artist in history," and others.[1] Most of these models hinge on interpretations of events between mid 1911 and mid 1913, that is, around Duchamp's 25th year, for this brief period saw a sudden and thoroughgoing change in the form, material, purpose, and style of his work, a change that suggests a major shift in his attitude toward life.

As Paz says, 1912 was the "climactic year of [Duchamp's] most important oil-on-canvas works."[2] This was the year of *The King and Queen Surrounded by Swift Nudes*, *Nude Descending Staircase, No. 2*, *The Passage from the Virgin to the Bride*, and other paintings (as well as of the first drawings for *The Bride Stripped Bare by Her Bachelors, Even*, also known as the *Large Glass*, 1915–23). These paintings, though some considered them daringly innovative in their day (especially the *Nude . . .*), were safely within the estheticizing easel-painting tradition that had held sway since the Renaissance. They were recognizable stylistic extensions of formal sequence already under way in Cubism, Futurism, Orphism, and elsewhere; their oil-and-canvas substance with the most common and traditional in Western art; and their claim to attention was based on the concepts of esthetic composition, formal evolution, craft, and subjective inspiration that were fundamental to the Modernist ideology.

In the next year, however, 1913, all these qualities were erased from Duchamp's work, with the stunning suddenness of a conversion. Easel painting stopped; the traditional emphasis on the artist's hand and skill stopped. The Romantic exaltation of the creative act, and even the notion of the artist's sensibility as a guiding force, were denied. As an alternative to these, Duchamp introduced chance, first in the *Erratum Music*, then in the *Three Standard Stoppages*. This was the year of the first readymade (though not so called until 1915), *Bicycle Wheel*. Painterliness gave way to a style close to mechanical drawing in *Chocolate Grinder, No. 1*. Linguistic elements, including puns, began to supplement optical ones; irony, mockery, and lampoon came to the forefront. These new approaches annihilate from Duchamp's work the inherited codes that his paintings had been pursuing only the year before.

In attempting to understand this turn, which was to be so portentous for the art of the rest the twentieth century, many critics have scrutinized the events of Duchamp's life in 1911–13 for club Burnham, for example, focuses on the two-month trip to Munich in 1912: little is known of Duchamp's reasons for going there, and Burnham hypothesizes that he was seeking obscure alchemic texts whose perusal effected his change of direction.[3] Marquis and others argue that the course of Duchamp's life was altered by the Salon des Indépendants' rejection of *Nude Descending a Staircase, No. 2*, in the same year—an event that he described frankly as "really a turning point in my life, I can assure you."[4] The shock of this rebuke, Marquis feels, awakened him to the limits of his abilities as a painter (he couldn't draw hands, she says), and, to salvage a career doomed to be overshadowed by those of his older brothers, Jacques Villon and Raymond Duchamp-Villon, he undertook methods that both demanded less skill and were less susceptible to judgments of quality. In 1954, Jean Reboul mapped out a third approach, beginning the psychoanalytic analysis of Duchamp from his art, which he declared to be the work of a "schizophrenic"—strong language indeed to apply to someone whose life does not seem to have been characterized by psychic breakdowns. In supporting his argument, Reboul cites the works on glass, quoting an authority's opinion that "it is as if there were a pane of glass between them [the schizophrenics] and their fellow-men."[5] (But surely this is a misleadingly simple infer-

ence—wouldn't it follow, for example, that those who paint on opaque canvas or board cannot even *see* other people?) Duchamp, perhaps thinking of Reboul's article, told Cabanne in 1966, "I've never had . . . melancholy or neurasthenia."[6]

Schwarz, working in the '60s, gave the psychoanalytic approach more substance. On the basis of themes in Duchamp's paintings of 1911–12, he concluded that the artist was incestuously obsessed with his sister Suzanne, and that when she married in 1911 he underwent a trauma that, like an earthquake, rearranged his mind, his work, and his life. It was the need to repress or at least conceal these feelings that prompted him to turn away from his oil paintings toward new media both less personal and more obscure, to abandon an expressive form for a depersonalized art that would sidestep his unhappy subjectivity. Schwarz argues his case well,[7] though the evidence is cryptic at best for his theory, which seems a lot to read into Duchamp's rather oblique paintings. But his psychoanalytic interpretation acts interestingly with his alchemic one, translating Duchamp's supposed unfulfilled desire for Suzanne into the eternal quest for the alchemic union, whose tantalizing postponement is, in that lore, the force that drives the world. The bachelors' eternal inability to attain to the realm of the bride in the *Large Glass*, then, has both a personal and a cosmic significance. In the upper panel, the bride, or Suzanne, enters the bridal chamber, stripped bare for her mating; below, the bachelors masturbatorily grind their chocolate by themselves, all of them participants in the self-sustaining activity of a world awakened to life by the driving force of unconsummated desire. Similarly, Schwarz argues that *Young Man and Girl in Spring*, the painting from 1911 that was Duchamp's wedding present to his sister, both represents the idyllic childhood relationship of Marcel and Suzanne—and its ideal unattainability in adult life—and echoes alchemic diagrams of the solar and lunar (male and female) forces symmetrically flanking the Hermetic Androgyne in the center. Though Duchamp received such ideas with an amused and tolerant irony, they do to a degree seem true at least to his attitude. He said to Cabanne, for example, that it is not consummation that makes life alive, but the wooing, the seeking.

Schwarz's psychoanalytic model is argued more fully, and without the softening influence of his Jungian/alchemic approach, by

Marquis, in her detailed biography of 1981, *Marcel Duchamp: Eros, c'est la vie*. Marquis documents Duchamp's feeling that his mother was cold and distant, and proposes that he shifted his oedipal desire for her to Suzanne. After the shock he felt at his sister's marriage, the biographer suggests, his life was dominated by a paralyzing repression of his feelings, and this repression, acting with the Salon's rejection of the *Nude* . . . in 1912, ultimately led to an impotent withdrawal from painting. By Marquis' scheme, Duchamp disguised that withdrawal, claiming it as a transcendence of art rather than a failure at it. Through interviews, memoirs by those who knew him, and readings for his work, she finds him to have been remote and impersonal, never to have been intimate with women (his first marriage, in 1927, was brief, and may have ended unconsummated, and he did not marry again until he was 67), and to have made his art into an elaborate defensive wall behind which to hide a torment of unresolved feelings. The gradual deadening of his ability to communicate with others supposedly underlay not only his invention of an alter ego, Rrose Sélavy—his sexual (possibly homosexual) and creative self seeking to break out of the prison of his repression—but also his solipsistic obsession with games, especially, of course, with chess, as an alternative to life. And the techniques and ideas that came to dominate his art in 1913 and after—chance, the creation of art by designation of it rather than by the actual making of it, mechanical drawing, the interest in machines and the depiction of human beings as machines, cryptic verbal puzzles, mocking sardonic humor, ironic detachment, emphasis on the absurd and irrational—all these, according to Marquis, were depersonalizing tactics, expressing "the need to overthrow the subjective element," to liberate himself, "in a manner however tortuous and painful, from the emotion-laden ties of family and childhood."[8] "Duchamp muffled his, perhaps unconscious, emotional storm, inside an emotionally neutral, and increasingly icy, aesthetic statement."[9]

Marquis mistrusts Duchamp's turn away from subjectivity, a movement she seems to see as flatly unhealthy. In a broader cultural context, however, the desire to overthrow the subjective viewpoint appears as a more positive force. It has been a major goal of many important philosophers both ancient and modern, both Eastern and Western, from Plato's emphasis on universals to Edmund Husserl's

phenomenological reduction. It is the goal of many religious and meditational practices, from Patanjali's raja yoga to the Greek Orthodox "prayer of the heart." It is also the fundamental purpose of the scientific method. Doubtless there is a correlation between Duchamp's emotional state in 1913 and his subsequent art, and one would like to know more about it. But it is only a part of the work, and has little significance to the oeuvre's ever-ramifying meanings in twentieth century culture—or even to the meanings Duchamp intended, as far as those can be divined.

Of course this crucial period of Duchamp's life, 1911–13, contained other events besides his trip to Munich, his sister's marriage, and his rejection by the Salon. Various influences to which he is known to have been exposed at this time seem to have contributed in specific ways to the reformation of his work; the ambient interest among artists in the Golden Section and ideas about the fourth dimension, Henri Bergson's emphasis on coming to terms with the machine age, Alfred Jarry's absurdism, Francis Picabia's iconoclasm, Guillaume Apollinaire's humor, Stéphane Mallarmé's linguistic ambiguities, Jules Laforgue's provocative titles, the recently published notebooks of Leonardo da Vinci, Raymond Roussel's punning and the machines for making art he described in his novel *Impressions d'Afrique* (a performance version of which Duchamp saw in 1911), and others. But while these influences can explain details or aspects of Duchamp's post-1912 oeuvre, they cannot explain the apparent revolution in his general attitude. One influence that Duchamp himself openly acknowledged, however, though it has been largely ignored in the critical literature,[10] can account not only for specific details in his oeuvre but also for the change in his attitude around 1912–13.

It was in those crucial years that Duchamp worked at the first and almost the last job of his life, in the Bibliothèque Sainte-Geneviève, in Paris.[11] He later told Cabanne that he took the position out of disgust with art and art politics after the Indépendants' refusal to exhibit *Nude Descending a Staircase, No. 2*. "Cubism had lasted two or three years," he noted, "and they already had an absolutely clear, dogmatic line on it . . . as a reaction against such behavior coming from artists whom I had believed to be free, I got a job."[12] In the library, Duchamp sat at a desk for four hours a day,

with no duties but occasionally to give advice about where to locate a book. By his own account he read and thought a good deal and withdrew from social contacts, living quite solitary. And he told Schwarz that during this time he "had had the chance . . . of going through the works of the Greek philosophers once more, and that the one which he appreciated most and found closest to his own interests was Pyrrho."[13] The recollection has been treated as minor, but there is really no other thinker, no other philosophical source, of whom Duchamp ever spoke in such terms. The evidence suggests that his reading of some account of Pyrrho's life and teaching exerted a formative influence, confirming his own emerging skepticism.

Pyrrho of Elis (ca. 365-275 B.C.) is an important but little-known Western philosopher.[14] Interestingly, in terms of Duchamp's 1913 rejection of easel painting and his putative 1923 retirement from art in general, Pyrrho started out as a painter but abandoned art for philosophy. "He had no positive teaching," says an ancient authority, "but a Pyrrhonist is one who in manner and in life resembles Pyrrho."[15] Two sayings attributed to him have survived: first, "Nothing really exists, but human life is governed by convention." To exist, in the context of Greek thought, means to have an unchanging essence, so that statements about an existing entity are objectively either true or false. Instead, Pyrrho suggests that things indefinite in themselves are made to appear this way or that by human conventions and opinions, which may claim to be based on essential truths, but are not. The second saying reinforces this idea: "Nothing is in itself more this than that." The reality that we seek to delimit through our judgments and opinions, then, actually has no limits. According to Pyrrho's teaching as reported by one of his students, Timon of Phlius,[16] things are indistinct from one another, and thus are not be preferred over one another, but should be regarded with indifference. Without fixed essences, they are nonstable, and hence are nonjudgeable, or unable to be contained by concepts. If nothing is true, Pyrrhonists felt, then nothing is false either, the false can only be defined by its contradiction of the true. Therefore, Timon concludes, Neither our perceptions nor our opinions are either true or false." Language, in other words, is simply irrelevant to claims of truth; the delimiting of reality is not its proper function, which lies at the simpler levels of practical locutions such as "Please

pass the salt." Accordingly, Timon says, we should remain "without opinions" and "indifferent," beyond the tumult of the fluctuations of yes and no. Thus the Pyrrhonist moves into a posture characterized by "nonspeech" (aphasia). This, presumably, is why Pyrrho wrote no treatise on his thinking, but taught by example, demonstrating his ideas in his behavior.

Both logic and metaphysics entertain a notion called the "law of the excluded middle," which holds that any proposition must be either true or false—that there is no middle position between yes and no, this and that, true and untrue, and so on. Phyrrhonism confutes this so-called law, establishing a position that is neither affirmation nor negation but a kind of attention that is neutral and impartial while remaining alert and vivid. Pyrrho's central concept was the "indifference" (apatheia) that would lead to "imperturbability" (ataraxia). He recommended, for example, an attitude of indifference toward not only philosophical questions but the entanglements of everyday life, which are based on hidden philosophical presuppositions. It seems that Duchamp had a natural sympathy for this stance, and that Pyrrho articulated it for him, providing it with an intellectual basis.

As early as 1913, immediately after reading Pyrrho, Duchamp spoke of the "beauty of indifference," and, at various times, of the "irony of difference" and the "liberty of indifference."[17] Pyrrho's recommendation to cultivate a neglect of opinions is reflected frequently in Duchamp's discourse. When asked about his "moral position" at a certain time in the past, for example, he once replied, "I had no position."[18] Similarly, when discussing some critical notes he had written on various artists, he said, I didn't take sides."[19] To Arturo Schwarz he explained, "You see, I don't want to be pinned down to any position. My position is the lack of a position."[20] "To talk about truth and real, absolute judgment," he also remarked, "I don't believe in it all."[21] The following dialogue took place with Cabanne:

Cabanne: One has the impression that every time you commit yourself to a position, you attenuate it by irony or sarcasm:
Duchamp: I always do. Because I don't believe in positions.
Cabanne: But what do you believe in?

Duchamp: Nothing, of course! The word "belief" is another error. It's like the word "judgment," they're both horrible ideas, on which the world is based. . . .

Cabanne: Nevertheless, you believe in yourself? . . .

Duchamp: I don't believe in the word "being." The idea of being is a human invention. . . . It's an essential concept, which doesn't exist at all in reality.[22]

Duchamp's "irony of indifference" directly relates to Pyrrhonism, as does much else in the exchange. The critique of the concept of being, with its presumption of essence, is central to Pyrrhonism ("Nothing really exists. . . ."). The being/nonbeing pair are alternatives like yes and no, or true and false, and the Pyrrhonist "position" is outside such pairs. It is thus also outside the concepts of self, which supposedly *is*, and belief, which either affirms or negates.

 This Pyrrhonist antiposition laid the foundation for key areas of Duchamp's work. When he was asked, for example, what determined his choices of readymades, he replied, "It's very difficult to choose an object, because, at the end of 15 days, you begin to like it or to hate it. You have to approach something with an indifference, as if you had no esthetic emotion. The choice of readymades is always based on visual indifference and, at the same time, on the total absence of good or bad taste."[23] Thus to regard the readymades as demonstrating that ordinary objects possess the esthetic qualities usually valued only in art would seem a misunderstanding of Duchamp's intention. "When I discovered readymades," he wrote in 1962 to Hans Richter, "I thought to discourage esthetics." But later artists, he continued (referring to the Neo-Dadaists), "have taken my readymades and found esthetic beauty in them. I threw the bottle-rack and the urinal into their faces as a challenge and now they admire them for their esthetic beauty."[24] The readymades carry Pyrrhonist indifference into the realm of art. Similarly, Duchamp explained the famous door in his Paris studio, at 11 rue Larrey, which when it closed one doorway opened another, as "a refutation of the Cartesian proverb: 'A door must be either open or shut' "—that is, as a refutation of the law of the excluded middle.[25] Other works, such as his roulette system that enables the player to break even rather than win or lose, reflect that same attitude. *L'Opposition et les cases conjuguées sont reconciliées*

(Opposition and sister squares are reconciled), the book on a rarely encountered chess endgame that Duchamp wrote, with Vitaly Halberstadt, in 1932, has been described as follows: "The king 'may act in such a way as to suggest he has completely lost interest in winning the game. Then the other king, if he is a true sovereign, can give the appearance of being even less interested.' Until one of them provokes the other into a blunder, 'the two monarchs can waltz carelessly across the board as though they weren't at all engaged in mortal combat.' "[26] Duchamp himself said that following the system in the book "leads inevitably to drawn games"[27]—that is, to the Pyrrhonist position between yes and no.

In a letter of 1929, Duchamp wrote, "Anything one does is all right and I refuse to fight for this or that opinion or their contrary. . . . Don't see," he went on, "any pessimism in my decisions—they are only a way toward beatitude."[28] Pyrrho's "imperturbability," a state of perfect equanimity, seems to have been what Duchamp meant by "beatitude." Such a position is not pessimistic, any more than Duchamp's assertion that he believed in nothing is nihilistic. For his statement was a critique not of life, but of the authority that opinions hold over life. Duchamp might say he believed in nothing, but he could also declare, "I'm antinothing. I'm revolting against formulating."[29]

Many have commented on the apparent similarities of attitude between Duchamp and the later Ludwig Wittgenstein, the Wittgenstein of the *Philosophical Investigations*.[30] When Duchamp, late in life, was given a précis of Wittgenstein to read, he commented that he saw the similarity but hadn't known anything of Wittgenstein's work before. This is not so surprising, since what echoes Wittgenstein in Duchamp is equally reminiscent of Pyrrho. Duchamp's Pyrrhonist remark "There is no solution because there is no problem,"[31] for example, finds close parallels in a number of Wittgenstein's statements, such as "The deepest problems are not problems at all."[32] The same applies to the correlations that critics have made between Duchamp and Zen.[33] His denial of language-based constructions of reality, renunciation of opinion, avoidance of affirmation and negation as unreal alternatives, maintenance of a posture of indifference, and focus on the quality of the passing moment have seemed to many to be oriental in flavor; this impression arises from Pyrrhonism's striking similarities with the Zen tra-

dition.[34] Duchamp's statement that "Every word I am telling you is stupid and wrong"[35] could have been uttered by Pyrrho, and also by the Zen master who said "The moment you open your mouth you are wrong."[36] The commonalities that John Cage and others noticed may be accounted for by Duchamp's solitary reading and reflection on Pyrrho in the Bibliothèque Sainte-Geneviève in his 25th year.

If a true Pyrrhonist is "one who resembles Pyrrho," Duchamp could well be given that title. The essence of Pyrrho's teaching, in the words of an ancient author, was that "he would maintain the same composure at all times"[37]—something frequently said of Duchamp. Similarly, the report that Pyrrho "would withdraw from the world and live in solitude" recalls Duchamp's often reclusive life-style. The Pyrrhonists never presented a positive teaching, save a Zen-like admonition to attend to the quality of every present moment without the distracting overlays of opinions or interpretations; and Duchamp never wrote a manifesto, or pontificated on what art should be, except by example. He turned from a so-called "retinal" art to an art with a philosophical function immediately after reading that Pyrrho had quit painting for philosophy. And finally, the Pyrrhonist stance outside affirmation and negation, outside speech, recalls what is meant by the "silence of Marcel Duchamp."[38] His was not a literal silence, like that of the ancient philosopher Cratylus (a forerunner of Pyrrho who refused to teach verbally, thinking that to make any statement whatever was to submit to "formulating," but, says Aristotle, would only hold up his finger, pointing to the direct experience of the moment). On the contrary, Duchamp was a man of many words. As far as expressing opinions goes, however, these amounted to a silence, for in his use of language he attempted to avoid assumptions that would limit reality. Casual conversation was acceptable, since it is involved in the pleasure of the moment. Like James Joyce, he enjoyed puns and other multidirectional verbal objects, which go beyond positing or negating, reflecting instead the labyrinthine relationships that seem to converge on any given moment of experience. The notes in *The Green Box*, 1934, and elsewhere are cryptic enough that they too avoid direct statement. If Duchamp was in fact interested in alchemy, incidentally, that was perhaps because it too posits an ultimate attitude beyond the distinction between yes and no.

The Pyrrhonism of Duchamp's work from 1913 onward offers a philosophical context in which to view his youthful turning point. Personal factors were, of course, involved—the search for an objective, detached stance must be at the same time a move away from some subjective situation or other. Still, it is not necessary to believe that whatever emotions Duchamp wanted to out-distance seethed tormentingly inside him for the rest of his life. Perhaps the imperturbability, or "beatitude," of indifference flowed coolly in to calm the troubled surface of his young and adaptable mind.

The psychoanalytic model holds that Duchamp's work after 1912 is itself the proof that his inner problems were not resolved but hidden by his ongoing repression. This seems to be suggested by the paucity of his oeuvre, its mute lack of self-expressiveness, its mocking ironic distance, its unnaturally prolonged *enfant terrible* rebelliousness, its hints of repressed sexuality, its subterfuges of critical evaluation, its determined absurdity, its solipsism, and so on. (Most of these qualities, incidentally, are as egregious to the formalists as they are to the psychoanalysts.) The problem with this approach is that it subjects Duchamp to the very affliction he sought to remedy for art: it removes his work from its context in the world of ideas. Seen within such a context, the work acquires a directness and a coherence that are altogether rational.

It has sometimes been objected that there is a contradiction in a philosopher's espousing indifference and then proceeding to argue against the views of other philosophers. But in the Pyrrhonist tradition the undermining of one view is not held to imply the affirmation of the contrary view. (This would represent acceptance of the law of the excluded middle.) The indifferent position, or nonposition, does not preclude one from engaging in debate; it only precludes one from maintaining a positive doctrine. One mode of Pyrrhonist practice was to attempt to turn others toward imperturbability by analyzing their views of reality and revealing the unproven assumptions and inner contradictions hidden within. Some Pyrrhonist authors forged massive collections of negative arguments, intended to annihilate all types of opinion and to leave nothing in their place but the "non-speech" of opinionlessness. Similarly, Duchamp's indifference did not keep him from arguing, in the mute acrostics of his work, against what he perceived as prevailing dogmatic rigidities. Such a program,

in fact, underlies his oeuvre in general, alongside the other levels of meaning and intention that activate its complex dynamism.

Duchamp once described himself as engaged in "a renunciation of all esthetics, in the ordinary sense of the word."[39] The qualifying phrase "in the ordinary sense of the word" shows that this was not, as it has often been called, an "esthetic nihilism."[40] In European art since the eighteenth century, esthetics "in the ordinary sense of the word" means the esthetic theory adumbrated by the third Earl of Shaftesbury and fully articulated by Kant in his *Critique of Judgment* (1790), and various German metaphysical elaborations by Hegel, Schelling, Schopenhauer, and others. Whether Duchamp studied these philosophers along with the Greeks at his desk in the Bibliothèque Sainte-Geneviève is unknown and unimportant; unlike Pyrrhonism, the ideas in question were pervasively in the air, as familiar to any well-read person, and certainly to as cerebral an artist as Duchamp, as his or her address. According to Marquis, the collector and patron Walter Arensberg once "thought he discerned a pattern in Duchamp's work. 'I get an impression,' he wrote, 'when I look at our paintings of yours from the point of view of their chronological sequence, of the successive moves in a game of chess.' Duchamp readily agreed to the analogy."[41] It was the system of Kantian esthetics, and its hold on Modern art, that Duchamp's work was devised to checkmate.

The foundation of the Kantian doctrine is the notion of a sense of taste through which we respond to art. Being literally a sense, like seeing or scenting, this quality is noncognitive, nonconceptual; it is a *sensus communis*, innate and identical in everyone; it is a higher faculty, above worldly concerns; it is governed by its own inner necessity.[42] Duchamp's work at once intuitively and systematically illuminates the flaws in this teaching. For example, Kant's theory implies that literature or language cannot be art, since words are conceptual entities; Duchamp's inclusion of linguistic elements in his work—punning titles and inscriptions, sets of notes—forces the dilemma that either these works are not art or art is conceptual as much as sensual. The readymades take aim at the idea of the universal sense of taste—calling a urinal "art," for example, resulted in a rift of opinion so intense as to throw into question the idea of a *sensus communis*—and also, of course, at the idea of art's noble separateness

from the world. The introduction of chance procedures illustrates a mode of artistic decision-making that takes literally Kant's injunction that esthetics should lie outside human desires and prejudices, and yet is not even conceivably acceptable in Kantian terms. At the same time, it lampoons the Kantian notion of esthetic necessity. And so forth.

What is most significant in Kant's esthetic is the idea that taste is a universal constant, an unchanging faculty—an essence. This is the element of his thinking that most contradicts the Pyrrhonist position, which denies the possibility of essences ("Nothing really exists"), and abstains from all the judgments of a thing's quality to which they give rise. Duchamp astutely focused his attack on this crucial point. Esthetics for him had nothing to do with some transcendentally autonomous and self-validating faculty, like a soul. Instead, he proposed a relativistic view of taste as "a habit. The repetition of something already accepted. If you start something over several times, it becomes taste. Good or bad, it's the same thing, it's still taste."[43] Taste here is simply the shape of one's limitations, the ingrained habitual system of prejudices that is the stumbling block to a generalized appreciation of life. As Duchamp told Cabanne, "One stores up in oneself such a language of tastes, good or bad, that when one looks at something, if that something isn't an echo of yourself, then you do not even look at it. But I try anyway."[44] His goal, then, was "to reduce my personal taste to zero."[45] If the constrictions of habit, of "taste" and its belief system, could be eliminated, Duchamp felt, life could be a "sort of constant euphoria,"[46] a Pyrrhonist realm of beatific imperturbability and generalized openness.

Many of the qualities that have been regarded as deficiencies in Duchamp's oeuvre are calculated demonstrations of this point of view. The work's visual unimpressiveness expresses its avoidance of judgment by the conventional criteria of taste. Its appearance of internal inconsistency, its shifts of modes, genres, and materials, express his desire not to define or to delimit the space in which art unfolds. The paucity that psychoanalytically inclined critics have taken as evidence of emotional problems in fact suggests Duchamp's refusal to repeat himself, on the ground that repetition would establish his work as merely one style among many, competing with others for authority, like the dogmatic Cubism of the 1912 Salon. To

create many works on the same principle is to be dominated by a dead habit. Chance and the readymade, Duchamp's two great tactics for creating art that neither pleased nor offended his own customs of taste, were his avenues for the discovery of objects that he had not been taught to see by his experience of looking at art. Aware that taste changes from one historical phase to the next, and thus cannot really be either universal or necessary, Duchamp referred to it as "a fleeting infatuation," which momentarily "disappears."[47] "Why," he asked, "must we worship principles which in 50 or 100 years will no longer apply?"[48]

A second major element of "esthetics in the ordinary sense of the word" was the myth of art's sacredness promulgated by Kant's successors. To Hegel, for example, the successful artwork was an embodiment of the absolute or the infinite; it represented, he wrote, the "spirit of beauty . . . to complete which the history of the world will require its evolution of centuries."[49] According to Hegel's contemporary Schelling, art "opens . . . the holy of holies. . . . When a great painting comes into being it is as though the invisible curtain that separates the real from the ideal world is raised."[50] For Schopenhauer, similarly, art was "the copy of the [Platonic] Ideas"— that is, the embodiment of eternal and sacred truths.[51] The Romantic tradition, which includes Modernism, deeply incorporated this idea. For Duchamp, however, art was not a link to the universal and permanent, a channel toward the sublime,[52] but a device with which to break mental and emotional habits, and to discourage the projection of one's self one's opinions, as absolute. It was a vehicle of Pyrrhonist indifference. Where the Romantic artist was supposedly a kind of priest or mystic adventurer, Duchamp, in connection with quitting art, remarked that he was "defrocked."[53] "I'm afraid I'm an agnostic in art," he said. "I just don't believe in it with all the mystical trimmings. As a drug it's probably very useful for a number of people, very sedative, but as religion it's not even as good as God."[54] His works were a systematic undermining of the whole phenomenon of art's "aura," which Walter Benjamin was to discuss. Everyday objects have no "aura," nor are they "unique" or "original." Neither are the photographs and mechanical reproductions that frequently appear in Duchamp's work. The use of chance also takes traditional esthetic decision-making out of art, emphasizing its embeddedness in nature

(which Hegel said it transcended). The technique of mechanical drawing bleaches the emotionality out of images. Even Duchamp's adoption of a female persona, Rrose Sélavy, was a negation of art's essentially male-heroic tradition.

Duchamp's work, clearly, is not merely a survivalist response to "an overwhelming inner conflict,"[55] nor the effect of an infantile destructive nihilism. It could only seem so, really, to commentators for whom there is no world outside the Kantian inheritance. It is, instead, a precise and mature theoretical critique, an overthrow of the Kantian esthetic along with the demonstration of a Pyrrhonist openness as a space for the art of the future to move in. (What art has done in that space is open to debate: as Clement Greenberg put it, "Duchamp . . . locked advanced-advanced art into what has amounted to hardly more than elaborations, variations on, and recapitulations of his original ideas."[56]). Duchamp tried to ring the death knell for formalism, for the belief in art as a spiritual transcendence, and for the Romantic cult of beauty. Of course that cult still has its faithful, and they have rightly perceived him as the enemy. Despite his work's enormous art-historical importance, it is the subject of a deep strain of hostility. In his New York *Times* obituary for Duchamp, for example, Alexander Keneas calls his work "vaudeville."[57] In that same generally formalist organ, John Canaday similarly spoke of the work in terms of "horseplay," "a parasitic appendage, an amusement, a vaudeville performance." According to Canaday, Duchamp was, "along with Picasso amd Matisse, one of the trio of most powerful influences on twentieth century art," yet "unlike his two peers, [he] has exerted an influence primarily destructive."[58] In fact, he was no less than "the most destructive artist in history."[59] This attitude, which might be regarded as old-fashioned, is still dominant in the Marquis biography of 1981, which presents Duchamp as a failed artist and an essentially destructive force—"a powerful figure which knew how to destroy in the most creative ways."[60]

Other types of responses have acted to tame Duchamp's work in less obvious ways. One is the common description of both the artist and his work as "enigmatic." The headline of the New York *Times* obituary, for example, reads, "Marcel Duchamp, Is Dead at 81; Enigmatic Giant of Modern Art." Calvin Tomkins similarly called Duchamp, "the most enigmatic presence in contemporary art."[61]

This often applied term neatly slots Duchamp's work away into the category of the mysterious and the vague, of things whose meaning is deliberately obscure enough that we need not trouble too long to understand it. A related response has been to focus on Duchamp's legendary status. Baruchello, Marquis, and others propose that his primary achievement was his own self-mythification—as if the work had no point in itself but to draw attention to its maker. Duchamp remarked sanely that "the idea of the great star comes directly from a sort of inflation of small anecdotes,"[62] and clearly he himself was the subject of this kind of inflation. His occasional collusion in the process—the many deliberately myth-making photographs he posed for, say—should not obscure the fact that his work had definite purposes, which it went about in a direct and businesslike way.

Yet another strategy to tame the critical thrust of Duchamp's work—and, tacitly, to reestablish the hegemony of Kantian esthetics—has been articulated by Greenberg, Baruchello, and others. In this reading, Duchamp was one avant-garde tactician among many. His techniques were on the same scale as those of, say, the Fauves, or the Cubists, or, later, the Abstract Expressionists. But the fact is that they were not. Duchamp's avant-gardism overthrew the Kantian foundation on which most of the other varieties were based, from Impressionism to Color Field. It was a meta-avant-gardism, which went beyond proposing a new embodiment of the Kantian ideology to overthrowing it altogether. Similarly, Tomkins, as if to compliment Duchamp on his subversiveness (but really making him ordinary), claims that "art has a way of undermining all esthetic theories."[63] But Duchamp's undermining of theory was not just one among many; he dismantled a theoretical structure that had accommodated most of the avant-gardes that were growing up around him, and that had been solidly in place since the eighteenth century.

The recent movement among artists, dealers, and critics to reduce the readymade (which Duchamp called "perhaps the most important single idea to come out of my work"[64] to a style accomplishes the same end. Much current readymade work, though it may be attractive, and even intelligent in its focus, should not be regarded as Duchampian. It may *look* Duchampian, but to concentrate on the look is to miss the point. Duchamp's readymades function as a rejection of style; today the readymade has become a style—even what

could be described as an academic style.[65] Where *Fountain* shocked, and the snow shovel aimed at indifference, this generation of ready-mades placates and pleases. His works are often involved in language; the current versions are mainly mute form. He rejected commodification; today's objects affirm it. What Duchamp saw happen to painters through the repetition that he opposed—"They no longer make pictures; they make checks"[66]—has also come true for ready-made artists, who relentlessly repeat, writing checks against what has become a habit or taste.

The recent prevalence of such works demonstrates not that the Duchampian influence is ongoing, but that it is in a sense dead. The absorption of the once critical readymade into the mainstream market indicates not that Duchamp's theoretical critique has lost validity, but that his formal embodiment of it has lived itself out, as he himself said that a painting dies in about 50 years. An accurate receiver of the Duchampian message would, at this moment, stay as far from the look of his work as possible, since the look of his work has now become part of the rigidity of habit that it was designed to pry loose. The point of Duchamp's violation of the gallery space—the urinal flung in their faces—was not to establish a new *style* of exhibited object, but to suggest that humans can exhibit *anything at all* to one another, with the countless ranges of meaning and types of appreciation that this realization opens up. When Arensberg likened Duchamp's paintings to a chess game, Duchamp responded, "But when will I administer checkmate or will I be mated?" The recent slavish and academic imitation of the mere *look* of his work constitutes, however unconsciously, the closest approach yet to checkmating Duchamp.

SECTION FOUR

Commentary by G. Roger Denson

Reincarnations and Visitations:
 Modernisn and Postmodernism
 All Over Again

Excerpt by Thomas McEvilley

From *On the Manner of Addressing Clouds*

Reincarnations and Visitations: Modernism and Postmodernism All Over Again

Throughout the body of his criticism, McEvilley aims at overturning the hegemonic impulse of the late modernist tradition. But McEvilley's view of modernism and postmodernism is distinguished from all other prominent accounts advanced today in that he believes that the modernism and postmodernism of the twentieth century are not unique, and he extensively cites the period of the ancient Greek democracies between about 550 and 350 B.C.E. as a leading example of another modernism parallel to our own.

As with the modernism most of us are familiar with, the ancient Greek modernist tradition took effect in literature, music, and the fine arts, as well as in social and political experimentation. "Then, as now," McEvilley writes in "On the Manner of Addressing Clouds" (1984), modernism "arose in the context of a positivistic democracy carried away by emerging international hegemony to an almost giddy sense of its ability to solve social and cultural problems. It was also a modernism that was followed by a postmodernism of sorts, an age we have come to know as Alexandrian, in which the tradition of the new was reversed while the chains of hegemony were substantially loosened."

It wasn't just classical Greece that McEvilley sees producing modernism. We can infer from his writing that a kind of modernism characterized several great civilizations as they approached or reached the twin pinnacles of their economic prosperity and cultural achievement. Beside the Greeks, McEvilley cites the ancient Egyptians, Sumerians, Romans, Indians, and Renaissance Italians, and we may, through his example, easily imagine modernisms of China, Japan, Persia, Turkey, Nigeria, Peru, and Mexico among numerous other nations and cul-

tures that have produced modernist and postmodernist epochs. In McEvilley's sense of the word, "modernism" is an endeavor that, though not continuous, advances and recedes in prominence. Modernism, by his definition, is the widespread repudiation and discarding of traditions that developed over centuries or millennia "on the historicist assumption that something better will inevitably replace them"—that is, a myth of the inevitability of progress.

Such collective bravado does not usually accompany the succeeding phase of cultural development, the postmodernism of each great civilization, which McEvilley characterizes as the inner imperative to turn to one's own history. "While it was not possible to regain in all innocence what had been sacrificed to the Modernist impulse, it was possible, through quoting, to enter into a new relationship with it. . . . A period in which traditions are destroyed is apt to be followed by a period of nostalgic longing for them and attempts to reconstruct them. The guilt of having destroyed them is allayed by incorporating them into the very context of their destruction."

This expanded view of modernism and postmodernism puts McEvilley somewhat in conflict with Jean-Francois Lyotard when he opines in *The Postmodern Condition* (1979) that the grand narrative has lost its credibility, regardless of what mode of unification it uses, and regardless of whether it is a speculative narrative of emancipation. In many respects, by charting modernism and postmodernism as together comprising a recurring pattern of history—and their alternations seem to account for the entire history of civilization—he describes a cyclical, grand narration reminiscent of Arnold Toynbee's theory of history. But unlike Toynbee (whose special expertise, like McEvilley's, lay in Greek history and literature), he is not imposing a unifying or underpinning design or causation on history; McEvilley understands that contingencies and the lacunae in knowledge forever undermine any intelligible design or theory of origins. And then he considers such designs as presuming a theological overview, which he has spent most of his career exposing and shunning, in the narratives of modernism.

His grand narration of modernism and postmodernism is more akin to an epic poem filled with radical ellipses and oscillating appearances and disappearances of figures, events, and ideas than to a linear story with a distinct beginning, direction, and end. So per-

haps McEvilley is not as oppositional to Lyotard as at first he seems. Indeed, he seems in complete agreement with the French theorist that all forms of culture and knowledge are inextricably bound up with established systems of meaning production, and McEvilley plays a direct role in the discourses which Lyotard claims operate within postmodern culture to seek and expose these links. He is also like Lyotard when he shows himself to be practical about, rather than ideologically threatened by, the splintering of languages and models that exists in postmodernism and multiculturalism without requiring some universal metalanguage to unify them.

This is a radical departure from the modernism of a critic like Clement Greenberg, who attempted to define it according to a narrow program by which each medium distinguishes itself in its "purity," and from this purity each medium establishes its own standard of quality. This idea of a medium individuating itself and intensifying its own purity—an anthropomorphized example of a consciousness defining its own possibilities and limitations—has come to Greenberg through his reading of Kant's *Critiques*, which we know from this famous admission in "Modernist Painting" (1961):

> I identify Modernism with the intensification, almost the exacerbation of this self-critical tendency that began with the philosopher Kant. Because he was the first to criticize the means itself of criticism, I conceive of Kant as the first real Modernist . . . The Enlightenment criticized from the outside, the way criticism in its more accepted sense does; Modernism criticizes from the inside, through the procedures themselves of that which is being criticized.

If anything, Greenberg's narrow assessment of modernism was the culmination and provoking closure of modernism, and amid the disarray and plurality of reactions to this narrowness, the postmodernism of the late twentieth century was spawned. Among the many reactions, we find McEvilley's to be the most capacious. But he shares some of his views with other prominent commentators on modernism's demise.

Habermas comes quickly to mind in his interpretation of modernity as an endeavor revolting against the normalizing functions of historic tradition, tradition that the modernist sees as neutralizing the standards of morality and unity. Like Habermas, McEvilley char-

acterizes the modernist avant-garde as promoting a largely ahistorical succession of positions, or, to continue the rhetoric Habermas has already established, the modernist avant-garde directed itself against the false normativity of history. Both authors express the view that the past for the modernist is believed to be objectified by historicist scholarship, but it is a scholarship virtually useless to the avant-garde artist who disposes of the past as a stratagem to oppose the neutralization of both art and history by the museum and institution.

McEvilley's abundant, active, and integrated historicism stands in stark contrast to the modernist's seemingly schizophrenic relationship to history. He too opposes the neutralization of history, but rather than use it merely as a backdrop for the cultural production of his time, as Greenberg did, he sees cultural production immersed in and engaging in a rapport with history. His writing embodies the view that activating history in the creative process is more effective in preventing history from becoming neutralized by institutions than is the modernist's stratagem of negating and neglecting it.

From McEvilley we get a glimpse of the notion that history is the present as much as it is the past, but it is also the future, and this is his amendment to the modernist's myopia, which only envisioned the present to be the future. If the modernist's present was the future, the postmodernist's is the past. But McEvilley distinguishes himself from both predilections, by becoming like Janus, the Roman god who sees in both directions of time simultaneously, scrutinizing the past to prevent its closures from choking the discourse and production of the future. From McEvilley we get a sense that it is useless to exalt a futurist predilection while neglecting the historicist proclivity. If the modernist avant-garde was without hindsight, it was a temporary situation, for as McEvilley demonstrates, the postmodernism that ineluctably follows all modernist epochs will just as ineluctably place the modernist programs in greater historical relief.

McEvilley seems even more in concert with Habermas' view that modernist aesthetics were at fault in assuming the rationalization of everyday life could be saved from cultural impoverishment through the breaking open of a single cultural sphere, that of art. Like Habermas, McEvilley implies that in providing one specialized knowledge—largely that of a reflexive abstraction, and a dishonest or delusional one at that—only the audience invested in this specialism

was gratified, and not society as a whole. In this respect, McEvilley would agree with Habermas' view that in the modern context of communication processes—those including everyday conversation, deeper cognitive languages, moral expectations, and subjective expressions and evaluations—there must be a cultural tradition, or an umbrella of relationship, that provides access more generally if a larger population is to be enriched by its projects. This interpretation of modernism's defiant specialism helps us understand why the public funding of art is under attack today from a myriad of special interest groups who position themselves outside the cultural umbrella. For the modernism that McEvilley and Habermas target is a sweeping attitude responsible for the evolution of a civilization fragmented into myriad enclaves, each without an understanding of the others. This, we have seen from McEvilley's essays in the first section of this book, has resulted from the misconception that the social and the aesthetic realms are incompatible.

In this sense McEvilley expands upon Frederic Jameson's notion that postmodernism is the effacement and erosion of some key boundaries or separations in modernism, most notably the distinction between so-called high culture and popular culture, and the creative and critical faculties of the mind. But he adds to the list of Jameson's boundaries being effaced and eroded those conventionally defining the spheres of the Western and non-Western, the aesthetic and the ethnological, the artistic and the functional, and the learned and the primitive (also known as the traditions of folk or outsider art).

Jameson has qualified one of the chief distinctions of modernism to be its invention of a personal, private style that is as incomparable as one's own body. Personal style, Jameson says, signifies that modernist aesthetics was organically linked to the conception of a unique self and private identity, a unique personality and individuality, which can be expected to generate its own singular vision of the world. When comparing McEvilley with Jameson, we see how he expands on this theme by showing that, though Jameson is correct in his equation of modernism with the veneration of individuality and unique production, Jameson has not taken into account that the modernist attitude of the last two hundred years is also found in some cultures of the distant past, as well as in some cultures extant in distant geopolitical regions.

I also interpret McEvilley as having a broader view of the individualist subject than almost all other commentators on this provocative issue. In his essays "I Am Is A Vain Thought" and "On the Manner of Addressing Clouds," he shows that he is in agreement with both Jameson and Roland Barthes when he relegates the emphasis on the individual or the individualist subject to the past, and considers such a notion as dead. "It is not the individual who makes images," McEvilley offers in "On the Manner of Addressing Clouds," but "the vast image bank of world culture that images itself forth through the individual," which he then qualifies as a "transpersonal mind aimlessly and relentlessly processing us through its synapses." But McEvilley also sees the individualist subject as something that is likely to be reincarnated once civilization tires of its current preoccupation with the reassessment of past views of modernism and history rather than with present views of modernism and the future. Furthermore, he sees that the artist's intentions are always present, even when the endeavors of quoting, appropriating, and ironically referencing previous productions and ideas are taken to the extreme.

Anthony Giddens, in his book *Modernity and Self-Identity: Self and Society in the Late Modern Age* (1991) advances the view that, though individual life and the self interlace modernity, they must be understood also to expand the institutional role in society, as the modern institution features prominently in what he calls "an increasing interconnection between the two 'extremes' of externality and intentionality: globalizing influences on the one hand and personal dispositions on the other." Few theorists in the field of art, however, past or present, concentrate on this interconnection more thoroughly in the realms of history, the world, and the self, than McEvilley.

Because of this, his writing seems in opposition to the view expressed by Giddens that "modernity institutionalizes the principle of radical doubt and insists that all knowledge takes the form of hypotheses: claims which may very well be true, but which are in principle always open to revision and may have at some point to be abandoned." McEvilley's treatment of subjectivity and skepticism, as represented in this book, makes Giddens' trust in institutions seem naive. Surely the competitiveness of the many modernist schools and movements has

given a central role to radical doubt and hypothetical formulations, but the institutions of modernism, as McEvilley's tireless dissent against them illustrates, are too often too full of self-importance and hegemonic tendencies to allow this radical doubt and hypothetical nature to be leveled against their own edifices. To paraphrase Terry Eagleton, the process of reification seeps in everywhere, even into the domain of radical doubt, and once reification has extended an empire across the whole of social reality, effacing the very criteria by which it can be recognized for what it is, it can then triumphantly abolish itself, returning everything to normality. This is why some postmodernist discourses like Derrida's deconstruction include the component of their own dismantling in the discourses themselves.

Even this self-fulfilling dismantling of postmodernist discourse is not something new to our culture and time, as McEvilley has pointed out that it has features in common with Madhyamika Buddhism, which was the dialectical forerunner of Zen, and with Greek skeptical thought. And of course, even this urge to dismantle the self can be reified. Which is why the acknowledgement of intercultural and historical quoting is so important to McEvilley; for it is our continuity with the past and our common interests with distant cultures that survive all the fragmentation, bursts of innocent creation, and short-term reifications. Quoting from the past or from faraway places is seemingly constant, even when, as in our high modernist phase, the West saw its most significant production as vitally avant-garde. Historicism again informs discourse and production, this time in showing modernism and postmodernism as links in a chain of other modernisms and postmodernisms.

In this respect, of all writers on postmodernism McEvilley seems to have the most in common with Terry Eagleton. Eagleton, after all, in his article "Capitalism, Modernism and Postmodernism" (published in the July–August issue of *New Left Review*, thirteen months after McEvilley published "On the Manner of Addressing Clouds" in *Artforum*), has expressed the view that "history and modernity play a ceaseless cat-and-mouse game in and out of time, neither able to slay the other because they occupy different ontological sites." And later in the same article he states that all historical epochs are modern to themselves, though not all live their experience in this ideological mode.

I think that McEvilley is likely to agree with Eagleton (and here also with Jameson) that aesthetic modernism is a strategy designed often in desperation to resist commodification, in which its art forms hold out by the skin of their teeth against the social forces which would degrade it to an exchangeable object. In creating a rarified atmosphere in which only the specialists can flourish, artworks insulate themselves at the same time they repel the acquisitive nature of humanity. In this view, McEvilley and Eagleton seem to agree that abstraction, or purist tendencies in general, are devised to fend off the reduction of art to a commodity status, which itself is a product of the expansive economies that characterize most modernist periods.

Although McEvilley easily advances the most capacious position on modernism and postmodernism, I find myself at odds with his rather dark opinion that the most recent incarnation of modernism was monolithic and existed largely as a set of prohibitions. I cannot see one modernism at work over these past two hundred years, but rather a vast array of modernisms coinciding with, succeeding, and debating with one another. I also cannot forget that the modernists regarded their new art and aesthetics as radically liberating from past prohibitions and taboos. McEvilley is well aware of this, too, though I suspect he downplays it for the obvious rhetorical purpose of examining and correcting the most heinous and repressed closures of late modernism.

And modernism was sweeping in its liberations! At least from the point of view of the capitalist, the European male, and the heterosexual. I often think that those writers and artists who defend modernism today still picture the liberating moments of modernist history fondly (with or without blatant omissions). The greater history of European art and ideas, and much of the history of the arts and ideas of Asian, American, African, and Australian civilizations, was largely concerned with religious, ceremonial, political, and memorial representations, or else ornamentations that had no meaning except that found in the simple effect of pleasure. The proscriptions and prescriptions of these cultural models may not have struck the artists concerned as constraining. Yet during those instances in world cultural history which show evidence that local state and religious censorship loosened or changed with the passing of regimes, there must have been an enhanced consciousness of the restraints

that determined artistic production, and some anxiety expressed, and some dissent at least wished, if not voiced, during these times.

If artists or patrons of premodern history and far cultures ever conceived of the production value of the objects we now call art as somehow ontologically significant apart from the subjects they represent, or as having value and function apart from their status as ornamental or sacred objects (and we must admit at this juncture that we don't know great portions of this story), such views were not of the dominant consensus handed down through history. What Westerners know well is that with the European Renaissance, this framing of art and ideas began to change radically in Europe; with Romanticism we began to think of art as ontologically distinct; but with modernism, the objects produced by artists took on an ontological singularity that has rarely been encountered in other cultural contexts. In this sense the modernism that roots itself in the Renaissance was a liberating force for anyone who wanted to secure their individuation from the masses; it was also to become one of the most capacious and varied in range of all cultural epochs recorded. So many threads of production, so many movements and styles and ideologies were assimilated within its parameters: outside of the raw facts of colonialism and imperialism, how can anyone see modernism as monolithic and prohibitive in a purely cultural sense?

Much of the cultural theory that many postmodernists denounce was developed in the cause of liberating art from the fetters of religion, philosophy, and even poetry. These liberations were largely celebrated by its artists and the amateurs who appreciated and supported them. From the postmodern perspective, European cultural production for the last two millennia has largely been determined by the ontologies of Christianity, Plato, Aristotle, and the many other thinkers recounted in our history. To the artists of the time, these ontologies may have been grandly liberating and vital systems of meaning. It seems only after each epoch's end do artists express the prejudice that the waning structures of meaning are oppressive or stagnant. The waxing ones, meanwhile, such as the modernism of the mid-nineteenth century, are hailed as subversive by some and emancipating by others. The neutralizing and normalizing effect of institutions, however, has helped to make the systems of modernism that once were subversive and emancipating now seem stagnant and

obstructive to thought and originality. It's true that proscriptions were often issued in the movements of modernism, but these were features of the competitive ideologies within modernism, not of the larger umbrella of modernism.

Apart from McEvilley, some theorists of postmodernism seem to forget how liberating democracy and laissez-faire capitalism seemed at the turn of the nineteenth century in the West. Or in the study of art history, they forget how emancipating the line of cultural change was during the seventeenth and eighteenth centuries. Take for example the famous French literary battle during the last quarter of the seventeenth century, *Querelle des Anciens et Modernes*, in which modern writers fought the restrictions imposed on contemporary literature by ancient models. Waged amid a flurry of discoveries in the newly liberated natural sciences, the *Querelle*, and published dialogues like Charles Perrault's *Parallèle des Anciens et des Modernes* (1688–97), spurred on writers, artists, philosophers, and scientists to call themselves "Moderns," as they were becoming increasingly conscious of the achievements of their time. The cognoscenti felt they were shaking off the authority of classical antiquity that had weighed on the Renaissance—though in a sense they were only reviving it in a truer form. There was great excitement all over intellectual Europe as the concept of modern progress spread (though a very similar concept had preexisted in the Greco-Roman era). The *Querelle* buttressed this claim to the point that its hold over writers on art and aesthetics could be seen as late as 1977, when Suzi Gablik's *Progress In Art* appeared and still tried to show that modernism was improving upon the cultural contributions of the ancients.

The distinction between the arts, morality, politics, and the sciences, which to many postmodern critics seems to hinder the development of future art, was pronounced by the *Querelle*—rightly or wrongly—as a distinctly modern freedom that was absent from the art and discourse of the ancient, medieval, and Renaissance epochs. Similarly, Immanuel Kant's importance to modernism, particularly his construction of a theory of beauty that was exalted and made as respectable as a theory of truth or a theory of goodness, was profoundly emancipating for generations of artists and theorists up to Greenberg's time. But postmodernists like McEvilley saw artists and audiences around the world recombining art, politics, ideology, and

function without second thought of the dictates of thinkers who died two centuries before. It was obvious to anyone who acutely observed cultural development in the 1960s and 1970s that it is no longer liberating or even relevant to perpetuate the separations of aesthetics from the rest of human endeavor, yet still the institutions of modernism continue to legislate taste according to the old principles.

This does not necessarily mean that modernism has been exhausted. In fact, it coincides with postmodernism, as do premodern ideas. Postmodernism predominates among many intellectuals today, but it has not wiped modernism from the face of the earth. McEvilley in particular identifies colonialism with modernism, but even if all the modernisms of history coincide with colonialist occupations, and the evidence going back to the pylons of nineteenth dynasty Egypt, the stelae of Babylonia, Assyria, and Akkad and the Royal Standard of Ur indicate they may, modernism equally indicates itself to be inclined to anti-colonialist and anti-authoritarian sentiments. I see colonialism as a premodern, but then my premodernism may be for McEvilley a modernism of old. On the other hand, democracy is in its working manifestation a wholly modernist system—even when considering McEvilley's account of its brief experiment in the Athens of fifth and fourth century B.C.E., which, we must remember, he holds to be the modernist era of ancient Greece. All that postmodernism has been able to do is improve upon democracy's civil expansion by redefining definitions of identity and the individual along lines of race, ethnicity, gender, and sexual preference, which is an immense contribution indeed.

To my mind, the transition from modernism to postmodernism is one from succeeding competitions between short-lived ideologies and simultaneous competitions among a diverse and ongoing number of options. McEvilley is thus correct in assuming that postmodernism, or its most capacious manifestation as multiculturalism, abrogates ideologies of purism, essentialism, and foundationalism in favor of those promoting diversity, contingency, and relativity. I think he is also correct in describing modernism as the fetishization and false universalization of the value judgement. Each one of the competitive movements within modernism was promoted as purer, or more essential, or more in line with the truth than its competitors. But these movements, sometimes at least (exceptions being many

Marxist societies) acknowledged they had competitors rather than merely outlawing them as was the order of premodernist societies, and the number of competing ideologies and productions proliferated at an astounding and unprecedented rate.

The genesis of pluralism lies in this contest of ideologies, in which all the proponents of pure, essential, and foundational systems were forced to look at, and coexist with one another. It wasn't the purism, essentialism, or foundationalism of these ideologies that was modernist: these principles can be traced to various sources in antiquity (again, what I, and not necessarily McEvilley, call premodernist). What I see as modernist is really the emergence or movement toward a tolerance of so many different kinds of ideologies. Eventually so many ideologies emerged that the notions of diversity, contingency, and relativity had to be grappled with. And they are still being grappled with, though now they are also being assimilated within many of the competing ideologies of postmodernism and multiculturalism.

Although we know that, historically, great centers of international trade had to recognize and contend with the issues of diversity, contingency, and relativity in the practice of daily intercourse, the local overview usually reduced that practice to underlining principles like those of universality and absolute truth. In other words, although each culture manifested its truths and values differently, it was usually believed that beneath these differences one fundamental human essence presided. And though these assumed universal essences and foundations varied in description from model to model, such differences were always attributed to lapses in human knowledge. Only systems of thought that assumed diversity, contingency, and relativity as the ubiquitous and ever-changing order of the world, and in which purities, essences, and foundations are but ideals, are able to conclude that it is not lapses in human knowledge that accounted for the different models of the world but rather the ever-changing nature of relationships in the world that made essentialist and foundational models of reality seem inadequate.

Because McEvilley's education was steeped in the nonfoundational, antiessentialist, pluralist systems of ancient Greece and India, he was able to recognize that postmodernism was assimilating difference, contingency, and relativity as its defining principles. He would naturally challenge the systems of modernism that made pure form,

human essence, and aesthetic universalism central to its practice. Modernism did generate a succession of systems that were purist, essentialist, and foundationalist, and modernism by and large did exalt these values. But in recognizing this tendency of modernism alone, we neglect that modernism also afforded an arena in which the succeeding ideologies could negate one another. To my mind it is this alternation between the promotion and negation of ideas that defines modernism. Modernism seems to be a conflict and succession of difference. Postmodernism, on the other hand, seems to be the recognition that differences can coexist and that models need not be reconciled in any single essence or foundation, that there is no unity necessary for their coexistence except the unity that comes paradoxically in diversity.

Like Lyotard, Jameson, and Habermas, McEvilley is suggesting we are presently combatting essentialist and foundationalist models and moving toward building a civilization in which there is no all-encompassing discipline, no ontology, or epistemology, religious faith or cosmology which legitimizes or grounds all other inquiries and systems. He is in very practical yet global terms saying what Deleuze and Guattari suggest more poetically: that we replace the conventional views of the mind, its privileging of a (falsely) innate aesthetic response, the belief in absolute and pure form that such an aesthetics presupposes, the romantic notion of historical necessity that grows from notions of absolute value, and the colonialist impetus (continuing discretely today) that uses historical necessity as its apology. And we are to replace them all with a nomadic virtuosity that allows us to examine the models that exist outside the West and that existed prior to the late modern era. For in reference to the artworld, he sees the conjunction of all these false, divisive, and unnecessary issues today as nothing more than pretexts for the aggrandizement of careers, the appreciation of art's commercial value and the securing of art historical legitimacy along Eurocentric lines.

Of course, McEvilley's critique of modernism's closures has been virtually ratified by an entire generation. Formalism rarely lays claim today to displacing content or resisting interpretation; Western primitivism is hardly ever discussed without some acknowledgement of what it meant to colonial powers of the past and what it

means today to postcolonial populations; the appellation "primitive" applied to tribal peoples has been shown to be Eurocentric; and objective knowledge and facts, even science, have been advanced by many to be but an intersubjective consensus among interested parties who at best remove their egos but not their most basic biases from the collection of data and shared discourse.

McEvilley's criticism has always been nomadic in its freedom of analysis, literary style, and the choice of cultural models it visits. Perhaps I place too much stress on my own bias and method of working, but McEvilley has shown his interest in a nomadic approach in "Arrivederci, Venice: The Third World Biennials" when he conjectures that in the emerging biennials different cultures are presenting their images to one another in a more or less open exchange, and that by doing so "the forces that shape the world are laid out in diagrammatic clarity only to shift as they both incorporate and resist one another." And in the introduction to his book *Art and Otherness*, McEvilley stresses that "all judgments, in fact, are relative (to claim otherwise is to claim divine revelation), and a relative judgment is not necessarily unreal: it is limited only in its applicability. As the conditions that produce them change, so judgments of quality change." In "The Tomb of the Zombie," he describes postmodernism as "a shifting sequence of impure and conflated positions which give up no options." And in his essay "Revaluing the Value Judgment," when he is arguing that we become more self-conscious in our exercise of the value judgment, he urges that "we should learn to relativize our own value judgments, to see them as arising from certain circumstances, and to see that other circumstances would give rise to different ones." This is the last step one makes in deciding whether to continue using one's customary system of values or to adopt a new system suggested by others, however temporarily. We make such decisions only after we visit the circumstances of others, and this visitation, or rather the attitude of actively visiting the circumstances of others, is the nomadic project.

For if there is a nomadic enterprise today, it is no doubt that of the consumption of culture; and if there is a nomadic profession, it surely must be that of the cultural critic or, variously, the critic of art, literature, cinema, music, or theatre. In the expanding agora of international civilization, the disparity in models of reality and identity

multiplies at an unprecedented rate. Augmented by technology and individual subjectivity, the individual's will, once restrained by local custom and existential conditions, is released in a creational and explorational mobility. Add to this the magnitude of the geocultural convergence and collision eroding conventional territorial boundaries and identifications (defining ethnicity, nationality, race, class, gender, and sexual preference), then one can see how adventurous culturophiles might, at will, make great ideological and territorial leaps in a few contemplative moments and without moving at all. This is true whether the culturophile keeps to the culture of her origins or moves beyond her own enculturation to embrace those of others.

McEvilley realizes that because there are so many models of reality and identity existing simultaneously, because there are so many societies and cultures converging in a global community, because discourse is being negotiated among them, and because we are recognizing multiple histories of the world, we require a critical attitude that rides with the shifts in civilization's discourse. The best of today's critics are ready to visit the models of any given community—ideological, spiritual, political, economic, technological, scientific, aesthetic—at any given time without obstructing communication or insinuating personal models on them. This does not mean that we must have expertise in those models or even accept them personally, but we must be ready to defer and then adapt all personal criteria responsively in acknowledgement of the world's diversity. One would hope that this preparation for nomadic migration would abjure and subvert authoritarian and hegemonic criteria.

Nomadic criticism is at least as old as Herder, who 200 years before McEvilley identified the relativity of the worldly context and ideological models propelling an artform. He may have been the first modern Western critic on record to have raised the currency of difference. McEvilley expands the path paved by Herder when he approaches art that is foreign or new and *provisionally* and *practically* suspends the ideology and customary modus operandi of his own life to understand those essential in the life of another individual. This doesn't mean that he stops believing what he customarily believes, or that he doesn't ever apply those beliefs while visiting the models and operations of others, for he must believe in nomadism to defer all

other personal models. But in accepting nomadic principles, it is no longer as difficult to see that public discourse must heed the parity of its participants and respect a diversity of models to succeed, rather than impose ideologies as truths.

Nomadic criticism renders relativism and pluralism dynamically. For relativism and pluralism uphold the subjective in a static way and recognize the integrity of difference without engaging it. The nomadic project, by contrast, encourages both individuals and public to migrate from model to model, to engage those models to enhance communication and relations, to increase the odds for finding the best possible explanations or solutions to specific problems, and, perhaps most importantly, to resist authoritarian approaches in thought and life. But it also offers a sense of play that may be instrumental in levitating even the most serious activities. As every assertion is potentially authoritarian, we can only protect ourselves from hegemonies by asserting an authority of nomadism or relativism, in which, paradoxically, all models are allowed to be voiced and asserted, but in a public arena in which no one model can dominate the others. Conflict will be perpetual; discord will continue; difference will prevail. Assertions amidst such difference are conversational, to be debated, to be heard. Nomadic criticism recognizes the diversity of the world that is always operative.

In "The Selfhood of the Other," from the catalogue to *Africa Explores*, published by the Center for African Art in New York, McEvilley reveals his nomadic attitude fully:

One would think that a postcolonial attitude must acknowledge different theories of knowledge, including some that imply the falsity of one's own inherited assumptions. One is bound, in other words, to betray one's own specific ethnic inheritance in the attempt to open oneself to the reality of others—"to try to do away with my own presence," as Todorov says, "for the other's sake." . . .

Acknowledging a variety of conflicting theories as equal approaches to reality of course precludes any attempt to establish an objective or universal scale of certainty. Matters of truth and its security of self become accepted simply as parts of what Michel Foucault called the game of truth and falsity. So in attempting to get into a postcolonialist (as distinct from neo-colonialist) frame of mind, both the European and the African must develop the ability to switch value frameworks and cognitive frameworks at will.

There are common cognitive acts which parallel this idea. Suppose, for example, that one is presented with a sheet of paper that has markings on it and is then questioned about its quality. One will first have to know what the markings are intended to be. if they are identified as a poem, let's say, they may seem very bad, but when they are identified as a cartoon they may be judged to be very good; if they are identified as a drawing in the high art sense they may seem to be mediocre, as a map, abominable, and so on. Similarly a post-Modern epistemology involves a constant shifting identity such that one could say, If I were a Zulu I might say this work is not so good; If I were a French aristocrat, hey, it's great; an ancient Egyptian, run of the mill; an American entrepreneur, simply boring—and so on. Thus the etic attitude is not singular and elevated above others, but a compendium of many emicnesses. (And what is one really, in the midst of this unanchored or rudderless sailing on cognitive seas? This one does not know yet.)

*I*t is important that we realize that our Modernism is not unique. In an earlier instance, in the ancient Greek democracies from about 550 BC till about 350 BC, the tradition of the new was fully in effect in literature, music, and the fine arts, as well as in social and political experimentation. The achievements of the sculptors Pheidias and Polykleitos posed the problems for Lysippos and Praxiteles, and so on. Euripides and other poets transformed the inherited metrical system into complex free verse, as happened in late-nineteenth century poetry in Europe and America. Timotheus, Euripides' friend, and other composers called the New Musicians, leveled distinctions between modal harmonies with an increasing chromaticism which parallels the breakdown of the key in early Modern music. In theater, the proscenium arch was breached as radically by Aristophanes (who once had the actors throw water and wheat chaff on the audience in the middle of a play) as by Vsevolod Meyerhold. Socialism grew, meanwhile, until in Pericles' Athens the state was the leading employer.

Then, as now, Modernism arose in the context of a positivistic democracy carried away by emerging international hegemony to an almost giddy sense of its ability to solve social and cultural problems. Thus, certain of the future, a culture gives away its past. Traditions that developed over centuries or millennia are discarded almost casually on the historicist assumption that something better will inevitably replace them. The intellectual origin of this activity was in the work of the Sophists, who are the first humans on record for stating publicly that convention is not a binding law but a material for us

to shape as we want it. For our period, Hume and Voltaire and the other thinkers of the Age of Reason served that function.

The innocent confidence that the Modernist imperative requires ended, in the Greek case, with the catastrophic loss first of hegemony, then of self-rule. In the age that followed, called the Alexandrian, the tradition of the new was reversed. The idea of solving (and hence posing) one more formalist problem was no longer inspirational. The inner imperative of Greek art and culture turned toward its past. While it was not possible to regain in all innocence what had been sacrificed to the Modernist impulse, it was possible, through quoting, to enter into a new relationship with it. Theocritus wrote in the dialect of Sappho—which he had never heard; his readers were expected to recognize the allusion as a foundational content in his work. In time, new literary genres arose that featured quoting, like the "Scholars' Conversation," in which learned people play an intricate game of responding quotations and allusions; and the *cento*, a poem that was made up entirely of lines quoted from other poems. A huge industry arose in copies of great classical statues.

A period in which traditions are destroyed is apt to be followed by a period of nostalgic longing for them and attempts to reconstruct them. The guilt of having destroyed them is allayed by incorporating them into the very context of their destruction. It seems clear that we are involved in an experience that parallels to some extent that of the Greeks. Similar value judgments have been rendered in both cases. The Alexandrian age is often regarded as one of exhaustion, as a time when Greek culture replayed the elegant achievements of its past, arraying them as a last review of antique riches before giving up the ghost. Post-Modernism, too, has been decried as a failure of nerve, a submission of free will, an abortive termination of a project that was not yet complete. But what could it mean for a project based on institutionalizing change to be "complete"? The idea that cultural history is inherently dominated by an arc of progress is a form of disguised millennialist historicism which is, really, a superstition. The great superstition of the post-Sophistic Greek culture was its faith in the efficacy of reason as an engineer of social change; in our time this superstitious faith has been redoubled by the religious overtones with which Darwinism has entered into ideas of social and spiritual advancement. The puritanical urgency of the Modernist imperative

was based on hidden residues of mythic structures which still carried with them the intensity of divine promise. Clearly, progress has been expected to produce, in time, a human condition so improved as to be virtually Edenic: a state so good that the idea of further progress becomes inconceivable. One thinks of those prophetic cults that have expected the Millennium (or the Revolution, or the Aquarian Age) to arrive within a few days, years, or decades. In this sense Modernism was yet another disguised form of the Christian prophecy of the End of History (which is striving), and the attainment of the ahistorical Edenic paradise again (as reward for that striving).

If we are to derive a beneficial lesson from this our Alexandrian time, it will be in part by paying attention to what it reveals about the delusions of our Modernism, and about our own ability, or eagerness, to be so deluded. To do so, one must relate to quotations as a type of content. The flaw in Modernism was precisely its conviction that it was not quoting and varying, but creating. Seen in this larger context, Alexandrian or post-Modern quoting is simply a process of bringing out into the open what all modes of expression do all the time anyway, but without usually bothering to acknowledge (or even realize) it. Quoting is an inevitable component in all acts of communication; it is what makes communication possible. Communication operates upon a foundation of habits; that is, codes shared between the senders and receivers of messages. Every message thus is a quotation or allusion to the whole mass of past messages in the same code, which have established the habits of recognition. To speak without quoting would be gibberish—or rather, it would not be speech at all, but sound, like wind or waves. Communication not based on quoting is a mythic ideal, like the innocent eye; both are fragments of the myth of Eden, of an ahistorical condition in which, since there is no historical sequence, everything happens, as Breton said of the unconscious, "always for the first time." One thinks of the Medieval experiment in which two children were raised without ever hearing language, to see what language they would naturally speak—which was assumed to be the language of Eden. Of course they spoke none, having been given no examples of one to quote. In the beginning was the Word—and since then there's been the quotation.

In most acts of communication, the quoting level is in the background; it functions almost invisibly, the better to foreground the

specific present message. But when Theocritus quoted Sappho's dialect and meters, when Duchamp quoted the *Mona Lisa*, when a contemporary painter quotes Alexander Rodchenko or Francis Picabia, Jackson Pollock or Yves Tanguy or Andy Warhol, with full certainty that the quotation will be recognized, the relationship is directly reversed because the fact of quoting is placed in the foreground.

It is no surprise that such activity should be common in cultures that, like ours or that of Alexandrian Greece, have opened their receivers to the sign-systems of foreign cultures; such an experience either teaches one the relativity of one's own values and codes, or produces a xenophobic reaction designed to avoid that realization. Both modern Europe and Alexandrian Greece focused special attention on the semiotic impersonality of cultural expression. The Greek rulers of Egypt, for example, in a hypersophisticated act of political manipulation, created for the native proletariat a new religion constructed cold-bloodedly out of extant symbolic codes. In our time, Roland Barthes expressed the impersonality of semiotic transactions as "the death of the Author": it is not an individual who speaks, he said, but Language that speaks through the individual. In the same sense, it is not the individual who makes images, but the vast image bank of individual. That image bank (like language) can be viewed as a vast transpersonal mind aimlessly and relentlessly processing us through its synapses. To that extent, art based on quoting postulates the artist as a channel as much as a source, and negates or diminishes the idea of Romantic creativity and the deeper idea on which it is founded, that of the Soul. If we feel an ethical resistance to quoting it may be because we hold too dear the idea of Soul, because we cherish an essentialist prejudice about what art *should be.* At such a moment one thinks of Wittgenstein's advice to *look and see what it is.*

Despite its apparent disparagement of the idea of an integral self, quoting is an art mode in which the artist's intentions are brought into unusual prominence. Allusion, for example, always involves awareness of the artist's intention to allude, rather than to plagiarize. Irony, also, which must be an ingredient in most works of this type, involves a judgment about the artist's intentions. The old feeling of the leap of the artist's insight is not gone, but considerably altered in range and relevance: that leap is now a meta-leap, made up of the

ruins of past leaps. Quotational painting is addressed as much to the
mind as to the eye. The idea that intelligence should be in an antag-
onistic relationship to the senses is an abomination, like all
Manichaean-type dualisms. The dualisms of form and content, spirit
and matter, mind and body, are all really the same dualism, one
which arose in part as an archaic propaganda system to support an
unchanging form of the state. As a second-generation form of con-
ceptual art, this recent painting cannot be regarded as painting pure
and simple in the old sense. If this is understood, Duchamp's phrase
"stupid as a painter" will not apply; alternately, if the work lacks the
kind of intelligence appropriate to it, it will be student work, or prim-
itive work, or spurious. Further, since wit functions by a substitution
of expectations, by a simultaneous invoking and denying of condi-
tioned responses, it is potentially a means of insight into condition-
ing. The semiotic sensing involved produces a means of locating or
defining the present, that is, oneself. When an artist quotes a famil-
iar icon from the past in a clearly contemporary work, we sense semi-
otically the difference between the Then and the Now of the work
and at the same time the relationship between them. That relation
locates our present stance with a sometimes uncanny precision,
which yields a subtle strangeness and an actual pleasure in the mind's
tasting and appreciating of it. We sense the refoldings and redefin-
ings of the vast image bank of all cultures and its creators. To this
degree it is our own aesthetic habits that are held up as objects of
contemplation in these ideograms of the history of taste.

A key function of this contemplative/critical regurgitation of
images is to replay or reconfront the problem of abstraction, or, to
call it by the other side of the coin, the problem of representation.
Oddly, though our artists explored the interfaces and relations
between these modes for nearly a century, neither they nor we were
able to see clearly what we had to see: that representation is not rep-
resentation and abstraction is not abstraction. Quotational art places
the historical repertoire of art styles into the realm of nature, not in
the sense that they are treated as laws of nature, but that they become
simply more objects occurring on the screen of consciousness. The
various styles that once were thought of as either representational or
abstract may now be seen as neutral data which, according to con-
vention, may be viewed as either this or that. The very distinction

between representation and abstraction was an artificial convention: all image codes are neutral in this respect, until we project onto them one value or the other. What is being demonstrated is something about convention, and something about habit.

One of the great discoveries of our time, as of the Sophistic age in ancient Greece, has been the discovery of the neutrality of information. At its most effective, quotational work directs us toward this realization and brings us face to face with our own internal resistance to it. It focuses our attention less upon the images themselves than on our odd feelings about them, which have been made strange—and thus made visible—by achronological structuring. Our habit-expectations about temporal succession (and thus about history) are defined by the atemporal image-cluster. To the extent to which that atemporality, or ahistoricism, seems strange or unacceptable, to that extent we are still controlled by the old habit-expectations. Those expectations were based on a false conviction of our own innocence; our ability to see innocently, to see "always for the first time," is affronted by the quoting process, as is the ultimately myth-based conviction of a historical inevitability. The confrontation with one's sense of the strangeness of it offers a glimpse of freedom, as we see that our expectations, our history, our selves, are all artifacts thrown off by infinite regresses of quotations, and that finally, freed from the myths of innocence and inevitability, we may do with them whatever we want.

Heads It's Form, Tail It's Not Content

The quotations and footnotes of this essay have emerged as a lacunary map of certain moods in our history (no attempt has been made to make the map complete). Some of the critics quoted have since changed their positions; others were less inflexible than out-of-context quoting might imply (Michael Fried, for example, cautioned sanely that "the formalist critic [should] bear in mind at all times that the objectivity he aspires toward can be no more than relative."[84]) In a sense this mapping is a response to Ezra Pound's dictum,

Every critic should give indication of the sources and limits of his knowledge.[85]

1. Erwin Panofsky, *Meaning in the Visual Arts*, Garden City, New York: Doubleday/Anchor Books, 1955, p. 22.
2. Jack Burnham, *The Structure of Art*, New York: George Braziller, p. 13, 1971.
3. Rosalind Krauss, "A View of Modernism," *Artforum*, p. 49, September 1972.
4. Michael Fried, *Three American Painters*, Cambridge, MA: Fogg Museum, Harvard University, 1965, p. 39.
5. Alan Tormey, "Art and Expression, A Critique," in *Philosophy Looks at the Arts*, ed. Joseph Margolis, rev. ed. Philadelphia: Temple University Press, 1978, p. 359.
6. Cf. Nicholas Calas, *Art in the Age of Risk*, New York: E.P. Dutton and Co., 1968, p.136. By reducing art to pure structure the minimalists make it impossible for the artist to express emotions. When Michael Fried claims that Noland and Olitski are painters of feeling, he does not explain how a structure of concentric circles, a pyramid of V lines, or a monochrome field are to be viewed as expressing feelings.
7. Douglas Davis, "Post Post-Art I," *Village Voice*, June 25, 1979, p. 37.
8. Fried, *Three American Painters*, pp. 33–37.
9. Clement Greenberg, "Modernist Painting," in *The New Art*, ed. Gregory Battcock, New York: E.P. Dutton and Co., 1973, p. 74.
10. Clement Greenberg, *Art and Culture*, Boston: Beacon Press, 1961, p. 6.

11. Clement Greenberg, "Complaints of an Art Critic," *Artforum*, October 1967, p.39; see also Greenberg, "The Necessity of Formalism," *New Literary History* 11 (1971–72), pp. 174ff.

12. Douglas Davis, *Artculture: Essays on the Post-Modern*, New York: Harper and Row, Icon Editions, 1977, p. 140.

13. Frank Cioffi, in *Philosophy Looks at the Arts*, ed. Margolis, p. 320.

14. Greenberg, *Art and Culture*, p. 6.

15. Jonathan Culler, *Saussure*, Glasgow: Fontana Collins, 1976, p. 19.

16. Claude Levi-Strauss, *Structural Anthropology*, English translation by Jacobson and Schoelf, New York: Basic Books, 1963, p. 141.

17. Ibid., p. 131.

18. Fried, *Three American Painters*, p. 5.

19. Robert Rosenblum, "The Abstract Sublime," in *New York Painting and Sculpture 1940–1970*, ed. Henry Geldzahler, New York: E.P. Dutton, 1969, p. 357.

20. Fried, *Three American Painters*, p. 14.

21. Joseph Campbell, *The Mythic Image*, Princeton, NJ: Princeton University Press for the Bollingen Foundation, 1974.

22. Calas, *Art in the Age of Risk*, p. 134.

23. Greenberg, *Art and Culture*, p. 139.

24. William S. Wilson III, "Art Energy and Attention," in *The New Art*, ed. Battcock, p. 247.

25. Calas, *Art in the Age of Risk*, p. 145.

26. For related approaches to Mondrian, see Robert P. Welsh, "The Birth of de Stijl Part 1, Mondrian: The Subject Matter of Abstraction," *Artforum*, April 1973, pp. 50–53, and Erik Saxon, "On Mondrian's Diamonds, *Artforum*, December 1979, pp. 40–45.

27. For detailed discussion of this interpretation of Klein's work, see Thomas McEvilley, "Yves Klein, Messenger of the Age of Space," *Artforum*, January 1982, pp. 38–51, "Yves Klein, Conquistador of the Void," in *Yves Klein: A Retrospective*, Houston and New York: Institute for The Arts and The Arts Publisher, Inc., 1982, pp. 19–88, and "Yves Klein and Rosicrucianism," ibid., pp. 238–254.

28. Greenberg, *Art and Culture*, pp. 171–74.

29. Davis, *Artculture*, pp. 5–6.

30. Wilson, "Art Energy and Attention," p. 251.

31. Fried, *Three American Painters*, p. 22.

32. Davis, *Artculture*, p. 46, referring to Dan Flavin's sculpture.

33. Harold Rosenberg, "Art and Words," in *Idea Art*, ed. Gregory Battcock, New York: E.P. Dutton and Co., 1973, p. 153.

34. Ibid., p. 151.

35. Greenberg, *Art and Culture*, p. 225.

36. Ibid.

37. Burnham, *The Structure of Art*, p. 4.

38. See *Art as Art: The Selected Writings of Ad Reinhardt*, ed. Barbara Rose, New York: Viking Press, 1975, p. 189 and elsewhere. For a fuller analysis of these and related textual comparisons, see Thomas McEvilley, *The Monochrome Adventure: A Study in the Form and Content of Modern Painting*, limited edition, Los Angeles: Full Court Press, 1981.

39. Rosenberg, "The American Action Painters," in *New York Painting and Sculpture, 1940–1970*, ed. Geldzahler, p. 345.
40. Cited by Douglas Davis, *Artculture*, pp. 16–17.
41. Sheldon Nodelman, "Sixties Art: Some Philosophical Perspectives," *Perspecta* 11 (1967), p. 79.
42. Ibid., p. 78.
43. Davis, "Post Post-Art, II," *Village Voice*, August 13, 1979, p. 40.
44. Greenberg, *Art and Culture*, p. 5.
45. Joseph Kosuth, "Art After Philosophy," in *Conceptual Art*, ed. Ursula Meyer, New York: E.P. Dutton & Co., 1972, pp. 158–170.
46. Aristotle, *Metaphysics*, 1006b1–10.
47. The philosopher Antisthenes used the Law of Identity to reject all discourse on the grounds that since A is only A, any nontautological predication, such as that A is B, is absurd. This is the only way in which the Law of Identity can be used as a conclusion of thought, and even when used in this way it applies equally to all things and does not accord to art any special status. For a discussion of this line of ancient thought, see Thomas McEvilley, "Early Greek Philosophy and Madhyamika," *Philosophy East and West* 31, 2 (April 1981), pp. 141–164.
48. Kosuth, "Art After Philosophy," p. 153.
49. As Douglas Davis also has noted, *Artculture*, pp. 16–52.
50. Susan Sontag, *Against Interpretation and Other Essays*, New York: Noonday Press, 1966, p. 5.
51. Ibid., p. 7.
52. Marv Friedenn, *If Horses or Lions had Hands*, Los Angeles: Full Court Press, 1981, p. 73.
53. Sontag, *Against Interpretation*, p. 11.
54. Ibid., p. 14.
55. Ibid., p. 5.
56. Ibid., p. 11.
57. Aristotle, *Metaphysics*, 1075b20, 1029a.
58. J. Maritain cited in Panofsky, *Meaning in the Visual Arts*, p. 5.
59. Ibid., p. 16.
60. Donald Kuspit, *Clement Greenberg: Art Critic*, Madison, WI: The University of Wisconsin Press, 1979, p. 18.
61. Calas, *Art in the Age of Risk*, p. 147.
62. Of course there is precedent for many elements of Greenbergian formalism in early 20th-century art criticism, e.g. in Roger Fry, who wrote of "the esthetic emotion" and of "the pre-eminence of purely plastic aspects" (Roger Fry, *Transformations: Critical and Speculative Essays on Art*, Garden City, NY: Doubleday Anchor Books, 1956, pp. 6–14, originally published 1926).
63. Terence Hawkes, *Structuralism and Semiotics*, Berkeley, CA: University of California Press, 1977, p. 152.
64. Ibid.
65. Margolis, *Philosophy Looks at the Arts*, p. 366.
66. Frank Cioffi, "Intention and Interpretation in Criticism," in ed. Margolis, ibid., p. 324.
67. Ibid.
68. Edward Said, "The Text, the World, the Critic," in *Textual Strategies:*

Perspectives in Post-Structuralist Criticism, ed. Josue V. Harari, Ithaca, NY: Cornell University Press, 1979, p. 171.

69. The only cultural context in which one hears claims of undifferentiated awarenesses or thoughts-without-objects is in Vedantic and other claims of absolute mystical states—and surely that is not what Fried means by attributing "feeling" to the works of Noland and Olitski.

70. Calas, *Art in the Age of Risk*, p. 208.

71. A letter of 1888, cited by R. W. Alston, *Painters' Idiom*, London, 1954, p. 132.

72. For examples see A. Mookerjee, *Tantra Asana*, New York: G. Wittenborn, 1971, pl. 97, and *Tantra Art*, New Delhi, New York, Paris: Kumar Gallery, 1966, pl. 95.

73. Kasimir Malevich, "Suprematism," in *The Non-Objective World*, ed. L. Hilbersheimer, Chicago, 1959, p. 67.

74. Gershom G. Scholem, *Major Trends in Jewish Mysticism*, New York: Schocken Books, 1941, p. 297.

75. *Agnes Martin*, exhibition catalogue, Munich (Kunstraum), 1973, p. 42.

76. Letter to Betty Parsons, Oct. 18, 1951, cited by Lawrence Alloway in exhibition catalogue, *Robert Rauschenberg*, Washington, DC (Smithsonian Institution), 1976, p. 3.

77. Jules Olitzki, "Painting in Color," *Artforum*, January 1967, p. 20.

78. In *Brice Marden*, exhibition catalogue, New York (Guggenheim Musuem), 1975, p. 11.

79. Allen Leepa, "Minimal Art and Primary Meanings," in *Minimal Art: A Critical Anthology*, ed. Gregory Battcock, New York: E.P. Dutton and Co., 1968, p. 208.

80. Calas, *Art in the Age of Risk*, p. 120.

81. Joseph Margolis, *The Language of Art and Art Criticism*, Detroit: Wayne State University Press, 1976, pp. 91–92.

82. Jacques Derrida, *Writing and Difference*, trans. by Alan Bass, Chicago: University of Chicago Press, 1979, p. 18.

83. Davis, "Post Post-Art, I," p. 40.

84. *Three American Painters*, p. 6.

85. In T.S. Eliot, ed., *Literary Essays of Ezra Pound*, New York: New Directions, 1968, p. 56.

Seeking the Primal Through Paint: The Monochrome Icon

1. Pseudo-Longinus, *On the Sublime*, ed. W. Rhys Roberts (New York: Garland, 1987).

2. Presented by Plotinus at *Enneads* 5.8.1.

3. F. W. Schelling, *System of Transcendental Idealism*, VI.3. See Albert Hofstadter and Richard Kuhn, eds., *Philosophies of Art and Beauty, Selected Readings in Aesthetics from Plato to Heidegger* (Chicago: University of Chicago Press, 1976), p. 373.

4. Which Rudolph Otto wrote of in *The Idea of the Holy* (Oxford University Press, 1968).

5. Schelling, *System of Transcendental Idealism*; Hofstadter and Kuhn, *Philosophies of Art and Beauty*, p. 372.

6. James McNeil Whistler, "Ten O Clock Lecture," in *The Gentle Art of Making Enemies* (first ed., New York: John W. Lovell, 1890), p. 155.

7. Cited by R. W. Alston, *Painter's Idiom* (London: 1954), p. 132.

8. P. D. Ouspensky, *A New Model of the Universe* (New York: Random House, 1971), pp. 6–8.

9. Cited in Alston, *Painter's Idiom*; my emphasis.

10. William Seitz, *Claude Monet, Seasons and Moments* (New York: Museum of Modern Art, 1960), pp. 23, 30.

11. From Rene Gimpel's unpublished journal; cited in ibid., p. 4.

12. Cited in *Claude Monet: Letzte Werke*, exh. cat. (Basel: Galerie Beyeler, 1962), p. 6.

13. Ouspensky, *A New Model of the Universe*, pp. 6–8.

14. Cited by Lucy Lippard, "The Silent Art," *Art in America 55*, no. 1 (January–February 1967): 58–63, cited at 59.

15. Kasimir Malevich, "Suprematism," in L. Hilbesheimer, trans., *The Non-Objective World* (Chicago: Theobald, 1959), pp. 66–102, cited at 67.

16. Ibid.

17. Ibid., figs. 79 and 80.

18. Ibid., figs. 87 and 88.

19. For example, Jacques Dupin, who writes: "Through painting Miró rediscovers the way all the mystics followed." *Joan Miró, Life and Works* (New York: Abrams, 1961), p. 160.

20. As in *Composition Abstract* (1927; Musée d'Art Moderne, Paris).

21. For example, *Dreieckscomposition* (1928; Walrauf-Richartz Museum, Cologne).

22. As in *Komposition Nr. 122* (1941), Wallrauf Richartz Museum, Cologne, a green near-monchrome with token Platonism of thinly painted blue triangles.

23. As in *Relation de lignes et couleurs* (1939), a white near-monochrome with four little squiggles of different colors.

24. As in *Composition-Relief* (1937), a geometrical abstraction in the style of Mondrian but almost entirely white.

25. In the Wallrauf-Richartz Museum, Cologne.

26. For Klein's life and work, see Thomas McEvilley, "Yves Klein, Conquistador of the Void," in *Yves Klein, A Retrospective* (Houston: Institute for the Arts, and New York: The Arts Publisher, 1982).

27. For details, see Maurice Tuchman, ed., *The Spiritual in Art: Abstract Painting, 1890–1985* (New York: Abbeville Press for the Los Angeles County Museum, 1986).

28. See Thomas McEvilley, "Yves Klein and Rosicrucianism," in *Yves Klein, A Retrospective*, pp. 238–55.

29. "Discourse on the Occasion of Tinguely's Exhibition in Duesseldorf, January, 1959," trans. Thomas McEvilley, ibid., p. 234.

30. From Yves Klein, "The Monochrome Adventure," ibid., p. 220.

31. Translated as in G. C. C. Chang, *The Hundred Thousand Songs of Milarepa* (New Hyde Park, N.Y.: University Books, 1962), pp. 102, 103, 128, 146, 147.

32. Ibid., p. 147.

33. From "The Monochrome Adventure," in *Yves Klein, A Retrospective*, p. 220.

34. Related to the author by Rotraut Klein-Moquay, Klein's widow.

35. Cited by Enrico Crispolti, *Lucio Fontana, catalogue raisonné des peintures, sculptures et environments spatraux*, 2 vols. (Brussels: Arxiu Lucio Fontana-La connaissance, 1974), vol. 1, p. 7.

36. Ibid.
37. Fontana in the 1951 *Manifesto Tecnico*, in ibid., p. 120.
38. Ibid., pp. 123–24.
39. Otto Piene cited in Lawrence Alloway et al., eds., *Zero* (Cambridge, Mass.: 1970), p. xxi.
40. Ibid., xx.
41. Ibid.
42. Ibid., p. 14.
43. Ibid.
44. Mack cited in Alloway et al., eds., *Zero*, p. xi, from the exhibition catalogue, "Vision in Motion—Motion in Vision" (Antwerp, Hessenhuis: March 1959).
45. All quotations are from Alloway et al., eds., *Zero*, pp. 230–32.
46. Piero Manzoni, "Free Dimension," *Azimuth*, no. 2 (Milan 1960): 46–47.
47. Piero Manzoni, in *Piero Manzoni, Paintings, Reliefs and Objects: Writings by Piero Manzoni*, translated from the Italian by Caroline Tisdall and Angelo Bozzola (London: Tate Gallery Publications, 1974), p. x.
48. For example, *Untitled 1948/49*, Wallrauf-Richartz Museum, Cologne.
49. Irving Sandler, *The Triumph of American Painting* (New York: Harper and Collins, 1970), p. 158.
50. Ibid., pp. 158, 162, 170.
51. Barbara Rose, *Readings in American Art* (New York: Praeger, 1968), p. 142.
52. Clyfford Still, in T. Sharpless, *Clyfford Still* (Philadelphia: Institute of Contemporary Art, University of Pennsylvania: Institute of Contemporary Art, University of Pennsylvania, 1963).
53. Barnett Newman, *Tiger's Eye* 1, no. 6 (1948), 51–53.
54. Barnett Newman, "The First Man Was an Artist," 1947, in Herschel B. Chipp, ed., *Theories of Modern Art: A Sourcebook by Artists and Critics* (Berkeley: University of California, 1968), p. 551.
55. Gershom Scholem, *Major Trends in Jewish Mysticism* (New York: Schocken, 1954).
56. Henry Bowie, *On the Laws of Japanese Painting* (New York: Dover, n.d.), p. 43.
57. Osvald Siren, *The Chinese on the Art of Painting* (New York: Schocken, 1971), pp. 95, 97.
58. Herbert Guenther, *Buddhist Philosophy in Theory and Practice* (Baltimore: Penguin, 1971), p. 21.
59. Translation by Edward Conze, *The Perfection of Wisdom in Eight-Thousand Lines* (Bolinas, Calif.: Four Seasons Foundation, 1973), p. 110.
60. Ad Reinhardt, "Timeless in Asia," *Art News* 58, no. 9 (January 1960): 32–35.
61. *Ad Reinhardt*, exh. cat. (New York: The Jewish Museum, 1966), p. 10.
62. "Twelve Rules for a New Academy," in Barbara Rose, ed., *Art as Art: The Selected Writings of Ad Reinhardt* (New York: Viking, 1975), pp. 203–6.
63. Mark Rothko, "The Romantics Were Prompted," *Possibilities*, no. 1, (Winter 1947–48): 48.
64. Mark Rothko to Harold Rosenberg, *The Dedefinition of Art* (New York: Collier Books, 1973).
65. Mark Rothko to Dore Ashton, as related to the author in a conversation.
66. From a statement written and signed by filmmaker John Huston in Houston, Texas, April 9, 1977; Rothko Chapel Archives.
67. Rosenberg, *The Dedefinition of Art*, pp. 100–8.

68. Sandler, *Triumph of American Painting*, pp. 175, 183.
69. Brian O'Doherty, *American Masters* (New York: Dutton, n.d.), pp. 154, 155, 156, 157, 165, 166.
70. Robert Motherwell, "What Abstract Art Means to Me," *Museum of Modern Art Bulletin* (Spring 1951), reprinted in Frank O'Hara, *Robert Motherwell* (New York: Museum of Modern Art, 1965), p. 45.
71. Robert Motherwell, "A Tour of the Sublime," *Tiger's Eye* (December 15, 1948), reprinted in ibid., p. 45.
72. Ibid., pp. 41, 42.
73. Mark Rothko, cited in Rosenberg, *The Dedefinition of Art*.
74. Robert Rauschenberg, cited by Lawrence Alloway, *Robert Rauschenberg*, exh. cat. (Washington, D.C.: Smithsonian Institution, 1976), p. 3.
75. Ibid.
76. Brice Marden, in ibid.
77. Bob Law, *7 Aus London*, exh. cat. (Bern: Kunsthalle, 1973), n.p.

Doctor, Lawyer, Indian Chief

1. Richard E. Oldenburg, "Foreword," in William Rubin, ed., *"Primitivism" in Twentieth Century Art: Affinity of the Tribal and the Modern*, New York: The Museum of Modern Art, 1984, p. viii.
2. The Museum of Modern Art, New York, press release no. 17, August, 1984, for the exhibition *"Primitivism" in Twentieth Century Art: Affinity of the Tribal and the Modern*, p. 1.
3. Revised and republished as Robert Goldwater, *Primitivism in Modern Art*, New York: Vintage Books, 1967. In 1933, 1935, 1941, and 1946, the Modern itself had exhibitions of archaic and primitive objects separately from its Modern collections. René D'Harnancourt, director of the Museum for nineteen years, was an author on the subject.
4. William Rubin, *Dada and Surrealist Art*, New York: Harry N. Abrams, 1965.
5. Two by Rubin, three by Kirk Varnedoe, two by Alan G. Wilkinson, and one each by Ezio Bassani, Christian F. Feest, Jack Flam, Sidney Geist, Donald E. Gordon, Rosalind Krauss, Jean Laude, Gail Levin, Evan Maurer, Jean-Louis Paudrat, Philippe Peltier, and Laura Rosenstock.
6. Presumably, it is this passage that Lynn Cooke refers to as "what Thomas McEvilley . . . calls the primitive with primitivism." I did not actually use that locution. See: "The Resurgence of the Night Mind: Primitive Revivals in Recent Art," in Susan Hiller, ed., *The Myth of Primitivism: Perspectives on Art*, London and New York: Routledge, 1991, p. 141.
7. Varnedoe, "Contemporary Explorations," in Rubin, *"Primitivism,"* pp. 662, 679, 681.
8. Krauss, "Giacometti," in Rubin, *"Primitivism,"* p. 510.
9. ubin, "Modernist Primitivism: An Introduction," in Rubin, *"Primitivism,"* p. 11.
10. Ibid.
11. Ibid., p. 25.
12. In an article published a year or so after this one appeared, and very much like this one, Hal Foster quotes this phrase ("argument from silence") in

quotation marks without attributing it except with the phrase "as others have pointed out." I do not in fact believe that any other author has made this point with this phrase. See: Hal Foster, "The 'Primitive' Unconscious of Modern Art," *October* 34, Fall 1985, p. 49 n.

13. Rubin, "Picasso," in Rubin, "*Primitivism*," pp. 328–330.

14. Ibid., p. 328.

15. Michelle Wallace, apparently referring to this paragraph, wrote the following, some years after this essay first appeared: "Thomas McEvilley, [Rubin's] respondent in *Artforum*, would have us shed Western aesthetics for Western anthropology, although, as James Clifford points out in his contribution to the debate, both discourses assume a primitive world in need of preservation, or, in other words, no longer vital and needless to say, incapable of describing itself." See: Michelle Wallace, "Modernism, Postmodernism and the Problem of the Visual in Afro-American Culture," in *Out There: Marginalization and Contemporary Culture*, Russel Ferguson et al., ed., New York: The New Museum of Contemporary Art, and Cambridge, MA: The MIT Press, 1990, p. 47. But the following words, in the same paragraph, seem to have escaped her attention: "No attempt is made [in the "*Primitivism*" exhibition] to recover an emic, or inside, sense of what primitive aesthetics really were or are," where "emic" is glossed with the phrase "the emic viewpoint—that of the tribal participant." I am not, in other words, guilty of her charge that I regard the so-called primitive world as "incapable of describing itself"; on the contrary, that is precisely what I have called for. On pp. 43–44 above I complain that "Rubin has made highly inappropriate claims about the intents of tribal cultures *without letting them have their say*. . . ." (Italics added.) Again, on p. 46 above, one finds: " . . . are we not ready yet . . . to let those silenced cultures speak to us at last?" In fact, not only do I call for tribal accounts of tribal cultures, I call also for their accounts of white Western culture. In the follow-up exchange of letters with Rubin and Varnedoe in *Artforum*, I refer approvingly to Robert Farris Thompson who "has taken Picasso and Amedeo Modigliani reproductions to Africa and recorded the impressions of them given by priests and priestesses of traditional religions of Africa." See the republication of this material in *Discourses: Conversations in Postmodern Art and Culture*, New York: The New Museum of Contemporary Art, and Cambridge, MA: The MIT Press, 1990, p. 388. Wallace, as quoted above, further implies that I "assume a primitive world . . . no longer vital." Perhaps she missed such passages as the following from my side of the dispute: "Roland Kirk plays the didgeridoo in Texas while Mozart's Suzanna sings from a radio in the outback. Today, any artist can be stylistically primitive or stylistically Modern. To perpetuate, on the basis of differences in look, the distinction that obtained a century ago is to commit a blindness worse than that of the eye. There is no longer much justification for the distinction; today, primitive and Modern are elements in a single vocabulary. In the emerging global information moment, classical Yoruba tradition will take its place beside classical Greek tradition, primitivist Modernism beside Modernist primitivism. This is the great and epochal subject that Rubin and Varnedoe so willfully missed." (*Discourses*, p. 394.) One wonders if Wallace has really read this material.

16. Marvin Harris, *Cultural Materialism: The Struggle for a Science of Culture*, New York: Vintage Books, 1980, p. 32.
17. Rubin, "Modernist Primitivism," in Rubin *"Primitivism,"* p. x.
18. Ibid., p. 51.
19. Edmund Carpenter, *Oh, What a Blow That Phantom Gave Me!*, New York: Holt, Rinehart and Winston, 1973, p. 54.
20. Ibid., pp. 53, 56.
21. Rubin, "Modernist Primitivism," in Rubin, *"Primitivism,"* p. 5.
22. Ibid., p. 19.
23. Sally Price quotes this passage skeptically, without apparent understanding of the context it appears in and without attention to the ethnographic evidence in support of it. See: Sally Price, *Primitive Art in Civilized Places*, Chicago and London: University of Chicago Press, 1989, p. 43.
24. Rubin, "Modernist Primitivism," in Rubin, *"Primitivism."*
25. Varnedoe, "Preface," in Rubin, *"Primitivism,"* p. x.
26. Cited in Peter Fuller, *Beyond the Crisis in Art*, London: Writers and Readers Publishing Cooperative Ltd., 1980, p. 98.
27. Arthur Rimbaud, *Une Saison en enfer (A season in hell)*, trans. Louise Varèse, New York: New Directions, 1961, p. 7.
28. Hamish Maxwell, in Rubin, *"Primitivism,"* p. vi.
 For further remarks on some of the themes explored in this article, see the appendices.

History, Quality, Globalism

1. This is the text of a talk delivered at the Stedelijk Museum in Amsterdam in 1990.

Arrivederci, Venice: The Third World Biennials

1. Gerardo Mosquero, "Speakeasy," *New Art Examiner* vol. 17 no. 1, November 1989, p. 13.
2. Ibid.
3. Ibid.
4. See, for example, Diogenes Laertius VI.22.
5. Quoted in X. S. Thani-Nayagam, "Indian Thought and Roman Stoicism," *Tamil Culture* 10 no. 3, 1963, p. 17.

"I am," Is a Vain Thought

1. Christian David Ginsburg, *The Essenes: Their History and Doctrines; The Kabbalah: Its Doctrines, Development and History*, New York: Macmillan and Co., 1956, p. 158.
2. Cited by Douglas Hofstadter, *Gödel, Escher, Bach: An Eternal Golden Braid*, New York: Random House, Vintage Books, 1980, p. 597.
3. *Houston Chronicle*, February 9, 1983.
4. *New York Post*, January 3, 1983.

5. See Yoel Hoffman, *The Idea of Self East and West: A Comparison between Buddhist Philosophy and the Philosophy of David Hume*, Calcutta: Firma KLM Private Ltd., 1980, p. 40. The term "point-instant events" is Hoffman's.

6. Hofstadter, *Gödel, Escher, Bach*, p. 574.

7. Lama Anagarika Govinda, *The Psychological Attitude of Early Buddhist Philosophy*, New York: Samuel Weiser, 1974, pp. 80, 85.

8. Bhadantacariya Buddhaghosa, *The Path of Purification (Visuddhimagga)*, English trans. by Bhikku Nanamoli, Kandy, Sri Lanka: The Buddhist Publication Society, 1975, p. 118.

9. The translation, which is quite literal, is my own. For the Sanskrit text and commentary, see Edward Conze, *Buddhist Wisdom Books, Containing The Diamond Sutra and The Heart Sutra*, London: George Allen & Unwin Ltd., 1958.

10. Wittgenstein was expressing his agreement with Georg Christoph Lichtenberg (1742–1799), who was in turn chastising Descartes. See G.E. Moore, "Wittgenstein's Lectures in 1930–33," *Mind* LXIV (1955), pp. 13–14.

11. Gilbert Ryle, *The Concept of Mind*, New York: Barnes & Noble, University Paperbacks, 1962, pp. 168, 186.

12. P.F. Strawson, "Persons," in *Essays in Philosophical Psychology*, ed. Donald F. Gustafson, Garden City, NY: Anchor Books, 1964, p. 388.

13. Roland Barthes, "The Death of the Author," in *Image, Music, Text*, English trans. by Stephen Heath, New York: Hill and Wang, 1977, pp. 143–145.

14. Barthes, "Death of the Author," ibid., p. 145.

15. B.F. Skinner, *Beyond Freedom and Dignity*, New York: Alfred A. Knopf, 1971, passim; *About Behaviorism*, New York: Alfred A. Knopf, 1974, pp. 54, 197.

16. G. Jefferson, "The Mind of Mechanical Man," *British Medical Journal* June 25, 1949, p. 1110.

17. For some work on mechanical/physiological modeling of memory, motivation, and emotion, see, e.g., Karl H. Pribram, "The Foundation of Psychoanalytic Theory: Freud's Neuropsychological Model," in *Brain and Behavior* 4, ed. K.H. Pribram, Baltimore, MD: Penguin Books, 1969, pp. 395–432; John C. Eccles, "Conscious Memory: The Cerebral Processes Concerned in Storage and Retrieval," in *The Self and Its Brain*, ed. Karl H. Popper and John C. Eccles, London: Springer International, 1977.

18. Erich Neumann, *The Great Mother: An Analysis of the Archetype*, English trans. by Ralph Mannheim, Princeton, NJ: Princeton University Press, Bollingen Series 47, 1955.

19. B.A.O. Williams, "Personal Identity and Individuation," in *Essays*, ed. Gustafson, p. 328; Carl G. Jung, *The Structure and Dynamics of the Psyche*, *Collected Works* Vol. 8, Princeton, NJ: Princeton University Press, p. 390, 1969, ; Patanjali, *Yoga Sutras*, IV. 9: see the English translation by James Houghton Woods, *The Yoga-System of Patanjali with the Yoga Bhasya of Veda-Vasya and the Tattva-Vaicradi of Vachaspati Micra*, Delhi/Varanasi, Motilal Banarsidass, 1966, Harvard Oriental Series Vol. 17.

20. Ryle, *Concept of Mind*, p. 160.

21. E.M. Forster, "The Machine Stops," in *The Eternal Moment and Other Stories*, New York: Harcourt Brace Jovanovich, Harvest Books, 1956, pp. 11, 14, 13.

22. Saint Augustine, *Confessions*, English trans. by R.S. Pine-Coffin, Baltimore, MD: Penguin Books, 1961, p. 114.

23. Buddhaghosa, *Path of Purification*, p. 72.
24. Andy Warhol, *The Philosophy of Andy Warhol (From A to B and Back Again)*, New York: Harcourt Brace Jovanovich, 1975.
25. Herbert V. Guenther, *Philosophy and Psychology in the Abhidharma*, Berkeley, CA: Shambhala Publications Inc., 1976, p. 9.
26. Guenther, ibid., p. 11.
27. Roland Barthes, *Writing Degree Zero*, English trans. by Annette Lavers and Colin Smith, New York: Hill and Wang, 1968, pp. 51, 67, 69, 77.
28. Alfred Korzybski, *Science and Sanity: An Introduction to Non-Aristotelian Systems and General Semantics*, Lakeville, CT: The International Non-Aristotelian Library Publishing Co., 1933.
29. For elaboration of this line of thought see Jerry Mander, *Four Arguments for the Elimination of Television*, New York: William Morrow, 1978.
30. Walter Benjamin, "The Work of Art in the Age of Mechanical Reproduction," in *Illuminations*, New York: Schocken Books, 1969, pp. 218–219.
31. Henri Poincaré, *Science and Method*, English trans. by Francis Maitland, New York: Dover Publicatins, 1952, p. 59. Heisenberg cited in *On Aesthetics in Science*, ed. Judith Wechsler, Cambridge, MA: The MIT Press, 1981, p. 1.
32. Karl R. Popper, *The Open Society and Its Enemies*, Vol. 1, The Spell of Plato, Princeton, NJ: Princeton University Press, 1971.

Penelope's Night Work: Negative Thinking in Greek Philosophy

1. W.K.C. Guthrie, *History of Greek Philosophy*, 5 volumes, Cambridge: Cambridge University Press, 1962–1975.
2. Cf. Philip P. Hallie, *Scepticism, Man and God: Selections from the Major Writings of Sextus Empiricus* (Middletown, Connecticut: Wesleyan University Press, 1964), p. 113.
3. Christopher Norris, *Deconstruction: Theory and Practice* (London and New York: Methuen, 1982), p. 73.
4. Gorgias DK 82b3; Aristotle, *Phys.* 191a27; Simplicius, *Phys.* 78.24.
5. For a much fuller exposition of Zeno's paradoxes with a similar sense of their meaning, see H.D.P. Lee, *Zeno of Elea* (Amsterdam, 1967 [1936]).
6. For the text see *Sextus Adv. Math.* 7.65 ff. (= DK B3), and the Pseudo-Aristotelian work *On Melissus, Xenophanes and Gorgias*. Citations of and quotations from Sextus Empiricus will follow the Loeb edition and translation by R. G. Bury, 4 volumes, Cambridge, Mass., and London, 1933–1949. *OP = Outlines of Pyrrhonism, AL = Against the Logicians*, APh = *Against the Physicists*.
7. DL 9.55. References to and quotations of Diogenes Laertius will follow the text and translation of R. D. Hick's Loeb edition, 2 volumes, Cambridge, Mass., 1925.
8. In general, Anglo-American scholars treat Democritus as a proto-empiricist (which clearly he was to some extent) and ignore his apparent phenomenalism, for which see Jean-Paul Dumont, *Le Scepticisme et le Phénomène* (Paris, 1972).
9. DK 68B7. Δόξα, from δοκεω, "to seem (to a subject)", is usually translated "opinion, dream, fantasy," etc. "Subjectivity" is the appropriate general term.

10. The view of language expressed by Hermogenes in Plato's *Cratylus* (384c) is here, as by many scholars, considered Democritean.

11. See DL 9.72, Sextus *AL* 1.136. The question of how Democritus related his skeptical attitude to his atomic theory is open. For a counterview to mine see Guthrie, *op. cit.*: II.453–465.

12. DK 68A113, B11, B69, B156.

13. *Rep.* 533cd. For a fuller exposition of this passage see my "Early Greek Philosophy and Madhyamika," *Philosophy East and West* 31.1 (April, 1981), pp. 150–152.

14. J. N. Findlay, *Plato: the Written and the Unwritten Doctrines* (London, 1974), pp. 229–254.

15. Guthrie, *op. cit.*: V. 53.

16. *Enn.* 5.5.6; 6.7.41; 6.9.3; 5.3.11; 5.1.8; 5.3.10; 5.1.6; 1.8.2; 4.1.1; 5.5.6; 6.9.6; 1.8.2; 5.5.6; William Inge, *The Philosophy of Plotinus*, II. 107–108.

17. DL 2.92–93; *AL* 1.190 ff.

18. On the possibility that Pyrrhonism somehow derived from Indian sources see my "Pyrrhonism and Madhyamika," *Philosophy East and West* 32.1 (January, 1982), pp. 3–35.

19. Ap. Plu. *Adv. Col.* 1108f (= DK 68B156).

20. Plato, *Prot.* 166c; Plu. *Adv. Col.* 1109a. Also, Aristotle uses it in discussing Protagoras at *Met.* 1009b10–11.

21. Phillip DeLacy, "'ουσαλλον and the Antecedents of Ancient Scepticism," *Phronesis* 3 (1958), p. 61.

22. *Met.* 1062b2–7.

23. Cic. *Luc.* 28.

24. A summary is preserved *ap.* Aristocles. See H. Diels, ed., *Poetarum Philosophorum Fragmenta*, fasc. 3, pt. 1 of Wilamowitz, ed., *Poetarum Graecorum Fragmenta* (Berlin, 1901), pp. 175–176; for an English translation see Burnet in *ERE* under 'Sceptics'.

25. On the relation, or lack of relation, between this formula and various elements in Indian philosophy, see my "Pyrrhonism and Madhyamika," pp. 22–25.

26. *OP* 1.8, 12, 25–30.

27. Jacques Derrida, *Of Grammatology*, trans. G. S. Spivak (Baltimore: Johns Hopkins University Press, 1977), p. 24.

28. Friedrich Nietzsche, *Twilight of the Idols and The Antichrist*, English trans. by R. J. Hollingdale (Baltimore: Penguin Books, 1968), p. 27. Ludwig Wittgenstein, *Tractatus Logico-Philosophicus*, English trans. by D. F. Pears, and B. F. McGuiness (London: Routledge and Kegan Paul, 1961), p. 189.

29. Jacques Derrida, "The Supplement of Copula," in Josue V. Harari, ed., *Textual Strategies: Perspectives in Post-Structuralist Criticism* (Ithaca, New York: Cornell University Press, 1979), p. 91.

Empyrrhical Thinking (And Why Kant Can't)

1. Arturo Schwarz, *The Complete Works of Marcel Duchamp*, London: Thames and Hudson, 1969. Octavio Paz, *Marcel Duchamp: Appearance Stripped Bare*, 1978, reprint ed. New York: Seaver Books, 1978. Jack Burnham, "Unveiling

the Consort," *Artforum* IX nos. 7 and 8, March and April 1971; "Duchamp's Bride Stripped Bare," *Arts* 46 nos. 5, 6, and 7, March, April, and May 1972. Gianfranco Baruchello and Henry Martin, *Why Duchamp: An Essay on Aesthetic Impact*, New Paltz, New York: McPherson & Company, 1985. Pierre Cabanne, *Dialogues with Marcel Duchamp*, French ed. 1967, English trans. 1971, reprint ed. New York: Da Capo Press, 1979. André Breton, quoted in Cabanne, p. 16. Alice Goldfarb Marquis, *Marcel Duchamp, Eros, c'est la vie: A Biography*, Troy, New York: the Whitston Publishing Company, 1981. John Canaday, "Iconoclast, Innovator, Prophet," *The New York Times*, 3 October 1968, p. 51.

2. Paz, p. 184.
3. Burnham, "Unveiling the Consort, Part One," *Artforum*, March 1971, p. 59.
4. Quoted in Calvin Tomkins, *The Bride and the Bachelors*, New York: Penguin, 1976, p. 22. The Independents were particularly reluctant to accept the title of the *Nude . . .*, and asked Duchamp to change it. He preferred to withdraw the painting from the show.
5. Quoted in Robert Lebel, *Marcel Duchamp*, London: Trianon Press, 1959, p. 71.
6. Cabanne, p. 15.
7. Schwarz, pp. 98–99, 105–107, and passim.
8. Marquis, pp. 76, 80.
9. Ibid., p. 96.
10. Except for brief mentions by Schwarz, p. 33 and note 23, and Paz, p. 35.
11. Most authorities give 1913 for the commencement of Duchamp's employment at the library (for example Paz, p. 185; Cabanne, p. 114; Anne d'Harnoncourt and Kynaston McShine, eds., *Marcel Duchamp*, New York: the Museum of Modern Art, 1973, p. 14). At least one gives 1912 (Jean-Christophe Bailly, *Duchamp*, New York: Universe Books, 1986, p. 112). Lebel describes the period of employment as "early in 1913" (Lebel, p. 27). Perhaps the job began late in 1912 and ran into 1913.
12. Cabanne, p. 17.
13. Schwarz, p. 38, note 23.
14. For a discussion of Pyrrho's thought see Thomas McEvilley, "Penelope's Night Work: Negative Thinking in Greek Philosophy," *Krisis* 2, pp. 41–59, 1985.
15. Diogenes Laertius, *Lives and Sayings of the Philosophers*, trans. R. D. Hicks, Cambridge: Harvard University Press, 1966, vol. 2 p. 483.
16. Timon's remarks are preserved in a text of Aristocles found in Hermann Diels, ed., *Poetarum Philosophorum Fragmenta*, fascicle 3, part 1, of U., von Wilamowitz, ed., *Poetarum Graecorum Fragmenta*, Berlin, 1901, pp. 175–76.
17. See, for example, Paz, p. 48; Schwarz, p. 39; Marquis, p. 182; or Harriet and Sidney Janis, "Marcel Duchamp, Anti-Artist," in Joseph Masheck, *Marcel Duchamp in Perspective*, Englewood Cliffs, N.J.: Prentice Hall, Inc., 1975, p. 36.
18. Cabanne, p. 17.
19. Ibid., p. 85.
20. Quoted in Schwarz, p. 194.
21. Cabanne, p. 70.
22. Ibid., pp. 89–90.

23. Ibid., p. 48.
24. Quoted in Alexander Keneas, "The Grand Dada," the New York *Times*, 3 October 1968, pp. 1, 51,.
25. Marquis, p. 227.
26. Henri-Pierre Roché's explanation as cited by Marquis, p. 234.
27. Quoted in Marquis, p. 234.
28. Letter to Katherine Dreier, 1929, quoted in Marquis, p. 236.
29. Quoted in Marquis, p. 311.
30. See, for example, Schwarz, p. 34.
31. Ibid.
32. Ibid.
33. John Cage, for example, remarks, "I asked him once or twice, 'Haven't you had some direct connection with oriental thought?' And he always said no. . . . There weren't any specific oriental sources. But there may have been other sources." Moira and William Roth, "John Cage on Marcel Duchamp: An Interview," In Masheck, p. 154.
34. See McEvilley, "Pyrrhonism and Madhyamika," *Philosophy East and West* 32 no. 1, January 1982, pp. 3–35.
35. Schwarz, p. 34.
36. Seung Sahn, quoted in Stephen Mitchell, ed. *Dropping Ashes on the Buddha: The Teaching of Zen Master Seung Sahn*, New York: Grove, 1976, p. 135.
37. Diogenes Laertius, vol. 2, p. 477.
38. Joseph Beuys, for example, entitled a 1964 performance *Das Schweigen von Marcel Duchamp wird überbewertet* (The silence of Marcel Duchamp is overvalued).
39. Cabanne, p. 42. Duchamp was referring specifically to his work on the *Large Glass*.
40. See, for example, Keneas.
41. Marquis, p. 285.
42. In the section of the *Critique of Judgment* called "Analytic of the Beautiful" Kant posits what he calls four "moments," each comprising a related group of propositions. According to the first "moment," the pure esthetic judgment or sense of taste has nothing to do with cognition or concepts. This is the basis of Modernism's rejections of content and iconography, of its stress on form— of formalism. It is also the basis of the saying "Stupid as a painter," to which Duchamp declared his work to be the corrective when he said that he wanted to put art back into the service of the mind. (In the Kantian view, this goal is innately antiartistic, since art cannot possibly have anything to do with the mind.) Kant's second moment attributes universality to the esthetic judgment, which is held to be the same in all people—a *sensus communis*, as Kant put it. Some disagreement may of course arise, but only because of subjective distortions of a faculty everywhere constant. In this view, an artwork is objectively good or bad, right or wrong, depending on its conformity to the universal sense of taste. This is the basis of formalism's emphasis on "quality." The third moment argues that the esthetic judgment is purposeless or functionless, that it is, in other words, above the tumults and desires of worldliness. This is the basis of the formalist distinction between high and low, or pure and practical, art. It is also related to the idea of art as a higher spiritual realm, above the baser instincts. And the fourth moment, rather like

the second, posits the a priori necessity of the esthetic judgment, which, properly exercised, is declared to be necessarily correct. This is the basis of the dogmatic authoritarianism displayed by many formalist critics.

43. Cabanne, p. 48.
44. Ibid., p. 94.
45. Quoted in Paz, p. 28.
46. Quoted in Marquis, p. 96.
47. Cabanne, p. 71.
48. Quoted in Keneas.

Carried to the limit, Duchamp's theory—for it is a theory—duplicates some of what it was intended to oppose. Like the Kantian doctrine of taste, it posits something like a free, pure, absolute faculty of mind, beyond habit systems and conditioning. The danger was surely recognized by Pyrrho, who refrained from formulating theory per se, and one suspects Duchamp was aware of it too.

49. Georg Wilhelm Friedrich Hegel, *The Philosophy of Fine Art*, in Albert Hofstadter and Richard Kuhns, eds., *Philosophies of Art & Beauty*, 1964, reprint ed. Chicago: The University of Chicago Press, Phoenix Books, 1976, p. 445.
50. Friedrich Wilhelm Josef von Schelling, *System of Transcendental Idealism*, in ibid., p. 373.
51. Quoted in ibid., p. 448.
52. Duchamp sometimes fell into this kind of discourse, which was all-pervasive during his youth, as when he said, "Art opens onto regions that are not bound by time or space." (Quoted in Paz, p. 88.) But these remarks are contradicted by countless other statements he made. He felt, for example, that the cracks in the *Large Glass* brought it into the world: "It's a lot better with the breaks, a hundred times better. It's the destiny of things." (Cabanne, p. 75.)
53. Cabanne, p. 67.
54. Quoted in Tomkins, pp. 18–19.
55. Marquis, p. 206.
56. Clement Greenberg, "Counter-Avant-Garde," in Masheck, p. 124.
57. Keneas.
58. John Canaday, "Philadelphia Museum Shows Final Duchamp Work," the New York *Times*, 7 July 1969.
59. Canaday, "Iconoclast, Innovator, Prophet," p. 51.
60. Marquis, p. 312.
61. Tomkins, p. 9.
62. Cabanne, p. 104.
63. Tomkins, p. 1.
64. Quoted in Schwarz, p. 39.
65. Greenberg's definition of academic art is relevant here: "The academic artist tends, in the less frequent case, to be one who grasps the expanded expectations of his time, but complies with these too patly. Far more often, however, he is one who is puzzled by them, and who therefore orients his art to expectations formed by an earlier phase of art." In Masheck, p. 131.
66. Quoted in Marquis, p. 310.